ULTIMATE PARIS DESIGN

teNeues

ULTIMATE
PARIS
DESIGN

Editor:	Aitana Lleonart
Layout:	Ignasi Gracia Blanco
Translations:	Jay Noden (English), Sybille Schellheimer (German), Marion Westerhoff (French), Marta Alegría (Spanish), Barbara Burani (Italian)
Copy editing:	Conan Kirkpatrick (English), Sally Schreiber (English interviews), Nina Tebartz (German), Catherine Jennings (French), Maider Olarra (Spanish), Paola Lonardi (Italian)

Produced by Loft Publications
www.loftpublications.com

Published by teNeues Publishing Group

teNeues Publishing Company
16 West 22nd Street, New York, NY 10010, USA
Tel.: 001-212-627-9090, Fax: 001-212-627-9511

teNeues Verlag GmbH + Co. KG
Am Selder 37
47906 Kempen
Germany
Tel.: 0049-(0)2152 916 0, Fax: 0049-(0)2152 916 111

Press department: arehn@teneues.de

teNeues Publishing UK Ltd.
P.O. Box 402
West Byfleet, KT14 7ZF
Great Britain
Tel.: 0044-1932-403509, Fax: 0044-1932-403514

teNeues France S.A.R.L.
4, rue de Valence
75005 Paris, France
Tel.: 0033-1-55 76 62 05, Fax: 0033-1-55 76 64 19

www.teneues.com

ISBN: 978-3-8327-9139-1

© 2007 teNeues Verlag GmbH + Co. KG, Kempen

Printed in Spain

Bibliographic information published by Die Deutsche
Bibliothek. Die Deutsche Bibliothek lists this publication
in the Deutsche Nationalbibliografie; detailed bibliographic
data is available in the Internet at http://dnb.ddb.de.

Contents

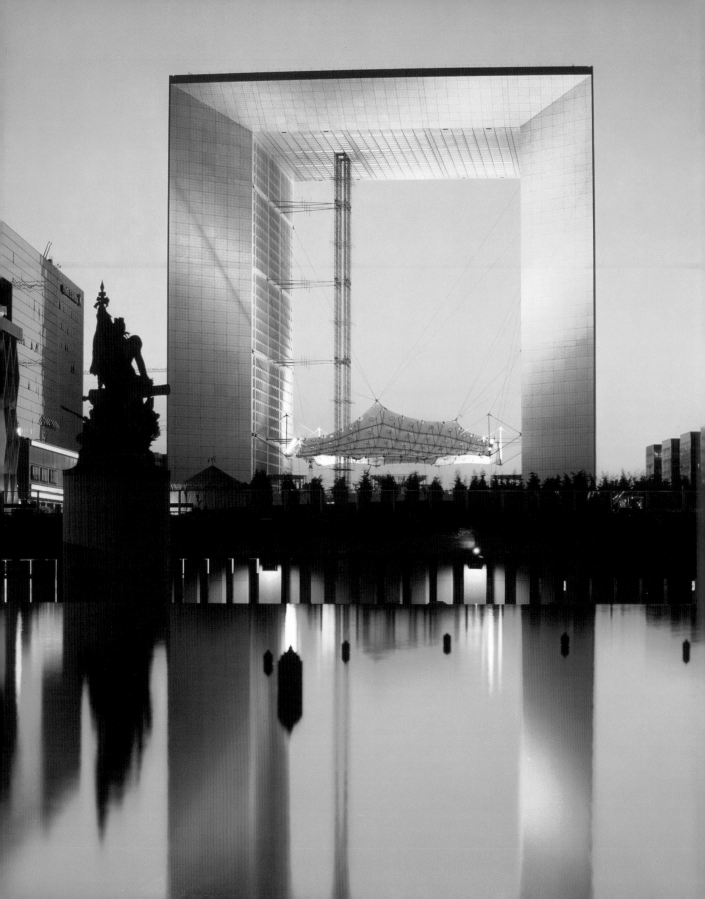

Introduction

The Illumination of Paris

Romantic, enchanting and cosmopolitan. These are the words used by many to describe the French capital. It is also known as the "City of Light" for being the first to use electric light in its buildings; providing its residents with a unique and marvelous spectacle. However, it also owes its allonym to its pioneering spirit, which it has always manifested when it comes to the arts, humanism, politics and human rights.

At the end of the 3rd century B.C., the Celtic *Parisii* tribe settled in the area known today as the Île de la Cité and gave the city its future name. After the Roman invasion, there was a period of prosperity during the Middle Ages, which saw the construction of such buildings as the cathedral of Notre-Dame, one of the emblems of the city. The Sorbonne and Sainte Chapelle followed in the 13th century. After many years of conflict, Paris re-emerged many times in the course of the Renaissance period. A large number of the buildings and monuments that give the city its splendor come from this period. During the 1920s and 1930s, Paris evolved into the world's center for the avant-garde, reaffirming its prestige among intellectuals.

One must also not forget that the most famous symbol of the city was harshly criticized when it was inaugurated in 1889 for the Universal Exposition, which was held in the French capital. Its magnitude and absolute modernity was unconvincing to many Parisians. The monument in question is, of course, the Eiffel Tower, which although not without its critics, has many more admirers, who have enjoyed its enchanting grandeur and incredible views over both banks of the Seine.

The vast cultural and historical legacy that this city possesses is undeniable; however, in recent years there have been those who wonder whether the development of Paris has come to a standstill. Some think of it as a museum–city, whose splendor will never fade; while others believe more attention should be paid to the future of a city that seems to be stuck in the past. For this reason, in the early 1980s, François Mitterrand initiated the futuristic "Grands Projets", a number of architectural initiatives designed to lend the city a new flair, such as the National Library or the glass pyramid at the Louvre.

From Montmartre, to the Arc de Triomphe, the Champs-Élysée or the Notre-Dame and crossing the bridges of the Seine towards the Saint Germain district and up to Montparnasse, the city boasts elegance and diversity. Paris has been characterized by the life that has flowed through its veins for hundreds of years, as well as by its countless artists for whom this city has been an inexhaustible source of inspiration.

This book brings together work from today's well-established architects and designers, who have been able to reach out with their projects and carry their Parisian soul to the far corners of the globe. It also presents the creations of newer artists, whose work already forms part of today's artistic panorama of the French capital.

To this very day, Paris continues to be the city of glamour, an essential escape for lovers, a reference for fashion and an inspiration to designers and architects, who, despite having conquered the world and never tiring of travel, know that Paris will always await them with its unmistakable character.

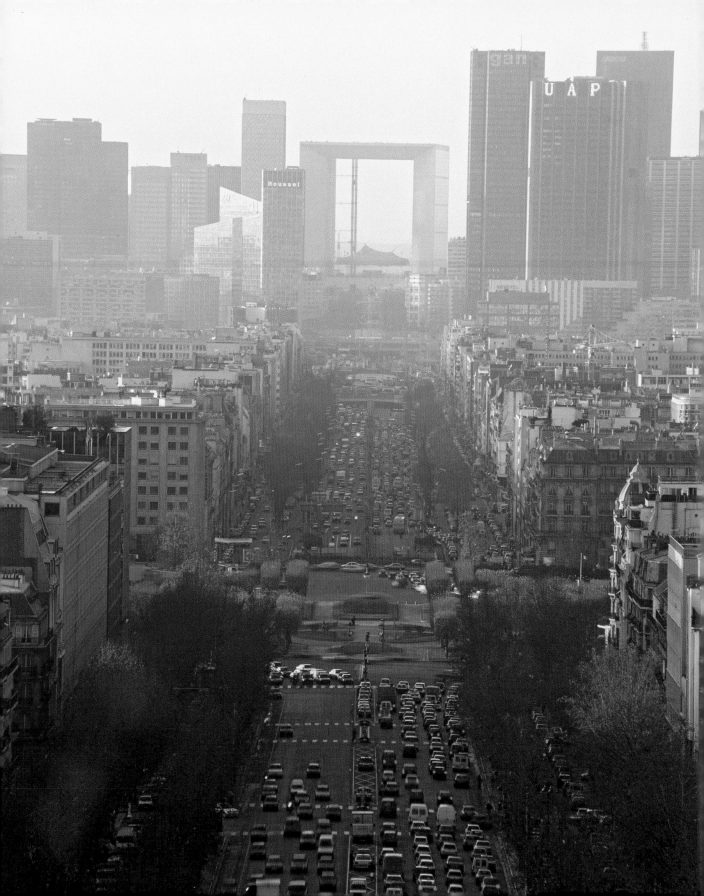

Einleitung

Leuchtendes Paris

Romantisch, bezaubernd und kosmopolitisch: So hat man die französische Hauptstadt schon oft bezeichnet. Sie wird auch „Stadt des Lichts" genannt, da sie die Erste war, deren Gebäude über elektrisches Licht verfügten und die ihren Bürgern damit ein für die damalige Zeit ungewöhnliches und wunderbares Schauspiel bot. Doch verdankt sie diesen Beinamen auch ihrem Pioniergeist, den sie immer wieder unter Beweis stellte, sowohl die Kunst, als auch den Humanismus, die Politik und die Menschenrechte betreffend.

Gegen Ende des 3. Jahrhunderts v. Chr. ließ sich der keltische Stamm der *Parisii* auf dem Gebiet der heutigen Île de la Cité nieder und gab der Stadt somit ihren späteren Namen. Nach der römischen Invasion kam es während des Mittelalters zu einer Phase des Wohlstands, während derer Gebäude wie die Kathedrale von Notre-Dame, eines der Wahrzeichen der Stadt, errichtet wurden. Die Sorbonne und die Sainte-Chapelle folgten im 13. Jahrhundert. Nach vielen Konfliktjahren lebte Paris im Zuge der Renaissance abermals auf. Während dieser Epoche wurde ein Großteil der Gebäude und Monumente errichtet, denen die Stadt ihren Glanz verdankt. Während der zwanziger und dreißiger Jahre des 20. Jahrhunderts verwandelte sich Paris in die Welthauptstadt der Avantgardekunst, was ihr Ansehen bei den Intellektuellen bekräftigte.

Man darf nicht vergessen zu erwähnen, dass das inzwischen bekannteste Symbol der Stadt zum Zeitpunkt seiner Einweihung 1889 im Rahmen der Weltausstellung, welche die französische Hauptstadt ausrichtete, heftig kritisiert wurde. Die Bedeutung und die absolute Modernität dieses Monuments überzeugten die wenigsten Pariser. Die Rede ist ganz offensichtlich vom Eiffelturm, der, obwohl er auch einige Kritiker hat, von den meisten Menschen bewundert wird, die seine bezaubernde Erhabenheit und seine unglaubliche Aussicht auf beide Seineufer genossen haben.

Das große kulturelle und historische Erbe der Stadt ist unbestreitbar. Während der letzten Jahre wurde jedoch die Frage aufgeworfen, ob die Entwicklung von Paris zum Stillstand gekommen sei. Manche halten sie für eine Museumsstadt, deren Glanz nie verblassen wird. Andere dagegen glauben, dass man der Gegenwart und der Zukunft mehr Beachtung schenken sollte in einer Stadt, die in der Zeit stillgestanden zu sein scheint. In diesem Sinne initiierte François Mitterrand Anfang der achtziger Jahre die futuristischen „Grands Projets", eine Reihe von Bauinitiativen, mit denen er der Stadt ein neues Flair verleihen wollte, wie zum Beispiel der Bibliothèque Nationale oder die Glaspyramide des Louvre.

Vom Montmartre über den Triumphbogen, die Champs-Élysées oder Notre-Dame und von den Seinebrücken, die zum Stadtviertel Saint Germain führen, bis hin zum Montparnasse: Paris ist elegant und facettenreich, geprägt von dem Leben, das seit Hunderten von Jahren in ihrem Innersten pulsiert sowie von den zahllosen Künstlern, die in dieser Stadt eine Heimat und eine unerschöpfliche Quelle der Inspiration gefunden haben.

Dieses Buch umfasst nun die modernen Werke von angesehenen Architekten und Designern, die es verstanden haben, mit ihren Projekten zu bewegen und ihre Pariser Seele in alle Winkel der Welt zu tragen. Zudem stellt es die Schöpfungen von jungen Künstlern vor, deren Arbeiten bereits Teil des aktuellen künstlerischen Panoramas der französischen Hauptstadt sind.

Paris ist noch immer die Stadt des Glamours, ein unvermeidliches Ziel für Liebende, ein Referenzpunkt für die Mode und eine Inspiration für Architekten und Designer, die, obwohl sie bereits die ganze Welt erobert haben und unermüdlich reisen, wissen, dass Paris mit seinem unverwechselbaren Wesen stets auf sie warten wird.

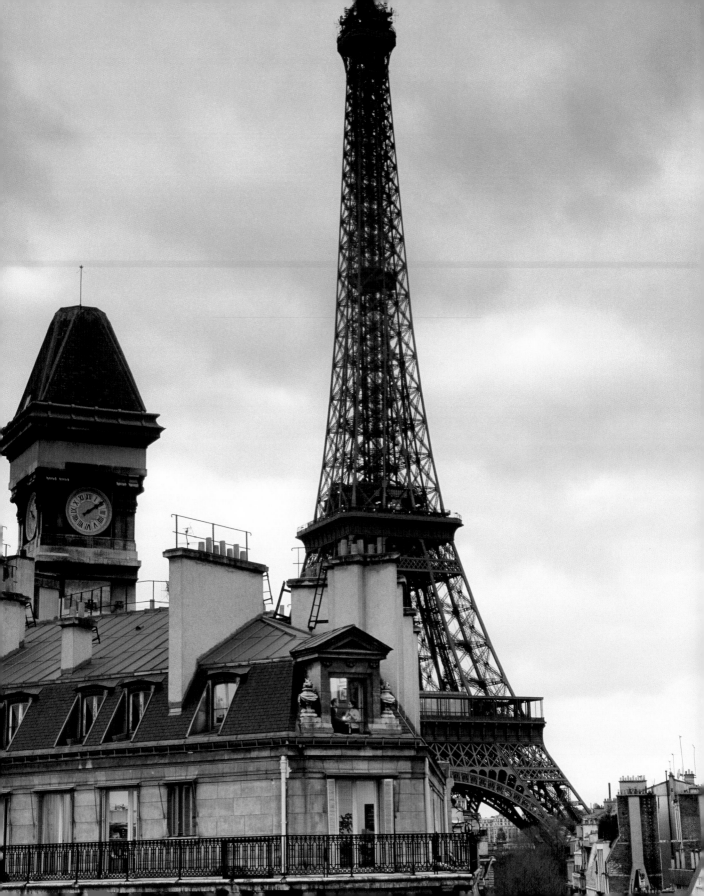

Introduction

Paris, ville lumineuse

Romantique, enchanteresse et cosmopolite. C'est ainsi que l'on a maintes fois défini la capitale française, connue aussi comme la Ville des Lumières pour avoir été la première à doter certains de ses édifices de lumières électriques, offrant ainsi à ses citoyens un spectacle merveilleux et insolite. Toutefois, ce surnom lui vient surtout de l'esprit pionnier dont elle a toujours fait preuve dans les domaines artistiques et humanistiques comme dans la politique et les droits de l'homme.

A la fin du IIIe siècle av. J.C., la tribu celte des *parisis*, qui s'installent sur le territoire connu aujourd'hui comme l'Île de la Cité, est à l'origine du futur nom de la ville. Après l'invasion romaine, s'annonce la première période prospère du Moyen-âge avec des constructions comme la cathédrale de Notre-Dame, un des emblèmes de la cité. La Sorbonne et la Sainte Chapelle suivent au XIIIe siècle. Après de longues années de conflits, Paris renaît dans le sillage de la Renaissance. De cette période datent la plupart des édifices et monuments qui confèrent à la ville toute sa splendeur. De 1920 à 1930, elle devient le centre mondial de l'avant-garde artistique, réaffirmant son prestige auprès des intellectuels.

N'oublions pas de rappeler qu'un des symboles les plus connus de la ville fût sévèrement critiqué lors de son inauguration en 1889, à l'occasion de l'Exposition Universelle célébrée dans la capitale française. En effet, sa taille et son modernisme extrême ne convaincront pas un grand nombre de Parisiens. Il s'agit, bien sûr, de la Tour Eiffel qui, mis à part quelques détracteurs, compte aujourd'hui de nombreux admirateurs, appréciant sa majesté envoûtante et les vues incroyables sur les deux rives de la Seine.

L'imposant héritage culturel de la ville est indiscutable. Toutefois, au cours des dernières années le débat s'est engagé sur le fait que Paris serait victime d'une certaine stagnation. Certains la considèrent comme une ville musée à la splendeur qui ne s'éteindra jamais ; d'autres plaident pour mettre davantage l'intérêt sur le présent et futur d'une ville qui semble s'être arrêtée dans le temps. Dans cette ligne de pensée, François Mitterrand lance, dans les années 1980, les « Grands Projets » futuristes, une série d'initiatives architecturales octroyant à la ville une allure nouvelle, à l'instar de la Bibliothèque Nationale ou la Pyramide de verre du Louvre.

De Montmartre, en passant par l'Arc de triomphe, les Champs-Élysées ou Notre-Dame, traversant ensuite les ponts de la Seine jusqu'au quartier de Saint Germain vers Montparnasse, la ville se dresse élégante et plurielle. Paris est resté modelé et façonné à la fois par la connaissance et l'observation de la vie qui depuis plusieurs centaines d'années coule dans ses entrailles, comme pour accueillir les artistes qui ont trouvé dans cette ville un foyer et une source inépuisable d'inspiration.

Cet ouvrage réunit les œuvres actuelles d'architectes et de designers consacrés qui ont su émouvoir avec leurs projets et porter leur âme parisienne vers les quatre coins du monde, aux côtés de créations d'artistes plus récents dont les travaux s'inscrivent déjà dans le panorama artistique actuel de la capitale française.

A ce jour, Paris continue d'être la ville du glamour, une escapade incontournable pour les amoureux, une référence pour la mode et source d'inspiration pour ces designers et architectes qui, en plus de conquérir et parcourir sans cesse le monde entier, savent que Paris les attend toujours, forte de l'essence unique qui la caractérise.

Introducción

Luminosa París

Romántica, encantadora y cosmopolita. Así es como se ha definido tantas veces la capital francesa, conocida también como la Ciudad de la Luz por ser la primera en dotar de luz eléctrica a algunos de sus edificios y ofrecer en aquel entonces un espectáculo maravilloso e insólito a sus ciudadanos. No obstante, este sobrenombre también se debe a su espíritu pionero que siempre ha demostrado tener, tanto en las cuestiones artísticas y humanísticas como en la política y los derechos humanos.

A finales del siglo III a. C., la tribu celta de los *parisii*, al asentarse sobre el territorio conocido hoy como Île de la Cité, dio origen al nombre que la ciudad tomaría más adelante. Después de la invasión romana, llegó la primera época de prosperidad, en la Edad Media, con edificios como la catedral de Notre Dame, uno de los emblemas de la ciudad. La Sorbona y la Santa Capilla llegarían con el siglo XIII. Pasados largos años de conflictos, París resurgió tras los pasos del Renacimiento. De este período son gran parte de los edificios y monumentos que aportan su esplendor a la ciudad. En la década de 1920 y 1930 se convirtió en el centro mundial de la vanguardia artística, reafirmando de su prestigio entre los intelectuales.

No cabe dejar de recordar que uno de los símbolos más conocidos de la ciudad fue duramente criticado en su inauguración en 1889, con ocasión de la Exposición Universal celebrada en la capital francesa. Su envergadura y absoluta modernidad no convencieron a muchos parisinos. Se trata, obviamente, de la Torre Eiffel que, si bien tiene algunos detractores, cuenta con muchos admiradores, que han disfrutado de su majestuosidad hechizadora y sus increíbles vistas hacia ambas orillas del Sena.

La vasta herencia cultural e histórica que posee la ciudad es indiscutible; no obstante, durante los últimos años se ha abierto el debate acerca del posible estancamiento que ha sufrido París. Hay quienes la consideran una ciudad-museo cuyo esplendor jamás se apagará y hay quienes abogan por prestar más atención al presente y al futuro de una ciudad que parece haber quedado detenida en el tiempo. En esta línea, François Mitterrand dio comienzo en los años 1980 a los "Grands Projets" futuristas, una serie de iniciativas arquitectónicas para conferir un nuevo aire a la ciudad, como la Biblioteca Nacional o la pirámide de cristal del Louvre.

Desde Montmartre, pasando por el Arco de Triunfo, los Campos Elíseos o Notre-Dame y cruzando los puentes del Sena hacia el barrio de Saint Germain hasta Montparnasse, la ciudad se alza elegante y plural. París ha quedado moldeada y conformada tanto por el conocimiento y la observación de la vida que desde hace cientos y cientos de años fluye por sus entrañas, como por acoger a los artistas que han encontrado en esta ciudad un hogar y una fuente inagotable de inspiración.

Este libro aúna los trabajos actuales de arquitectos y diseñadores consagrados, quienes han sabido conmover con sus proyectos y llevar su alma parisina hasta todos los rincones del mundo, además de las creaciones de artistas más noveles, cuyos trabajos sin embargo ya forman parte del panorama artístico actual de la capital francesa.

A día de hoy, París sigue siendo la ciudad del *glamour*, una escapada ineludible para los amantes, un referente para la moda y una inspiración para estos diseñadores y arquitectos quienes, a pesar de conquistar el mundo entero y viajar constantemente, saben que París les espera siempre con su inconfundible esencia.

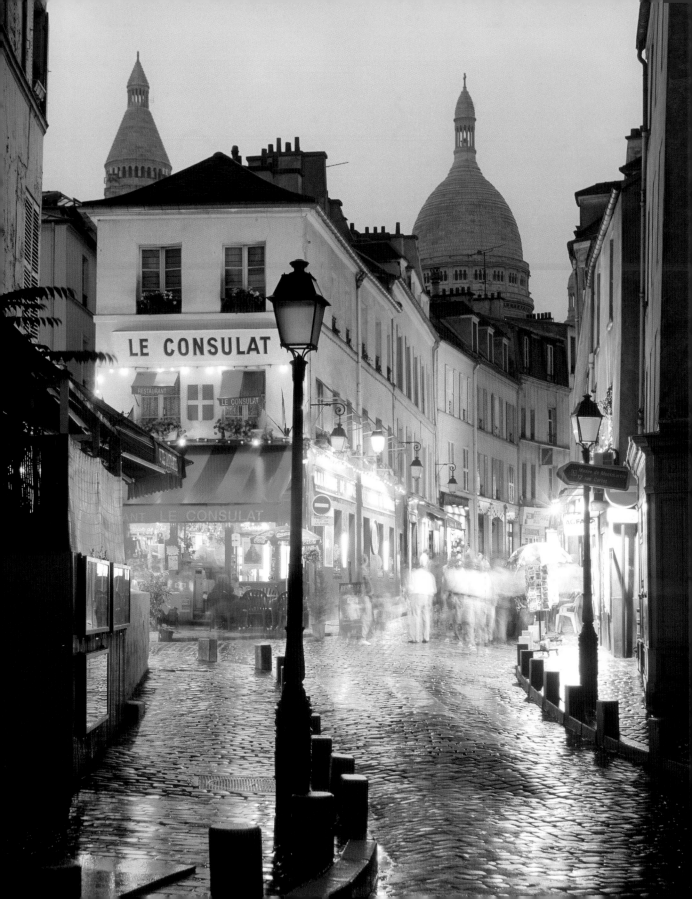

Introduzione

Luminosa Parigi

Romantica, affascinante e cosmopolita. Così è stata spesso definita la capitale francese, conosciuta anche come la "Ville Lumière" per essere stata la prima a dotare alcuni dei suoi edifici di luce elettrica, offrendo ai suoi cittadini uno spettacolo meraviglioso e insolito per l'epoca. Ciò nonostante, questo soprannome Parigi lo deve anche allo spirito pionieristico che ha sempre dimostrato, sia in ambito artistico ed umanistico, sia nel campo della politica e dei diritti umani.

Verso la fine del III secolo a.C., la tribù celtica dei *Parisii*, stanziandosi sul territorio oggi conosciuto come l'Île de la Cité, dette origine al nome che la città avrebbe fatto proprio. Dopo l'invasione romana giunse la prima epoca di prosperità, durante il Medioevo, caratterizzata da costruzioni come la cattedrale di Notre-Dame, uno degli emblemi della città. Nel XIII secolo sarebbe stata la volta della Sorbona e della Sainte Chapelle. Dopo lunghi anni di conflitti, Parigi risorse nel corso del Rinascimento. A questo periodo risalgono gran parte degli edifici e dei monumenti che conferiscono alla città il suo splendore. Durante gli anni '20 e '30 dello scorso secolo, essa si trasformò nella capitale mondiale dell'avanguardia artistica, così vedendo rafforzare il suo prestigio tra gli intellettuali.

Non bisogna dimenticare che uno dei simboli maggiormente noti della città fu duramente criticato alla sua inaugurazione nel 1889, in occasione dell'Esposizione Universale celebrata nella capitale francese. Il suo significato simbolico e la sua assoluta modernità non convinsero molti parigini. Si tratta, ovviamente, della Torre Eiffel che, nonostante abbia alcuni detrattori, può contare numerosi ammiratori che hanno goduto della sua ipnotica maestosità e dell'incredibile vista che offre su entrambe le rive della Senna.

La vasta eredità culturale e storica che possiede la città è indiscutibile, tuttavia, negli ultimi anni, si è aperto un dibattito sul quesito se l'evoluzione di Parigi stia vivendo un'impasse. C'è chi la considera una città-museo dallo splendore inestinguibile e c'è chi sostiene che in una città in cui sembra essersi fermato il tempo si dovrebbe prestare maggior attenzione al presente e al futuro. Animato da questo spirito François Mitterrand inaugurò, all'inizio degli anni '80, i futuristici "Grands Projets", una serie d'iniziative architettoniche per conferire nuovo fascino alla città, come la Biblioteca Nazionale o la piramide di vetro del Louvre.

Da Montmartre, passando per l'Arco di Trionfo, gli Champs-Elysées o Notre Dame e attraversando i ponti della Senna verso il quartiere di Saint Germain fino a Montparnasse, Parigi s'innalza elegante e ricca di sfaccettature, animata da quella vita pulsante che, da centinaia di anni, fluisce verso il suo interno, nonché dalla presenza di artisti che in questa città hanno trovato una patria d'elezione ed una fonte inesauribile d'ispirazione.

Questo libro riunisce le opere attuali di architetti e designer prestigiosi che con i loro progetti hanno saputo commuovere, portando la loro anima parigina in ogni angolo del mondo, ma anche le creazioni di artisti esordienti i cui lavori fanno già parte dell'odierno panorama artistico della capitale francese.

A tutt'oggi, Parigi continua ad essere città del *glamour*, destinazione ineludibile per gli amanti, punto di riferimento per la moda ed ispirazione per tutti i designer e gli architetti che, pur avendo già conquistato il mondo intero e nonostante siano costantemente in viaggio, sanno che Parigi li aspetterà sempre, pronta ad accoglierli con la sua inconfondibile essenza.

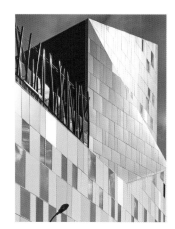 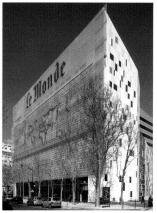 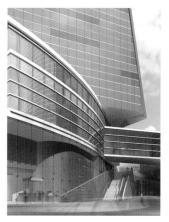 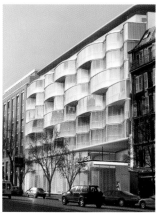

Architecture

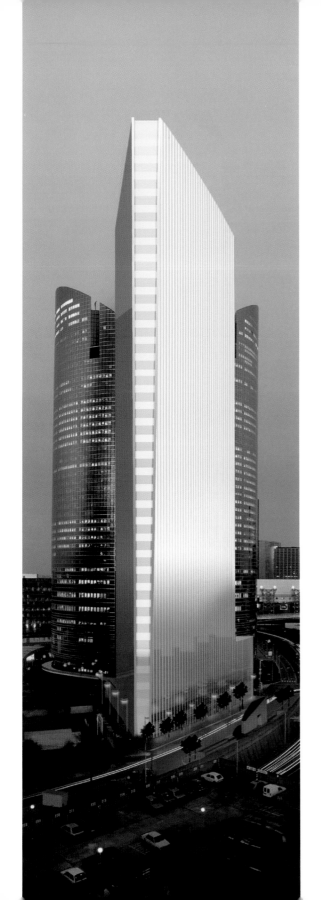

Atelier Christian de Portzamparc

Ateliers Jean Nouvel

Manuelle Gautrand Architect

Atelier Christian Hauvette

Dominique Perrault

Christian Biecher

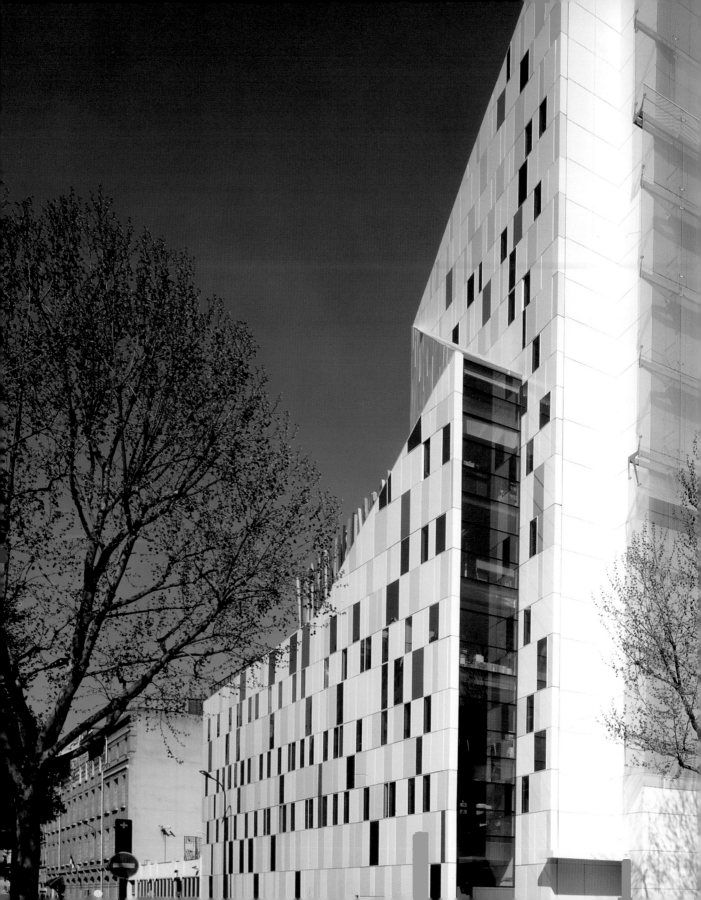

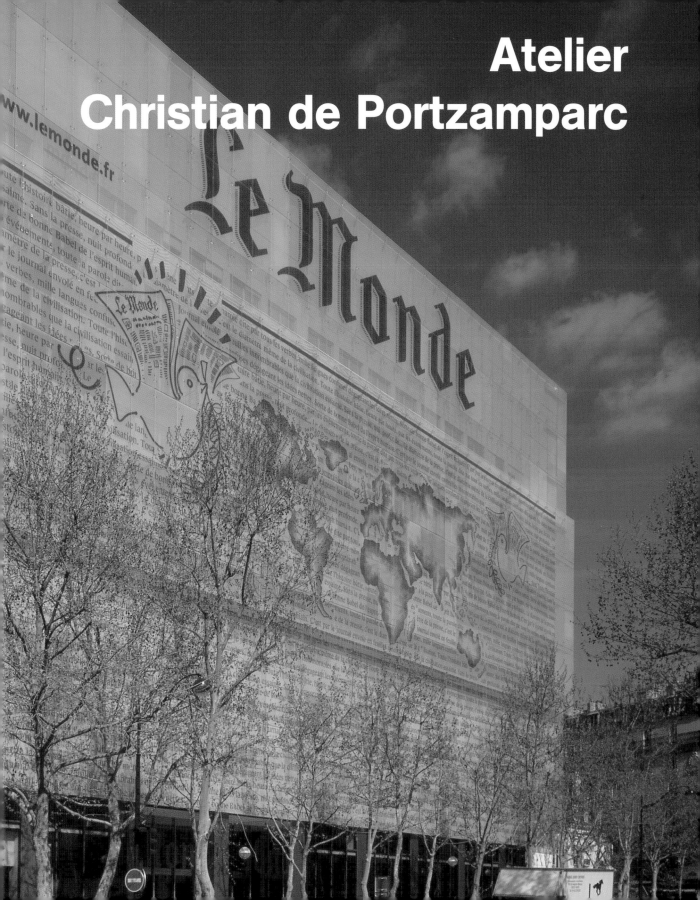

Atelier
Christian de Portzamparc

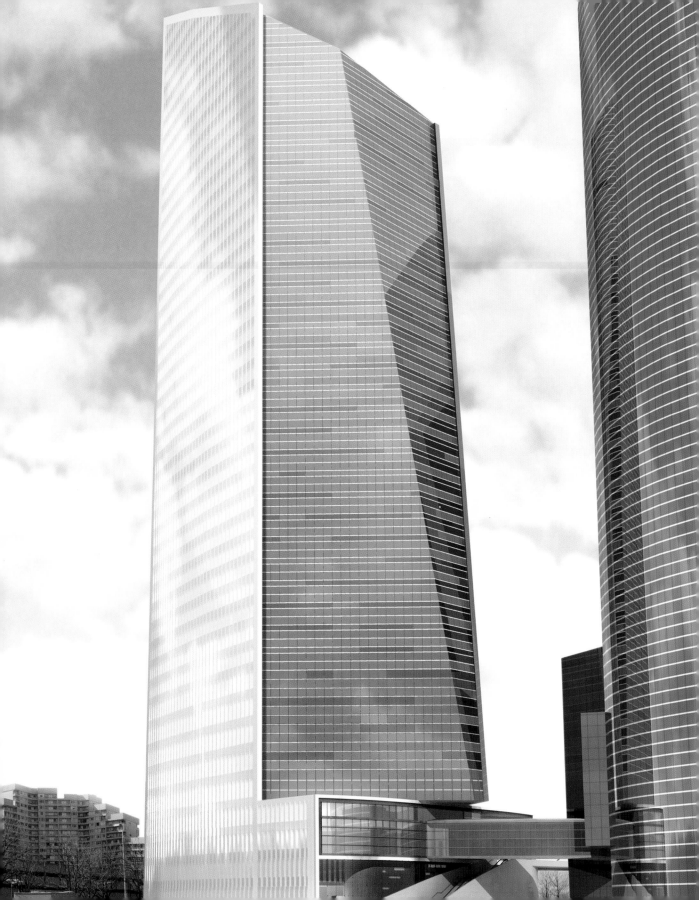

Atelier Christian de Portzamparc

1, rue de l'Aude, 75014 Paris

+33 140 64 80 00

+33 143 27 74 79

www.chdeportzamparc.com

studio@chdeportzamparc.com

Christian de Portzamparc

Christian de Portzamparc's interest in architecture was aroused by drawings of Le Corbusier. During his studies, he became aware of the rigidity and routine that characterized this field and concentrated on the social responsibility of this area. This is demonstrated by the apartment blocks that were built in the Les Hautes Formes destrict, where functionality co-exists with the creation of a pleasant and harmonious space.

Christian de Portzamparcs Interesse an der Architektur wurde durch einige Zeichnungen von Le Corbusier geweckt. Während seines Studiums bemerkte er die Starrheit und Routine, von denen diese Disziplin gekennzeichnet war, und konzentrierte sich auf die soziale Verantwortung, die sie übernehmen sollte. Beweis dafür sind die Wohnhäuser, die im Stadtviertel Les Hautes Formes entstanden sind, und in welchen die Funktionalität mit der Schaffung eines angenehmen und harmonischen Raumes einhergeht.

Des dessins de Le Corbusier ont éveillé chez Christian de Portzamparc un grand intérêt pour l'architecture. Au cours de ses études, comprenant la rigidité et la routine qui entourent cette discipline, il se concentre sur la responsabilité sociale qu'il doit assumer. Les immeubles de logements qu'il a réalisés dans le quartier des Hautes Formes, en sont la preuve : là, fonctionnalité cohabite avec création d'un espace agréable et harmonieux au cœur de la ville.

Unos dibujos de Le Corbusier suscitaron en Christian de Portzamparc un gran interés por la arquitectura. Durante sus estudios cayó en la cuenta de la rigidez y la rutina que rodeaban esta disciplina y se centró en la responsabilidad social que debía asumir. Muestra de ello son los edificios de viviendas que construyó en el barrio de Les Hautes Formes, en los que la funcionalidad convive con la creación de un espacio agradable y armónico en medio de la ciudad.

Sono stati alcuni disegni di Le Corbusier a suscitare in Christian de Portzamparc un grande interesse per l'architettura. Resosi conto della rigidezza e della ripetitività che caratterizzavano questa disciplina durante gli studi, decide di concentrarsi sulla funzione di responsabilità sociale che essa dovrebbe piuttosto svolgere. Dimostrano il suo intento i complessi residenziali da lui creati nel quartiere Les Hautes Formes in cui la funzionalità convive con la creazione di uno spazio piacevole e armonico nel cuore della città.

1944
Born in Casablanca, Morocco and moves to Marseille, France

1962-1969
Studies architecture at the École Nationale Supérieure des Beaux-Arts in Paris, France

1970
Opens his office in Paris, France

1975-1979
Les Hautes Formes neighborhood in Paris, France

1994
Wins the Pritzker prize of Architecture

Interview | Christian de Portzamparc

Which do you consider the most important work of your career? If I take into account the last few years I would say that the Philharmonie project in Luxembourg or, more recently the Cidade da Musica in Rio.

In what ways does Paris inspire your work? I'm inspired by other cities. Paris is a part of me.

Does a typical Paris style exist, and if so, how does it show in your work? Paris style transpires within my projects, whether consciously or unconsciously. When style references and common standards seem to vanish, they are still part, for better or for worse, of our patrimony and as such of our subconscious.

How do you imagine Paris in the future? I am working on conceiving a vision of Paris opening onto the future while preserving the essential character of the city.

Welches Werk halten Sie für das wichtigste Ihrer Karriere? Wenn ich auf die letzten Jahre zurückblicke, würde ich sagen: das Philharmonie-Projekt in Luxemburg, oder, in jüngster Zeit, die Cidade da Musica in Rio.

Wie inspiriert Paris Ihre Arbeit? Ich werde von anderen Städten inspiriert. Paris ist ein Teil von mir.

Gibt es einen typischen Pariser Stil, und wenn ja, wie macht dieser sich in Ihrer Arbeit bemerkbar? Der Pariser Stil durchdringt meine Projekte, bewusst oder unbewusst. Auch wenn Standards und Bezugspunkte des Designs zu verschwinden scheinen, sind sie doch noch Teil unseres Erbes und unseres Unterbewusstseins, im guten wie im schlechten Sinn.

Wie stellen Sie sich Paris in der Zukunft vor? Ich arbeite daran, eine Vision von einem Paris zu entwerfen, das offen für die Zukunft ist und gleichzeitig den essentiellen Charakter der Stadt bewahrt.

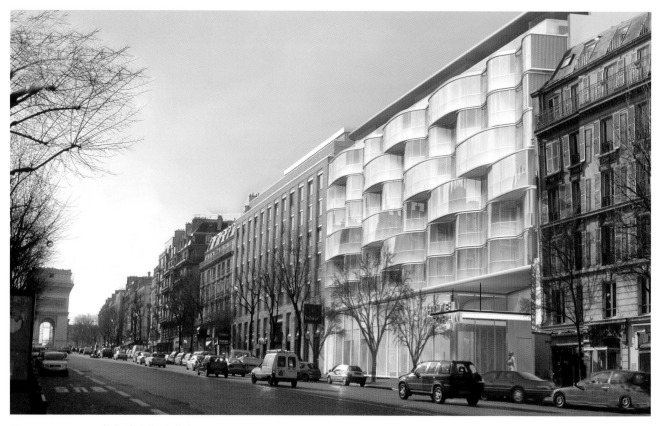

Quelle est à vos yeux l'œuvre la plus importante de votre carrière ? Si je tiens compte des dernières années, je dirais que c'est le projet de la Philharmonie au Luxembourg ou, encore plus récemment la Cidade da Musica de Rio.

Dans quelle mesure votre œuvre artistique s'inspire-t-elle de Paris ? Je suis inspiré par d'autres villes. Paris fait partie de moi-même.

Existe-t-il un style typiquement parisien, et si oui, comment se manifeste-t-il dans votre œuvre ? Le style de Paris imprègne mes projets, que ce soit consciemment ou inconsciemment. Lorsque les références de style et les standards communs semblent disparaître, ils font toujours partie, pour le meilleur ou pour le pire, de notre patrimoine et en tant que tel de notre subconscient.

Comment imaginez-vous le Paris du futur ? Je travaille sur la conception d'une vision de Paris s'ouvrant sur l'avenir tout en préservant le caractère essentiel de la ville.

¿Cuál cree que es el trabajo más importante de su carrera? Si tengo en cuenta los últimos años, destacaría la Filarmónica de Luxemburgo o, más recientemente, la Cidade da Musica en Río.

¿Cómo le inspira París en su trabajo? Me inspiran otras ciudades. París es una parte de mí.

¿Existe un estilo típico de París? Y si es así, ¿cómo se muestra éste en su obra? El estilo de París queda reflejado en mis proyectos, sea de manera consciente o inconsciente. Cuando las referencias de estilo y los estándares comunes parecen desaparecer, siguen todavía formando parte, para bien o para mal, de nuestro patrimonio y por tanto de nuestros subconscientes.

¿Cómo se imagina París en un futuro? Estoy trabajando para imaginarme una visión de París que se abra al futuro y que a la vez conserve el carácter esencial de la ciudad.

Quale ritiene sia l'opera più importante della sua carriera? Considerando gli ultimi anni, direi il progetto Philharmonie in Lussemburgo o, più recentemente, la Cidade da Musica a Rio.

In che modo Parigi ispira il suo lavoro? Sono ispirato da altre città. Parigi è una parte di me.

Esiste un tipico "stile parigino"? Se sì, come si manifesta nel suo lavoro? Lo stile di Parigi si rivela attraverso i miei progetti, consapevolmente o inconsapevolmente. Sebbene i riferimenti stilistici e gli standard comuni sembrino scomparire, essi continuano a far parte del nostro patrimonio e, di conseguenza, del nostro subconscio, nel bene e nel male.

Come immagina Parigi nel futuro? Sto lavorando per concepire una visione di Parigi che si apra al futuro conservando l'essenza caratteristica della città.

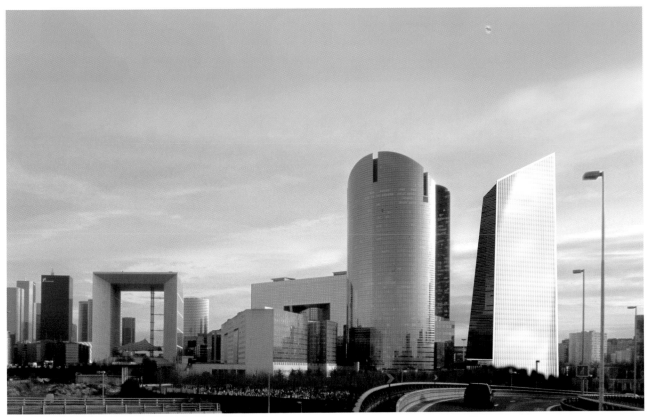

Le Monde

Year: 2001-2004

Photographs: © Atelier Christian de Portzamparc, Kamel Khalfi, Nicolas Borel

This project was about converting a building from the 1970s on Boulevard Auguste Blanqui in Paris into office space for the daily "Le Monde". The original height of the south façade has been maintained, but a diagonal cut was made through the building and side structures were added in order to counterbalance the gradient. The entrance consists of a large glass front with two levels and, on the main façade, the glass walls show a text by Victor Hugo about the freedom of the press.

Mit diesem Projekt sollte ein Gebäude der siebziger Jahre auf dem Boulevard Auguste Blanqui in Paris zum Bürogebäude der Tageszeitung „Le Monde" umgewandelt werden. Die ursprüngliche Höhe der Südfassade blieb erhalten, aber es wurden ein diagonaler Schnitt durch das Gebäude vorgenommen und seitliche Strukturen angefügt, um das Gefälle auszugleichen. Der Eingangsbereich besteht aus einer langen Glasfront mit zwei Ebenen. Auf der Hauptfassade zeigen die Glaswände einen Text Victor Hugos über die Pressefreiheit.

Ce projet concerne la transformation d'un édifice des années soixante-dix en bureaux du quotidien « Le Monde » sur le boulevard Auguste Blanqui, à Paris. La hauteur initiale de la façade sud a été maintenue, tout en réalisant une coupe en diagonale et ajoutant des structures latérales épousant la dénivellation. L'entrée présente une grande verrière s'élevant sur deux niveaux et sur la façade principale les écrans de verre gravé présentent le texte de Victor Hugo consacré à la liberté de la presse.

Este proyecto ha supuesto la transformación de un edificio de los años setenta en las oficinas del diario "Le Monde" en el bulevar Auguste Blanqui de París. Se ha mantenido la altura inicial de la fachada sur, pero se ha realizado un corte en diagonal y se han añadido unas estructuras laterales acordes con el desnivel. La entrada presenta una larga cristalera de dos niveles de altura y en la fachada principal las pantallas de cristal grabado muestran el texto que Victor Hugo dedicó a la libertad de prensa.

Questo progetto ha implicato la trasformazione di un edificio degli anni '70 negli uffici del quotidiano "Le Monde" nel Boulevard Auguste Blanqui a Parigi. Pur mantenendo l'altezza originale della facciata sud, essa è stata rinnovata da un taglio in diagonale e dall'inserimento di strutture laterali per compensare il dislivello. L'ingresso presenta una lunga vetrata con un'altezza a due livelli. La facciata principale è ornata da pannelli di vetro inciso che riportano il testo di Victor Hugo dedicato alla libertà di stampa.

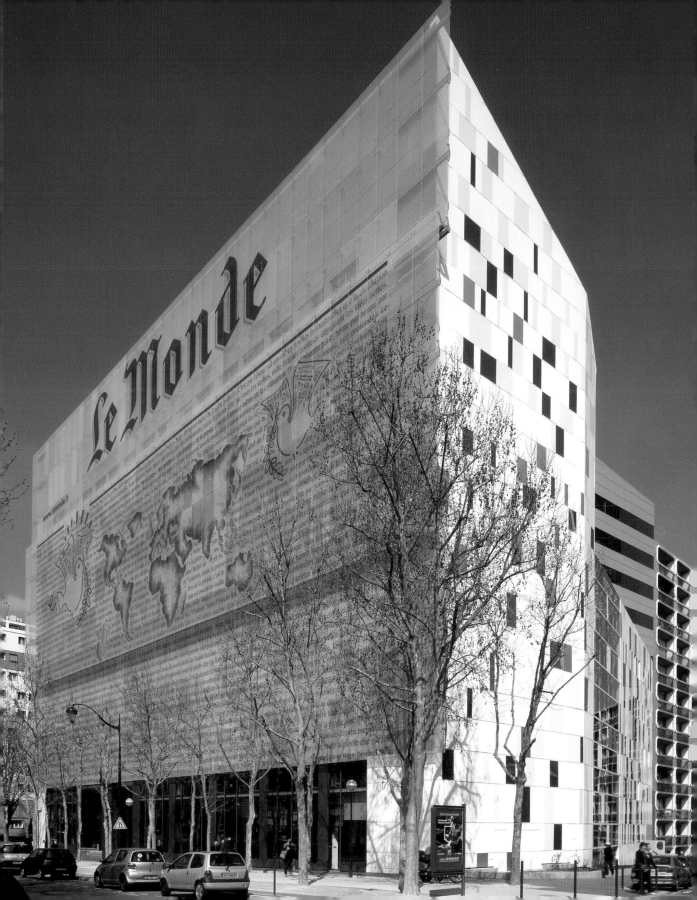

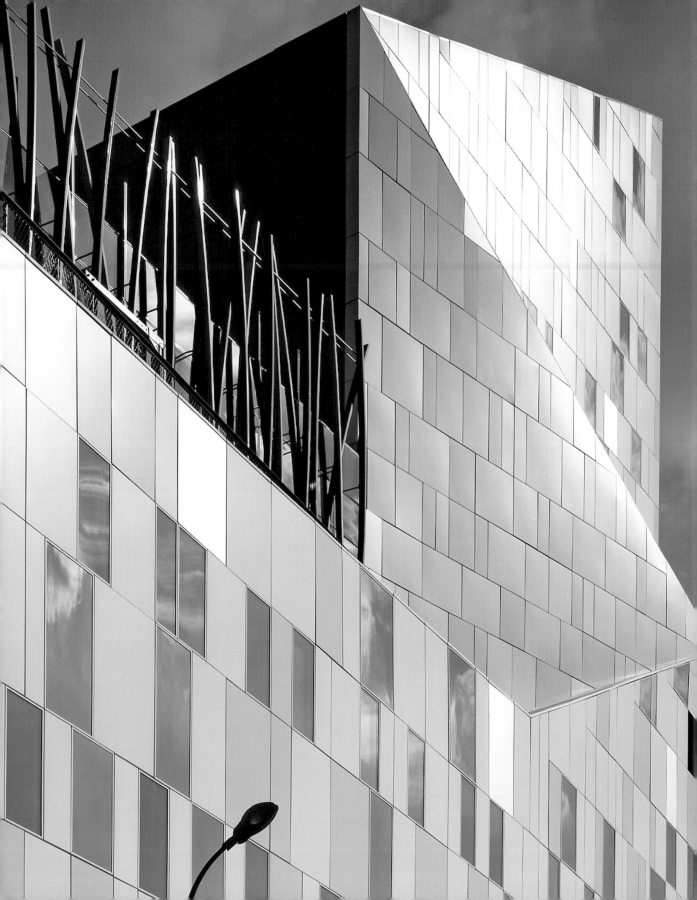

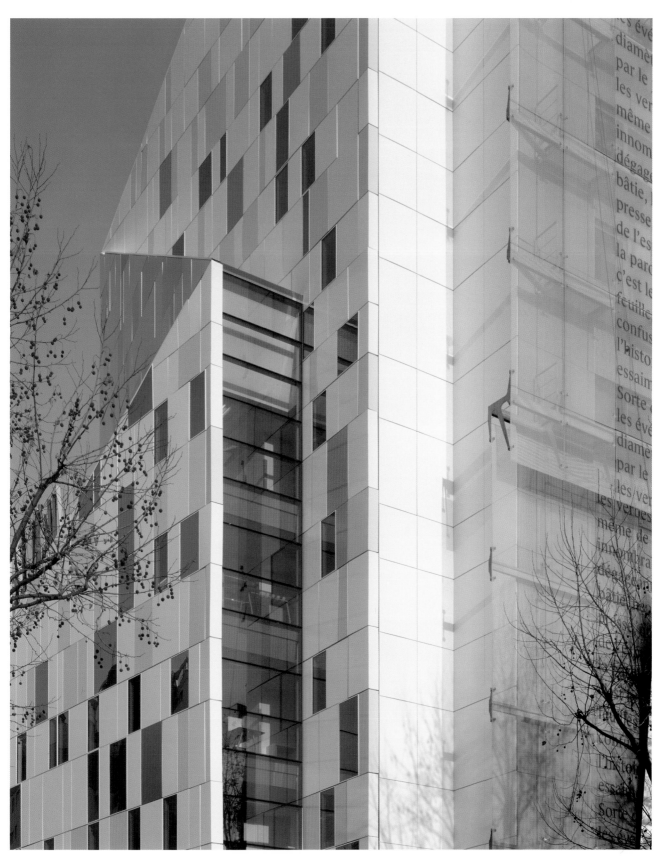

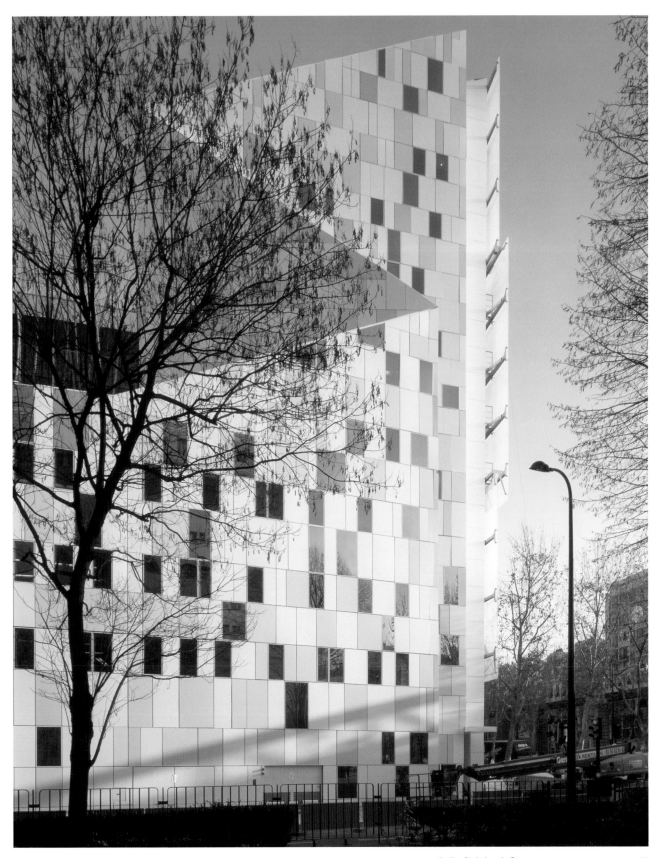

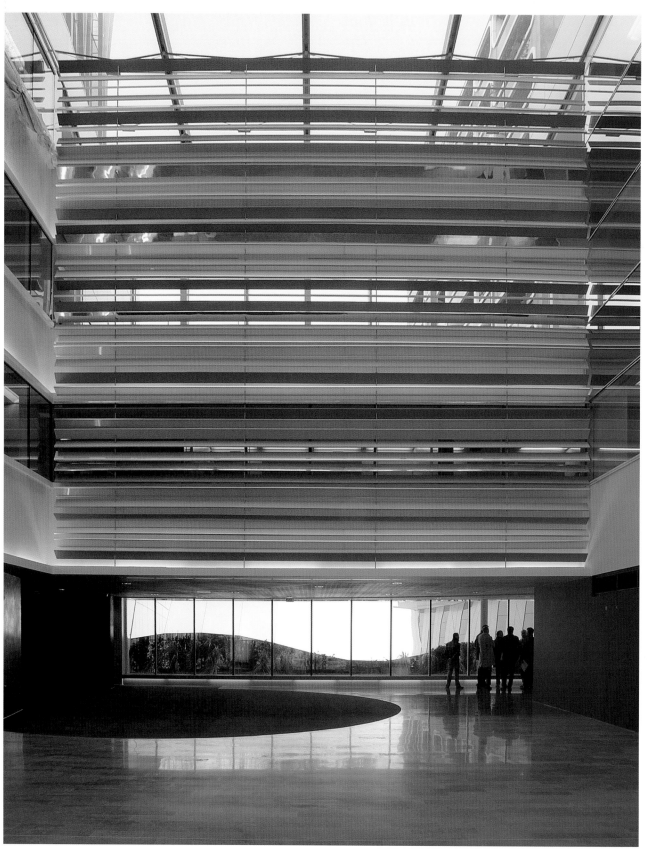

Atelier Christian de Portzamparc

Rendering

Sketches

Granite Tower

Year: Under construction

Photographs: © Atelier Christian de Portzamparc

Designated for office space, this granite tower stands in the district of La Défense and reaches a height of 590 ft. Although it appears to be an independent building, it is actually connected to the two adjacent towers. Together they form a triangle with the granite tower as the vortex. While the front consists of smooth surfaces that join in a rounded angle, the structure shows two prismatic flanks looking towards the cylindrical towers. The functional requirements to the structure have been fulfilled with this simple design through beauty and grace.

Dieser 180 m hohe Granitturm, der Büros beherbergen soll, wird im Bezirk La Défense errichtet. Obwohl er wie ein eigenständiges Gebäude aussieht, ist er in Wirklichkeit mit den beiden benachbarten Türmen verbunden. Zusammen bilden sie ein Dreieck, in dessen Scheitelpunkt der Granitturm steht. Während die Vorderfront aus zwei glatten, stumpf zusammentreffenden Flächen besteht, weist der Bau zu den zylindrischen Türmen hin prismaförmige Flanken auf. Die funktionellen Anforderungen an den Bau wurden in diesem schlichten Entwurf formschön-elegant erfüllt.

Cette tour de granit, destinée à des bureaux, s'élève dans le quartier de La Défense et atteint 180 m de haut. Sous une apparence d'édifice autonome, elle représente le versant d'un triangle formé avec les tours voisines auxquelles elle est reliée. Alors que la partie avant est composée de deux surfaces lisses qui se joignent en formant un angle arrondi, l'édifice exhibe deux flancs prismatiques tournés vers les tours cylindriques. Il combine cette esthétique aux besoins fonctionnels grâce à un canevas simple mais élégant.

Esta torre de granito destinada a oficinas se erige en el distrito de La Défense y alcanza los 180 m de altura. A pesar de su apariencia de edificio autónomo, representa el vértice de un triángulo formado junto con las torres vecinas, a las que está unido. Mientras la parte delantera esta compuesta por dos superficies lisas que se juntan en un ángulo redondeado, el edificio exhibe dos flancos prismáticos que miran hacia las torres cilíndricas. El edificio combina esta estética con las necesidades funcionales gracias a un boceto sencillo pero elegante.

Questa torre di granito destinata ad uffici si erge nel distretto de La Défense. Con i suoi 180 m di altezza essa appare a prima vista come un edificio autonomo; in realtà la Torre non è che la punta di un triangolo formato con le torri vicine con le quali crea un tutt'uno. Mentre la parte anteriore è composta da due superfici lisce che si uniscono in un angolo arrotondato, l'edificio della Torre di granito esibisce due fianchi prismatici, rivolti alle torri cilindriche. L'edificio concilia estetica e necessità funzionali grazie ad un disegno semplice ma elegante.

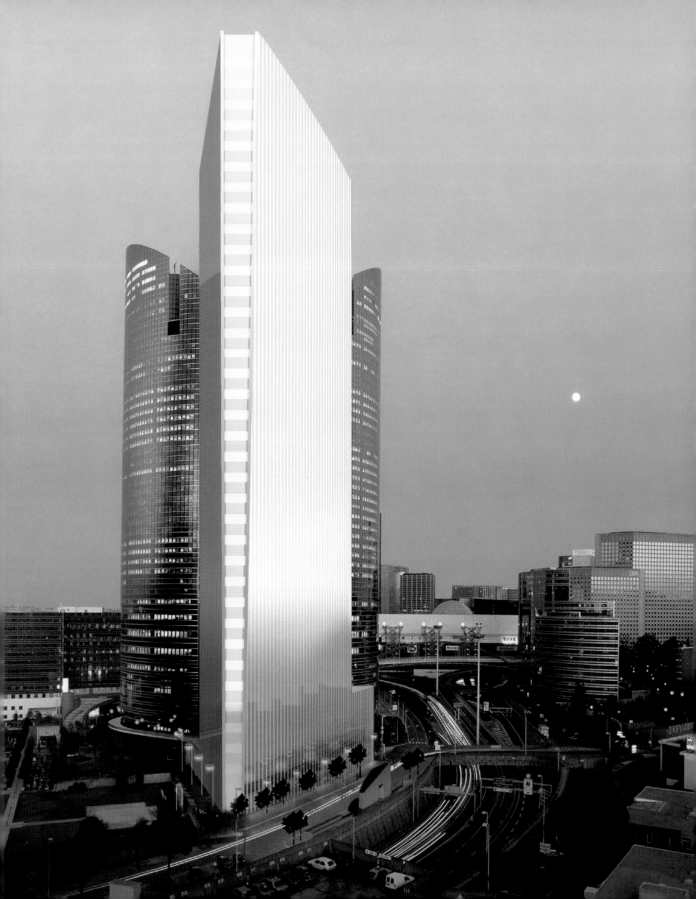

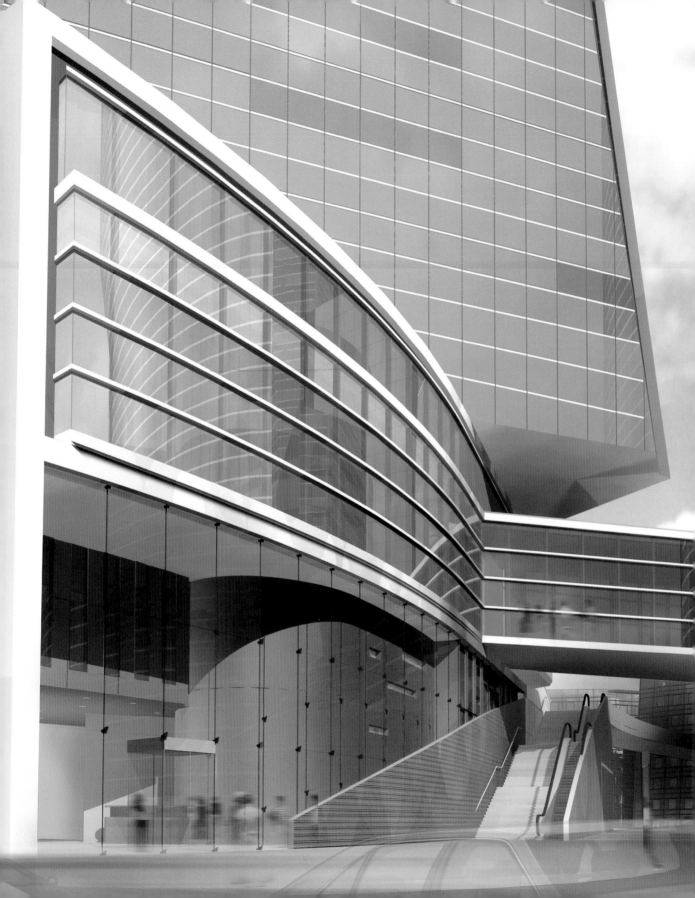

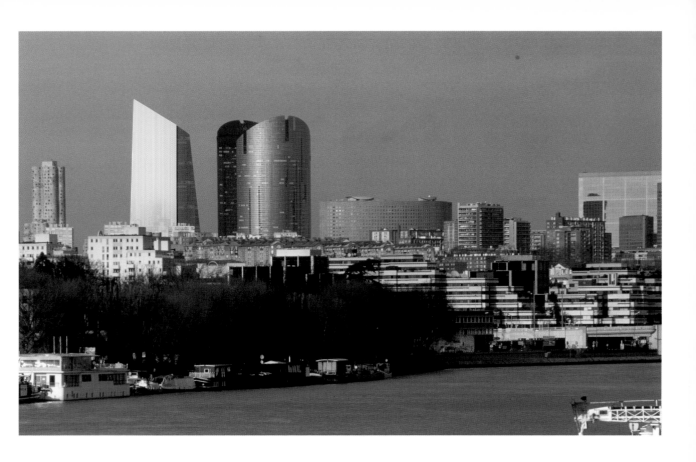

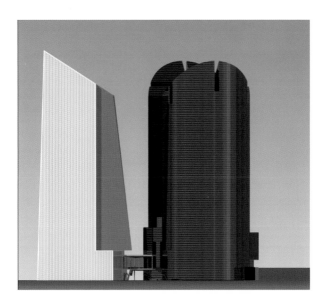

Rendering

Altarea Wagram

Year: Under construction
Photographs: © Atelier Christian de Portzamparc

The Altarea Wagram hotel is located in the old Théâtre de l'Empire near the Arc de Triomphe. Its design contrasts drastically with the adjacent stone buildings, creating an element of light and transparency in the city. Its façade of undulating glass panes lends a feeling of ease and brightness to the six stories. Behind the entrance, a sloping garden leads directly to the lobby of the hotel.

Das Hotel Altarea Wagram befindet sich im ehemaligen Théâtre de l'Empire in der Nähe des Triumphbogens. Das Design steht in starkem Kontrast zu den benachbarten Gebäuden aus Stein und erschafft ein neues lichtes und transparentes Element in der Stadt. Die Fassade aus gewelltem Glas verleiht den sechs Stockwerken Leichtigkeit und Helligkeit. Hinter dem Eingangsbereich führt ein abfallender Garten direkt in die Lobby des Hotels.

L'hôtel Altarea Wagram est situé dans l'ancien Théâtre de l'Empire, tout proche de l'Arc de Triomphe. Son design contraste radicalement avec les édifices en pierre contigus et se transforme en élément de lumières et transparences au cœur de la ville. Les volumes de la façade, aux vitres ondulées, confèrent légèreté et luminosité aux six étages de suites. Dans le prolongement de l'entrée, un jardin en pente mène directement au hall de l'hôtel.

El hotel Altarea Wagram está ubicado en el antiguo Théâtre de l'Empire, muy cerca del Arco de Triunfo. Su diseño contrasta drásticamente con los edificios de piedra colindantes y se convierte en elemento de luz y transparencias en la ciudad. Los volúmenes de la fachada, de cristales ondulados, aportan ligereza y luminosidad a los seis niveles de suites. Tras la entrada, un jardín que forma una pendiente conduce directamente hasta el vestíbulo del hotel.

L'hotel Altarea Wagram è ubicato nell'antico Théâtre de l'Empire, nelle immediate vicinanze dell'Arco di Trionfo. Il suo design contrasta drasticamente con quello degli edifici in pietra adiacenti, trasformandolo in un elemento di luce e trasparenza nella città. I volumi della facciata, con vetri ondulati, conferiscono leggerezza e luminosità ai sei piani dell'edificio. Dietro l'ingresso, un giardino in pendenza conduce direttamente alla lobby dell'hotel.

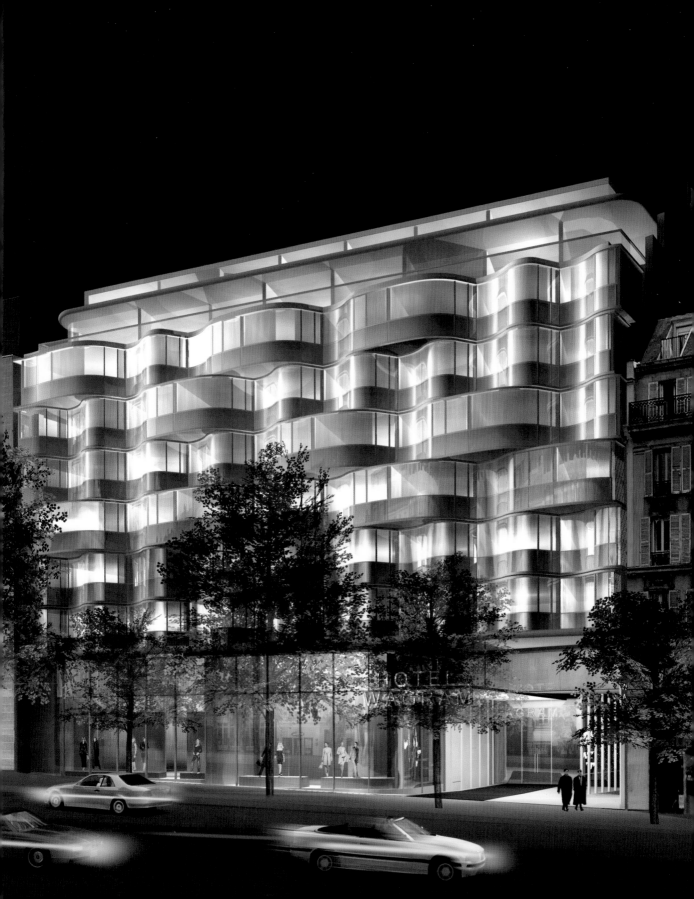

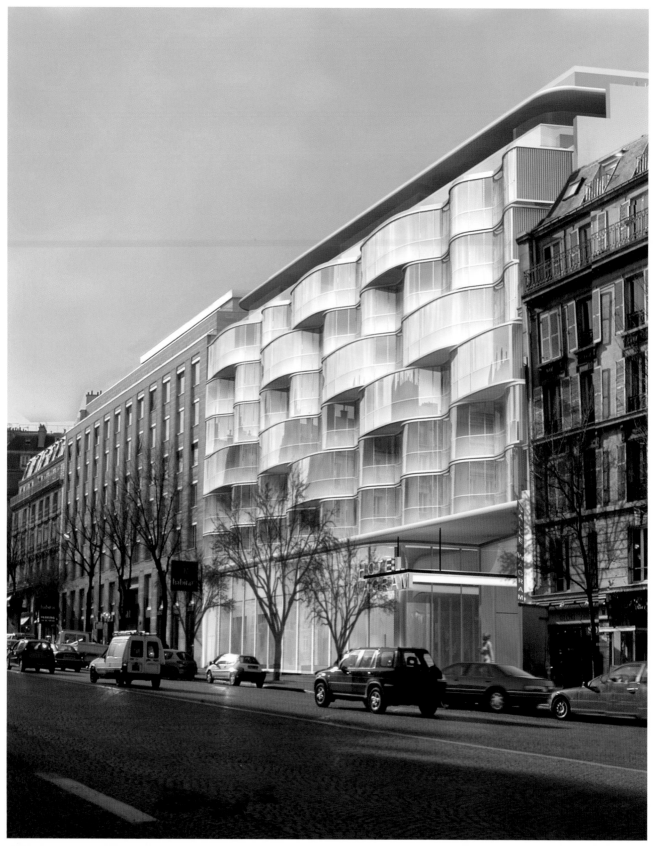

Atelier Christian de Portzamparc

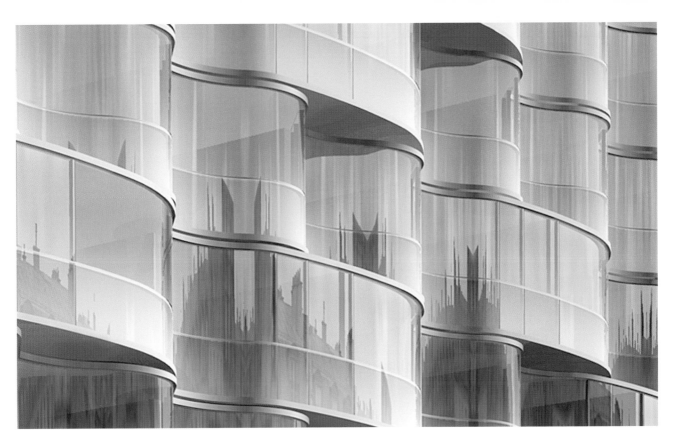

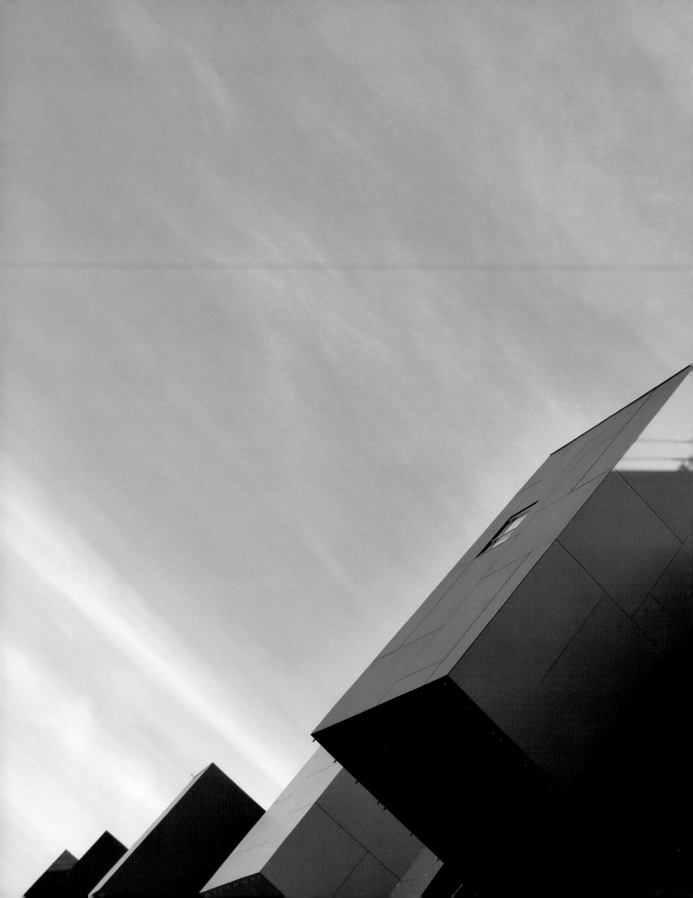

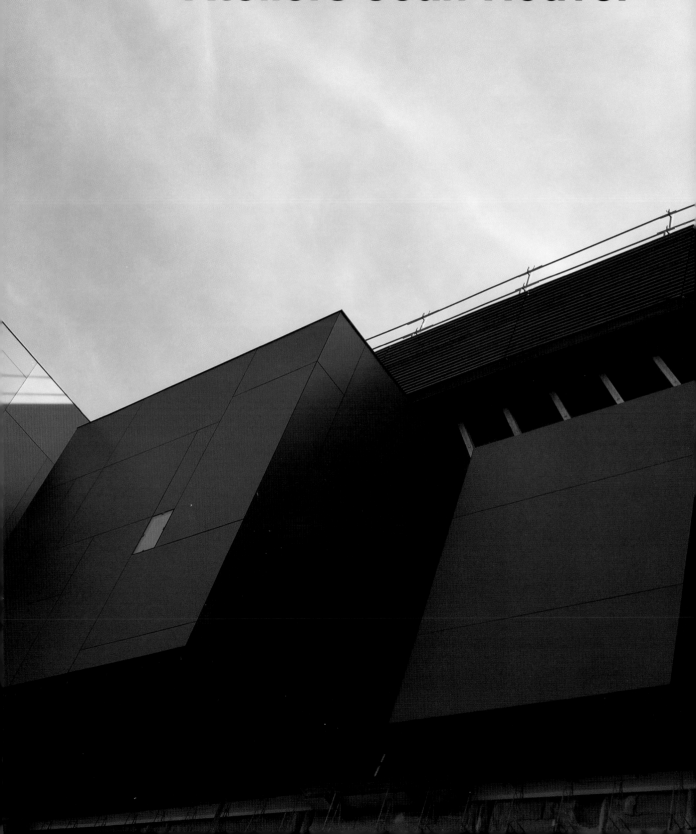

Ateliers Jean Nouvel

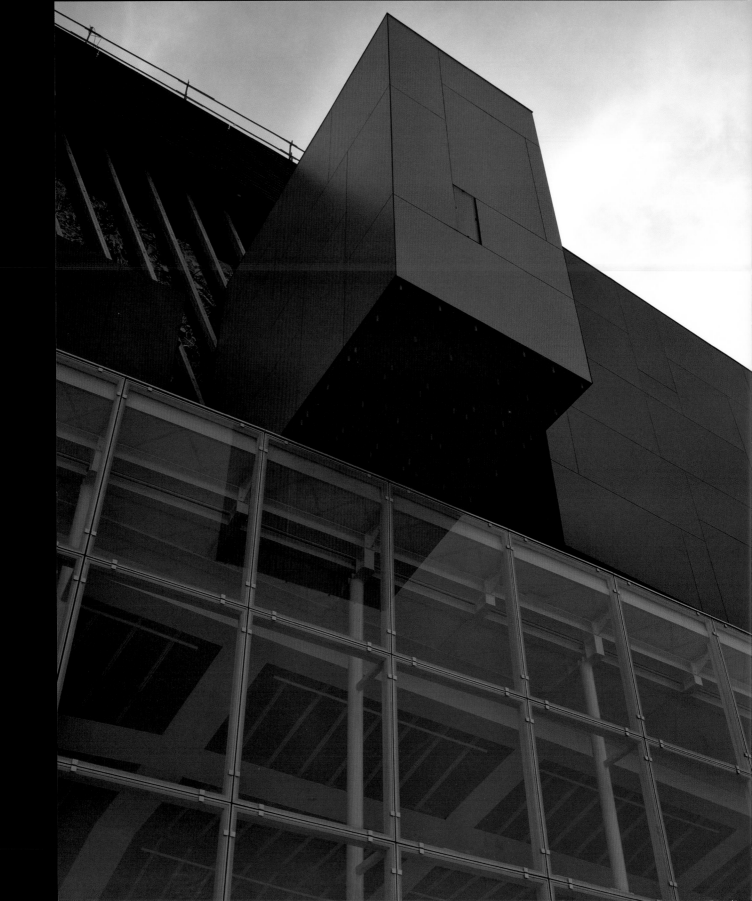

Ateliers Jean Nouvel

10, Cité d'Angoulême, 75011 Paris

+33 149 23 83 83

+33 143 14 81 10

www.jeannouvel.com

info@jeannouvel.fr

Jean Nouvel

The career of this architect appears to be unstoppable since he began directing his own projects in 1970. After participating in a host of construction projects and competitions, and being a partner in various architectural studios, Nouvel founded his own studio called Ateliers Jean Nouvel. It has been recognized with numerous prizes and awards owing to Nouvel's highly individual architectural trade language.

Die Karriere dieses Architekten scheint unaufhaltsam, seitdem er 1970 anfing, seine eigenen Projekte zu leiten. Nachdem er an verschiedenen Bauten mitgewirkt und an Wettbewerben teilgenommen hatte und Teilhaber verschiedener Architekturbüros gewesen war, gründete er sein eigenes Studio, das Ateliers Jean Nouvel. Dieses wurde mit einer Vielzahl von Preisen und Anerkennungen ausgezeichnet ob seiner sehr eigenen architektonischen Sprache.

La carrière de cet architecte n'a cessé de monter en flèche depuis qu'il commence à diriger ses projets, en 1970. Après avoir participé à nombre d'ouvrages et de concours et s'être associé à divers cabinets d'architecture, Nouvel devient autonome et fonde son propre studio, les Ateliers Jean Nouvel. Cet atelier est récompensé par de nombreux prix et distinctions, fruits de son langage architectural si personnel.

La carrera de este arquitecto ha sido imparable desde que empezó a dirigir sus proyectos, en 1970. Tras participar en múltiples obras y concursos, y haber sido socio de varios estudios de arquitectura, Nouvel se independizó y fundó su taller, el Ateliers Jean Nouvel, distinguido por los numerosos premios y reconocimientos que ha cosechado gracias a su lenguaje arquitectónico tan personal.

La carriera di questo architetto è in costante ascesa da quando ha cominciato a dirigere i propri progetti nel 1970. Dopo aver partecipato a diverse opere e concorsi ed essere stato socio di vari studi d'architettura, Nouvel si mette in proprio e fonda il suo atelier, l'Ateliers Jean Nouvel. L'atelier è stato avallato dai numerosi premi e riconoscimenti raccolti grazie ad un linguaggio architettonico estremamente personale.

1945
Born in Fumel, France

1976
Co-founder of the French architect movement Mars 1976

1980
Platinum Medal of the Académie d'Architecture Française

1987
Arab World Institute, Paris, France

1994
Establishes the Atelier Jean Nouvel

2000
Torre Agbar, Barcelona, Spain

2001
Royal Gold Medal of the Royal Institute of British Architecture (RIBA)

2006
Designer of the year By Salon Maison&Objet

Interview | Jean Nouvel

Which do you consider the most important work of your career? All architectural projects that make the space vibrate and change with the wind, the sun...

In what ways does Paris inspire your work? I've always been moved and inspired by light, such as the way the sun penetrates churches like it does in Sainte-Chapelle or Pierre Chareau's Glass House.

Does a typical Paris style exist, and if so, how does it show in your work? I always play with light, transparencies, textures, etc. all of which can be found in Paris. However, for each project I start by studying the place, its culture, its topography to create a dialogue with the surroundings.

How do you imagine Paris in the future? Paris is a city with a lot of history. The problem is new cities without any surroundings for inspiration and with new buildings that do not strike a conversation.

Welches Werk halten Sie für das wichtigste Ihrer Karriere? Alle architektonischen Projekte, die den Raum zum Vibrieren bringen und sich mit dem Wind und der Sonne verändern.

Wie inspiriert Paris Ihre Arbeit? Ich wurde schon immer vom Licht bewegt und inspiriert, beispielsweise von der Art und Weise, wie die Sonne in Kirchen einfällt, wie in Saint-Chapelle oder in Pierre Chareaus Glass House.

Gibt es einen typischen Pariser Stil, und wenn ja, wie macht dieser sich in Ihrer Arbeit bemerkbar? Ich spiele immer mit Licht, Transparenz, Texturen etc., und all das kann man in Paris finden. Allerdings beginne ich jedes Projekt, indem ich die Orte, ihre Kultur, ihre Topographie genau untersuche, um einen Dialog mit der Umgebung zu schaffen.

Wie stellen Sie sich Paris in der Zukunft vor? Paris ist eine Stadt mit viel Geschichte. Das Problem sind neue Städte ohne inspirierende Umgebung und mit neuen Gebäuden, die kein Gespräch ermöglichen.

Quelle est à vos yeux l'œuvre la plus importante de votre carrière ? Tous les projets d'architecture qui font vibrer l'espace, le font changer avec le vent, le soleil …

Dans quelle mesure votre œuvre artistique s'inspire-t-elle de Paris? J'ai toujours été ému et inspiré par la lumière, à l'instar du soleil qui pénètre les églises comme la Sainte-Chapelle ou la Maison de Verre de Pierre Chareau.

Existe-t-il un style typiquement parisien, et si oui, comment se manifeste-t-il dans votre œuvre ? Je joue toujours avec la lumière, les transparences, les textures, etc. et tout cela existe à Paris. Toutefois, à chaque projet, je commence par étudier l'endroit, sa culture, sa topographie pour instaurer un dialogue avec les alentours.

Comment imaginez-vous le Paris du futur ? Paris est une ville saturée d'histoire. Le problème vient des nouvelles villes sans aucun environnement pour source d'inspiration, avec de nouveaux immeubles qui ne nous parlent pas.

¿Cuál cree que es el trabajo más importante de su carrera? Todos los proyectos arquitectónicos que logren que el espacio vibre y cambie con el viento y el sol.

¿Cómo le inspira París en su trabajo? Siempre me he sentido inspirado y conmovido por la luz, por la forma en la que el sol se filtra en las iglesias como en la Santa Capilla o la Casa de Cristal de Pierre Chareau.

¿Existe un estilo típico de París? Y si es así, ¿cómo se muestra éste en su obra? Siempre juego con la luz, las transparencias, las texturas, etc. todo esto se puede encontrar en París. Sin embargo, en cada proyecto empiezo por estudiar el lugar, su cultura, la topografía para crear un diálogo con los alrededores.

¿Cómo se imagina París en un futuro? París es una ciudad con mucha historia. El problema está en las ciudades nuevas sin alrededores en los que inspirarse y con edificios nuevos que no dan pie a ninguna conversación.

Quale ritiene sia l'opera più importante della sua carriera? Tutti i progetti architettonici che fanno vibrare e cambiare lo spazio con il vento, il sole…

In che modo Parigi ispira il suo lavoro? Sono sempre stato commosso e ispirato dalla luce, per esempio dal modo in cui il sole penetra in chiese come la Sainte-Chapelle o nella Casa di vetro di Pierre Chareau.

Esiste un tipico "stile parigino"? Se sì, come si manifesta nel suo lavoro? Ho sempre giocato con la luce, le trasparenze, le testure, ecc., tutti elementi che si ritrovano a Parigi. Comunque, per ogni progetto, comincio dallo studio del luogo, della sua cultura, della sua topografia, per creare un dialogo con l'ambiente circostante.

Come immagina Parigi nel futuro? Parigi è una città con molta storia. Il problema sono le nuove città prive di luoghi d'ispirazione e con nuovi edifici incapaci di stimolare una conversazione.

Musée Du Quai Branly

Year: 2006
Photographs: © Pep Escoda

The concept of the Quai Branly Museum went beyond the design of a museum space: The idea was to create a bond between local culture and less familiar cultures exhibited throughout its 4,400,000 ft² of space. The complex, in the center of Paris, is formed by four buildings that combine different architectural styles and connect harmoniously with the surroundings. The main building stands on pillars and is formed like a gigantic curved wall made of glass.

Der Entwurf des Museums Quai Branly sollte nicht nur ein Museum projektieren. Es sollte eine Verbindung zu den weniger bekannten Kulturen geschaffen werden, die auf den 400.000 m² der Sammlung ausgestellt sind. Der Gebäudekomplex im Herzen von Paris besteht aus vier Bauten, die verschiedene architektonische Designs miteinander kombinieren und sich harmonisch in die Umgebung einfügen. Die Hauptgalerie ist auf Stelzen gebaut und hat die Form einer riesigen gebogenen Mauer aus Glas.

Le projet du Musée du Quai Branly va bien au-delà de la conception d'un espace muséal : il suppose la création d'un lieu de rencontre entre la culture indigène et celles qui sont moins connues, exposées sur une superficie de 400.000 m². L'ensemble, situé en plein cœur de Paris, est formé de quatre édifices qui associent différents designs architecturaux dans une union harmonieuse avec le paysage environnant. L'édifice principal est une passerelle en forme de mur gigantesque, tout en courbes et verre, érigé sur pilotis.

La proyección del Museo Quai Branly iba más allá del diseño de un espacio museístico: suponía la creación de un punto de unión con las culturas locales menos conocidas, expuestas en sus 400.000 m² de superficie. El conjunto, situado en pleno centro de París, está formado por cuatro edificios que combinan diferentes diseños arquitectónicos y enlazan armoniosamente con el entorno. El edificio principal es una pasarela en forma de gigantesco muro curvado y acristalado que se alza sobre unos pilares.

Il progetto del museo Quai Branly doveva andare ben oltre la progettazione di uno spazio museale: supponeva infatti la creazione di un trait d'union fra la cultura locale e le culture meno note esposte su una superficie di 400.000 m². Il complesso museale, situato in pieno centro a Parigi, è formato da quattro edifici che combinano diversi disegni architettonici e si sposano armoniosamente con il contesto. L'edificio principale è una passerella su pilastri sovrastata da un gigantesco muro ricurvo a vetri.

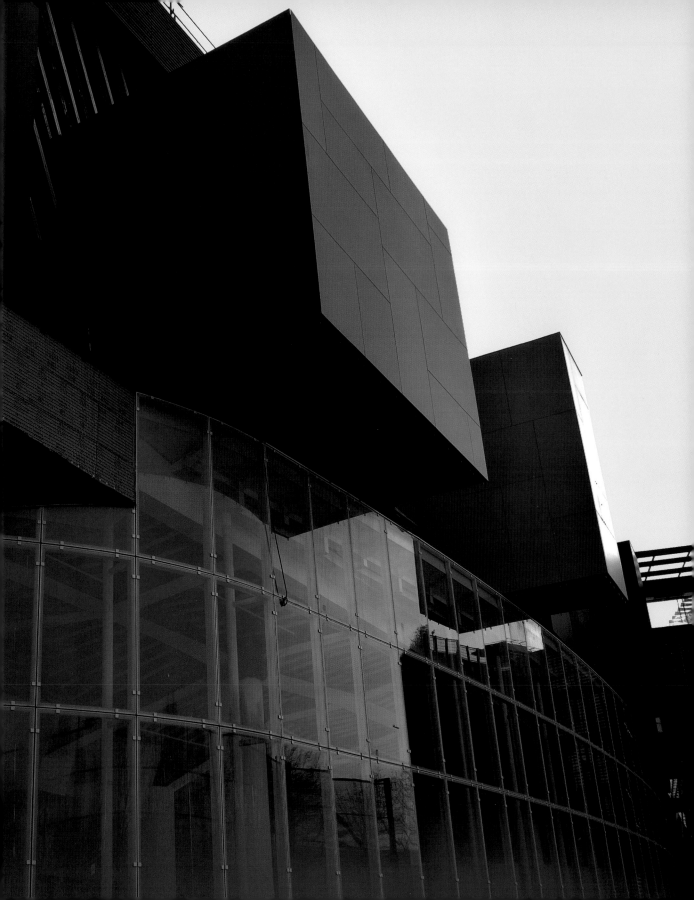

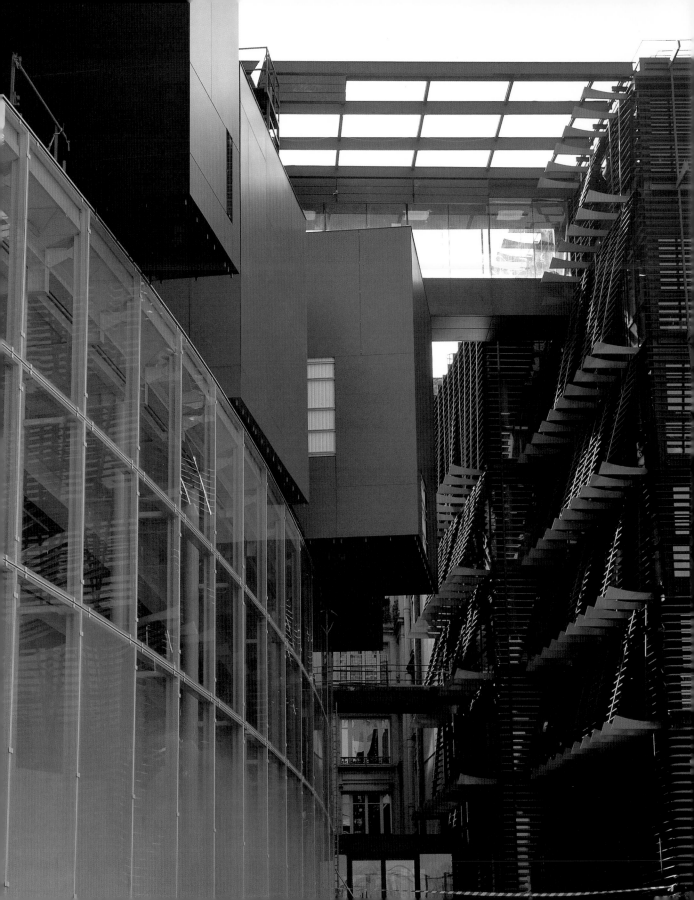

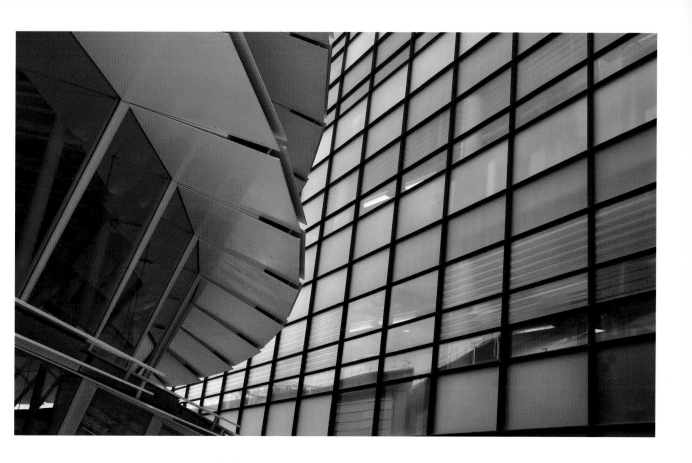

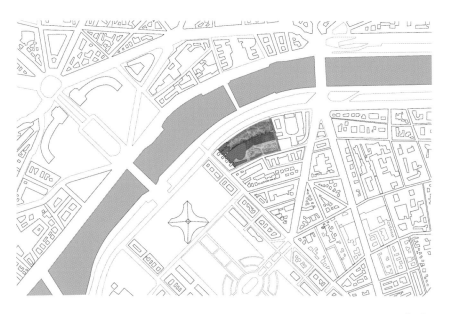

Site plan

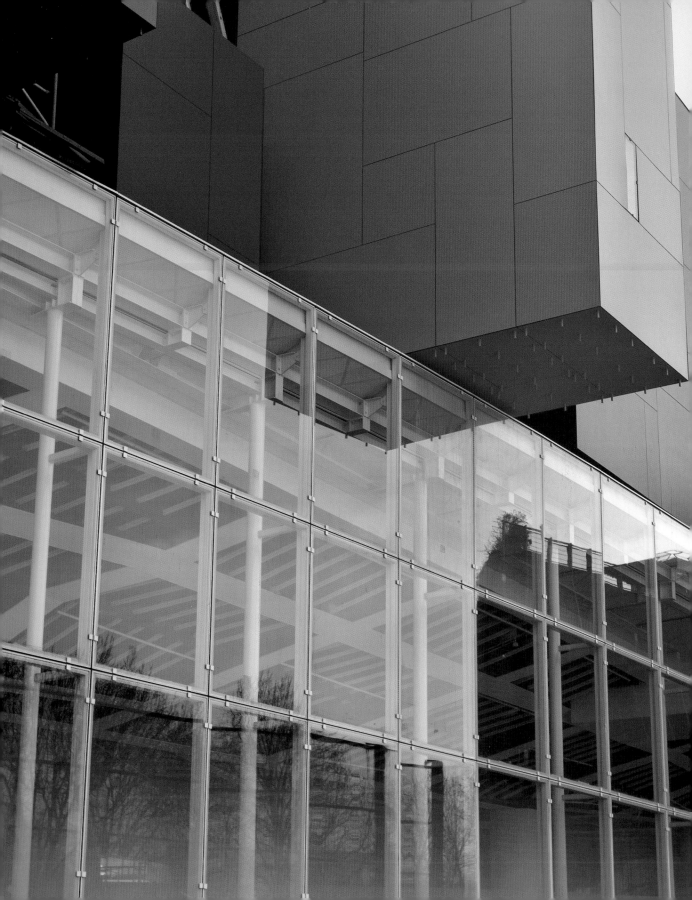

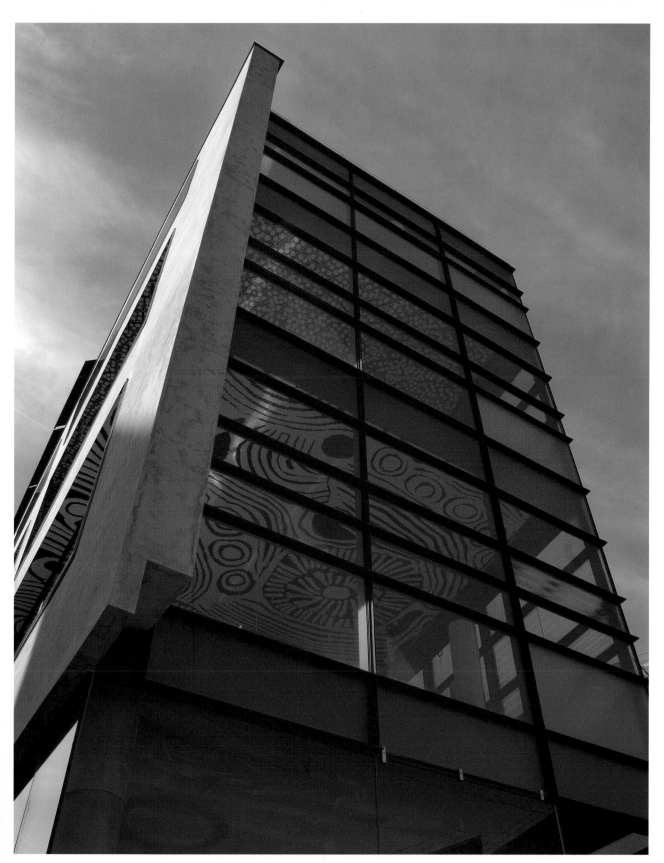

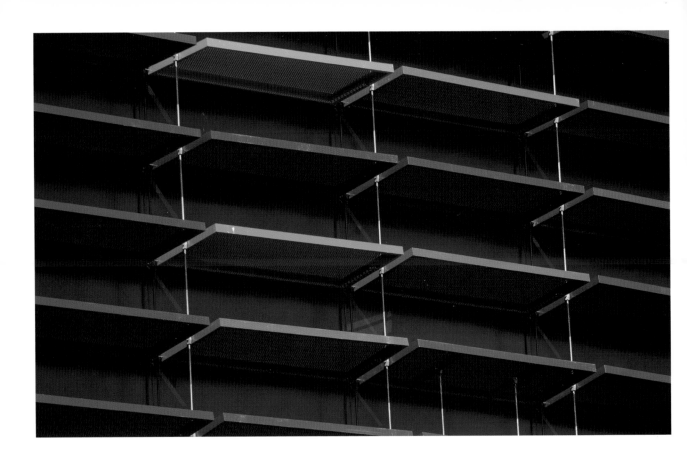

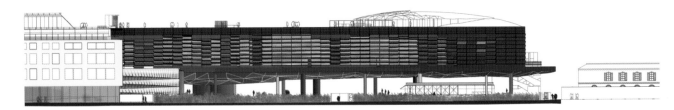

South elevation

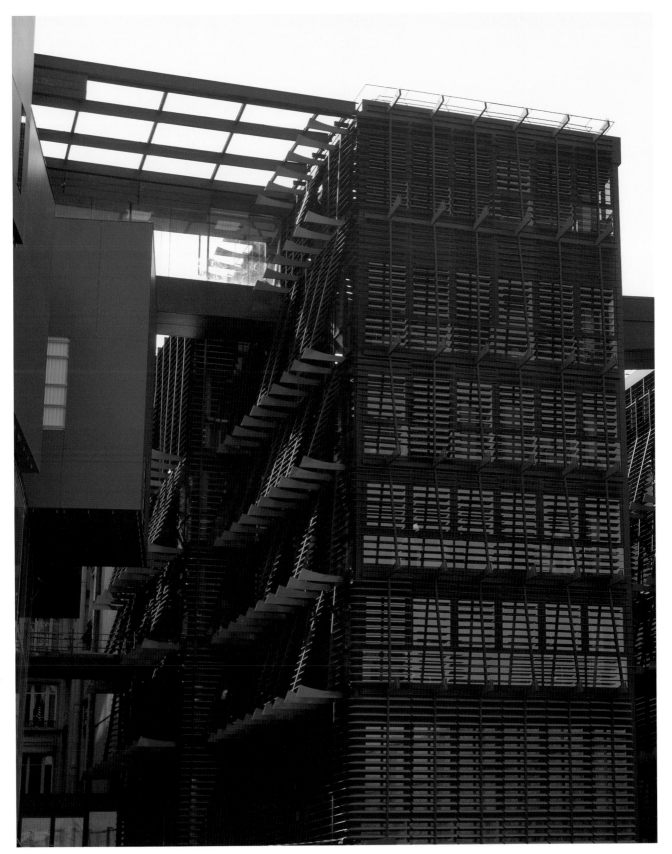

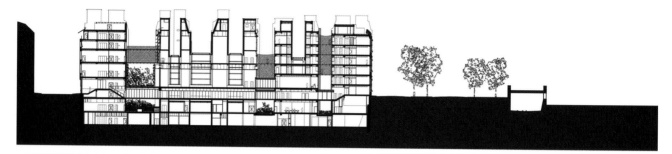

Cross section AA

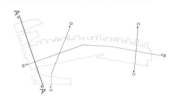

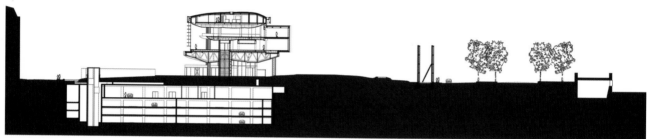

Cross section CC

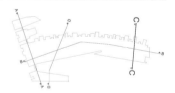

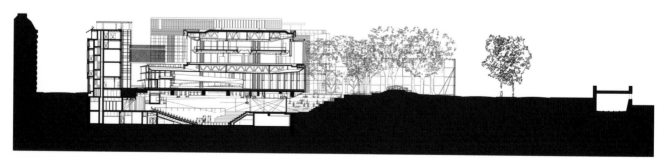

Cross section DD

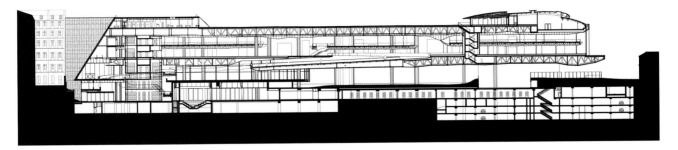

Lateral section BB

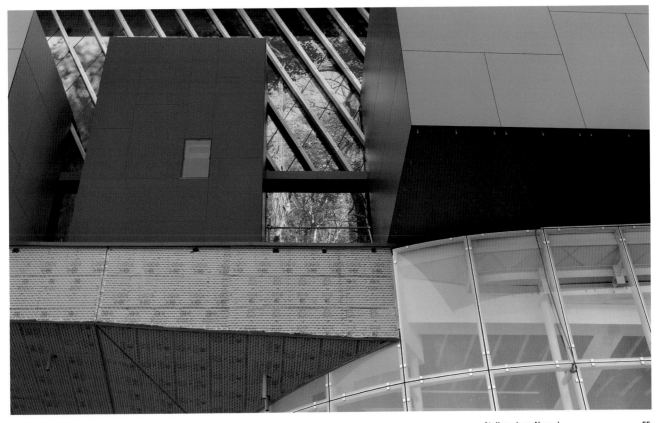

Urban District of Les Halles

Year: 2004

Photographs: © ajn/Jean Nouvel/artefactory

Jean Nouvel's proposal for the renovation of the Les Halles district may not have won the competition, but it still presents a complex design project full of great ideas. The aim was to allow this central area of Paris to reconcile its daily bustle with a feeling of harmony and offer local residents new spaces that would fulfill all their needs. One of the important criteria was tranquility, which Nouvel fulfilled by planning a large garden with different levels reflecting the archetypal Parisian garden.

Jean Nouvels Vorschlag für die Sanierung des Bezirks Les Halles war zwar nicht der Gewinner der Ausschreibung, stellt aber ein vielschichtiges Projekt voller großer Ideen dar. Ziel war es, das geschäftige Treiben dieses zentralen Pariser Viertels zu harmonisieren und neue Räume zu schaffen, die alle Bedürfnisse der Anwohner befriedigen. Eine der wichtigen Bedingungen war Ruhe, und diese wurde von Nouvel durch die Planung einer großen Grünanlage erfüllt, deren verschiedene Ebenen den typischen Pariser Garten zum Vorbild haben.

La proposition de Jean Nouvel de réhabilitation du quartier des Halles n'a pas été sélectionnée, pourtant c'est un projet complexe fourmillant de grandes idées. Le but était de parvenir à ce que cette zone centrale de Paris réconcilie l'effervescence quotidienne et l'harmonie, offrant à ses voisins de nouveaux magasins couvrant tous leurs besoins. Pour assurer le calme, autre grande priorité du projet, Nouvel avait créé un grand jardin agencé sur différents niveaux, reflet de l'archétype des jardins parisiens.

La propuesta de Jean Nouvel para rehabilitar el distrito de Les Halles no fue la ganadora, pero sí es un complejo proyecto repleto de grandes ideas. El objetivo era lograr que esta zona céntrica de París reconciliara el ajetreo diario con la armonía y ofreciera a sus vecinos nuevos espacios que cubrieran todas sus necesidades. La tranquilidad era otra de las grandes premisas, solucionada por Nouvel con un gran jardín dispuesto en diferentes niveles, un reflejo del arquetipo de los jardines parisinos.

Pur non essendo stata la vincitrice della gara d'appalto per la ristrutturazione del quartiere di Les Halles, la proposta di Jean Nouvel costituisce un complesso progetto pieno di grandi idee. L'obbiettivo era far sì che in questa zona centrale di Parigi potessero conciliarsi il trambusto quotidiano e l'armonia grazie alla creazione di nuovi spazi all'altezza delle esigenze degli abitanti. La tranquillità era un'altra delle grandi premesse, risolta da Nouvel con un ampio giardino disposto su diversi livelli, una reminiscenza dell'archetipo dei giardini parigini.

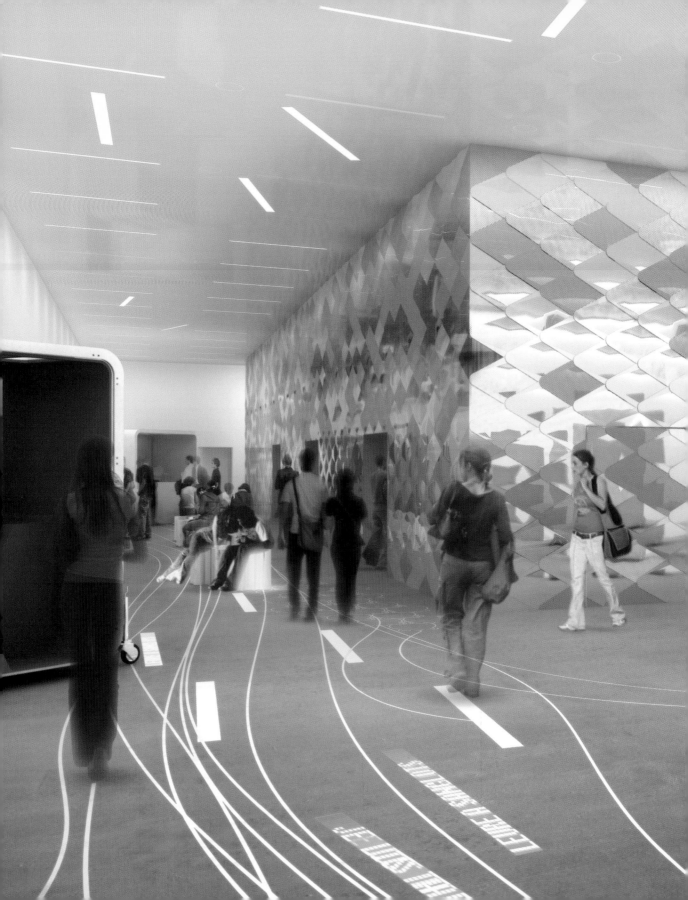

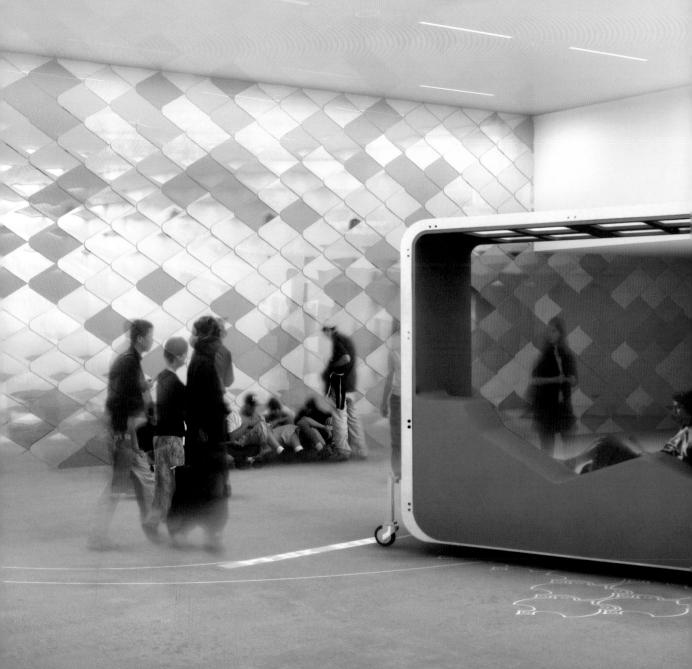

Manuelle Gautrand
Architect

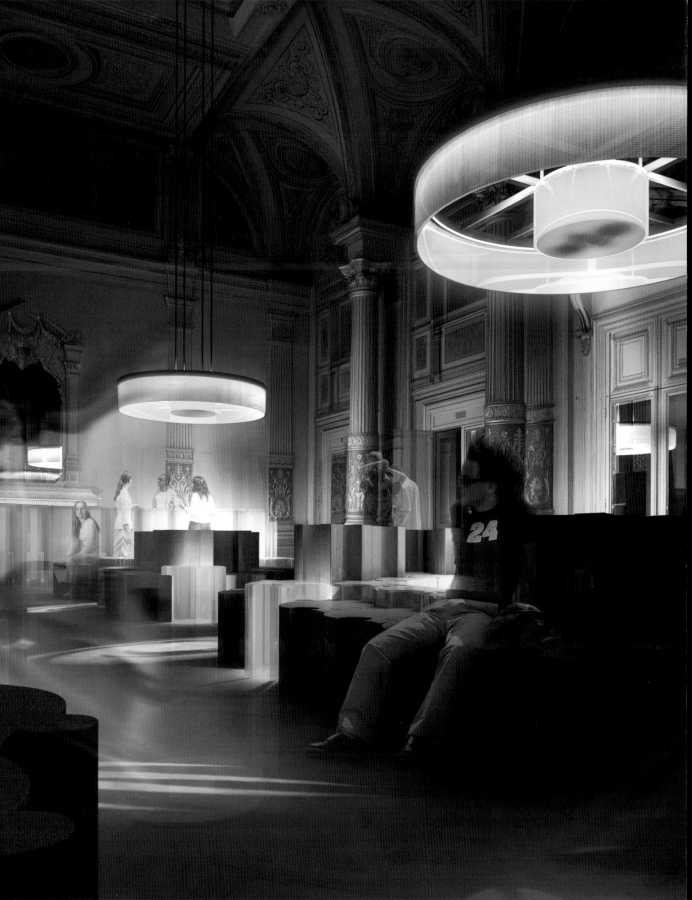

Manuelle Gautrand Architect

36, Boulevard de la Bastille, 75012 Paris

+33 156 95 06 46

+33 156 95 06 47

www.manuelle-gautrand.com

contact@manuelle-gautrand.com

Manuelle Gautrand

Despite being a young architect, Manuelle Gautrand has already designed numerous projects in France and has caught the attention of the international press. In 1993, she moved her office from Lyon to Paris, where she continues to work, participate in conferences and teach classes. The design of the Citroën showroom in the Champs-Élysées and the current redecoration of the Gaîté Lyrique theater into a cultural center have earned her great recognition.

Obwohl Manuelle Gautrand noch jung ist, hat diese Architektin bereits eine Vielzahl von Projekten in Frankreich entworfen und in der internationalen Presse Beachtung gefunden. Sie verlegte 1993 ihr Büro von Lyon nach Paris. Seitdem hat sie nicht aufgehört zu arbeiten, an Symposien teilzunehmen und Unterricht zu erteilen. Das Design des Showrooms von Citroën auf den Champs-Élysées und der Umbau des Gaîté Lyrique Theaters zu einem Kulturzentrum haben ihr großes Ansehen eingebracht.

Jeune architecte, Manuelle Gautrand a déjà conçu de nombreux projets en France et se fait remarquer par la presse internationale. En 1993, elle déménage son bureau de Lyon à Paris, où elle ne cesse de travailler, participer à des symposiums et donner des cours. Le design du *showroom* de Citroën sur les Champs-Élysées et sa réhabilitation du théâtre de la Gaîté Lyrique en un centre culturel ont contribué à sa renommée.

A pesar de ser una joven arquitecta, Manuelle Gautrand ya ha diseñado numerosos proyectos en Francia y ha sido destacada por la prensa internacional. En 1993 mudó su oficina de Lyon a París, donde no ha parado de trabajar, participar en simposios e impartir clases. El diseño del *showroom* de Citroën en los Campos Elíseos y su actual reconversión del teatro Gaîté Lyrique en un centro cultural le han reportado un gran reconocimiento.

Nonostante la giovane età, Manuelle Gautrand ha già realizzato numerosi progetti architettonici in Francia così imponendosi all'attenzione della stampa internazionale. Da Lione ha trasferito lo studio a Parigi nel 1993, dove ha continuato incessantemente a lavorare pur partecipando a simposi e impartendo lezioni. La progettazione dello *showroom* di Citroën sugli Champs-Élysées e la riconversione del teatro Gaîté Lyrique in un centro culturale le hanno valso grande prestigio.

1961
Born in Marseille, France

1985
Finishes her studies of Architecture in the École d'Architecture de Montpellier (ENSAM), France

1991
Opens her office in Lyon, which she transferred to Paris in 1993

1992
Award-winner of Albums de la Jeune Architecture

1996
Restructuring of the administrative unit of the Centre Georges Pompidou in Paris, France

2002
Receives the prize Delarue (silver medal) awarded by the French Académie d'Architecture

2005
Winner of the international MIPIM Architectural Review Future Project Awards 2005 for the Citroën Showroom in Paris, France

Interview | Manuelle Gautrand

Which do you consider the most important work of your career? At the moment, the most important one is the Communication Center for Citroën, on the Champs-Élysées, in Paris.

In what ways does Paris inspire your work? Paris doesn't inspire me directly. It's a beautiful city, although with a lack of modernity and an overwhelmingly important architectural heritage that suffocates us. I am definitely inspired by Asian cities, full of contrasts and amazing sights everywhere.

Does a typical Paris style exist, and if so, how does it show in your work? I think there isn't, but something forces us to analyze every site before developing a project: our heritage and culture make us more respectful towards these sites.

How do you imagine Paris in the future? I don't want to live in a museum, so I wish that Paris becomes more open in the future to modernity, and allows architects to innovate. And its beauty will be reinforced!

Welches Werk halten Sie für das wichtigste Ihrer Karriere? Zurzeit ist mein wichtigstes Werk das Communication Center für Citroën auf den Champs-Élysées in Paris.

Wie inspiriert Paris Ihre Arbeit? Paris inspiriert mich nicht direkt. Es ist eine schöne Stadt, aber ihr fehlt es an Modernität und ihr überwältigend wichtiges architektonisches Kulturerbe erstickt uns. Ich werde definitiv von asiatischen Städten inspiriert: Sie sind voller Kontraste und es gibt überall erstaunliche Sehenswürdigkeiten.

Gibt es einen typischen Pariser Stil, und wenn ja, wie macht dieser sich in Ihrer Arbeit bemerkbar? Ich glaube, es gibt ihn nicht, aber wir werden von irgendetwas dazu gezwungen, jeden Ort vor der Ausführung eines Projektes zu analysieren. Unser Erbe und unsere Kultur lassen uns Respekt vor diesen Orten haben.

Wie stellen Sie sich Paris in der Zukunft vor? Ich will in keinem Museum leben, daher wünsche ich mir, dass sich Paris in der Zukunft mehr der Modernität öffnet und es den Architekten erlaubt, Neuerungen einzuführen. Und die Schönheit der Stadt wird gesteigert werden!

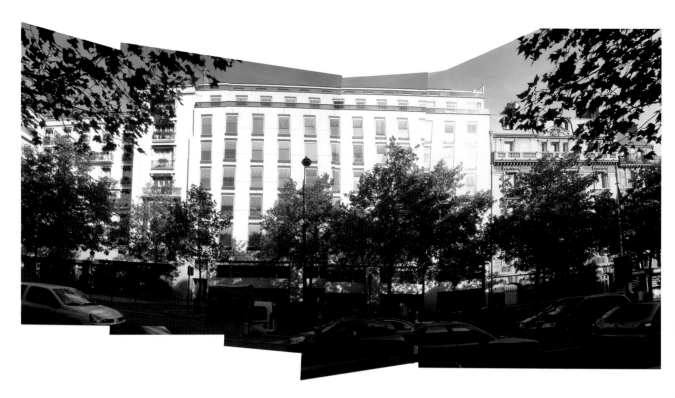

Quelle est à vos yeux l'oeuvre la plus importante de votre carrière ? A l'heure actuelle, la plus importante, c'est le Communication Center pour Citroën, sur les Champs-Élysées de Paris

Dans quelle mesure votre œuvre artistique s'inspire-t-elle de Paris ? Paris ne m'inspire pas directement. C'est une ville magnifique, malgré son absence de modernité et un héritage architectural extrêmement important qui nous étouffe. Je tire définitivement mon inspiration des villes d'Asie, débordantes de contrastes et de sites étonnants partout.

Existe-t-il un style typiquement parisien, et si oui, comment se manifeste-t-il dans votre œuvre ? Non, je ne crois pas qu'il y en ait un, mais quelque chose nous force à analyser chaque site avant de développer un projet : notre héritage et notre culture nous poussent à respecter ces sites.

Comment imaginez-vous le Paris du futur ? Je ne tiens pas à vivre dans un musée, et je souhaite que le Paris du futur s'ouvre davantage à la modernité et permette aux architectes d'innover. Et il s'en trouvera embelli!

¿Cuál cree que es el trabajo más importante de su carrera? En este momento el más importante es el Centro de Comunicación de Citroën en los Campos Elíseos de París.

¿Cómo le inspira París en su trabajo? París no me inspira directamente. Es una ciudad preciosa, pero tiene una falta de modernidad y un patrimonio arquitectónico abrumadoramente importante que resulta asfixiante. Me siento definitivamente inspirado por las ciudades asiáticas, llenas de contrastes y con increíbles panorámicas por todos los lados.

¿Existe un estilo típico de París? Y si es así, ¿cómo se muestra éste en su obra? Yo creo que no existe, pero algo nos obliga a analizar cada lugar antes de desarrollar un proyecto: nuestro patrimonio y nuestra cultura nos hacen ser más respetuosos con estos lugares.

¿Cómo se imagina París en un futuro? No quiero vivir en un museo, de modo que deseo que en un futuro París se abra a lo moderno y permita innovar a los arquitectos. De esta manera se resaltará su belleza.

Quale ritiene sia l'opera più importante della sua carriera? Fino ad ora, la più importante è il Centro di comunicazione per Citroën, sugli Champs-Élysées, a Parigi.

In che modo Parigi ispira il suo lavoro? Parigi non mi ispira direttamente. È una città meravigliosa, anche se le manca modernità ed ha un patrimonio architettonico di incommensurabile importanza che ci soffoca. Mi sento decisamente più ispirata dalle città asiatiche, piene di contrasti e di viste spettacolari ovunque.

Esiste un tipico "stile parigino"? Se sì, come si manifesta nel suo lavoro? Penso che non esista, ma qualcosa ci obbliga ad analizzare qualsiasi area prima di sviluppare un progetto: La nostra eredità e la nostra cultura ci rendono più rispettosi verso queste aree.

Come immagina Parigi nel futuro? Non voglio vivere in un museo, quindi spero che Parigi, nel futuro, si apra maggiormente alla modernità e permetta agli architetti di innovare. La sua bellezza ne verrebbe potenziata!

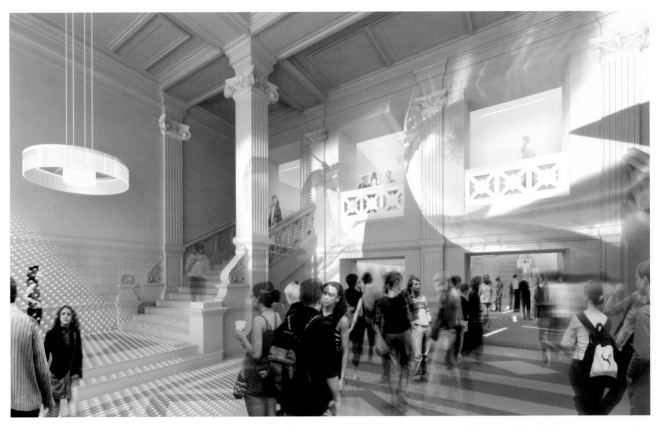

Manuelle Gautrand Architect

La Gaîté Lyrique

Year: Under construction

Photographs: © Manuelle Gautrand Architect/Platform

This project consists of the conversion of a theater into a center for digital arts and contemporary music, where artists have room for creating, producing and publishing their art. Aside from the main volumes, like the auditorium, the multimedia theater and the conference room, Gautrand used the building's structure to include flexible rooms, like the reception, an exhibition area and a café.

Dieses Projekt besteht in der Umgestaltung eines Theaters in ein Zentrum für digitale Künste und zeitgenössische Musik, das den Künstlern Raum bietet, ihre Werke zu schaffen, zu produzieren und zu verbreiten. Abgesehen von den Hauptbestandteilen, wie dem Konzertsaal, dem Multimediatheater und dem Konferenzsaal, nutzte Gautrand die Struktur des Gebäudes, um flexible Räume zu schaffen, wie die Rezeption, den Ausstellungsbereich und ein Café.

Dans ce projet, il s'agit de reconvertir un théâtre en un centre pour les arts numériques et la musique contemporaine où les artistes peuvent compter sur un espace servant à la diffusion, production et création. En plus des volumes principaux comme l'auditorium, le théâtre multimédia et la salle de conférence, Gautrand a optimisé la structure de l'édifice pour disposer d'autres espaces plus flexibles, comme la réception, une zone d'exposition et un café.

Este proyecto consiste en la reconversión de un teatro en un centro para las artes digitales y la música contemporánea, donde los artistas pueden contar con un espacio para la difusión, la producción y la creación. Además de los volúmenes principales, como el auditorio, el teatro multimedia y la sala de conferencias, Gautrand aprovechó la estructura del edificio para disponer otros espacios más flexibles, como la recepción, una zona de exposiciones y un café.

Questo progetto consiste nella riconversione di un teatro in un centro per le arti digitali e la musica contemporanea in cui gli artisti hanno a disposizione uno spazio di diffusione, produzione e creazione. Oltre ai volumi principali, come l'auditorio, il teatro multimediale e la sala per le conferenze, Gautrand ha sfruttato la struttura dell'edificio preesistente per ubicare altri spazi più flessibili, come la reception, una zona d'esposizione e un bar.

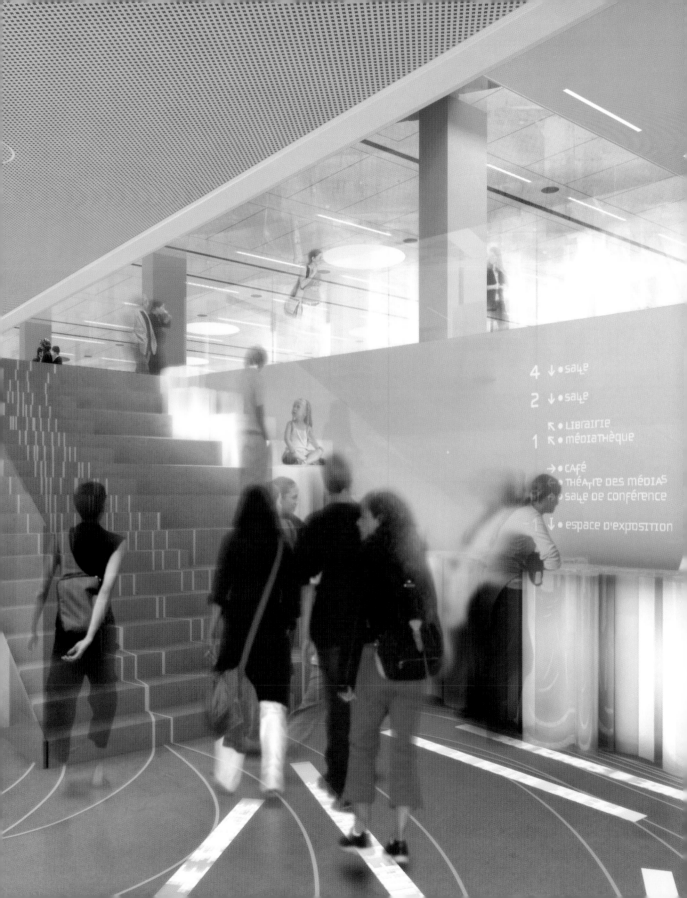

4 ↓ • salle

2 ↓ • salle

↖ • librairie
1 ↖ • médiathèque

→ • café
• théâtre des médias
• salle de conférence

−1 ↓ • espace d'exposition

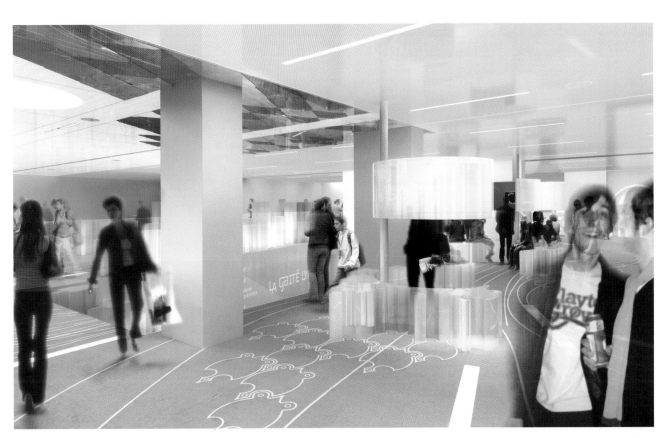

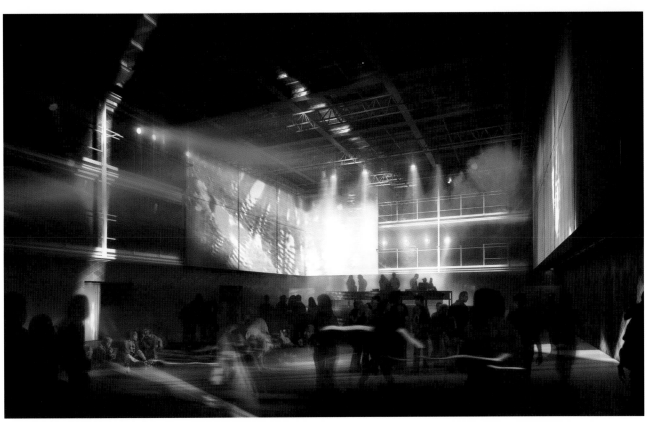

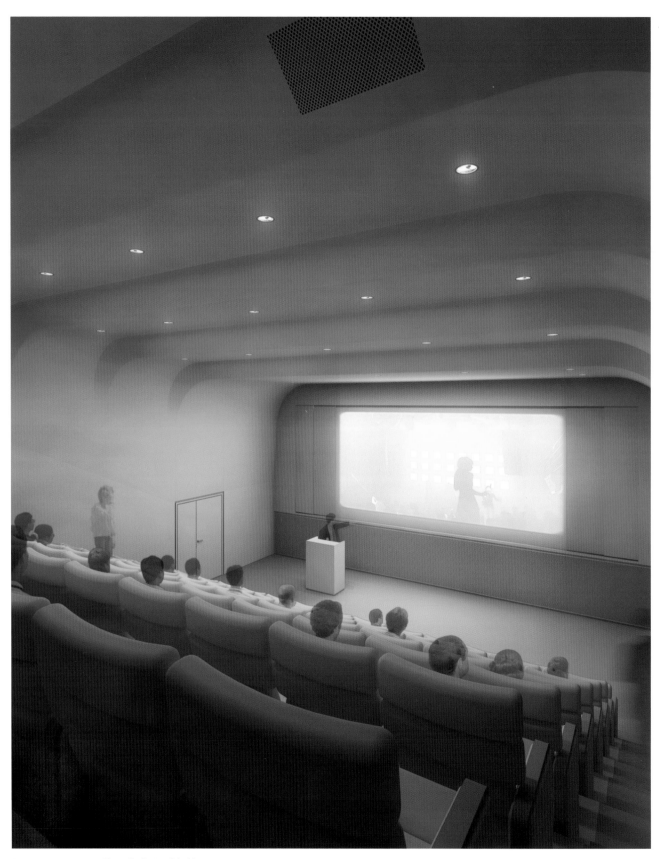

Manuelle Gautrand Architect

Plan

0 2 4

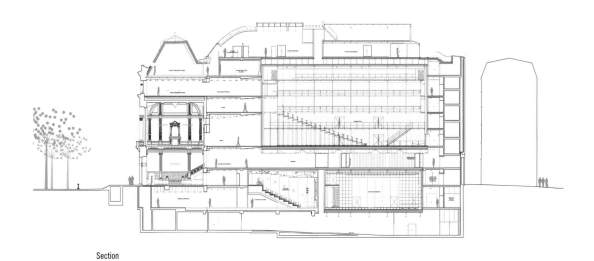

Section

36 Friedland. Office Building

Year: Under Construction (Estimated 2008)
Photographs: © Manuelle Gautrand Architect/Platform

The aim for the design of this luxurious office building, situated in Friedland Avenue, was to combine attractive and contemporary architecture with maximum functionality. Its most notable feature is the exceptional design of the façade (of glass and veined stone). This clear and open architecture allows for pleasant, light-filled offices, which provide a productive atmosphere.

Ziel dieses Entwurfs für ein Luxusbürogebäude in der Avenue Friedland war die Kombination einer formschönen modernen Architektur mit größtmöglicher Funktionalität. Das herausragende Merkmal ist die außergewöhnliche Vorderfront aus Glas und marmoriertem Stein, dessen lichte Architektur zudem helle und offene Arbeitsräume für eine produktive Atmosphäre schafft.

L'objectif poursuivi à l'heure de concevoir cet ensemble de bureaux de grand standing, situé sur l'avenue Friedland, est de combiner une architecture attirante et contemporaine à une fonctionnalité maximale. La principale caractéristique est le design exceptionnel de la façade (de verre et de pierre veinée). Cette architecture claire et dépouillée parvient à créer des bureaux lumineux et agréables créant une atmosphère productive optimale.

El objetivo perseguido a la hora de diseñar este edificio de oficinas de alto standing, situado en la avenue Friedland, era combinar una arquitectura atractiva y contemporánea con la máxima funcionalidad. La característica más notable es el excepcional diseño de la fachada (de cristal y piedra veteada). Esta arquitectura clara y despejada consigue crear luminosos y agradables despachos que proporcionan una óptima atmósfera productiva.

L'obiettivo perseguito durante la progettazione di questo edificio di uffici di alto standing, situato nell'Avenue Friedland, era combinare un'architettura accattivante e contemporanea con la massima funzionalità. La caratteristica più considerevole è l'eccezionalità del design della facciata (di cristallo e pietra marmorizzata). Questa architettura chiara e pulita riesce a creare luminosi e gradevoli uffici che costituiscono un ideale ambiente produttivo.

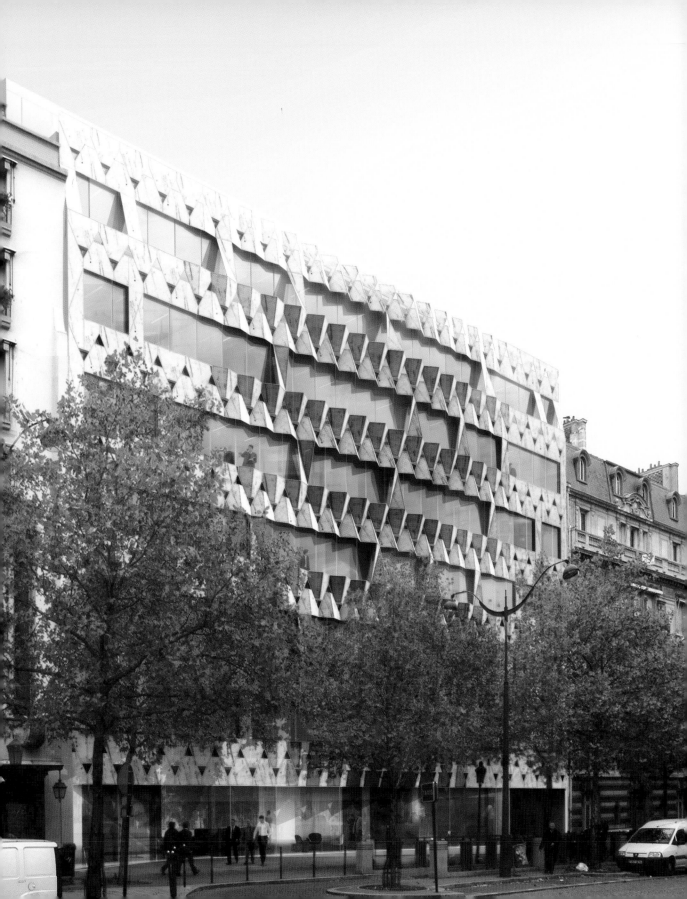

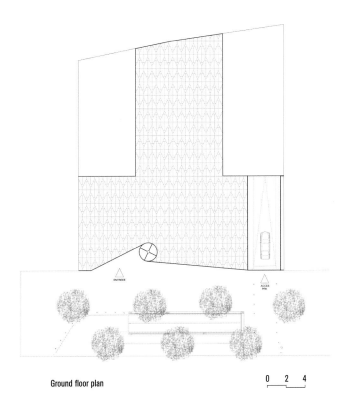

Ground floor plan

0 2 4

Section detail

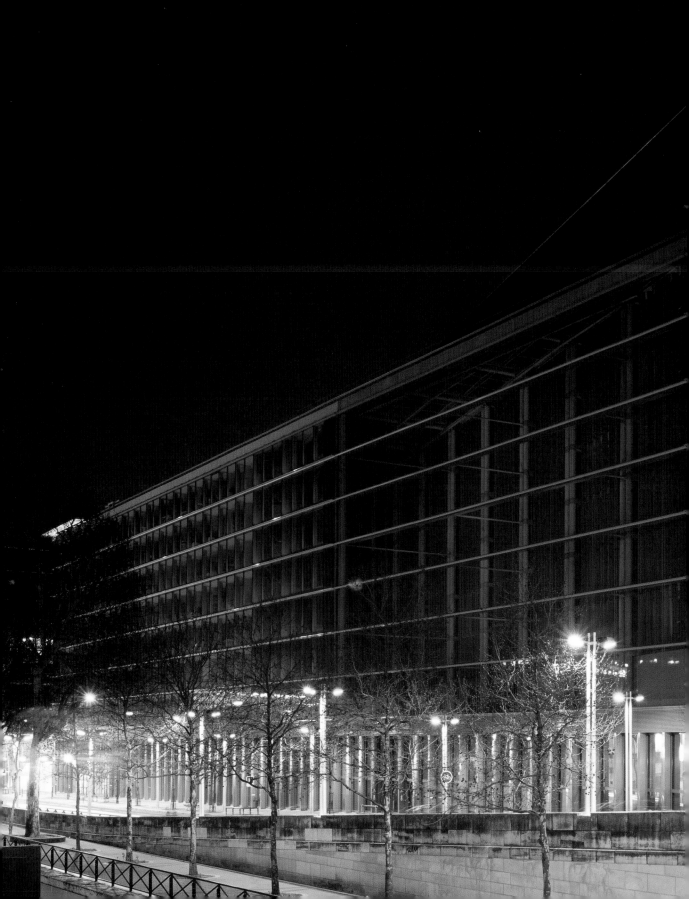

Atelier Christian Hauvette

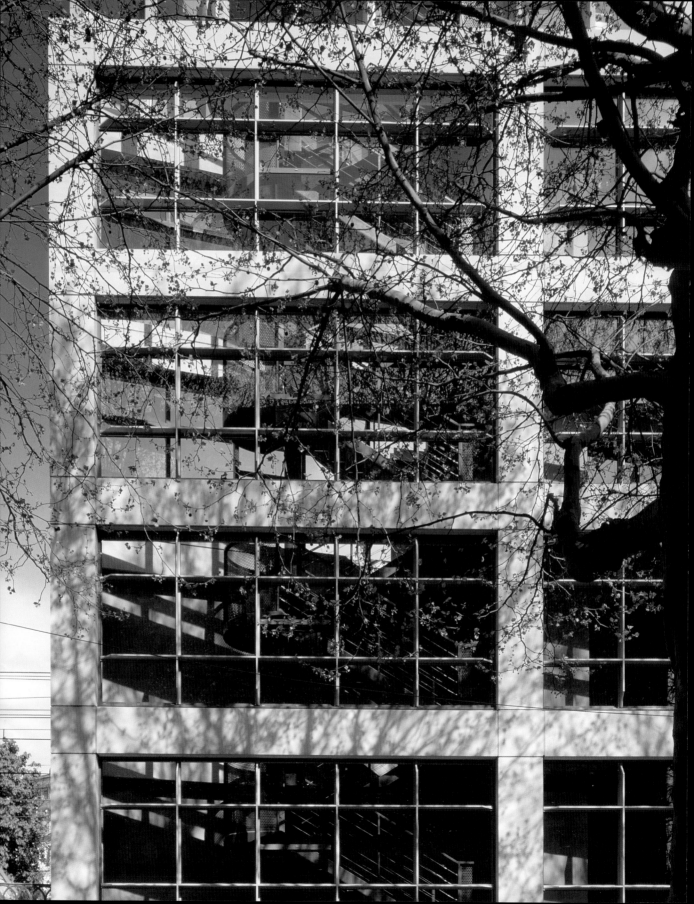

Atelier Christian Hauvette

7, rue Debelleyme 75003 Paris

+33 140 29 05 30

www.hauvette.net

hauvette@club-internet.fr

Christian Hauvette

Christian Hauvette was born in Marseille in 1944. After receiving his degree in architecture, he specialized in urban planning, a field that has brought him many awards such as the Medal of Honor from the Academy of Architecture. His projects focus on residential and office buildings as well as educational facilities. He has been offered several visiting professorships at universities in France and the United States.

Christian Hauvette wurde 1944 in Marseille geboren. Nach dem Abschluss seines Architekturstudiums spezialisierte er sich auf Städtebau, eine Disziplin, die ihm große Anerkennung, wie die Ehrenmedaille der Architekturakademie, einbrachte. Seine Projekte konzentrieren sich auf Wohn- und Bürogebäude und Bildungseinrichtungen. Ihm wurden mehrfach Gastprofessuren an Universitäten in Frankreich und den Vereinigten Staaten angeboten.

Christian Hauvette est né à Marseille en 1944. Diplômé d'architecture, il se spécialise dans l'urbanisme, discipline qui lui a valu diverses récompenses, comme la Médaille d'Honneur de l'Académie d'Architecture. Ses projets concernent surtout des immeubles de logements et de bureaux, ainsi que des centres d'éducation. Il est invité à plusieurs reprises à enseigner en tant que professeur de passage dans des universités en France et aux Etats-Unis.

Christian Hauvette nació en Marsella en 1944; tras recibir el título de arquitecto se especializó en Urbanismo, disciplina que le ha reportado múltiples reconocimientos, como la Medalla de Honor de la Academia de Arquitectura. Sus proyectos se centran en edificios de viviendas y de oficinas, además de centros educacionales. Ha sido invitado en varias ocasiones a participar como profesor invitado en universidades de Francia y Estados Unidos.

Christian Hauvette è nato a Marsiglia nel 1944. Dopo la laurea in architettura si è specializzato in urbanistica, disciplina in cui ha ricevuto molteplici riconoscimenti come la Medaglia d'onore dell'Accademia di architettura. I suoi progetti s'incentrano su complessi residenziali e uffici nonché centri educativi. Numerosi gli inviti a collaborazioni in veste di visiting professor da parte di università francesi e statunitensi.

1944
Born in Marseille, France

1969
Diploma of Urbanism from the Institute d'Urbanisme de l'Université de Paris, France

1986
Faculty of Law and Economics and Amphitheater in Brest, France. Competition, award-wining project

1991
Grand-Prix National d'Architecture

1999
Medal of Honor from the French Académie d'Architecture
Winner of the competition for the École Nationale Supériéure d'Ingénieurs du Mans (ENSIM)

2006
Appointed Officier des Arts et des Lettres by the French Ministry of Culture and Communication

Interview | Christian Hauvette

Which do you consider the most important work of your career? At the beginning of my career, I designed experimental projects that allowed me to find out the problems involved during construction. Amongst these projects, the most successful was the École Nationale Louis Lumière in Marne-la-Vallée.

In what ways does Paris inspire your work? Living and working in this cultural city has an influence on my spirit as an architect. This intellectual environment urges me to explore the interconnections with other art fields.

Does a typical Paris style exist, and if so, how does it show in your work? It's obvious that the style imposed in the 19th century, especially Haussmann's interventions, created a sense of unity, in contrast with the simplistic architecture of the 60's.

How do you imagine Paris in the future? Paris has expanded its territories, engulfing suburban neighborhoods. What needs to be accomplished is a cohesion between both parts, building up to reach a coherent architectural bond between the city center and these neighborhoods forming a new Paris.

Welches Werk halten Sie für das wichtigste Ihrer Karriere? Am Anfang meiner Karriere habe ich experimentelle Projekte entworfen, die mir erlaubten, die anfallenden Probleme während des Baus zu lösen. Unter diesen Projekten war das erfolgreichste die École Nationale Louis Lumière in Marne-la-Vallée.

Wie inspiriert Paris Ihre Arbeit? Das Leben und die Arbeit in dieser kulturträchtigen Stadt hat Einfluss auf mein Temperament als Architekt. Diese intellektuelle Umgebung drängt mich dazu, die Verknüpfungen zu anderen Kunstfeldern zu erforschen.

Gibt es einen typischen Pariser Stil, und wenn ja, wie macht dieser sich in Ihrer Arbeit bemerkbar? Es ist offensichtlich, dass der Stil, der sich im 19. Jahrhundert durchgesetzt hat – besonders die Projekte von Haussmann – einen Sinn für Einheit geschaffen haben, im Gegensatz zu der simplifizierenden Architektur der sechziger Jahre.

Wie stellen Sie sich Paris in der Zukunft vor? Paris hat sein Gebiet erweitert und die Vororte eingegliedert. Was fehlt ist die Verbindung zwischen den beiden Teilen. Ein neues Paris mit einem baulichen Bindeglied zwischen dem Zentrum und den Vororten muss errichtet werden.

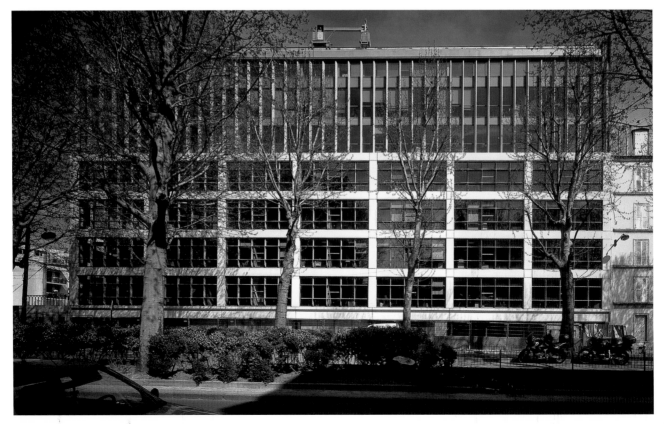

Quelle est à vos yeux l'œuvre la plus importante de votre carrière ? Au début de ma carrière, j'ai conçu divers projets expérimentaux qui m'ont permis de voir les problèmes liés à la construction. Parmi ces projets, le plus réussi est l'École Nationale Louis Lumière de Marne-la-Vallée.

Dans quelle mesure votre œuvre artistique s'inspire-t-elle de Paris ? Vivre et travailler dans cette ville culturelle influence mon âme d'architecte. Cet environnement intellectuel me pousse à explorer les interconnexions avec d'autres domaines.

Existe-t-il un style typiquement parisien, et si oui, comment se manifeste-t-il dans votre œuvre ? Il est évident que le style imposé au XIXe siècle, surtout après les interventions de Haussmann, a créé un sens d'unité, en contraste avec l'architecture simplificatrice des années soixante.

Comment imaginez-vous le Paris du futur ? Paris s'est étendu, engloutissant les banlieues voisines. Ce qu'il reste à faire, c'est de créer une cohésion entre les deux, construire pour atteindre une harmonie entre le centre de la ville et ses alentours formant un nouveau Paris.

¿Cuál cree que es el trabajo más importante de su carrera? Al principio de mi carrera diseñé proyectos experimentales que me permitieron descubrir los problemas que surgen durante la construcción. Entre estos proyectos, el más logrado fue el École Nationale Louis Lumière en Marne-la-Vallée.

¿Cómo le inspira París en su trabajo? Vivir y trabajar en esta ciudad cultural ejerce una influencia en mi espíritu como arquitecto. Este ambiente intelectual me anima a explorar las interconexiones con otros campos artísticos.

¿Existe un estilo típico de París? Y si es así, ¿cómo se muestra éste en su obra? Es obvio que el estilo impuesto en el Siglo XIX, especialmente las intervenciones de Haussmann, crearon un sentido de unidad, en contraste con la arquitectura simplista de los años 60.

¿Cómo se imagina París en un futuro? París ha ampliado sus territorios, tragándose los barrios suburbanos. Lo que es necesario alcanzar es una cohesión entre ambas partes, creciendo para alcanzar una coherencia entre el centro de la ciudad y estos barrios que componen el nuevo París.

Quale ritiene sia l'opera più importante della sua carriera? All'inizio della mia carriera, ho realizzato progetti sperimentali che mi hanno permesso di scoprire e risolvere durante il progetto in divenire i problemi connessi alla costruzione. Tra questi progetti, quello di maggior successo sia stato l'École Nationale Louis Lumière a Marne-la-Vallée.

In che modo Parigi ispira il suo lavoro? Vivere e lavorare in questa città culturale ha un'influenza sul mio spirito come architetto. Questo ambiente intellettuale mi spinge a esplorare le interconnessioni con altri campi artistici.

Esiste un tipico "stile parigino"? Se sì, come si manifesta nel suo lavoro? È ovvio che lo stile imposto nel XIX secolo, specialmente quello degli interventi di Haussmann, ha creato un senso di unità, in contrasto con l'architettura semplicistica degli anni '60.

Come immagina Parigi nel futuro? Parigi ha espanso il suo territorio, inghiottendo i quartieri periferici. C'è bisogno di portare a termine una coesione tra le due parti, costruendo per creare una coerenza tra il centro della città e i quartieri che formano la nuova Parigi.

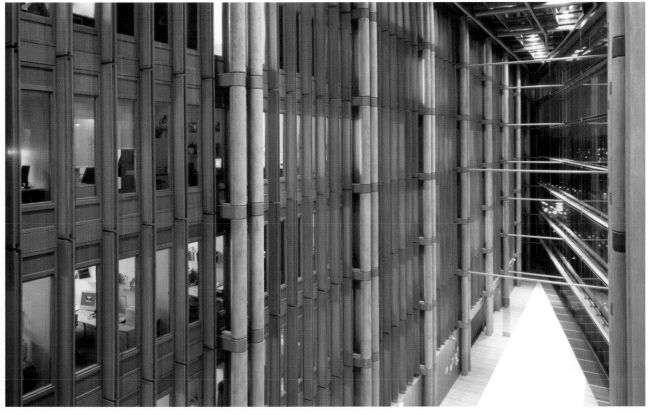

Office Building for the Savings and Loans Bank

Year: 2002

Photographs: © Georges Fessy

This two-part office building was built on a pointed plot next to the quays of the Seine. The different departments run along a central space. To break up the uniformity of the structure, different façades were designed for the various sides: On the north side, a large smooth glass surface facing the quay and a metal structure with windows on the south side.

Dieses zweiteilige Bürogebäude wurde auf einem spitz zulaufenden Baugrund am Seinekai errichtet. Die verschiedenen Arbeitsbereiche erstrecken sich entlang eines zentralen Raums. Um die gleichmäßige Struktur aufzubrechen wurden unterschiedliche Fassaden für die verschiedenen Seiten entworfen: im Norden eine große glatte Glasfläche zum Kai hin und eine Metallstruktur mit Fenstern an der südlichen Seite.

Cet ensemble de bureaux, dont la structure est divisée en deux parties, se situe sur une parcelle se terminant en pointe, située à côté des quais de la Seine. Les différents bureaux sont distribués le long de l'espace central. Pour compenser l'aspect linéaire de la structure, le choix s'est porté sur la conception de façades distinctes : un grand écran de verre à côté des quais, face la Seine, sur la face Nord, et une structure métallique et des fenêtres sur la façade sud.

Este edificio de oficinas, cuya estructura se divide en dos partes, está ubicado en una parcela acabada en punta, situada junto a los muelles del Sena. Los diferentes despachos se distribuyen a lo largo del espacio central. Para compensar la linealidad de la estructura se optó por diseñar fachadas distintas: una gran pantalla de cristal junto a los muelles en la parte norte, y una estructura metálica y ventanas en la fachada sur.

Questo edificio di uffici, la cui struttura si divide in due parti, è ubicato in una parcella che termina a punta e si trova vicino ai moli della Senna. I vari uffici si distribuiscono lungo lo spazio centrale. Per compensare la linearità della struttura si è preferito progettare facciate diverse: un grande pannello di vetro rivolto verso nord in direzione dei moli ed una struttura metallica con finestre sulla facciata sud.

Atelier Christian Hauvette

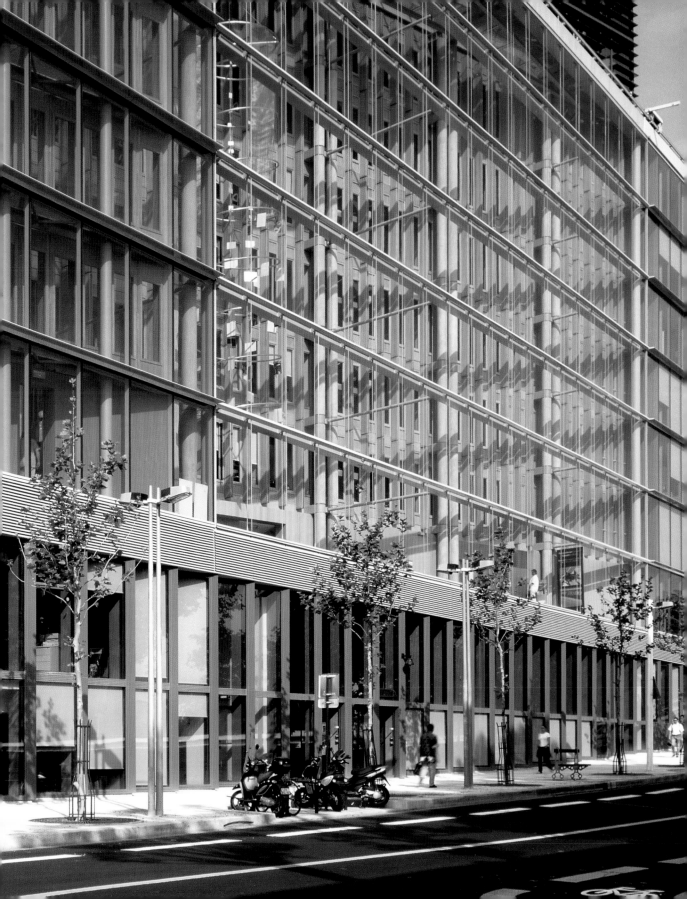

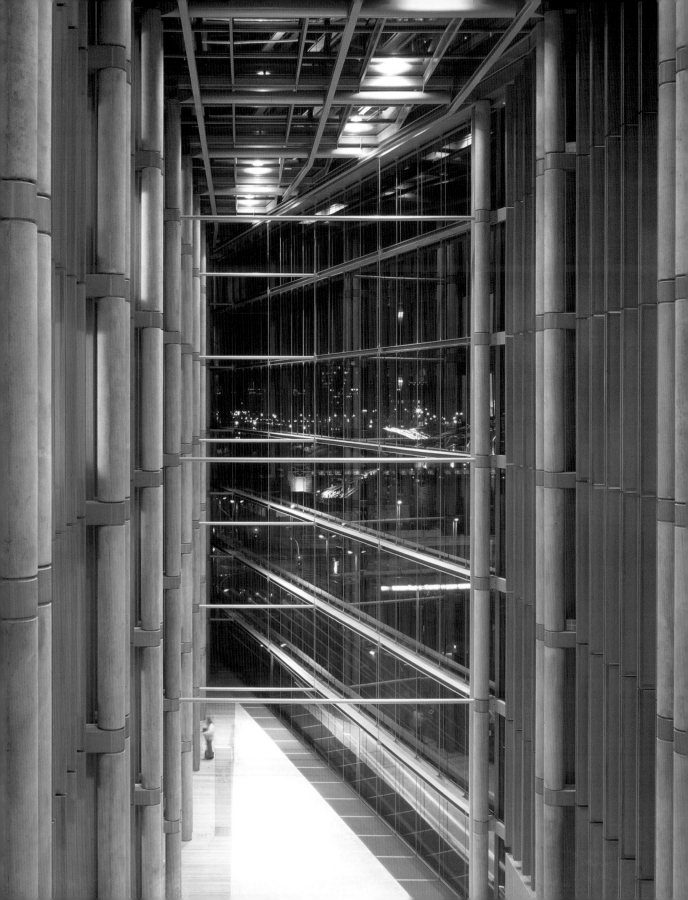

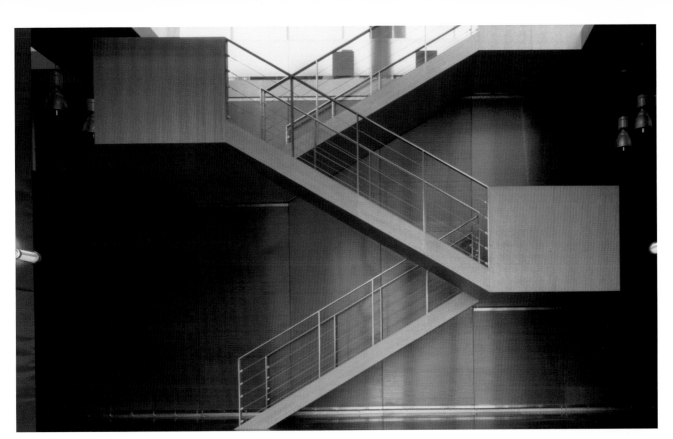

59 Apartments

Year: 2004
Photographs: © Kamel Khalfi

The fact that the ground on which this apartment building was erected is very narrow made it necessary to build upward in order to gain space. The two 11-story towers were constructed next to each other and have two large patios on the eight and ninth floors. The precast concrete parts are situated in the angles of the buildings, as are the largest windows.

Da das Grundstück, auf dem dieses Gebäude mit Mietwohnungen erbaut wurde, sehr eng ist, musste man nach oben bauen, um Raum zu gewinnen. Die beiden elf Stockwerke hohen Türme wurden nebeneinander errichtet und verfügen über zwei große Terrassen im achten und neunten Stockwerk. Die Fertigteile aus Beton befinden sich in den Winkeln der Gebäude, wo auch die größten Fenster zu finden sind.

L'étroitesse de la parcelle où est construit cet édifice d'appartements locatifs, situé à Courbevoie, a défini la nécessité de gagner de l'espace en hauteur en construisant onze étages. Les deux tours s'érigeant l'une à côté de l'autre, ont été aménagées pour accueillir deux grandes terrasses au huitième et neuvième étage. Les cadres en béton préfabriqué sont installés aux angles de l'édifice, juste à l'endroit où se trouvent les fenêtres plus larges.

La estrechez de la parcela en la que fue construido este edificio de viviendas de alquiler, ubicado en Courbevoie, determinó la necesidad de ganar espacio hacia arriba por medio de la construcción de once pisos. Las dos torres se erigen una al lado de la otra y han sido habilitadas para albergar dos grandes terrazas en la octava y la novena planta. Los marcos de hormigón prefabricados se sitúan en los ángulos del edificio, justo donde se encuentran las ventanas más amplias.

L'angusta parcella su cui è stato costruito questo edificio di case popolari ha determinato la necessità di guadagnare spazio in altezza attraverso la costruzione di undici piani. Le due torri si ergono una di fianco all'altra e sono state abilitate per ospitare due grandi terrazze all'ottavo e al nono piano. Le strutture prefabbricate di cemento sono collocate agli angoli dell'edificio, proprio dove si trovano le finestre più ampie.

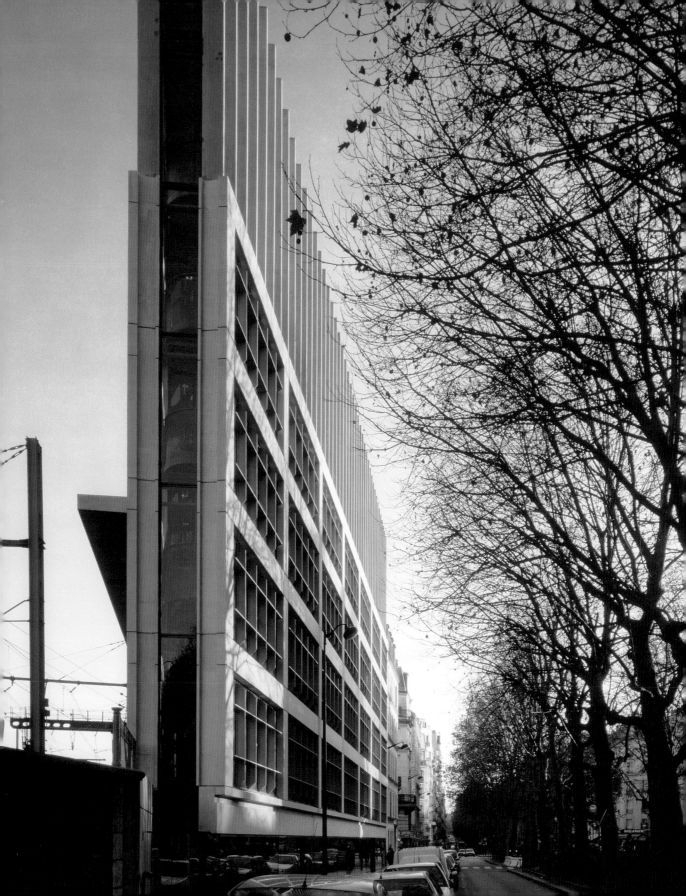

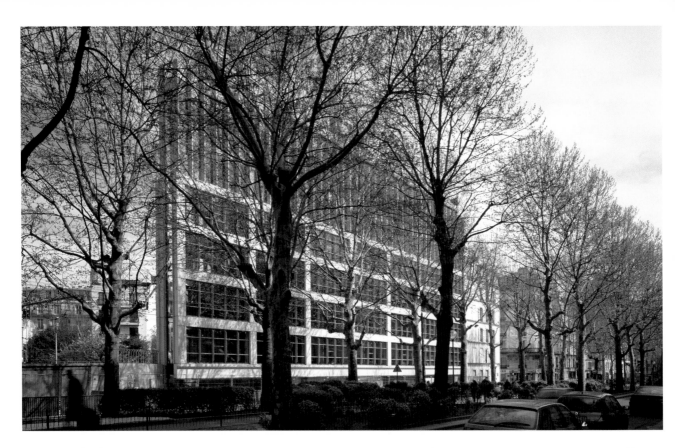

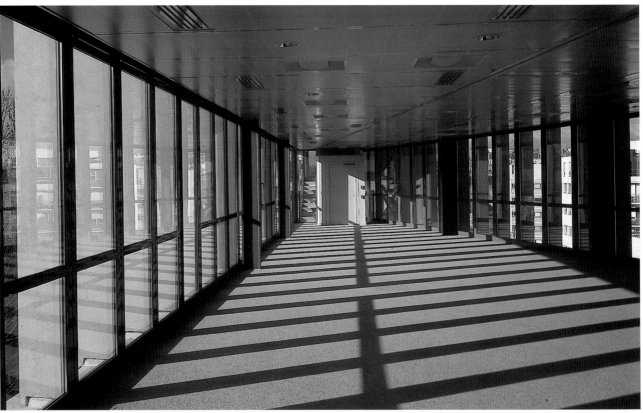

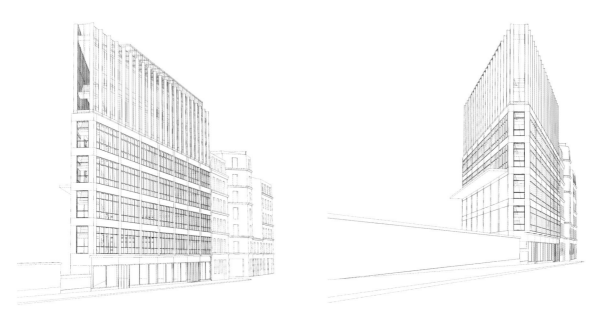

Elevations

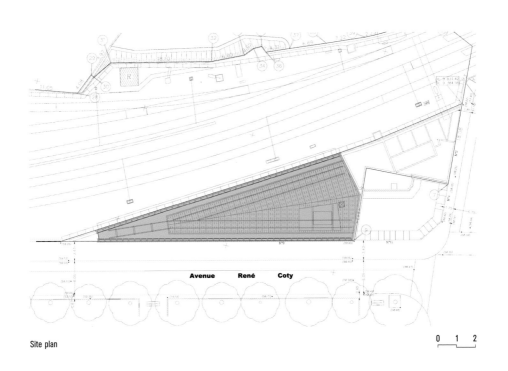

Avenue René Coty

Site plan

0 1 2

Office Building

Year: 2005
Photographs: © Géraldine Bruneel

This project was built on a narrow, triangular plot next to the train tracks near Denfert-Rochereau station. The symmetrical layout of the offices made it possible to provide the two façades of the structure with the same design. There are, however, distinguishable sections: Grid-like concrete structures frame the four lower floors; a dense vertical framework surrounds the upper floors and the top floor houses the main offices and conference rooms.

Dieses Projekt wurde auf einem engen dreieckigen Baugrundstück neben den Bahngleisen in der Nähe des Bahnhofs Denfert-Rochereau errichtet. Die symmetrische Anordnung der Büros erlaubte es, die zwei Fassaden des Gebäudes gleich zu gestalten. Dabei lassen sich unterschiedliche Sektionen unterscheiden: Gitterförmige Betonstrukturen rahmen die vier untersten Stockwerke ein, eine enge vertikale Verflechtung umgibt die oberen Geschosse und die letzte Etage beherbergt die Hauptbüros und Konferenzsäle.

Ce projet est implanté sur une parcelle étroite, de forme triangulaire, située le long des voies de chemin de fer, à quelques pas de la station Denfert-Rochereau. La distribution symétrique des bureaux conduit au design similaire des deux façades. On peut toutefois reconnaître des sections différentes : des structures de béton encadrent les quatre premiers étages, un treillis vertical dense vertical entoure les derniers étages et un niveau ultime, à l'image d'un attique, abrite les bureaux principaux et les salles de conférences.

Este proyecto se erige en una parcela estrecha, de forma triangular, situada a lo largo de las vías del tren, a poca distancia de la estación Denfert-Rochereau. La distribución simétrica de las oficinas permite que las dos fachadas tengan el mismo diseño; aunque a su vez se puedan reconocer secciones diferentes: unas estructuras de hormigón enmarcan los primeros cuatro pisos; un denso entramado vertical rodea las últimas plantas y un último nivel a modo de ático alberga los despachos principales y las salas de conferencias.

Questo progetto si erge su una parcella stretta, di forma triangolare, situata lungo i binari del treno, a poca distanza dalla stazione Denfert-Rochereau. La distribuzione simmetrica degli uffici fa sì che le due facciate presentino lo stesso disegno, che a sua volta lascia intravedere sezioni differenti: delle strutture di cemento incorniciano i quattro primi piani, una fitta impalcatura verticale circonda gli ultimi ed un ulteriore piano, adibito ad attico, ospita gli uffici principali e le sale per le conferenze.

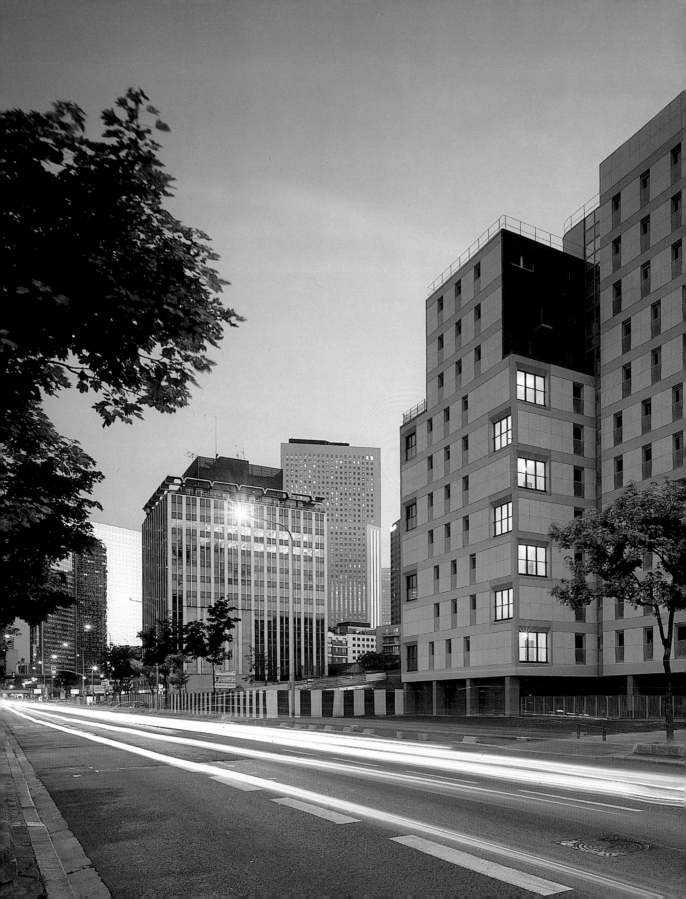

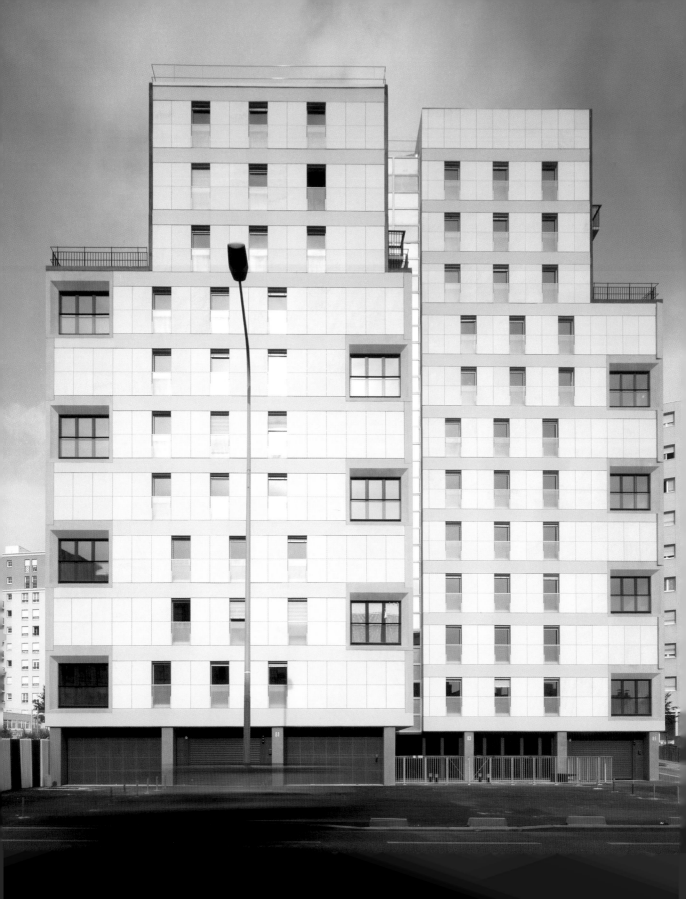

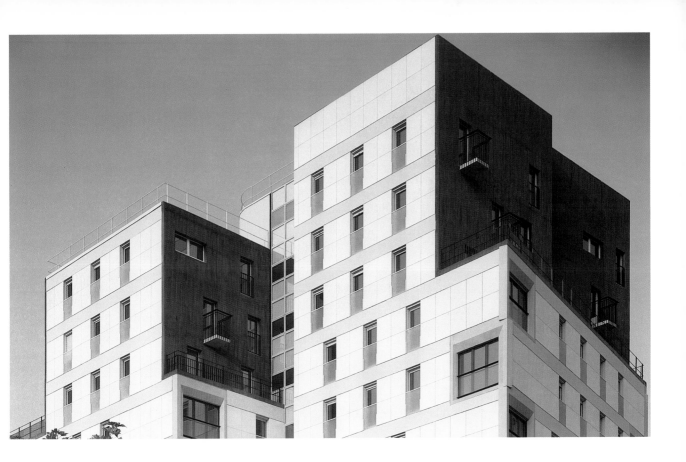

Elevation

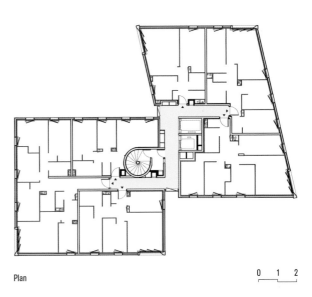

Plan

0 1 2

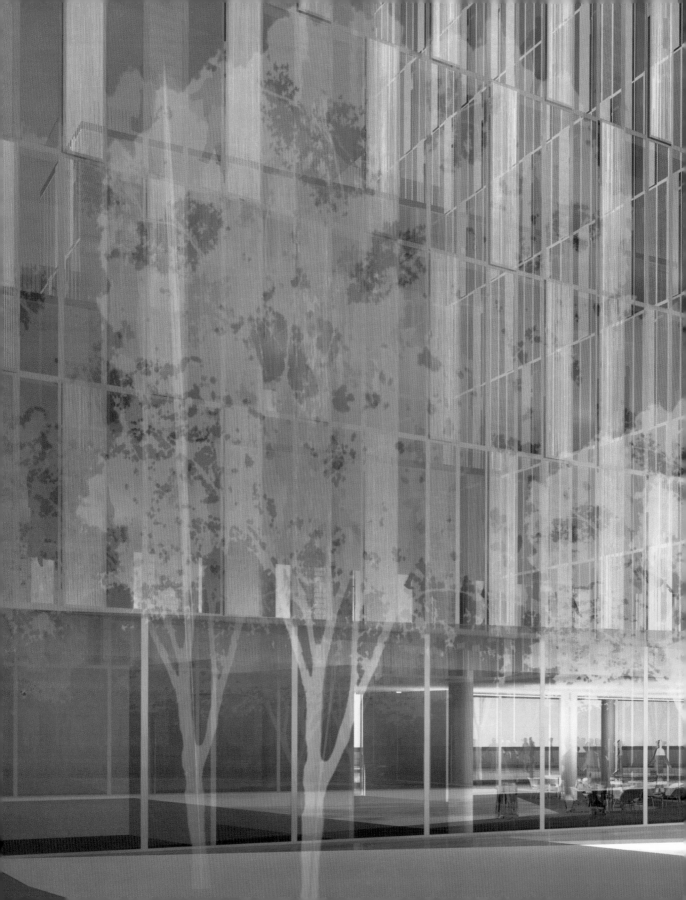

Dominique Perrault

Dominique Perrault

26, rue Bruneseau, 75629 Paris

+33 144 06 00 00

+33 144 06 00 01

www.perraultarchitecte.com

dominique.perrault@perraultarchitecte.com

Architect Dominique Perrault owes much of his recognition to his proposal, with which he won the contest for the construction of the French National Library in 1989. The structure was completed in 1995 and Perrault became the youngest internationally recognized name in contemporary architecture. In 1981, he started his architectural studio where he develops projects in the fields of architecture, stage design, installations and furniture. His work has been recognized with numerous prizes and awards.

Der Vorschlag, mit dem Dominique Perrault 1989 den Wettbewerb für den Bau der französischen Nationalbibliothek gewann, trug zum großen Teil zur Anerkennung dieses Architekten bei. Das Gebäude wurde 1995 fertiggestellt und Perrault zur jüngsten international anerkannten Figur der zeitgenössischen Architektur. 1981 gründete er sein Architekturbüro, mit dem er an architektonischen Projekten, Bühnenbildern, Installationen und Mobiliar arbeitet. Seine Arbeit wurde mit einer Vielzahl von Preisen und Anerkennungen ausgezeichnet.

La renommée de cet architecte est due, en grande partie, au succès de son projet, lauréat du concours pour la Bibliothèque National de Paris, en 1989, et terminé en 1995. Il devient alors la plus jeune figure renommée de l'architecture contemporaine. En 1981, il crée son studio où il développe des projets architecturaux, scénographiques, d'installations et de mobilier. Son travail a été récompensé de nombreux prix et mentions.

El reconocimiento de este arquitecto se debe en gran medida a que su propuesta fue la ganadora en el Concurso para la Biblioteca Nacional de París, en 1989, finalizada en 1995. Ello le ha convertido en la figura más joven de gran renombre dentro de la arquitectura contemporánea. En 1981 creó su estudio en el que desarrolla proyectos arquitectónicos, escenografías, instalaciones y mobiliario. Su trabajo ha sido galardonado con numerosos premios y menciones.

La fama Dominique Perrault la deve in gran misura alla vittoria della sua proposta al Concorso per la costruzione della Biblioteca Nazionale di Parigi nel 1989. Conclusosi nel 1995, questo progetto gli ha valso il prestigio internazionale quale più giovane personaggio di rilievo nel panorama dell'architettura contemporanea. Nel 1981 crea il proprio studio specializzato nella realizzazione di progetti architettonici e scenografici, installazioni e arredi. Il suo lavoro ha ricevuto numerosi premi e riconoscimenti.

Dominique Perrault

1953
Born in Clermont-Ferrand, France

1978
Diploma in architecture, École Nationale Supérieure des Beaux-Arts de Paris, France

1981
Opening of his office in Paris, France

1989
Winner of the international competition for the French National Library in Paris, France

1993
Grand Prix National d'Architecture, France

2001
World Architecture Award, first prize for the best industrial building, for the APLIX factory Media Library, Vénissieux, France

2005-2007
Office building, Boulogne Billancourt, France

Interview | Dominique Perrault

Which do you consider the most important work of your career? The National Library. Although I was a young architect, it will always be the most important work of my career because it has marked the physiognomy of Paris.

In what ways does Paris inspire your work? Paris inspired me very much throughout my studies. I studied its town halls, which made me understand the way Paris was built in 19th century.

Does a typical Paris style exist, and if so, how does it show in your work? Historical Paris is marked by a clear, coherent and visible organization. Everyone can find these features in my work, especially in my radical architectural concepts.

How do you imagine Paris in the future? As a bottle that is half full or half empty, with a large historical museum for the conservative aspects, and a big territory with an historical heart for the progressive.

Welches Werk halten Sie für das wichtigste Ihrer Karriere? Die Nationalbibliothek. Obwohl ich ein junger Architekt war, wird es immer das wichtigste Werk meiner Karriere bleiben, da es die Physiognomie von Paris bestimmt hat.

Wie inspiriert Paris Ihre Arbeit? Paris inspirierte mich sehr während meines Studiums. Ich befasste mich mit seinen Rathäusern, was mich verstehen ließ, wie Paris im 19. Jahrhundert erbaut wurde.

Gibt es einen typischen Pariser Stil, und wenn ja, wie macht dieser sich in Ihrer Arbeit bemerkbar? Das historische Paris ist von einer klaren, kohärenten und sichtbaren Organisation gekennzeichnet. Diese Merkmale kann jedermann in meiner Arbeit finden, besonders in meinen radikalen architektonischen Konzepten.

Wie stellen Sie sich Paris in der Zukunft vor? Als eine Flasche, die halbvoll oder halbleer ist, mit einem großen historischen Museum für die konservativen Aspekte und einem großen Gebiet mit historischem Herzen für die progressiven.

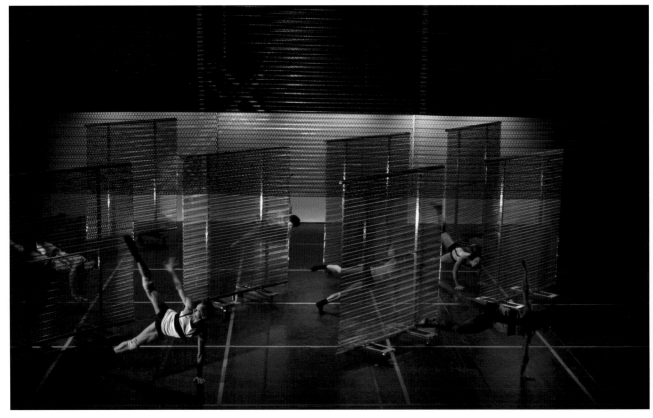

Quelle est à vos yeux l'œuvre la plus importante de votre carrière ? La Bibliothèque Nationale. Même si j'étais à l'époque un jeune architecte, elle restera toujours l'œuvre, la plus importante de ma carrière car elle a marqué la physionomie de Paris.

Dans quelle mesure votre œuvre artistique s'inspire-t-elle de Paris ? Paris m'a beaucoup inspiré tout au long de mes études. J'ai étudié ses mairies, qui m'ont fait comprendre la manière dont Paris a été construit au XIXe siècle.

Existe-t-il un style typiquement parisien, et si oui, comment se manifeste-t-il dans votre œuvre ? Le Paris historique se définit par une structure claire et visible. Tout le monde peut retrouver ces caractéristiques dans mon œuvre, spécialement dans mes concepts architecturaux extrêmes.

Comment imaginez-vous le Paris du futur ? Comme une bouteille à moitié pleine, à moitié vide, avec un immense musée historique pour les aspects conservateurs et un vaste territoire doté d'un cœur historique pour les progressistes.

¿Cuál cree que es el trabajo más importante de su carrera? La Biblioteca Nacional. Aunque en aquel momento era un joven arquitecto, ésta siempre será la obra más importante de mi carrera porque ha marcado la fisonomía de París.

¿Cómo le inspira París en su trabajo? París me ha inspirado mucho a lo largo de mi carrera. Estudié sus ayuntamientos, lo que me hizo comprender el modo en que se construyó París en el siglo XIX.

¿Existe un estilo típico de París? Y si es así, ¿cómo se muestra éste en su obra? El París histórico se caracteriza por una organización clara, coherente y visible. Cualquiera puede encontrar estos rasgos en mi obra, especialmente en mis conceptos arquitectónicos radicales.

¿Cómo se imagina París en un futuro? Como una botella que está medio llena o medio vacía, con un enorme museo histórico, para los aspectos conservadores, y un gran espacio con un corazón histórico, para los progresistas.

Quale ritiene sia l'opera più importante della sua carriera? La Biblioteca Nazionale. Anche se ero un architetto giovane, resterà sempre l'opera più importante della mia carriera perché ha modificato la fisionomia di Parigi.

In che modo Parigi ispira il suo lavoro? Parigi mi ha ispirato molto durante i miei studi. Ho studiato i suoi municipi, arrivando a comprendere il modo in cui Parigi fu costruita nel XIX secolo.

Esiste un tipico "stile parigino"? Se si, come si manifesta nel suo lavoro? La Parigi storica è segnata da un'organizzazione chiara, coerente e visibile. Chiunque può riconoscere queste caratteristiche nel mio lavoro, specialmente nella mia filosofia architettonica piuttosto radicale.

Come immagina Parigi nel futuro? Come un bicchiere mezzo pieno o mezzo vuoto: con un grande museo di storia dedicato ai suoi aspetti conservatori e un vasto territorio con un cuore storico che comprenda quelli progressisti.

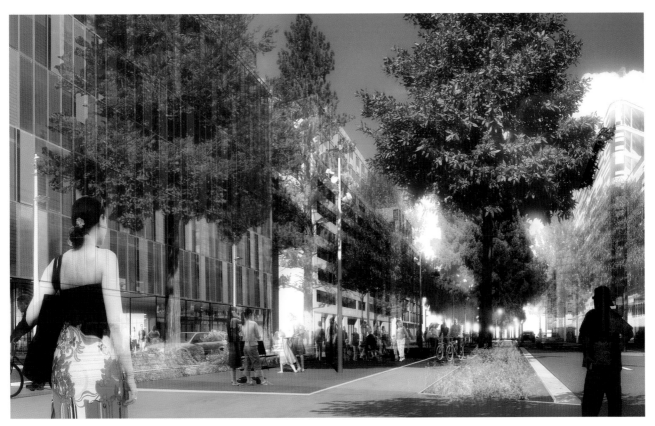

Parking Emile Durkheim

Year: 2002
Photographs: © ADAGP/A. Morin

This project consists of the renovation of a 330,000 ft² parking garage with 1,000 spaces designed to cover the parking needs of the National Library of France, which was also designed by Perrault. Each level is marked by a color—red, yellow, green and blue. The light effect is created by neon lights in tubes of tinted polycarbonate. The playful symbols on the pink floor add a tough of originality to this parking facility.

Bei diesem Projekt handelt es sich um die Umgestaltung eines Parkhauses mit 1.000 Plätzen und 30.775 m², das den Parkbedarf der französischen Nationalbibliothek decken sollte, die ebenfalls von Perrault entworfen wurde. Jedes Stockwerk ist durch eine Farbe gekennzeichnet: Rot, Gelb, Grün und Blau. Der Lichteffekt wird durch Neonstäbe in gefärbten Polycarbonatröhren erreicht. Die fantasievollen Symbole auf dem rosa Boden verleihen diesem Parkhaus eine originelle Note.

Le projet consiste à réhabiliter un parking de 1.000 places et 30.775 m² afin de couvrir les besoins de stationnement de la Bibliothèque Nationale de France, également réalisée par Perrault. Chaque étage se définit par une couleur - rouge, jaune, vert et bleu - obtenue grâce à un effet lumineux créé par des néons installés dans des tubes de polycarbonate tinté. Les icônes originales représentées sur le sol rose apportent une touche d'excentricité à ce garage.

El proyecto consiste en habilitar un aparcamiento de 1.000 plazas y 30.775 m² con el objeto de cubrir las necesidades de estacionamiento de la Biblioteca Nacional de Francia, que fue realizada también por Perrault. Cada planta se caracteriza por un color –rojo, amarillo, verde y azul– que se consigue por medio de un efecto luminoso creado con luces de neón instaladas en tubos de policarbonato tintado. Los originales iconos representados sobre el suelo rosa aportan un toque original a este garaje.

Il progetto consiste nell'abilitazione di un parcheggio di 1.000 posti e 30.775 m² con l'obiettivo di far fronte alle necessità di stazionamento della Biblioteca Nazionale di Francia, realizzata dallo stesso Perrault. Ogni piano è caratterizzato da un colore diverso, rosso, giallo, verde e blu, un effetto luminoso ricreato con luci al neon installate in tubi di policarbonato tinto. Le originali icone rappresentate sul pavimento rosa conferiscono al parcheggio un tocco di originalità.

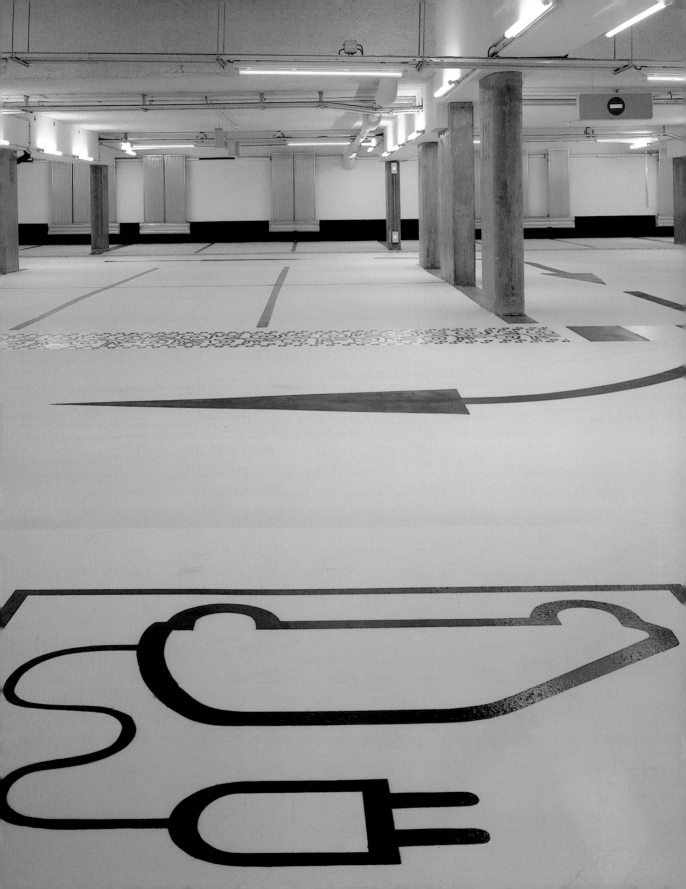

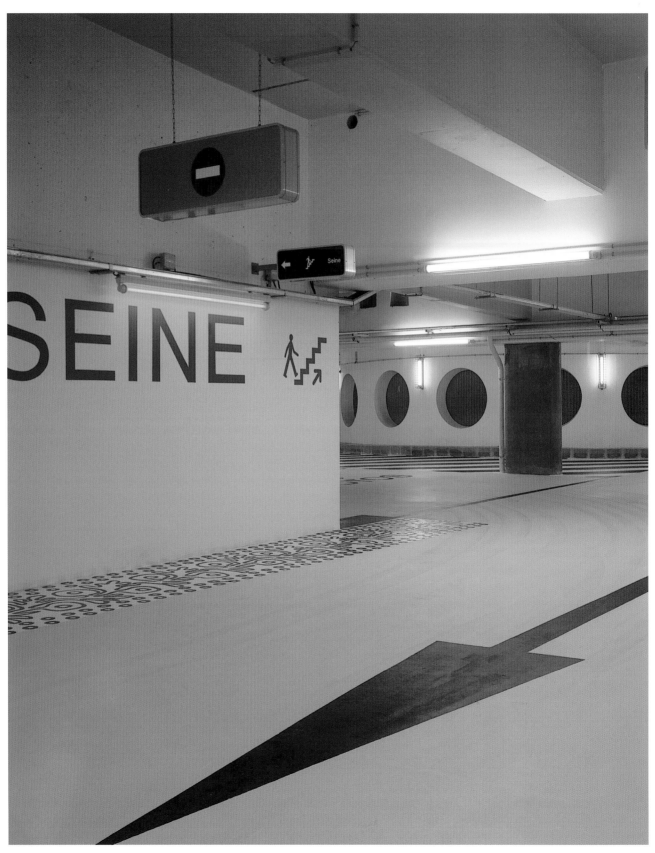

Dominique Perrault

Dominique Perrault

Office Building at Boulogne-Billancourt

Year: Under construction (estimated 2008)

Photographs: © Dominique Perrault Architecture

This office block is situated in the district of Boulogne-Billancourt, in the Île de France. Its eight stories and ground floor comprise 108,000 ft^2 of office space, 6,500 ft^2 of dining area and a 1,600 ft^2 cafeteria and club for the managers. The main building dominates the structure of the complex, on whose sides, a small atreum is enclosed by two transverse buildings. Its many long and narrow windows give the building a certain touch of elegance.

Dieses Bürogebäude liegt im Bezirk Boulogne-Billancourt, in der Region Île de France. Die acht Stockwerke und das Parterre umfassen 10.000 m^2 Bürofläche, 600 m^2 Kantine und 150 m^2 für eine Cafeteria und einen Club für die leitenden Angestellten. Der Hauptbau beherrscht die Struktur des Gebäudes, an dessen Seiten zwei Quergebäude einen kleinen Innenhof umschließen. Die vielen langen und schmalen Fenster verleihen diesem Gebäude eine gewisse Eleganz.

Cet ensemble de bureaux se trouve dans le quartier de Boulogne-Billancourt, en Île de France. Ses huit étages plus un rez-de-chaussée représentent 10.000 m^2 consacrés aux bureaux, dont 600 m^2 pour la salle à manger et 150 m^2 pour la cafétéria et un club réservé à la direction. Le volume principal préside en s'élançant de la structure de l'édifice. De ses extrémités surgissent deux volumes transversaux qui enferment un petit patio intérieur. Les multiples fenêtres, allongées et étroites, imprègnent ce projet de sveltesse.

Este edificio de oficinas está situado en el distrito de Boulogne-Billancourt, en Île de France. Sus ocho alturas más planta baja incluyen 10.000 m^2 dedicados a las oficinas, 600 m^2 al comedor y 150 m^2 a la cafetería y a un club para los directivos. El volumen principal se erige presidiendo la estructura del edificio, de cuyos extremos sobresalen dos volúmenes transversales que acogen un pequeño patio en su interior. Las múltiples ventanas, alargadas y estrechas, confieren esbeltez a este proyecto.

Questo edificio di uffici si trova nel distretto di Boulogne-Billancourt, sull'Île de France. I suoi otto livelli più il piano terra includono 10.000 m^2 destinati a uffici, 600 m^2 alla mensa e 150 m^2 alla caffetteria e a un club per i dirigenti. L'edificio principale sovrasta la struttura del complesso, dalle cui estremità sporgono due edifici trasversali che accolgono al loro interno un piccolo patio. Le molteplici finestre, lunghe e strette, conferiscono slancio a questo progetto.

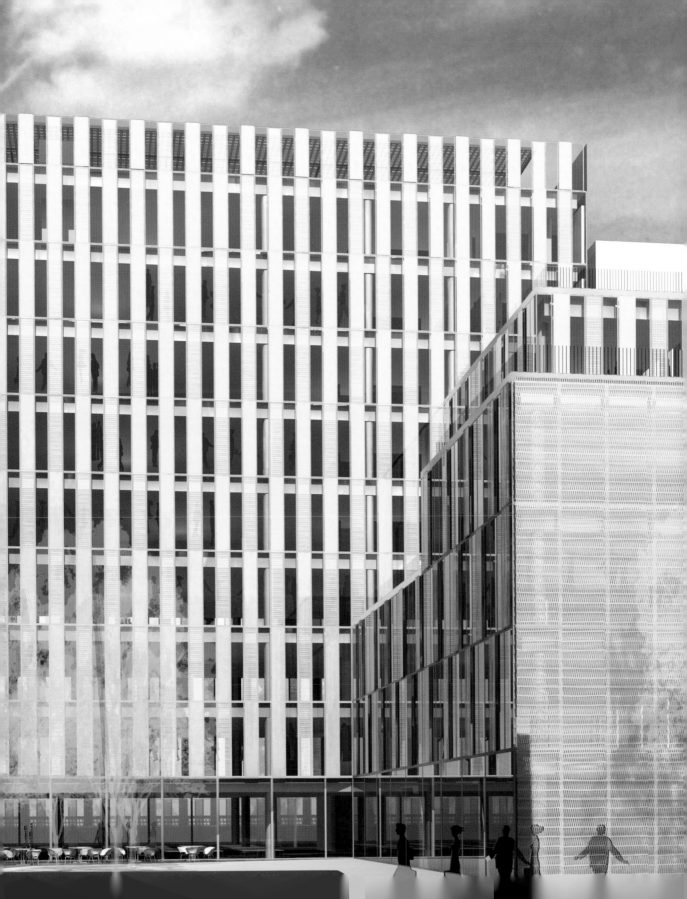

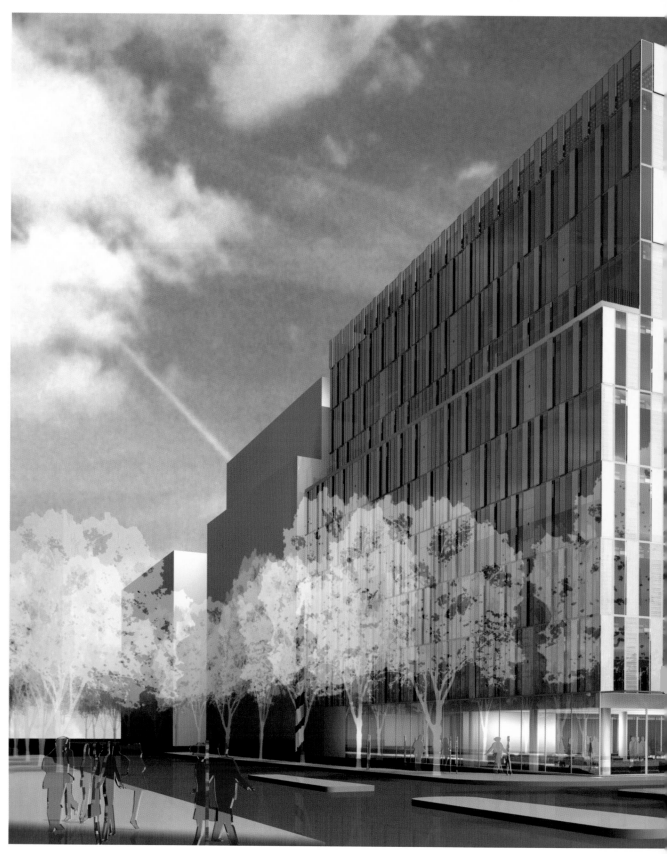

Dominique Perrault

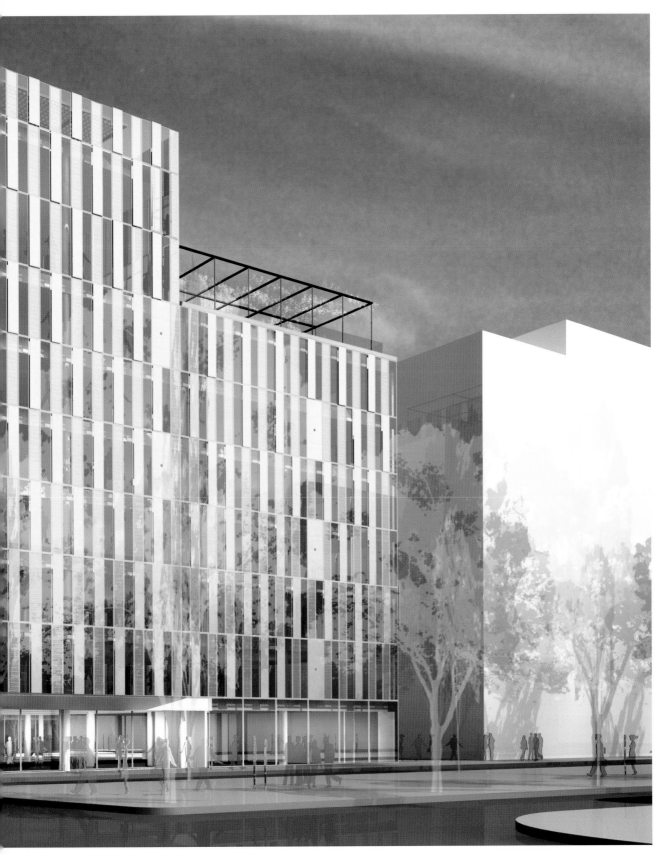

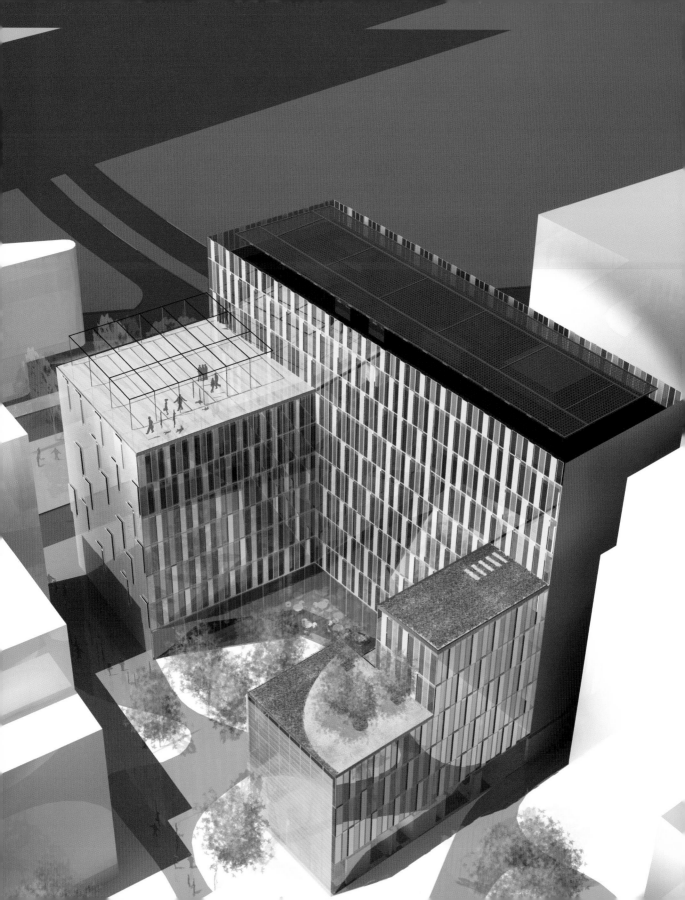

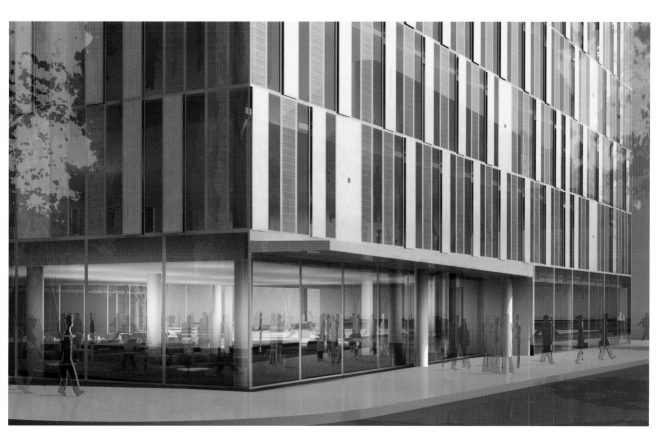

La Cité Radieuse

Year: 2005
Photographs: © Pino Pipitone

This scenery, designed by Frédéric Flamand for the choreography of "La Cité Radieuse" for the Marseille National Ballet, invites the audience to a game of reality and fiction. The dancers perform between two large moving screens on which images of previously shown scenes and even full views can be projected. The bizarre optical effect produced by this interaction between the past and the present is a combination of dance and architecture in movement.

Dieses Bühnenbild für die Choreographie von „La Cité Radieuse" von Frédéric Flamand für das Nationalballett von Marseille lädt den Zuschauer zu einem Spiel von Realität und Fiktion ein. Die Tänzer treten zwischen großen Leinwänden auf, die sich bewegen und auf die Bilder der kürzlich gezeigten Szenen und sogar Totalansichten projiziert werden. Der sonderbare optische Effekt aus diesem Zusammenspiel von Vergangenheit und Gegenwart ist ein Spektakel, das eine Mischung aus Tanz und bewegter Architektur darstellt.

Cette scénographie, conçue pour la chorégraphie de « La Cité Radieuse » de Frédéric Flamand pour le Ballet National de Marseille, invite le spectateur à pénétrer dans un jeu de réalité et fiction. Les danseurs évoluent entre de grands écrans qui bougent au fil de leur chorégraphie et sur lesquels sont projetés des images récentes et mêmes des plans généraux. L'étonnant effet optique qui résulte de ce mélange entre passé et présent est un spectacle à mi-chemin entre la danse et l'architecture en mouvement.

Esta escenografía, ideada para la coreografía de "La Cité Radieuse" de Frédéric Flamand para el Ballet Nacional de Marsella, invita al espectador a adentrarse en un juego de realidad y ficción. Los bailarines actúan entre grandes pantallas que van moviendo en su coreografía y en las que se proyectan imágenes recientes e incluso planos generales. El curioso efecto óptico que resulta de esta mezcla entre pasado y presente es un espectáculo a medio camino entre la danza y la arquitectura en movimiento.

Questa scenografia, ideata per la coreografia di "La Cité Radieuse" di Frédéric Flamand, eseguita dal Balletto Nazionale di Marsiglia, invita lo spettatore ad addentrarsi in un gioco di realtà e finzione. I ballerini interagiscono con la scenografia muovendosi tra grandi schermi mobili su cui vengono proiettate le immagini della coreografia nel suo divenire alternate a piani generali. Il curioso effetto ottico che risulta da questo mix tra passato e presente è uno spettacolo a metà strada tra la danza e l'architettura in movimento.

Dominique Perrault

Christian Biecher

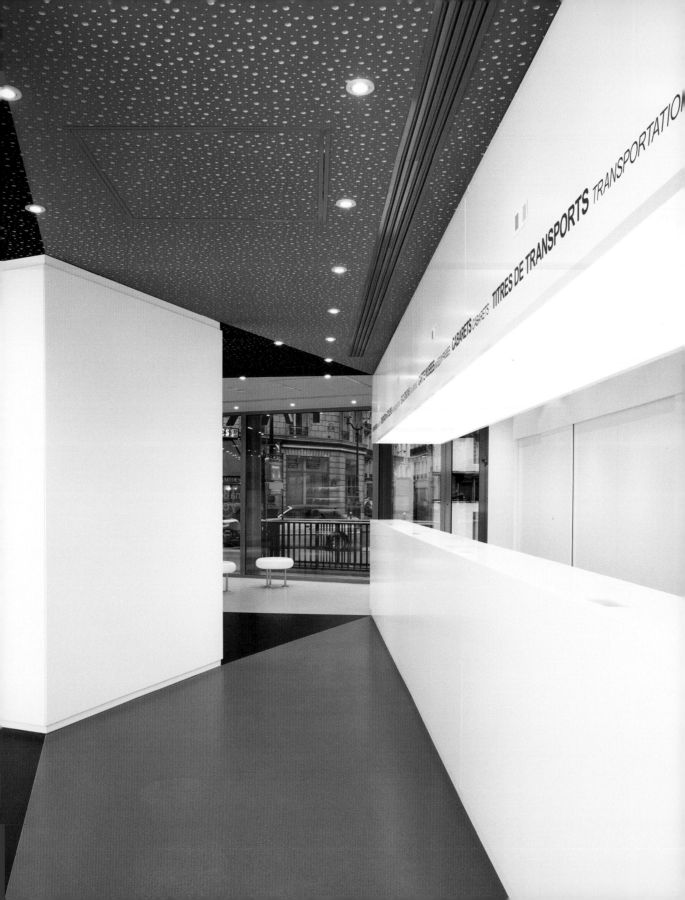

Christian Biecher

14, rue Crespin-du-Gast, 75011 Paris

+33 149 29 69 39

+33 149 29 69 30

www.biecher.com

info@biecher.com

Christian Biecher

1963
Born in Sélestat, France

1989
Degree from the École Nationale Supériore d'Architecture de Paris Belleville (ENSAPB), France

1997
Stablishes CBA (Christian Biecher & Associés) Interior design of Le Petit Café du Passage de Retz, Paris, France

2002
Elected designer of the Year by Salon Maison&Objet
Temporal exhibition "Christian Biecher Before" at the Musée des Arts Décoratifs, Paris, France

2005
Architectural design of the Paris Tourists Office, Paris, France
Silverwear for Christofle

Born in Paris, Christian Biecher belongs to the new generation of versatile architects, who feel at home in all areas of design. His career took off in the 1990s when he traveled around the world combining his interior designs with architecture design in projects such as Le Petit Café or the Paris Tourist Office. He also designs products for brands like Poltrona Frau, Christofle, Aridi or Neotu.

Der gebürtige Pariser Christian Biecher gehört einer neuen Generation vielseitiger Architekten an, die sich in allen Bereichen des Designs zuhause fühlen. Seine Karriere begann in den neunziger Jahren, als er die ganze Welt bereiste und seine Innengestaltungen mit dem architektonischen Design verband, wie zum Beispiel im Le Petit Café oder im Pariser Fremdenverkehrsbüro. Außerdem designt er Produkte für Marken wie Poltrona Frau, Christofle, Aridi oder Neotu.

Né à Paris, Christian Biecher appartient à la nouvelle génération d'architectes polyvalents qui évolue dans n'importe quel secteur de design. Sa carrière décolle dans les années 90, le poussant à voyager dans le monde entier et à travailler mêlant ses designs d'intérieur et d'architecture, comme Le Petit Café ou l'Office de tourisme de Paris. Il est également créateur de produits pour les marques, à l'instar de Poltrona Frau, Christofle, Aridi ou Neotu.

Nacido en París, Christian Biecher pertenece a la nueva generación de arquitectos versátiles, que se mueven en cualquier campo del diseño. Su carrera despegó en los años 90, lo que le llevó a viajar por todo el mundo y a trabajar combinando sus diseños de interiores con los arquitectónicos, como en Le Petit Café o en la Oficina de Turismo de París. También es creador de productos para marcas como Poltrona Frau, Christofle, Aridi o Neotu.

Nato a Parigi, Christian Biecher appartiene alla nuova generazione di architetti versatili capaci di muoversi con disinvoltura in qualunque campo del design. La sua carriera decolla negli anni '90, portandolo a viaggiare in tutto il mondo e a lavorare a progetti in cui il disegno d'interni ben si sposa con la progettazione architettonica, come nel caso di Le Petit Café o dell'Ufficio del Turismo di Parigi. È anche creatore di prodotti per marchi come Poltrona Frau, Christofle, Aridi e Neotu.

Interview | Christian Biecher

Which do you consider the most important work of your career? Probably the next project. Right now the Animation Center is important because it's my first complete building in downtown Paris. It's a design which has a lot of strength and freedom.

In what ways does Paris inspire your work? Paris doesn't inspire me, but people who live in Paris do. As I grow older, I need less inspiration; things come from the inside.

Does a typical Paris style exist, and if so, how does it show in your work? Style is a constraint, but I like it when limits excess. I don't like things that are heavy-handed or expressed too loudly.

How do you imagine Paris in the future? Paris is an old lady sleeping. I couldn't live here if I wasn't traveling all the time. I hope that Paris will wake up and welcome high rise buildings, ambitious architecture. Nothing seems to grow here, but trees.

Welches Werk halten Sie für das wichtigste Ihrer Karriere? Wahrscheinlich das nächste Projekt. Zurzeit ist ein Animationszentrum wichtig, da es mein erstes vollständiges Gebäude im Stadtzentrum von Paris ist. Es ist ein Design voller Stärke und Freiheit.

Wie inspiriert Paris Ihre Arbeit? Nicht Paris inspiriert mich, sondern die Menschen, die in Paris leben. Mit zunehmendem Alter benötige ich weniger Inspiration. Die Dinge kommen aus dem Inneren.

Gibt es einen typischen Pariser Stil, und wenn ja, wie macht dieser sich in Ihrer Arbeit bemerkbar? Stil ist ein Zwang, den ich jedoch mag, wenn er Maßlosigkeit begrenzt. Ich mag keine Dinge, die plump sind oder zu laut ausgedrückt.

Wie stellen Sie sich Paris in der Zukunft vor? Paris ist eine alte Dame, die schläft. Wenn ich nicht ständig auf Reisen wäre, könnte ich nicht hier leben. Ich hoffe, dass Paris erwachen und Hochhäuser und ehrgeizige Architektur willkommen heißen wird ... Dieser Tage scheint hier nichts zu wachsen, außer Bäumen.

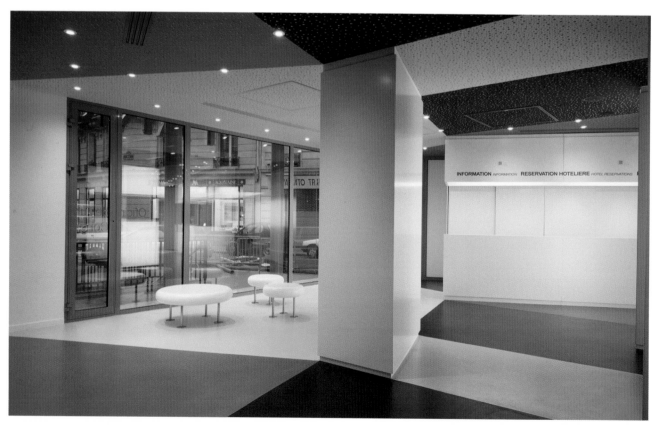

Quelle est à vos yeux l'œuvre la plus importante de votre carrière ? Le prochain projet, sans doute. En ce moment même, le Centre d'Animation est important parce que c'est mon premier édifice intégral au centre de Paris. C'est un design fort et libre.

Dans quelle mesure votre œuvre artistique s'inspire-t-elle de Paris ? Ce n'est pas Paris qui m'inspire, mais les habitants de Paris. En vieillissant, l'inspiration est moins indispensable, les choses viennent de l'intérieur.

Existe-t-il un style typiquement parisien, et si oui, comment se manifeste-t-il dans votre œuvre ? Style signifie contrainte, mais je l'accepte lorsqu'il limite l'excès. Je n'aime pas ce qui est maladroit ou exprimé trop violemment.

Comment imaginez-vous le Paris du futur ? Paris est une vieille dame endormie. Je ne pourrais y vivre si je ne voyageais tout le temps. J'espère que Paris va se réveiller pour accueillir des gratte-ciels, une architecture ambitieuse. Ces jours-ci, il semble que rien ne pousse, sauf les arbres.

¿Cuál cree que es el trabajo más importante de su carrera? Probablemente el próximo proyecto. Ahora mismo es importante el Centro de Animación porque es mi primer edificio completo en el centro de París. Es un diseño que tiene mucha fuerza y libertad.

¿Cómo le inspira París en su trabajo? París no me inspira, sino la gente que vive en París. Conforme me voy haciendo mayor, necesito menos inspiración; las cosas vienen de dentro.

¿Existe un estilo típico de París? Y si es así, ¿cómo se muestra éste en su obra? El estilo es una limitación, pero me gusta cuando limita el exceso. No me gustan las cosas que son torpes o que se expresan de forma exagerada.

¿Cómo se imagina París en un futuro? París es una señora mayor durmiente. No podría vivir aquí de no estar viajando todo el tiempo. Espero que París se despierte y acoja edificios altos, una arquitectura ambiciosa... actualmente, parece que lo único que crece aquí, son los árboles.

Quale ritiene sia l'opera più importante della sua carriera? Probabilmente, il prossimo progetto. In questo momento, considero importante il Centro d'Animazione perché è il mio primo edificio completo nel centro di Parigi. È un design pieno di forza e di libertà.

In che modo Parigi ispira il suo lavoro? Parigi non mi ispira, chi mi ispira è la gente che abita a Parigi. Più invecchio, meno ho bisogno d'ispirazione: le cose vengono da dentro.

Esiste un tipico "stile parigino"? Se sì, come si manifesta nel suo lavoro? Lo stile è un limite, ma mi piace quando limita gli eccessi. Non mi piacciono le forzature o le salite di tono.

Come immagina Parigi nel futuro? Parigi è una vecchia signora addormentata. Non potrei vivere qui se non viaggiassi continuamente. Spero che Parigi si risveglierà e accoglierà edifici elevati, un'architettura ambiziosa... In questi giorni qui non sembra evolversi e crescere nulla, a parte gli alberi.

Paris Tourism Office

Year: 2004
Photographs: © Luc Boegly

The entrance to this tourist office possesses a style seen more and more throughout Paris: A blend of history, like the building housing it, with technology and linear design. Red, blue, yellow, black and white take turns in a display of colors that also distinguish the various areas. Another key element is light, which is why a number of columns have been provided with illuminated glass panels.

Der Eingang zu diesem Fremdenverkehrsbüro ist von einer Ästhetik, die in ganz Paris immer mehr um sich greift: eine Mischung aus Historischem, wie dem Gebäude, das es beherbergt, Technologie und gradlinigem Design. Rot, Blau, Gelb, Schwarz und Weiß wechseln sich in einem Farbenspiel ab, das außerdem die verschiedenen Zonen voneinander abgrenzt. Licht ist ein weiteres Schlüsselelement, weshalb man an einigen Säulen beleuchtete Glasplatten angebracht hat.

L'entrée de ce bureau de tourisme est dotée d'une esthétique qui est le reflet fidèle de celle qui prédomine actuellement à Paris : un mélange d'histoire, comme l'édifice où elle se trouve, de technologie et de designs aux lignes épurées. Le rouge, le bleu, le jaune, le noir et le blanc s'alternent dans un jeu chromatique qui en outre sépare les différentes zones. La lumière est un des autres éléments clé : c'est pourquoi certaines colonnes sont pourvues de panneaux de verre translucide illuminés.

La entrada a esta oficina de turismo posee una estética que es fiel reflejo de la que predomina actualmente en la ciudad de París: una mezcla de lo histórico, como el edificio en el que se encuentra, con la tecnología y los diseños de líneas depuradas. El rojo, el azul, el amarillo, el negro y el blanco van alternándose en un juego cromático que además separa las diferentes zonas. La luz es otro de los elementos clave; por este motivo, en algunas columnas se han instalado paneles de cristal translúcido iluminados.

L'ingresso di questo ufficio del turismo possiede un'estetica che rispecchia fedelmente quella oggi predominante nella città di Parigi: una combinazione fra tradizione storica, evidente nell'edificio in cui è ubicato, tecnologia e design dalle linee essenziali. Il rosso, l'azzurro, il giallo, il nero e il bianco si alternano in un gioco cromatico che ha inoltre la funzione di delimitare le diverse zone. La luce è un altro degli elementi chiave; per questo motivo, in alcune colonne sono stati installati pannelli di cristallo traslucido illuminati.

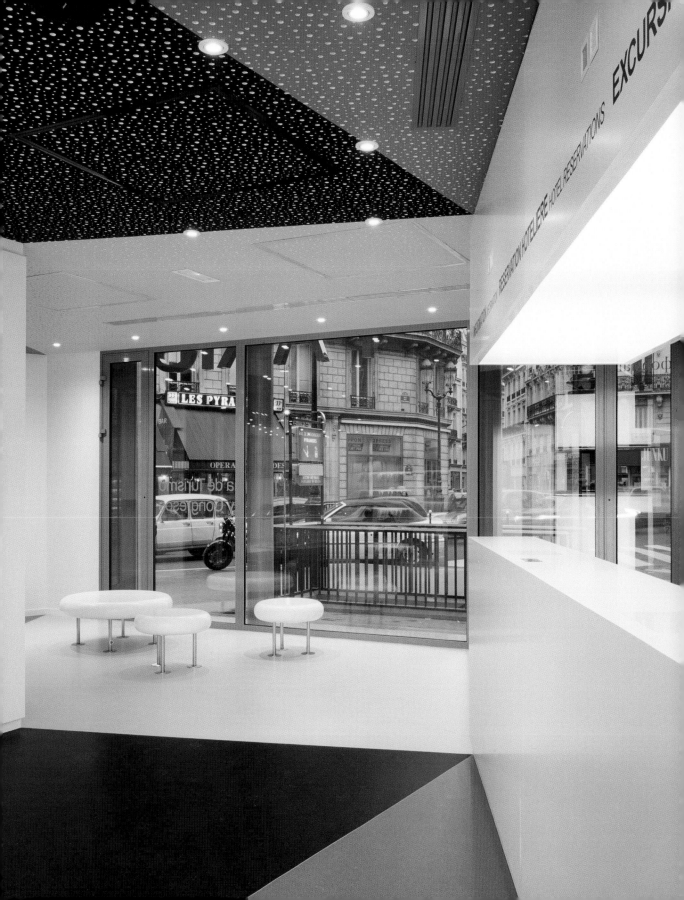

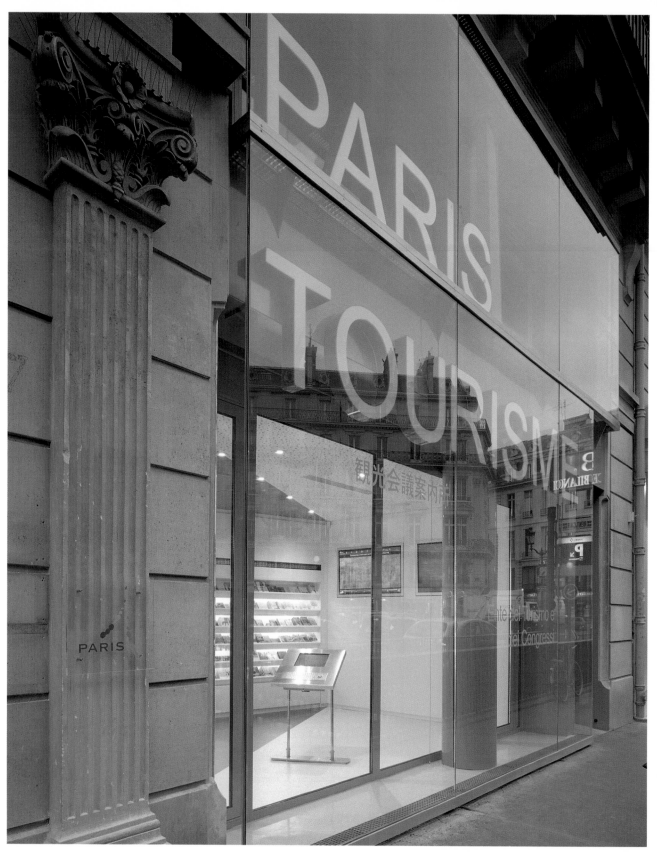

Christian Biecher

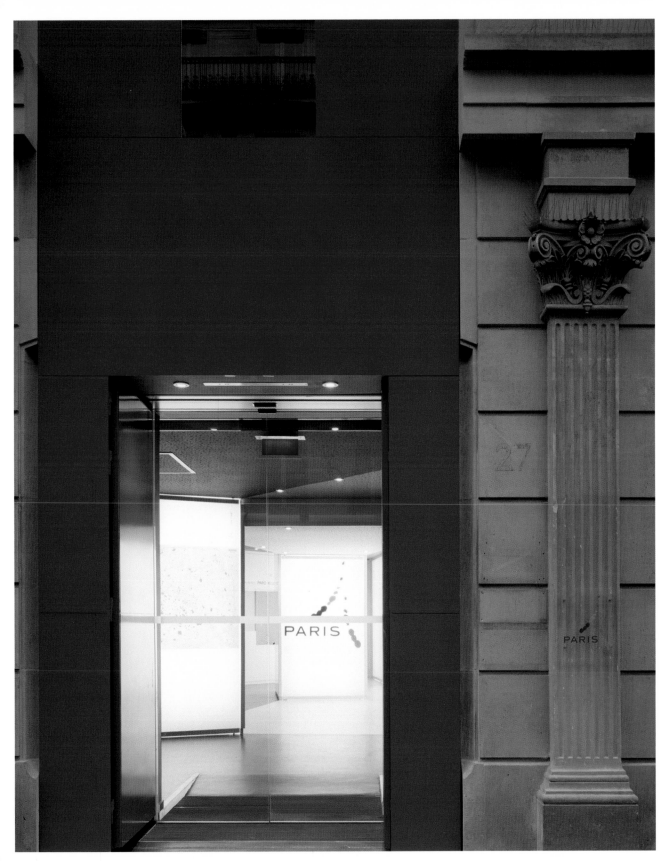

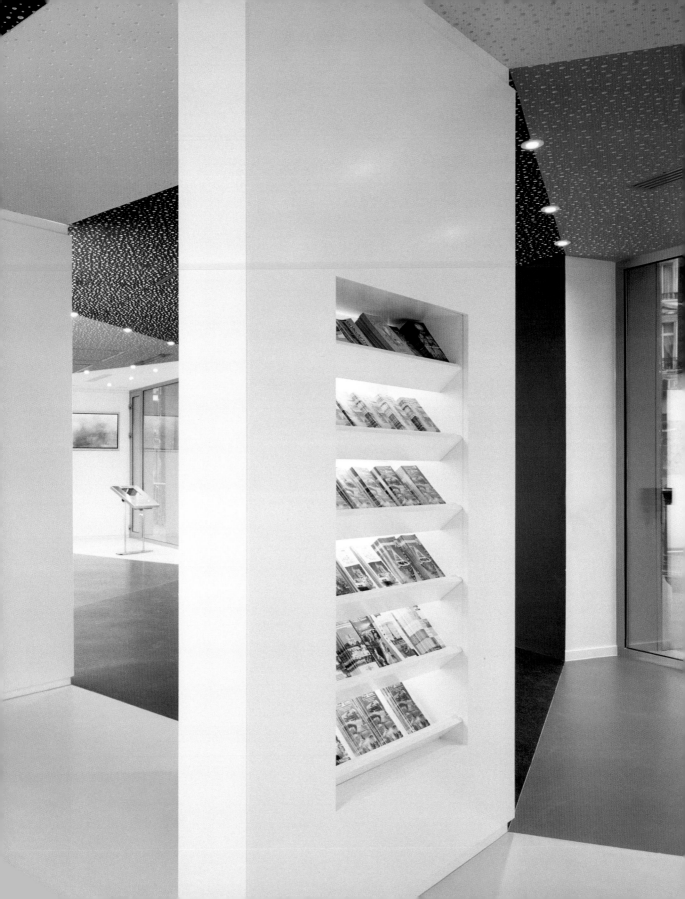

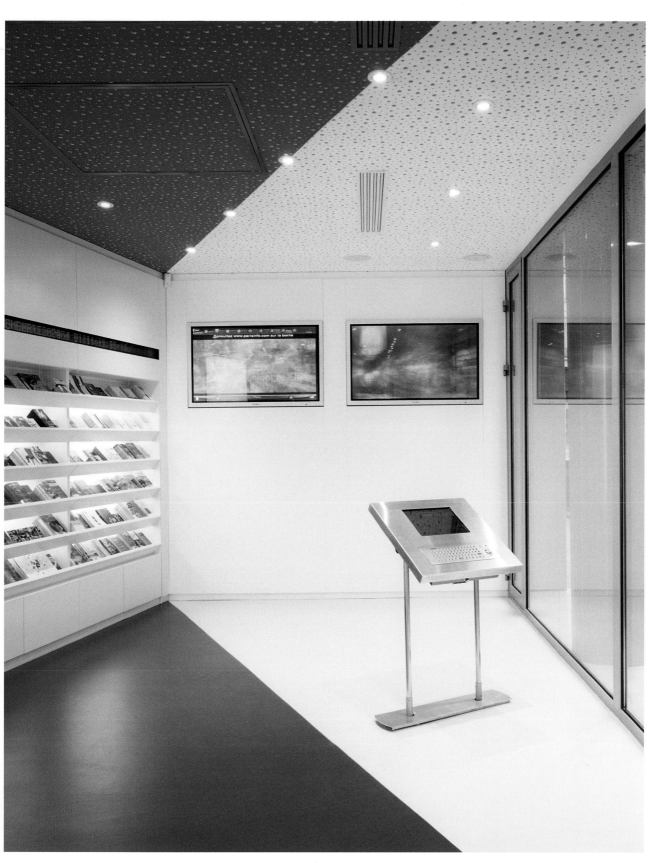

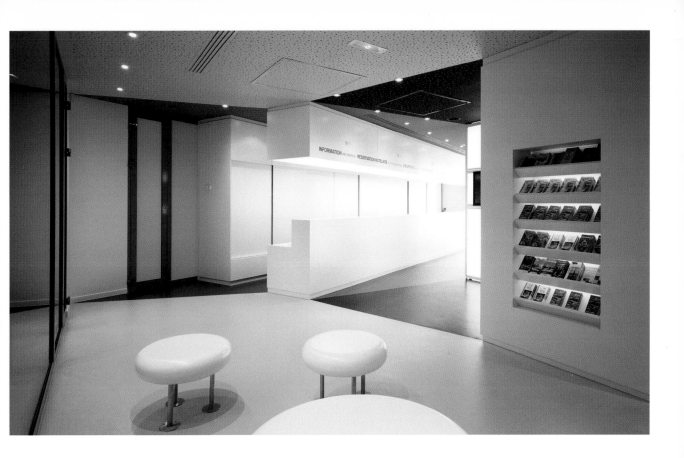

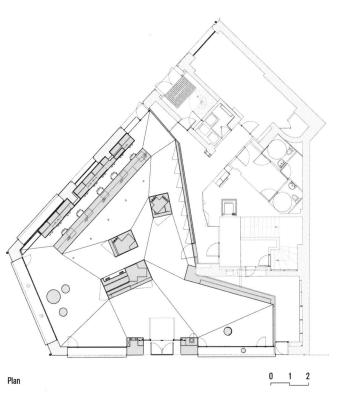

Plan

0 1 2

Boutique Pierre Hermé

Year: 2004

Photographs: © Luc Boegly

The confectionery by Pierre Hermé has a rectangular foundation and a design primarily characterized by the white granite plates on the walls and on the floor. This spatial simplicity allows for a playful interaction of the colors on the tables and display cases. Their layout in the center of the store invites customers to walk freely around the room and to walk up close to the products displayed in the stands and shelves, as if it were a museum. An innovative, clear and technical design, accentuated by the colors of the sun.

Diese Konditorei von Pierre Hermé hat eine rechteckige Grundfläche und ein Design, das wesentlich von den weißen Granittafeln an ihren Wänden und auf ihrem Boden geprägt ist. Diese räumliche Einfachheit erlaubt ein Spiel mit den Farben der Tische und Vitrinen. Ihre Anordnung im Zentrum des Geschäfts lädt dazu ein, den Raum frei zu durchlaufen und sich den Produkten zu nähern, die auf den Anrichten und Regalen ausgestellt sind, so als ob es sich um ein Museum handelte. Ein innovatives Design, klar und technisch, akzentuiert durch die Farben der Sonne.

Cette pâtisserie de Pierre Hermé, est dotée d'un design marqué par sa forme rectangulaire et par l'habillage en plaques de granit blanc des murs et sols. Cette simplicité spatiale permet de jouer avec les couleurs des tables et vitrines. Leur disposition au centre de la boutique invite à parcourir l'espace librement pour s'approcher des produits exposés sur les consoles et les étagères, à l'instar d'un musée. Un design innovateur, précis et technique, rehaussé des couleurs du soleil.

Esta pastelería de Pierre Hermé tiene un diseño marcado por su forma rectangular y por el revestimiento de placas de granito blanco en paredes y suelos. Esta simplicidad espacial permite jugar con los colores de las mesas y vitrinas. Su disposición en el centro de la tienda invita a recorrer el espacio libremente para acercarse a los productos, expuestos en los aparadores y los estantes, como si de un museo se tratara. Un diseño innovador, preciso y técnico, enfatizado por los colores de la dulce infancia.

Questa pasticceria di Pierre Hermé ha un design segnato dalla sua forma rettangolare e dal rivestimento di lastre di granito bianco di pareti e pavimento. Questa simplicità spaziale permette di giocare con i colori di tavoli ed espositori. La loro disposizione al centro del negozio invita a percorrere lo spazio liberamente per avvicinarsi ai prodotti, esposti nelle vetrine e sugli scaffali, come se ci si trovasse in un museo. Un design innovativo, preciso e tecnico, enfatizzato dai colori solari.

Christian Biecher

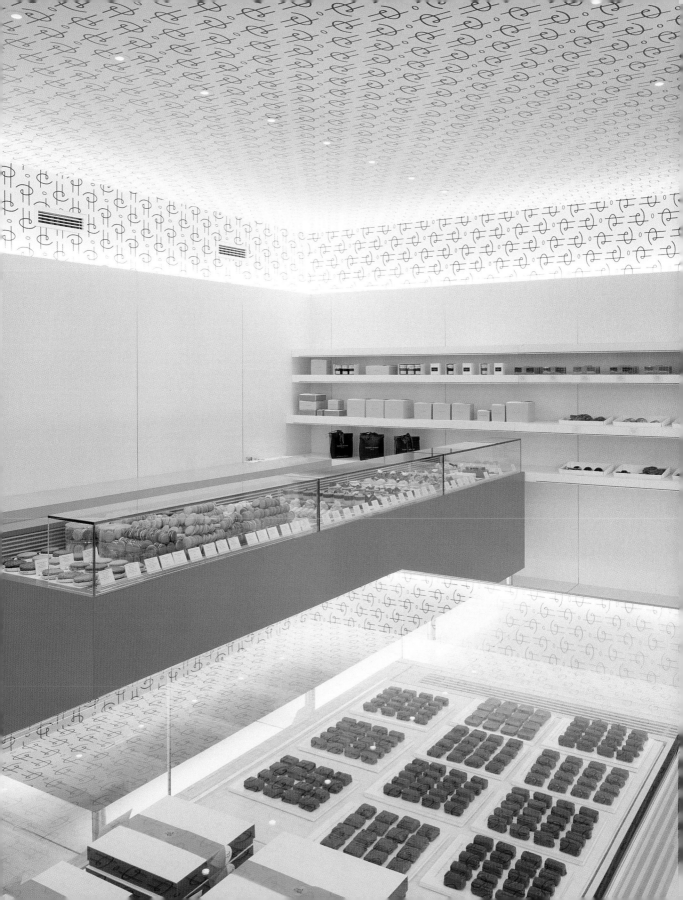

Christian Biecher

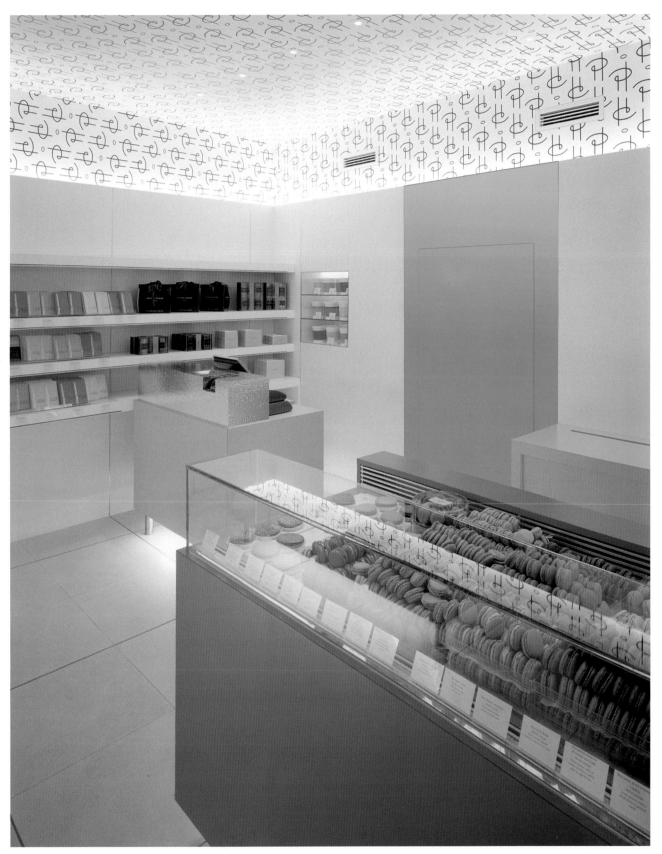

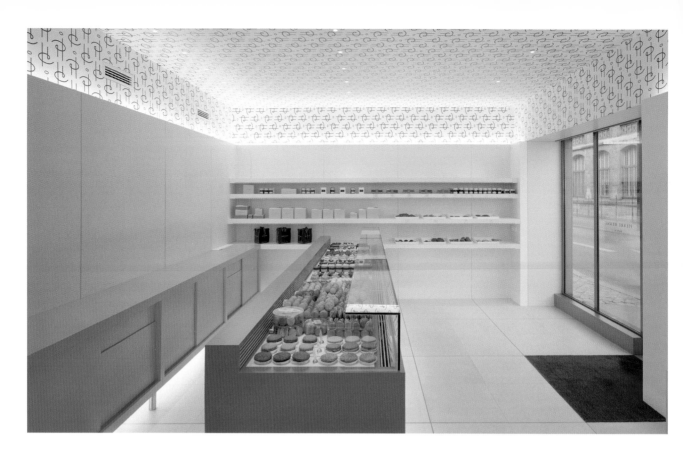

Plan

0 1

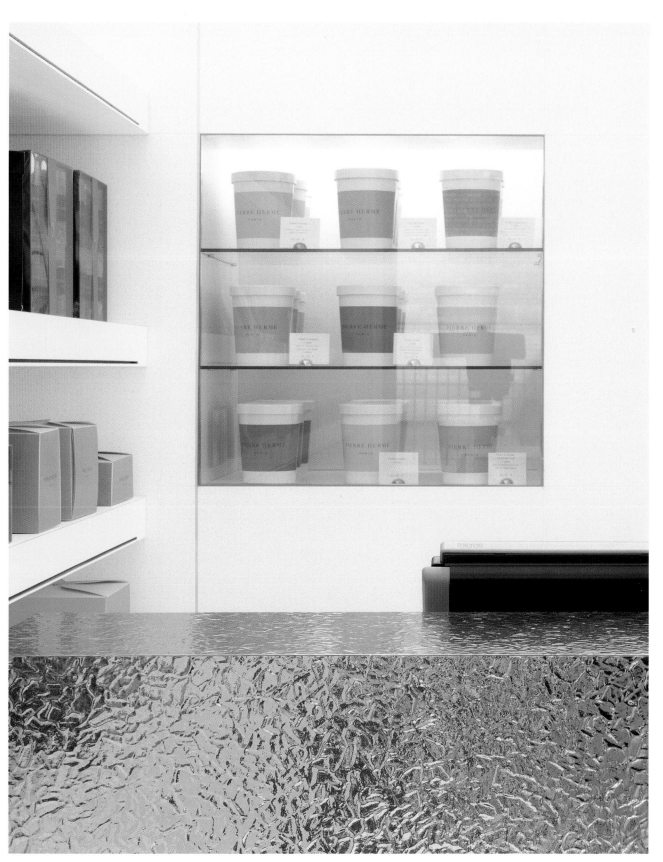

Centre d'Animation et de Spectacle

Year: Under construction
Photographs: © Christian Biecher & Associés (renders)

This animation center combines traditional and modern urban styles in harmony with the surrounding block, where it's located at the outermost point, giving it a modern touch. Transparent and opaque glass panels alternate on its façade, creating an interaction of rhythmically arranged rectangles. The interior has been designed in a decidedly simple and spacious manner to accommodate as many people as possible.

Dieses Animationszentrum kombiniert den traditionellen und den modernen städtebaulichen Stil und steht in Harmonie zu dem umstehenden Häuserblock an deren äußerstem Punkt es sich befindet und welcher es eine moderne Ästhetik verleiht. An der Fassade wechseln sich transparente und undurchsichtige Scheiben ab und bilden ein Spiel von rhythmisch angeordneten Rechtecken. Die Innenräume wurden betont schlicht und weitläufig gestaltet, um eine möglichst große Zahl von Personen fassen zu können.

Ce centre d'animation combine le style urbain traditionnel et le style moderne, en harmonie avec le reste du quartier, dont il constitue une des extrémités et à laquelle il apporte une esthétique moderne. Les vitres transparentes et opaques de la façade s'alternent dans un jeu de rectangles disposés selon un rythme. Pour accueillir un grand nombre de personnes, les espaces intérieurs ont été conçus selon des critères de simplicité d'organisation et de générosité dans les zones de circulation.

Este centro de animación combina el estilo urbanístico tradicional y el moderno, en armonía con el resto de la manzana, del que es uno de los extremos y al que aporta una estética moderna. Los cristales transparentes y los opacos de la fachada van alternándose en un juego de rectángulos dispuestos de manera rítmica. Para poder acoger a un gran número de personas, los espacios interiores se han diseñado bajo las premisas de simplicidad y generosidad.

Questo centro d'animazione combina lo stile urbanistico tradizionale e quello moderno, in armonia con il resto dell'isolato, di cui è una delle estremità e a cui apporta un'estetica moderna. I vetri trasparenti ed opachi della facciata si alternano in un gioco di rettangoli disposti in modo ritmico. Per poter accogliere un gran numero di persone, gli spazi interni sono stati progettati secondo le premesse della semplicità e della generosità nella disposizione di ampie zone di circolazione.

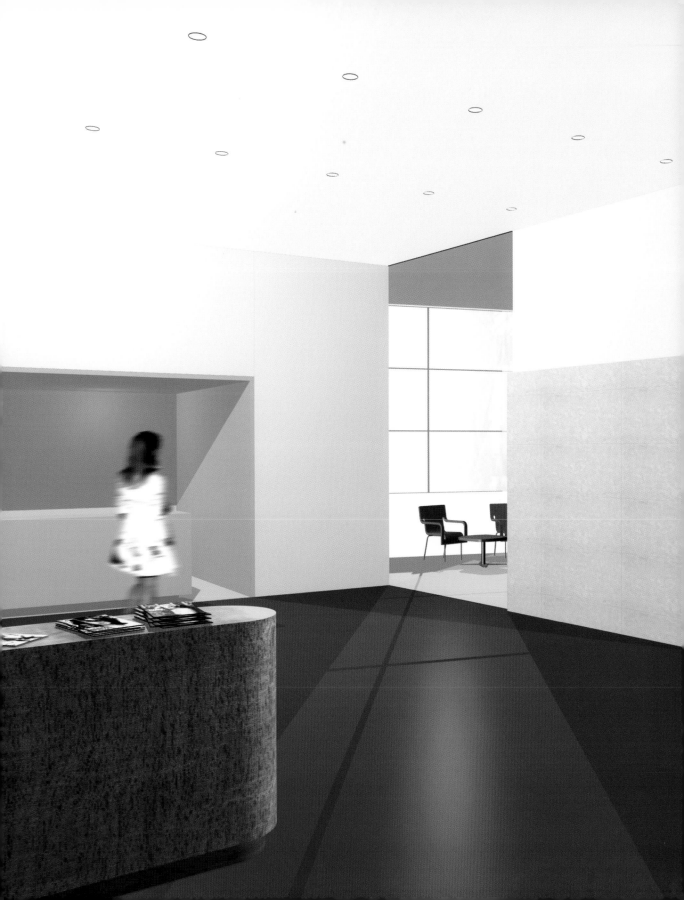

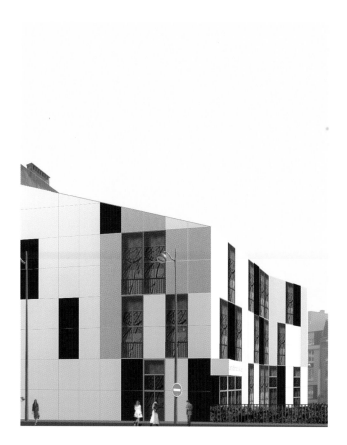

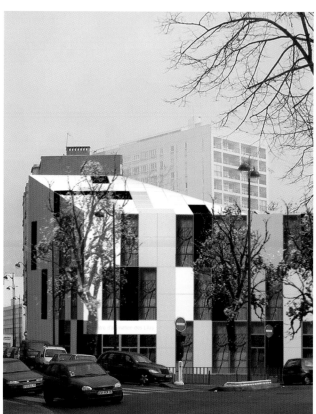

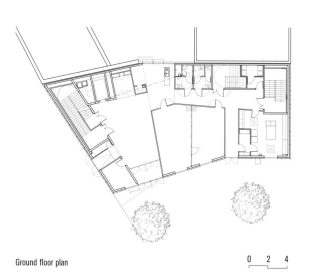

Ground floor plan

0 2 4

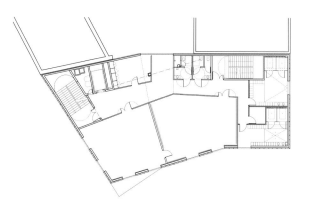

First floor plan

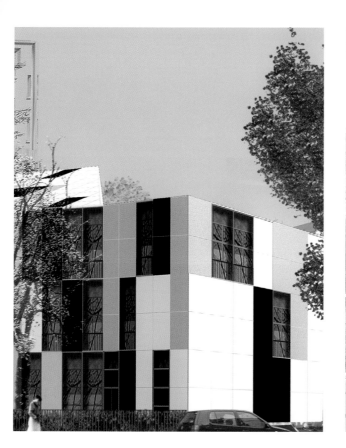

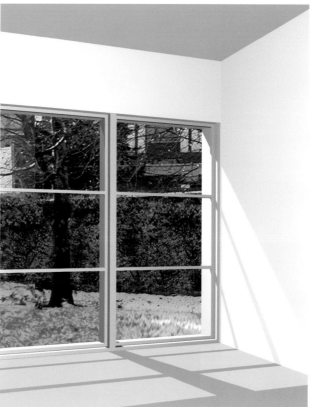

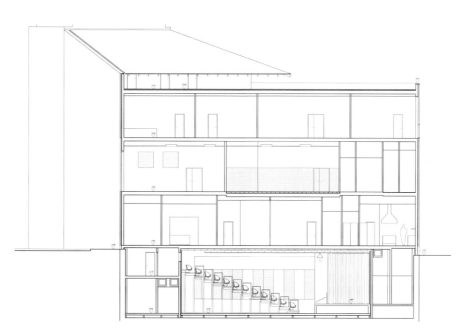

Section

 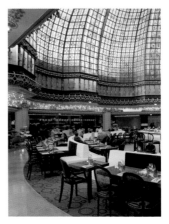

Interior Design

Patrick Jouin

Agence Christophe Pillet

Christian Liaigre

Matali Crasset Production

Christian Ghion

Didier Gomez

Imaad Rahmouni

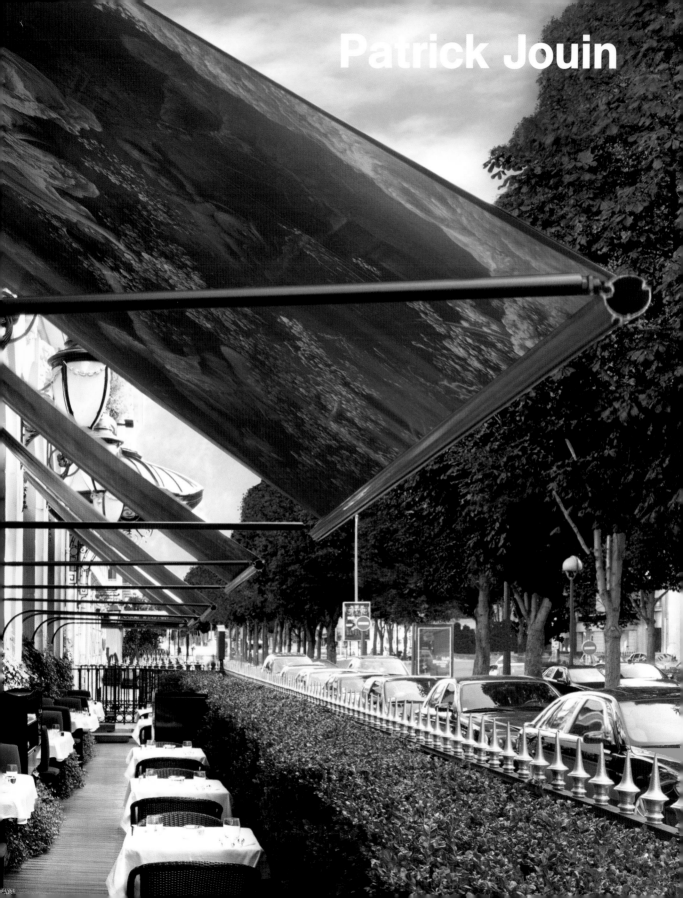

Patrick Jouin

Patrick Jouin

8, passage de la Bonne Graine, 75011 Paris

+33 155 28 89 20

+33 158 30 60 70

www.patrickjouin.com

agence@patrickjouin.com

Patrick Jouin graduated from the École Nationale Supérieure de Design Industriel (ENSCI) in 1992. After he worked for Thomson Multimedia, he began working in the studio of Philippe Starck. In 1998 he opened his own agency, where he specialized in interior design, stage decoration, product and architectural design. He is forever driven by the search for usefulness and functionality with modern but discrete designs that stand out for their attention to detail.

Patrick Jouin studierte an der École Nationale Supérieure de Design Industriel (ENSCI), wo er 1992 sein Diplom erhielt. Nachdem er für Thomson Multimedia gearbeitet hatte, begann er in Philippe Starcks Studio und gründete 1998 schließlich seine eigene Agentur. Bei seinen Inneneinrichtungen, Bühnenbildern, Produktdesigns und Architekturprojekten ist er stets auf der Suche nach Nützlichkeit und Zweckmäßigkeit in Verbindung mit einem diskreten und doch modernen Design, bei dem großen Wert auf Details gelegt wird.

En 1992, Patrick Jouin est diplômé de l'ENSCI, École Nationale Supérieure de Design Industriel. Après son passage chez Thomson Multimédia, il commence à travailler dans l'atelier de Philippe Starck. En 1998, il ouvre son agence où il crée des designs d'intérieur, industriels, de scénographie et d'architecture, toujours mû par la recherche de l'utilité et fonctionnalité, appuyées par un design discret mais moderne, exaltant son intérêt particulier du détail.

Patrick Jouin se diplomó en la École Nationale Supérieure de Design Industriel, ENSCI, en 1992. Tras su paso por Thomson Multimedia entró a trabajar en el estudio de Philippe Starck. En 1998 abrió su agencia, donde realiza diseños de interiores, de producto, escenografía y arquitectura, movido siempre por la búsqueda de la utilidad y la funcionalidad respaldadas por un diseño discreto aunque moderno, en el que destaca el gran cuidado por los detalles.

Laureatosi alla École Nationale Supérieure de Design Industriel (ENSCI) nel 1992, Patrick Jouin comincia a lavorare nello studio di Philippe Starck dopo una tappa alla Thomson Multimedia. Nel 1998 apre la propria agenzia specializzata in progettazioni d'interni, scenografiche e architettoniche nonché nel disegno di prodotti. Sostenute da un design discreto ma moderno, le sue realizzazioni rivelano la costante ricerca dell'utilità e della funzionalità pur risaltando la gran cura per il dettaglio.

Patrick Jouin

1967
Born in Nantes, France

1993-1994
Designer at "thim thom", THOMSON multimedia

1995-1999
Designer at Philippe Starck's studio in Paris, France

1998
Opens his own study in Paris, France
Special Prize of the International Press Jury-Paris Furniture Fair
VIA Label Prize for the Facto chair

2001
Concept car for Renault

2003
Named designer of the year by Salon Maison&Objet
Cassina furniture collection

2006
Travel + Leisure Design Award for Best Restaurant Mix in Las Vegas, USA

Interview | Patrick Jouin

Which do you consider the most important work of your career? None of them.

In what ways does Paris inspire your work? The mix of popular working class and designer chic and the places where these meet– the contrast between the artisans of Faubourg and Avenue Montaigne's *haute couture*, all of that inspires my work, but I am equally inspired by Tokyo or New York.

Does a typical Paris style exist, and if so, how does it show in your work? I don't think it shows in my work. The city's link to the past and nostalgia make it difficult to build and develop architectural projects, because everything already has a history. Paris is influenced by Paris itself.

How do you imagine Paris in the future? It will resemble the Paris of today. I see evolution regarding the level of traffic and you can tell people are trying to change their habits, which is quite a transformation for a city. The streetcars, for example, will be a big change.

Welches Werk halten Sie für das wichtigste Ihrer Karriere? Keins.

Wie inspiriert Paris Ihre Arbeit? Die Mischung aus Arbeiterklasse und Designer-Schick und die Orte, an denen beides zusammenkommt, der Kontrast zwischen den Handwerkern der Faubourg und der Haute Couture der Avenue Montaigne, dies alles inspiriert meine Arbeit, aber ich werde ebenso von Tokio oder New York inspiriert.

Gibt es einen typischen Pariser Stil, und wenn ja, wie macht dieser sich in Ihrer Arbeit bemerkbar? Ich glaube nicht, dass man ihn in meiner Arbeit bemerkt. Die Verbindung der Stadt zur Vergangenheit und der Hang zur Nostalgie machen es schwer, architektonische Projekte zu bauen und zu entwickeln, da alles bereits Geschichte hat. Paris wird von Paris selbst beeinflusst.

Wie stellen Sie sich Paris in der Zukunft vor? Paris der Zukunft wird dem heutigen Paris ähneln. Ich glaube, das Verkehrsaufkommen wird sich wandeln und man merkt, dass die Menschen versuchen, ihre Gewohnheiten zu verändern. Das ist allerhand Wandel für eine Stadt. Die Straßenbahn zum Beispiel wird eine große Veränderung darstellen.

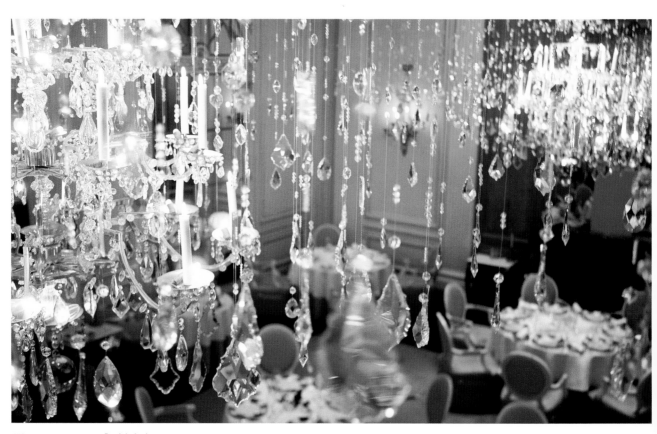

Quelle est à vos yeux l'œuvre la plus importante de votre carrière ? Aucune d'elles.

Dans quelle mesure votre œuvre artistique s'inspire-t-elle de Paris ? Le mélange de la classe ouvrière populaire et le chic des designers et les endroits où ils se rencontrent – le contraste entre les artisans du Faubourg et la haute couture de l'Avenue Montaigne, tous sont source d'inspiration, mais Tokyo ou New York m'inspirent tout autant.

Existe-t-il un style typiquement parisien, et si oui, comment se manifeste-t-il dans votre œuvre ? Je ne pense pas que cela transparaisse dans mon œuvre. Le lien de la cité avec le passé et la nostalgie accentue la difficulté de construire et développer des projets architecturaux, parce que tout à déjà une histoire. Paris est influencé par Paris même.

Comment imaginez-vous le Paris du futur ? Il ressemblera au Paris actuel. Je note une évolution au niveau de la circulation et il est visible que les gens essaient de changer leurs habitudes, ce qui est une sacrée transformation pour une ville. Les tramways, par exemple, seront un grand changement.

¿Cuál cree que es el trabajo más importante de su carrera? Ninguno de ellos.

¿Cómo le inspira París en su trabajo? La mezcla de la clase trabajadora popular con el diseño chic y los lugares donde éstos confluyen –el contraste entre los artesanos de Faubourg y la alta costura de la avenida Montaigne, todo esto inspira mi trabajo, pero igualmente me siento inspirado por Tokio o Nueva York.

¿Existe un estilo típico de París? Y si es así, ¿cómo se muestra éste en su obra? No creo que se refleje en mi obra. La conexión de la ciudad con el pasado y la nostalgia dificultan la construcción y desarrollo de proyectos arquitectónicos, porque todo tiene ya una historia. París está influido por París mismo.

¿Cómo se imagina París en un futuro? Se parecerá al París de hoy. Veo una evolución en cuanto al nivel de contaminación y se puede apreciar que la población procura cambiar sus hábitos, lo que realmente supone una transformación para una ciudad. Los tranvías, por ejemplo, constituirán un gran cambio.

Quale ritiene sia l'opera più importante della sua carriera? Nessuna.

In che modo Parigi ispira il suo lavoro? La mescolanza della classe lavoratrice e popolare con l'eleganza dei designer e i luoghi dove entrambe confluiscono; il contrasto tra gli artigiani del Faubourg e l'*haute couture* di Avenue Montaigne. Tutto questo ispira il mio lavoro, ma mi sento ugualmente ispirato da città come Tokyo o New York.

Esiste un tipico "stile parigino"? Se sì, come si manifesta nel suo lavoro? Non credo che si manifesti nel mio lavoro. Il legame della città col passato e una certa vena nostalgica rendono difficile la costruzione e lo sviluppo di progetti architettonici, perché tutto ha già una storia. Parigi è influenzata da sé stessa.

Come immagina Parigi nel futuro? Assomiglierà alla Parigi di oggi. Noto un'evoluzione rispetto al livello di traffico ed è evidente che la gente sta cercando di cambiare le proprie abitudini, la qual cosa è una trasformazione rilevante per una città. I tram, per esempio, rappresenteranno un grande cambiamento.

La Terrasse Montaigne

Year: 2005

Photographs: © Mario Pignata Monti

This terrace is situated in one of the most elegant enclaves of Paris, the Avenue Montaigne, and offers an outdoor restaurant where diners can enjoy a light menu underneath the green of the trees. The large awnings, illustrated with reproductions of works from Jean-Honoré Fragonard, help protect this enchanting restaurant from the sun and make it a popular meeting place, especially in the spring.

Diese Terrasse liegt in einer der elegantesten Zonen von Paris, der Avenue Montaigne, und bietet den Gästen ein Freiluftlokal, in dem sie ein leichtes Mahl unter dem Grün der Bäume genießen können. Die großen Markisen, die mit Reproduktionen von Werken Jean-Honoré Fragonards illustriert sind, schützen dieses bezaubernde Restaurant vor der Sonne und verwandeln es in einen beliebten Treffpunkt, der besonders im Frühling stark frequentiert wird.

Cette terrasse est située dans l'une des enclaves les plus élégantes de Paris, l'avenue Montaigne. Elle offre un espace à l'air libre où l'on peut savourer un menu léger sous la verdure des arbres et des haies. Les grands stores, illustrés de reproductions d'oeuvres de Jean-Honoré Fragonard, protègent ce restaurant enchanteur et en font un lieu de rencontre apprécié, surtout au printemps.

Esta terraza está situada en uno de los enclaves más elegantes de París, la avenida Montaigne, y ofrece un espacio al aire libre donde disfrutar de un menú ligero bajo el verdor de los árboles y de los setos. Los grandes toldos, ilustrados con reproducciones de obras de Jean-Honoré Fragonard, resguardan este restaurante encantador y hacen de él un apreciado lugar de encuentro, sobre todo durante la primavera.

Questa terrazza si trova in uno dei luoghi più eleganti di Parigi, l'Avenue Montaigne, ed offre uno spazio all'aria aperta dove godere di un menù leggero al riparo del verde di alberi e siepi. Le grandi tende parasole, illustrate con riproduzioni di opere di Jean-Honoré Fragonard, celano questo ristorante incantevole proteggendolo dal calore eccessivo del sole e facendone un apprezzato luogo d'incontro, sopratutto durante la primavera.

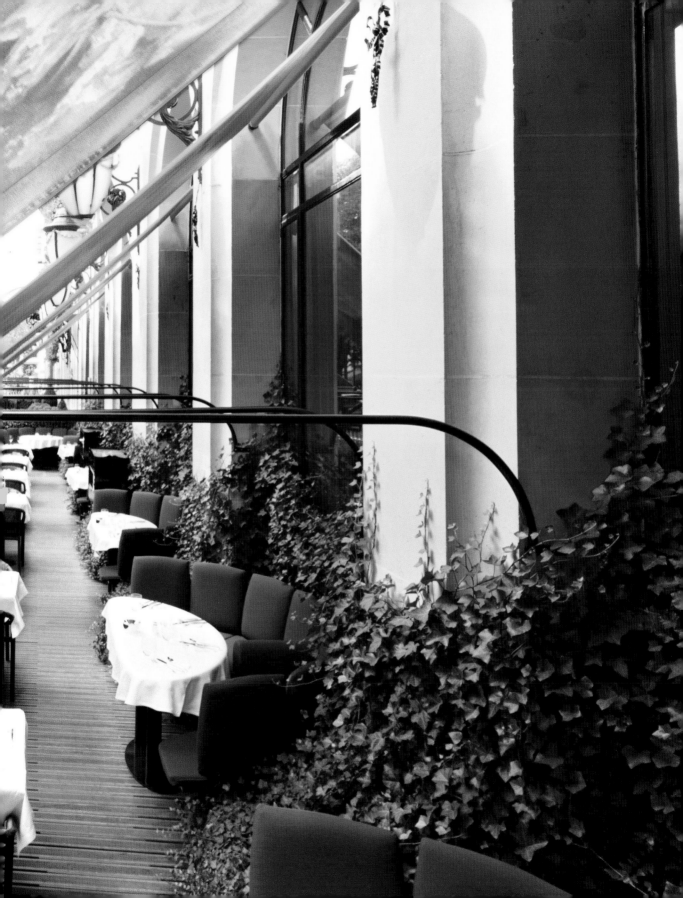

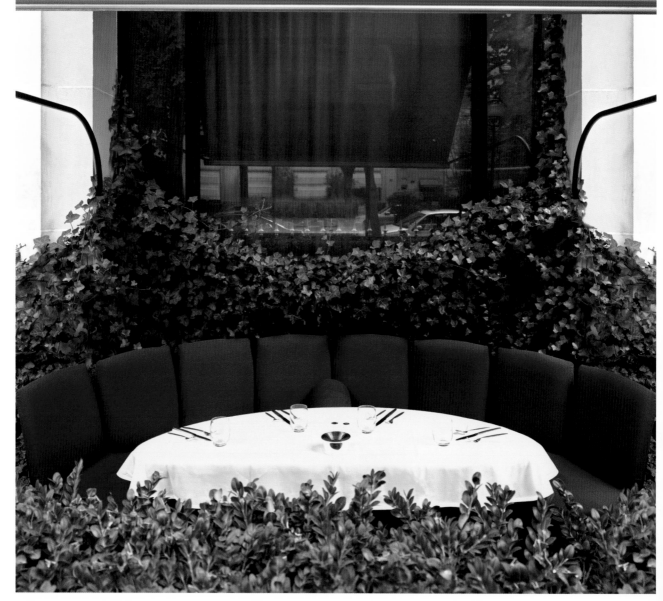

Patrick Jouin

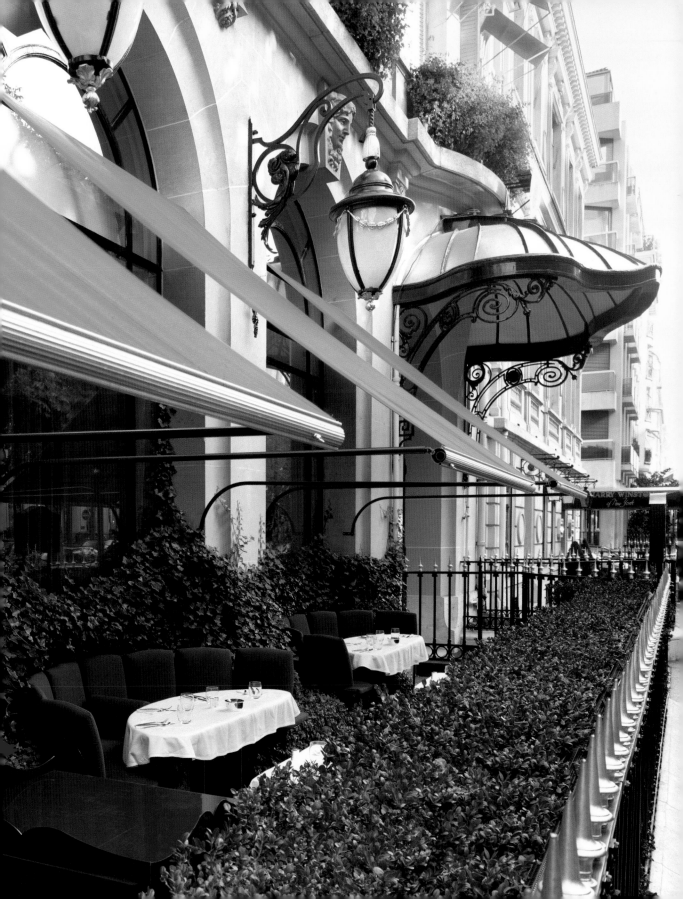

Alain Ducasse Restaurant at Plaza Athénée

Year: 2005

Photographs: © Thomas Duval

The culinary art of Alain Ducasse, the chef at this restaurant in the Plaza Athénée Hotel, can be tasted in this space designed by Patrick Jouin where magic and poetry are united in a harmonic dance. A small supernova of 5,000 crystals by Swarovski surrounds the ceiling lights, illuminating the entire room with its sparkles. The armchairs with their original design and leather upholstery in a revived Louis-XVI style lend color and an organic touch to this classic room.

Die Kochkunst von Alain Ducasse, Küchenchef dieses Restaurants im Hotel Plaza Athénée, kann man in einem Raum genießen, der von Patrick Jouin designt wurde und in dem sich die Magie und die Poesie zu einem harmonischen Tanz vereinen. Eine Explosion aus 5.000 Kristallteilen von Swarovski umgibt die Deckenlampen und erfüllt den gesamten Saal mit ihrem Funkeln. Die Sessel in einem erneuerten Louis-XVI-Stil mit ihrem originellen Design und ihrer Lederpolsterung verleihen diesem klassischen Raum Farbe und eine organische Note.

La cuisine d'Alain Ducasse, chef de ce restaurant situé à l'hôtel Plaza Athénée, peut se savourer dans un espace conçu par Patrick Jouin où magie et poésie s'unissent dans une danse harmonieuse. Une explosion de 5.000 pièces de cristal de Swarovski tombe du plafond autour des lampes, en un jeu de lumières illuminant toute la salle. Les fauteuils de style Louis XVI revisité ajoutent de la couleur et une touche organique à cet espace aux lignes classiques, par leur design original et leurs finitions en peau.

La cocina de Alain Ducasse, chef de este restaurante situado en el hotel Plaza Athénée, puede degustarse en un espacio diseñado por Patrick Jouin donde la magia y la poesía se unen en un baile armónico. Una explosión de 5.000 cristales de Swarovski pende del techo alrededor de las lámparas, en un juego de brillos por toda la sala. Las butacas de estilo Luis XVI renovado añaden color y una nota orgánica a este espacio de líneas clásicas, gracias a su diseño original y sus acabados en piel.

La cucina di Alain Ducasse, chef di questo ristorante situato nell'hotel Plaza Athénée, si può degustare in uno spazio, progettato da Patrick Jouin, nel quale magia e poesia si uniscono in un ballo armonico. Un'esplosione di 5.000 cristalli Swarovski pende dal soffitto, circondando le lampade, in un gioco di luccichii che pervade la sala. Le poltrone, in stile Luigi XVI rivisitato, aggiungono colore e un tocco organico a questo spazio dalle linee classiche, grazie al loro design originale e alle loro finiture in pelle.

Illumination of the Train Station Lille-Flandres

Year: 2004

Photographs: © Mario Pignata Monti

In 2004, the city of Lille was named the European capital of culture and, in light of this event, Patrick Jouin was commissioned to rebuild the Lille-Flandres train station. In collaboration with lighting designer Hervé Descottes, Jouin chose three colors (red, magenta and green) for the large surfaces of the three glazed roofs of the station, thus creating a magical light show to welcome travelers.

Die Stadt Lille war 2004 europäische Kulturhauptstadt und Patrick Jouin wurde mit der Umgestaltung des Bahnhofs Lille-Flandres für dieses Ereignis beauftragt. In Zusammenarbeit mit dem Lichtgestalter Hervé Descottes wählte Jouin drei Farben (Rot, Magenta und Grün) für die großen Flächen der drei Glasdächer des Bahnhofs. Dadurch schuf er ein magisches Lichtspiel, mit dem die Reisenden begrüßt werden.

Dans le cadre des cérémonies de la ville de Lille, élue capitale culturelle européenne en 2004, Patrick Jouin a été choisi pour transformer la station de train Lille-Flandres. En collaboration avec le designer de luminaires Hervé Descottes, Jouin a sélectionné trois couleurs (rouge, magenta et vert) pour habiller de verre la grande superficie des trois toitures de la station, créant ainsi un jeu magique de lumières pour accueillir les voyageurs.

En el contexto de las celebraciones en la ciudad de Lille, escogida capital cultural europea en el 2004, Patrick Jouin fue elegido para transformar la estación de tren Lille-Flandres. En colaboración con el diseñador de iluminación Hervé Descottes, Jouin eligió tres colores (rojo, magenta y verde) para cubrir la gran superficie de los tres tejados acristalados de la estación, creando así un mágico juego de luces para recibir a los viajeros.

Nel contesto delle celebrazioni nella città di Lille, eletta capitale culturale europea nel 2004, Patrick Jouin fu scelto per trasformare la stazione ferroviaria di Lille-Flandres. In collaborazione con il designer dell'illuminazione Hervé Descottes, Jouin optò per tre colori (rosso, magenta e verde) con cui coprire la grande superficie dei tre tetti in vetro della stazione, creando così un magico gioco di luci per accogliere i viaggiatori.

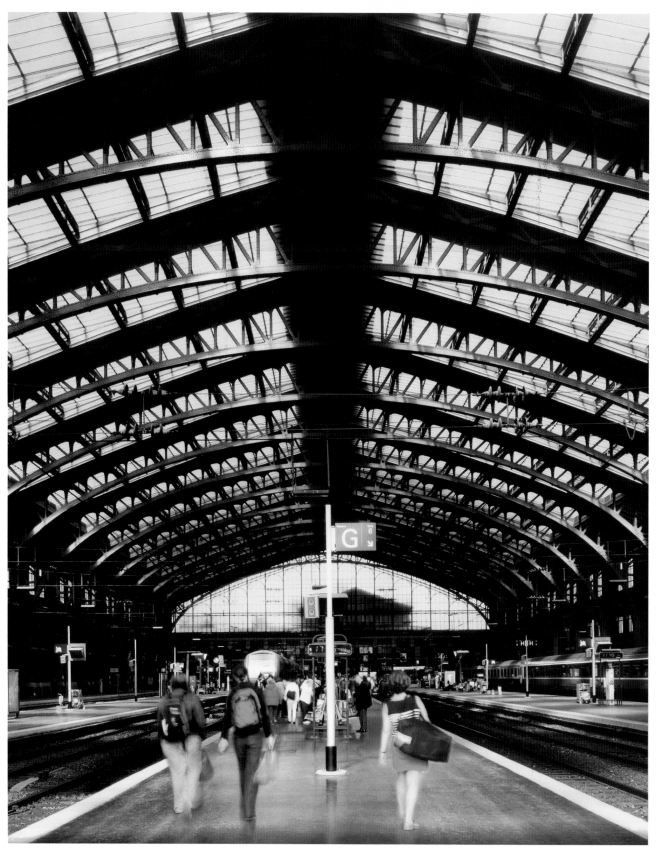

Patrick Jouin

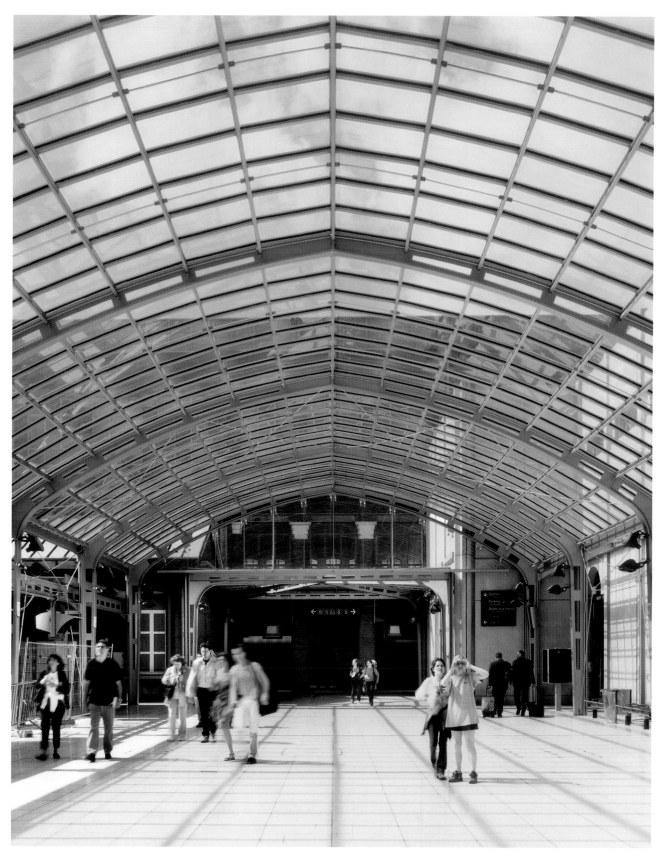

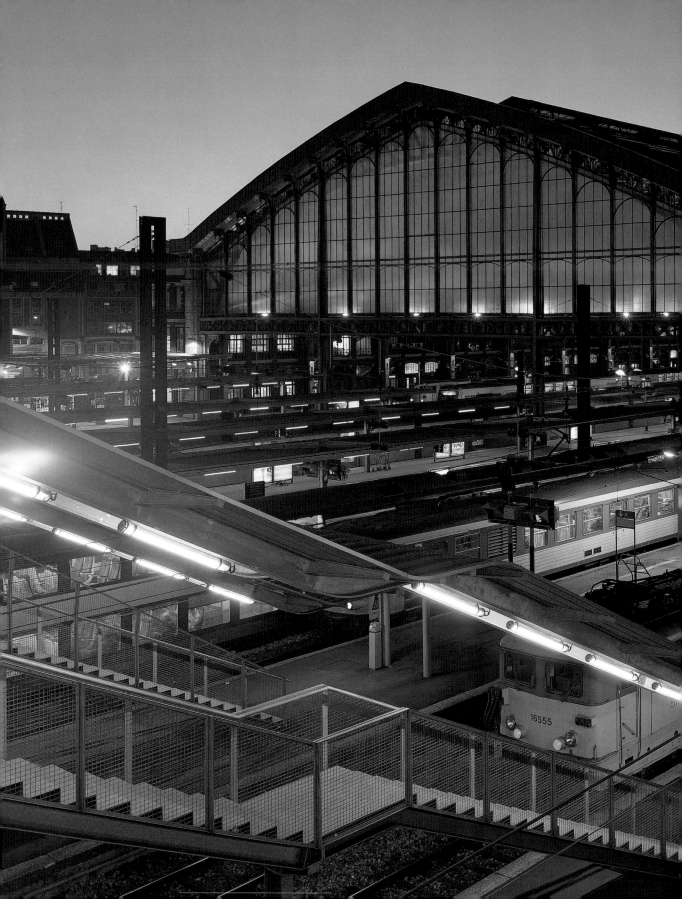

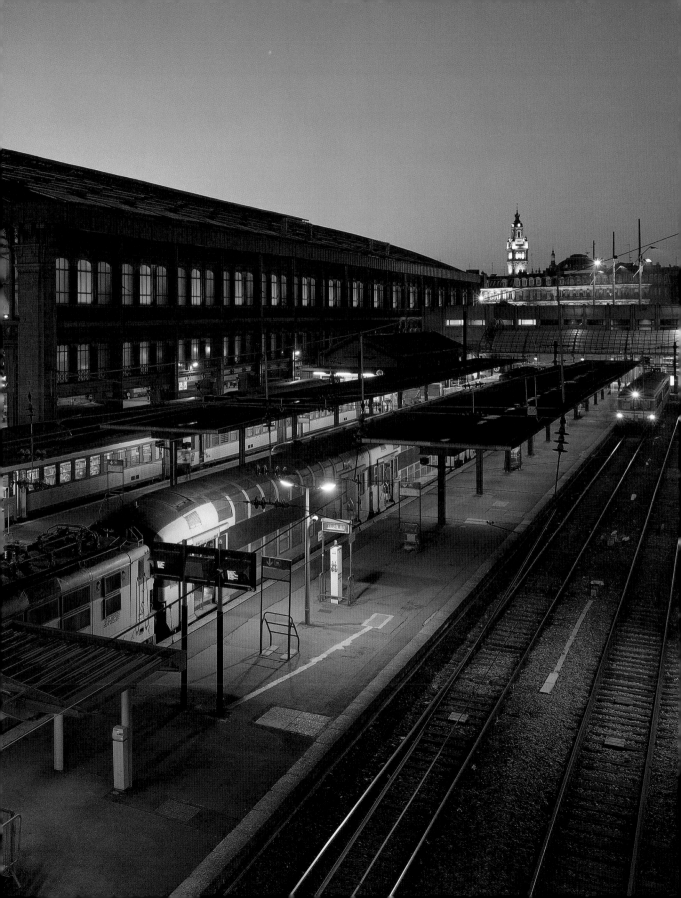

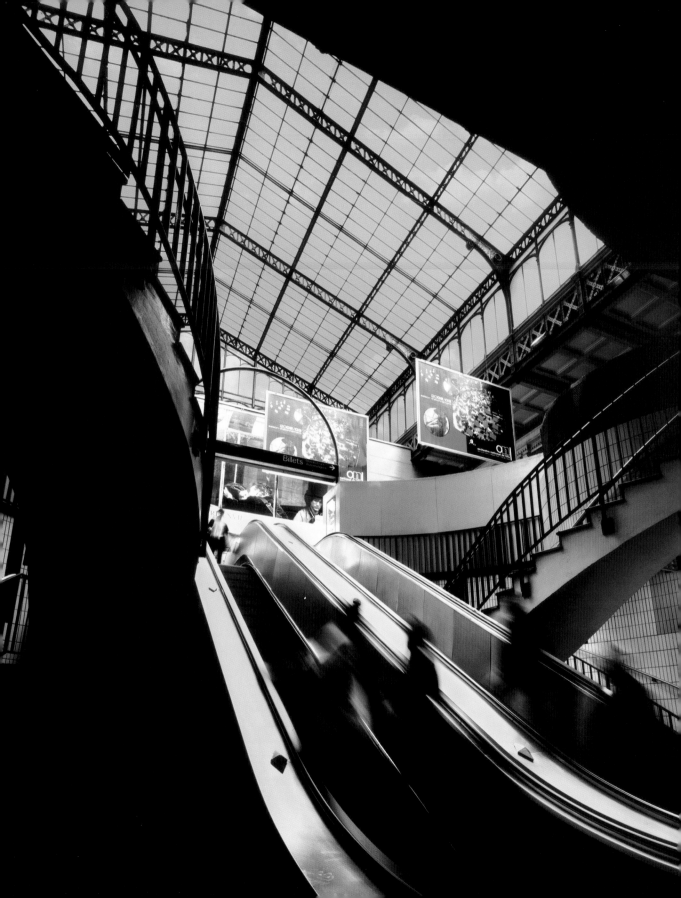

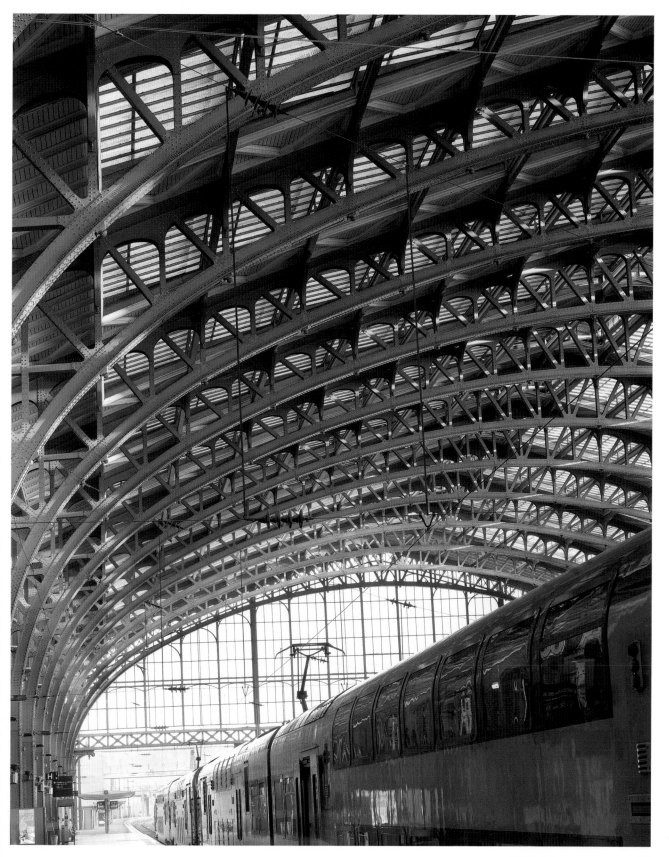

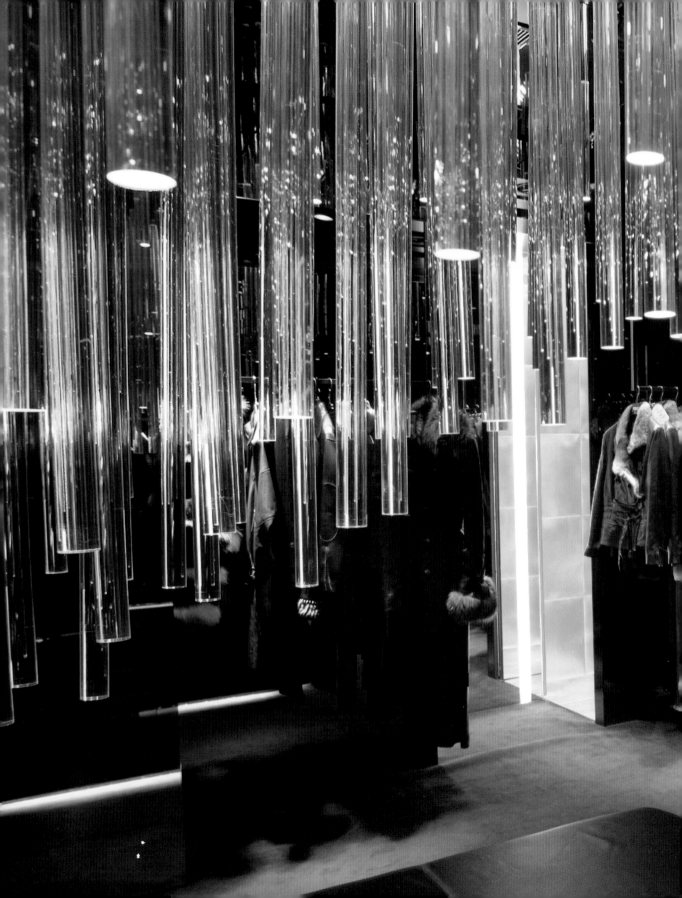

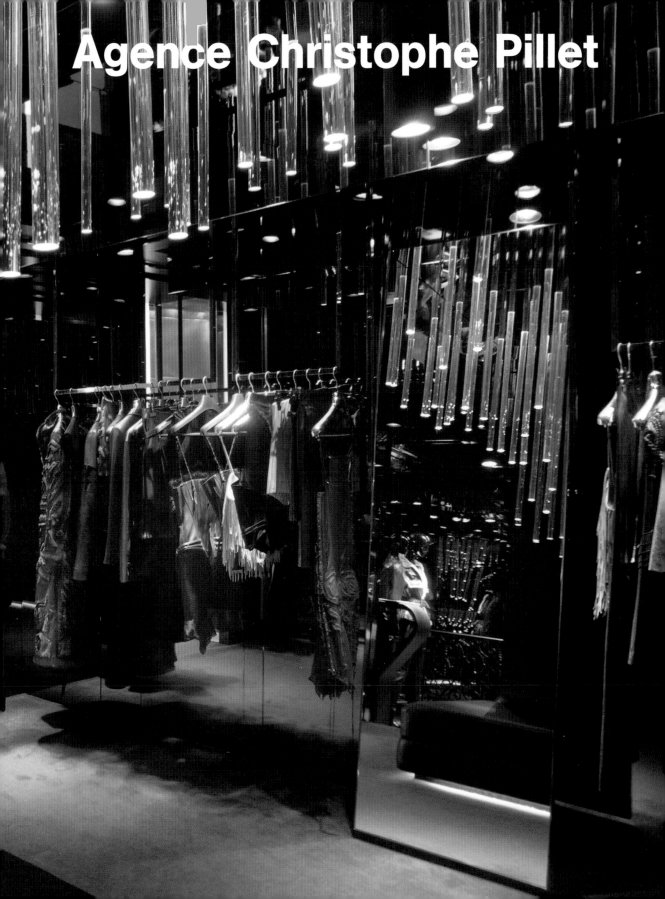

Agence Christophe Pillet

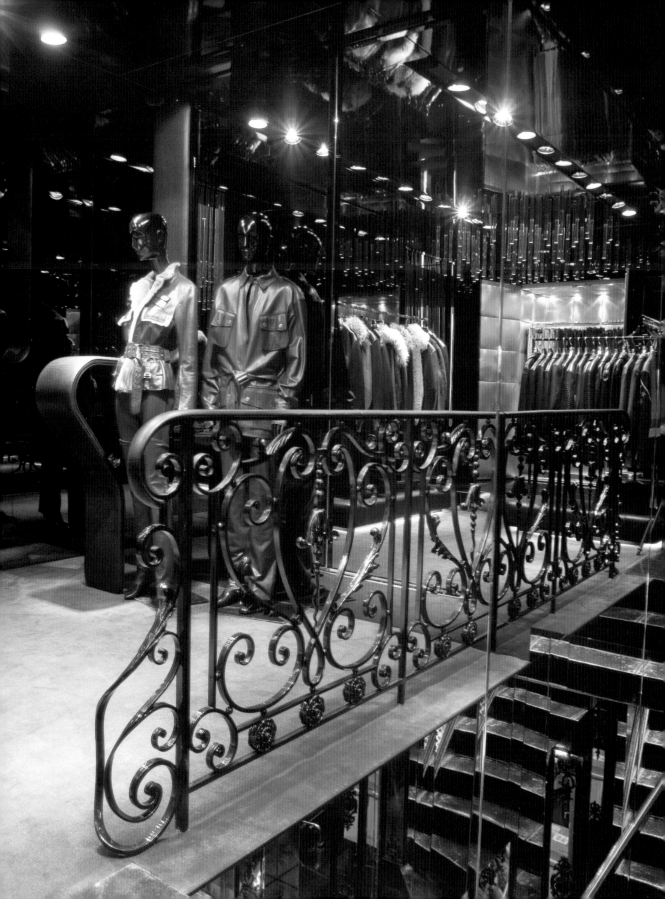

Agence Christophe Pillet

29, passage Dubail, 75010 Paris

+33 158 36 46 31

+33 142 25 01 25

www.christophepillet.com

info@christophepillet.com

Christophe Pillet

1959
Born in Montargis, France

1985
Graduate from L'École des Arts Décoratifs in Nice

1986
Master of Domus Academy, Milan, Italy

1993
Opens his own design agency

1999
First participation as Artistic Director of the Salon du Meuble in Paris, France

2002
Hôtel Particulier
Collection Loop et Diam for the porcelain manufacturer Bernardaud

2005
Meridiana armchairs for Driade
Hotel Sezz, Paris, France

2006
Boutique Catherine Malandrino, Paris, France

Christophe Pillet is one of the most important names in contemporary design in France. He graduated from the École des Arts Décoratifs in Nice. Prior to opening his own agency, he worked in Milan with Martine Bedin and with Philippe Starck in Paris. His versatility has enabled him to use his creativity in various subjects, such as architecture, furniture design and interior design.

Christophe Pillet ist einer der wichtigsten Vertreter des zeitgenössischen Designs in Frankreich. Er studierte an der École des Arts Décoratifs in Nizza. Bevor er seine eigene Agentur gründete, arbeitete er in Mailand mit Martine Bedin und in Paris mit Philippe Starck. Seine Vielseitigkeit ermöglichte es ihm, seine Kreativität in verschiedenen Disziplinen, wie Architektur, Möbeldesign und Innengestaltung, einzubringen.

Christophe Pillet est un des exposants phares du design actuel en France. Il est diplômé de l'Ecole des Arts Décoratifs de Nice et avant d'ouvrir son agence, il a travaillé à Milan avec Martine Bedin et à Paris avec Philippe Starck. Son esprit éclectique le mène à diversifier sa créativité dans des disciplines comme l'architecture, le design de mobilier et l'architecture d'intérieur.

Christophe Pillet es uno de los máximos exponentes del diseño actual en Francia. Se graduó en la École des Arts Décoratifs de Niza y antes de abrir su propia agencia, trabajó en Milán con Martine Bedin y en París con Philippe Starck. Su espíritu polifacético lo ha llevado a diversificar su creatividad en disciplinas como la arquitectura, el diseño de mobiliario y la arquitectura de interiores.

Christophe Pillet è uno dei massimi esponenti del design contemporaneo in Francia. Laureatosi presso l'École des Arts Décoratifs di Nizza, lavora a Milano con Martine Bedin e a Parigi con Philippe Starck e prima di aprire la propria agenzia. Il suo spirito caleidoscopico lo porta a cimentare la propria creatività in svariate discipline come l'architettura, il disegno d'arredo e l'architettura d'interni.

Interview | Christophe Pillet

Which do you consider the most important work of your career? The next one. I don't feel I have achieved anything that could be qualified as "the most important work of my career," even though I do have favorite products and interior designs such as Agatha Dreams for Ceccotti, Y's chair for Cappellini or the Malandrino boutique in Soho for Catherine Malandrino.

In what ways does Paris inspire your work? I truly don't know if Paris inspires me, even though living in Paris may produce some unconscious vibrations which infiltrate my work.

Does a typical Paris style exist, and if so, how does it show in your work? I think there is a typical so-called "Paris style," which is something I dislike. I try to stay as far away as possible from this nostalgic image of a pseudo classic-baroque style.

How do you imagine Paris in the future? I would like Paris to be a modern city but so far it hasn't headed in this direction.

Welches Werk halten Sie für das wichtigste Ihrer Karriere? Das Nächste. Ich habe nicht das Gefühl, irgendetwas erreicht zu haben, das man als „wichtigstes Werk meiner Karriere" bezeichnen könnte. Ich habe allerdings Lieblingsprodukte und -einrichtungen, wie Agathe Dreams für Ceccotti, Y's chair für Cappellini oder die Malandrino Boutique in Soho für Catherine Malandrino.

Wie inspiriert Paris Ihre Arbeit? Ich weiß wirklich nicht, ob Paris mich inspiriert, obwohl das Leben in Paris einige unbewusste Vibrationen erzeugen mag, die in meine Arbeit eindringen.

Gibt es einen typischen Pariser Stil, und wenn ja, wie macht dieser sich in Ihrer Arbeit bemerkbar? Ich glaube, dass es einen typischen, sogenannten „Pariser Stil", gibt, und er gefällt mir gar nicht. Ich versuche, mich so weit wie möglich von diesem nostalgischen Image mit seinem pseudoklassisch-barocken Stil zu distanzieren.

Wie stellen Sie sich Paris in der Zukunft vor? Mir würde es gefallen, wenn Paris eine moderne Stadt wäre, aber bis jetzt ist sie nicht auf dem Weg dorthin.

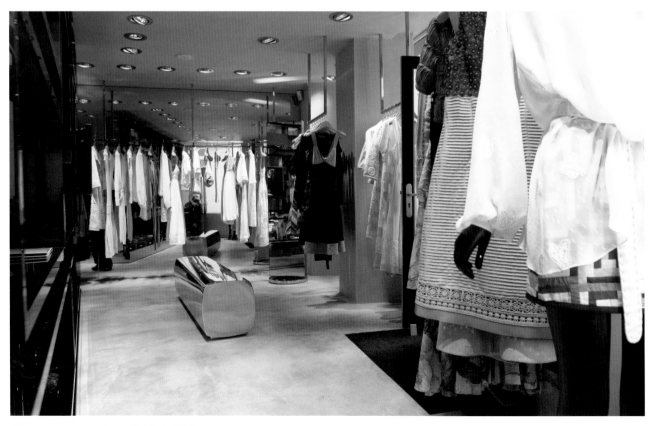

Quelle est à vos yeux l'œuvre la plus importante de votre carrière ? La prochaine. Je ne pense pas pouvoir dire d'une de mes dernières œuvres qu'elle est « la plus importante de ma carrière », même si j'ai des produits et des designs d'intérieur préférés, à l'instar d'Agatha Dreams pour Ceccotti, d'Y's chair pour Cappellini ou encore de la boutique Malandrino à Soho pour Catherine Malandrino.

Dans quelle mesure votre œuvre artistique s'inspire-t-elle de Paris ? Franchement, je ne sais pas si Paris m'inspire, même si le fait de vivre à Paris produit des vibrations inconscientes qui infiltrent mon œuvre.

Existe-t-il un style typiquement parisien, et si oui, comment se manifeste-t-il dans votre œuvre ? En effet, je pense qu'il y a un soi-disant « style parisien » que je n'aime pas du tout. J'essaie de m'éloigner le plus possible de cette image nostalgique d'un « pseudo style classique-baroque ».

Comment imaginez-vous le Paris du futur ? J'aimerais que Paris soit une ville moderne, mais jusqu'à présent, elle n'en prend pas le chemin.

¿Cuál cree que es el trabajo más importante de su carrera? El que está por llegar. No creo que haya realizado nada que pueda calificar como "el trabajo más importante de mi carrera", aunque realmente tenga productos y diseños de interiores favoritos como el de Agatha Dreams para Ceccotti, la silla Y para Cappellini o la boutique Malandrino en el SOHO para Catherine Malandrino.

¿Cómo le inspira París en su trabajo? La verdad que no sé si París me inspira, aunque el hecho de vivir en París puede que produzca ciertas vibraciones inconscientes que se filtren en mi trabajo.

¿Existe un estilo típico de París? Y si es así, ¿cómo se muestra éste en su obra? Creo que existe un llamado "estilo de París" que es algo que no me gusta. Intento alejarme lo máximo posible de esta imagen nostálgica de un estilo pseudo clásico-barroco.

¿Cómo se imagina París en un futuro? Me gustaría que París fuera una ciudad moderna pero hasta ahora no va encaminada en esta dirección.

Quale ritiene sia l'opera più importante della sua carriera? La prossima. Non ho mai la sensazione di avere realizzato quella che si può considerare "l'opera più importante della mia carriera", anche se ammetto che ho i miei prodotti e design preferiti: come Agatha Dreams per Ceccotti, la sedia Y per Cappellini o la boutique Malandrino a Soho per Catherine Malandrino.

In che modo Parigi ispira il suo lavoro? Sinceramente, non so se Parigi mi ispiri, anche se è possibile che vivere a Parigi produca delle vibrazioni inconsce che confluiscono nel mio lavoro.

Esiste un tipico "stile parigino"? Se si, come si manifesta nel suo lavoro? A New Penso che esista il cosiddetto "stile parigino", e non mi piace affatto. Cerco di mantenermi il più lontano possibile da questa immagine nostalgica di uno stile pseudoclassico-barocco.

Come immagina Parigi nel futuro? Mi piacerebbe che Parigi fosse una città moderna ma, fino ad ora, non ha imboccato questa strada.

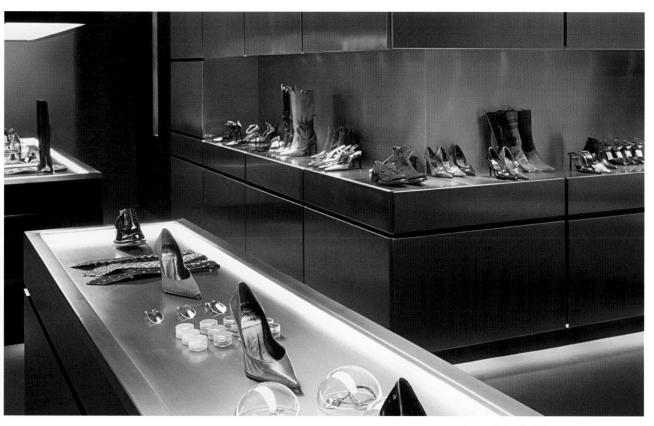

Boutique JC Jitrois

Year: 2002

Photographs: © Hervé Ternisien

The personality of designer Jean Claude Jitrois is present in all corners of this boutique, whose style is the result of a fusion between dark glamour and neo-baroque. The light reflected in the mirrors and in the unique cylindrical crystal overs of small lamps creates a subtle and mysterious space in harmony with the light golden touches. The stair case has an extraordinary visual impact with its sweeping wrought iron banister.

Die Persönlichkeit des Designers Jean Claude Jitrois ist in alle Winkel dieser Boutique gedrungen, deren Stil das Ergebnis einer Fusion von Neobarock und dunklem Glamour ist. Das Licht, das sich in den Spiegeln und den originellen zylindrischen Kristallmänteln kleiner Leuchten reflektiert, schafft einen raffinierten und geheimnisvollen Raum in Harmonie mit den gold-glänzenden Akzenten. Durch ihr geschwungenes schmiedeeisernes Geländer erhält die Treppe eine besondere optische Gewichtung.

La personnalité du designer Jean Claude Jitrois s'inscrit dans chaque coin de cette boutique dont le style est le fruit de la fusion entre un glamour sombre et le néo-baroque. La lumière reflétée par les miroirs et les petites lampes originales d'abat-jour en verre façonne un espace sophistiqué et mystérieux, en harmonie avec les touches d'or brillant. Grâce au dynamisme de leurs rambardes en fer forgé, les escaliers provoquent un impact visuel extraordinaire.

La personalidad del diseñador Jean Claude Jitrois se ha impreso en cada uno de los rincones de esta boutique, cuyo estilo es el resultado de la fusión entre un *glamour* oscuro y el neobarroco. La luz que reflejan los espejos y las pequeñas y originales lámparas de pantalla de cristal crean un espacio sofisticado y misterioso, en armonía con las pinceladas de dorado luminoso. Gracias al dinamismo de sus barandillas de hierro forjado, las escaleras provocan un extraordinario impacto visual.

La personalità del designer Jean Claude Jitrois è impressa in ogni angolo di questa boutique, il cui stile è il risultato della fusione tra *glamour* oscuro e neobarocco. La luce riflessa negli specchi e le piccole ed originali lampade schermate cilindriche di cristallo creano uno spazio sofisticato e misterioso, in armonia con i dettagli dorati luminosi. Grazie al dinamismo dei corrimano in ferro battuto, le scale creano uno straordinario impatto visivo.

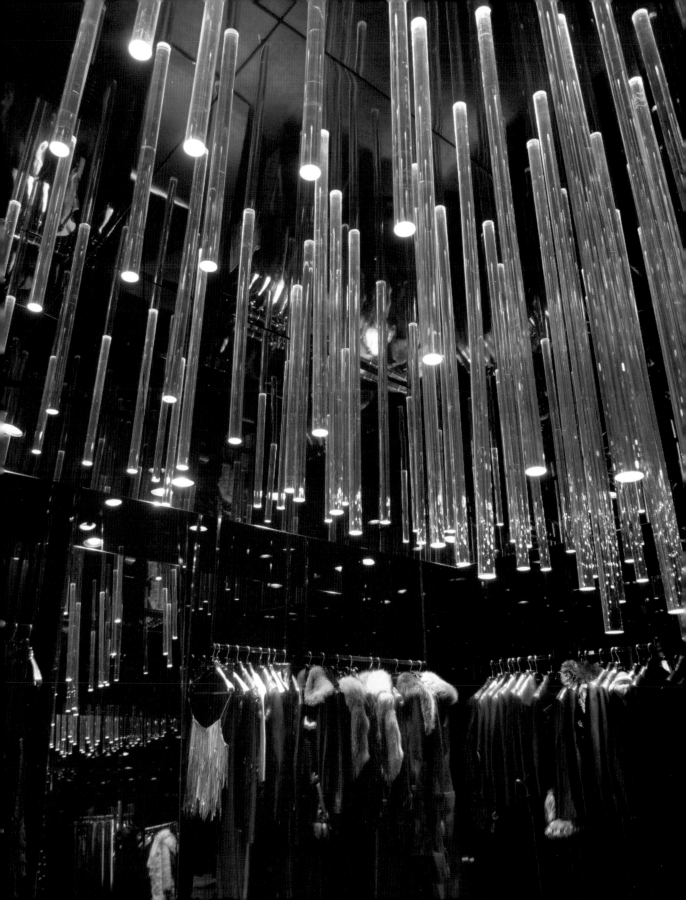

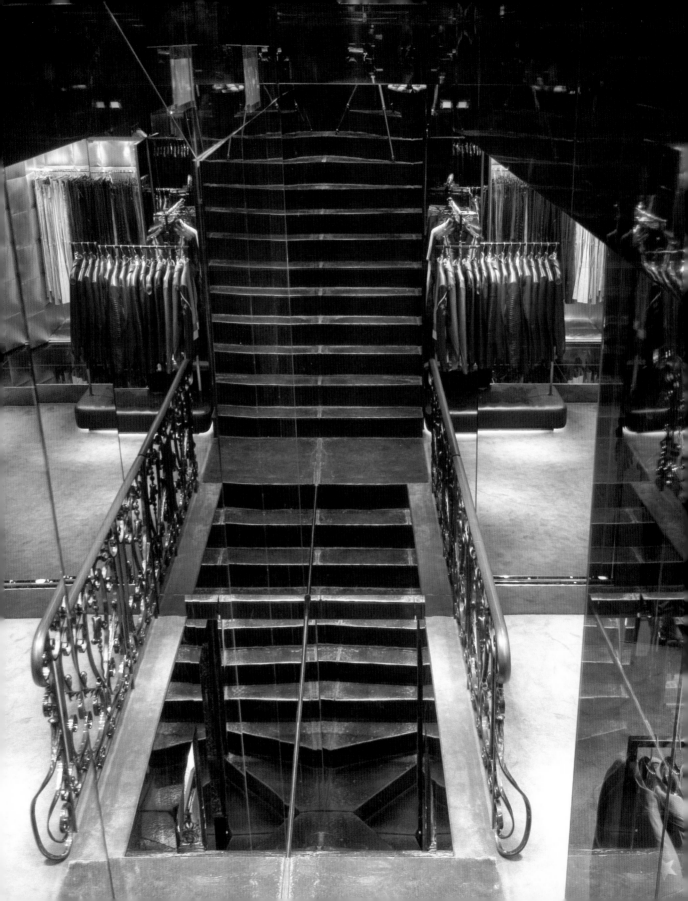

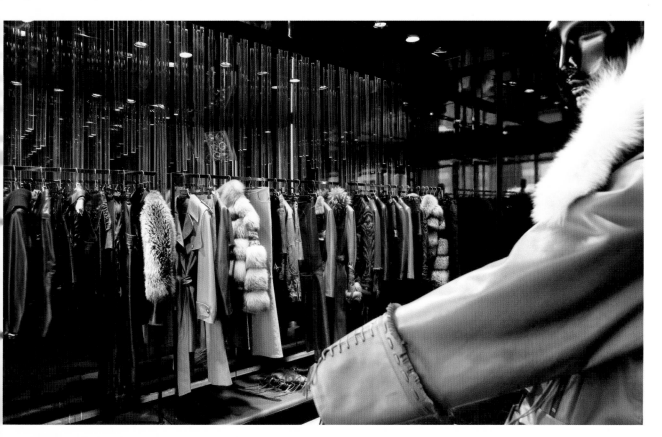

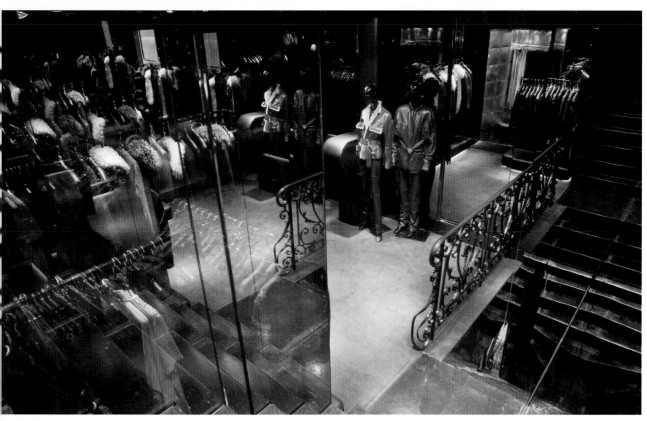

Boutique Catherine Malandrino Paris

Year: 2006
Photographs: © Stéphane Ruet

This boutique was designed more as a landscape than a shop. The idea was to create a space where one could experience, for just a moment, the sensation of sharing the world of Catherine Malandrino. Thus we find ourselves with beautifully handcrafted pieces of timeless elegance in a space impregnated with golden subtlety and geometric elements, such as the modular shelving displaying the footwear.

Diese Boutique wurde weniger wie ein Geschäft, sondern vielmehr wie eine Landschaft entworfen. Der Raum sollte so gestaltet werden, dass man für einen Moment das Gefühl hat, Catherine Malandrinos Welt zu teilen. Handwerklich kunstvoll gefertigte Stücke von zeitloser Eleganz in einem Raum erfüllt von goldener Raffinesse und geometrischen Elementen, wie die Modulregale, in denen das Schuhwerk ausgestellt ist.

Cette boutique est davantage conçue à l'image d'un paysage que comme une boutique. L'idée est de créer un univers où on ressent la sensation de partager, l'espace d'un instant, le monde de Catherine Malandrino. Nous nous trouvons ainsi devant des œuvres d'une élégance intemporelle dotée d'une touche artisanale, caractéristiques de ses collections, dans un espace imprégné d'une sophistication toute dorée et de jeux géométriques, à l'instar de l'étagère modulaire qui expose les modèles de chaussures.

Esta boutique fue concebida más como un paisaje que como una tienda. La idea fue crear un espacio donde experimentar la sensación de compartir, por un momento, el mundo de Catherine Malandrino. Así, nos encontramos con piezas de intemporal elegancia con un toque artesanal, típicas de sus colecciones, en un espacio impregnado de dorada sofisticación y de juegos geométricos, como la estantería modular que muestra las propuestas para el calzado.

Questa boutique è stata concepita più come un paesaggio che come un negozio. L'idea era creare uno spazio dove sperimentare la sensazione di condividere, per un momento, il mondo di Catherine Malandrino. Così ci troviamo di fronte ad elementi realizzati con arte e un tocco artigianale dall'eleganza senza tempo in uno spazio impregnato di dorata raffinatezza e di giochi geometrici, come nella scaffalatura modulare che mostra le proposte calzature.

Agence Christophe Pillet

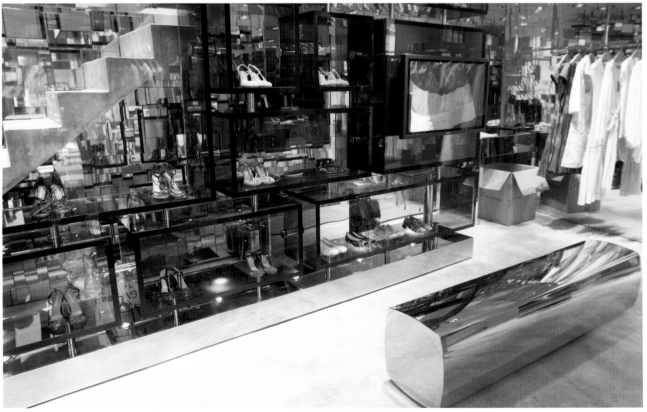

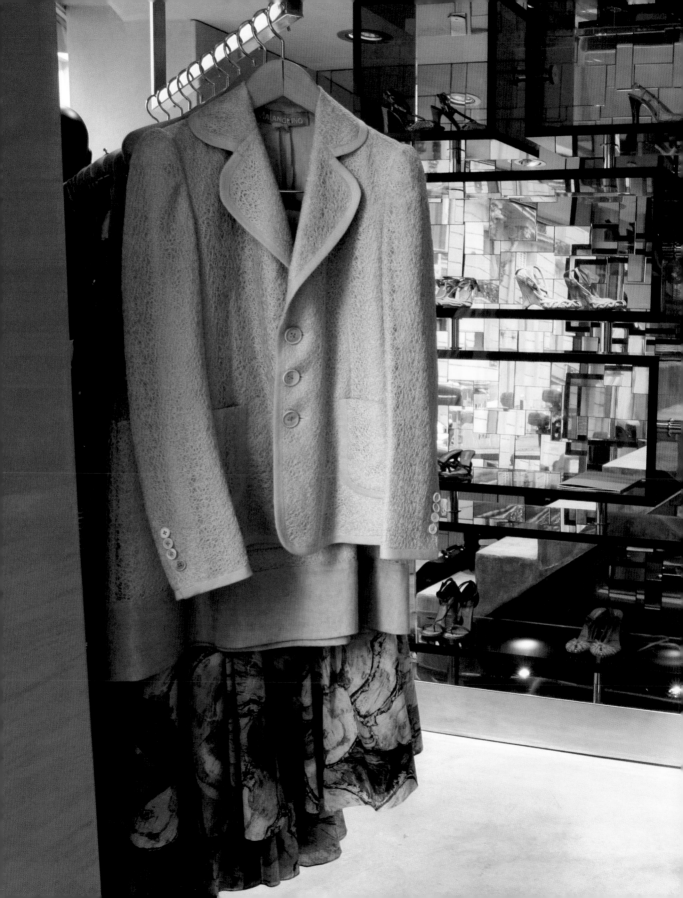

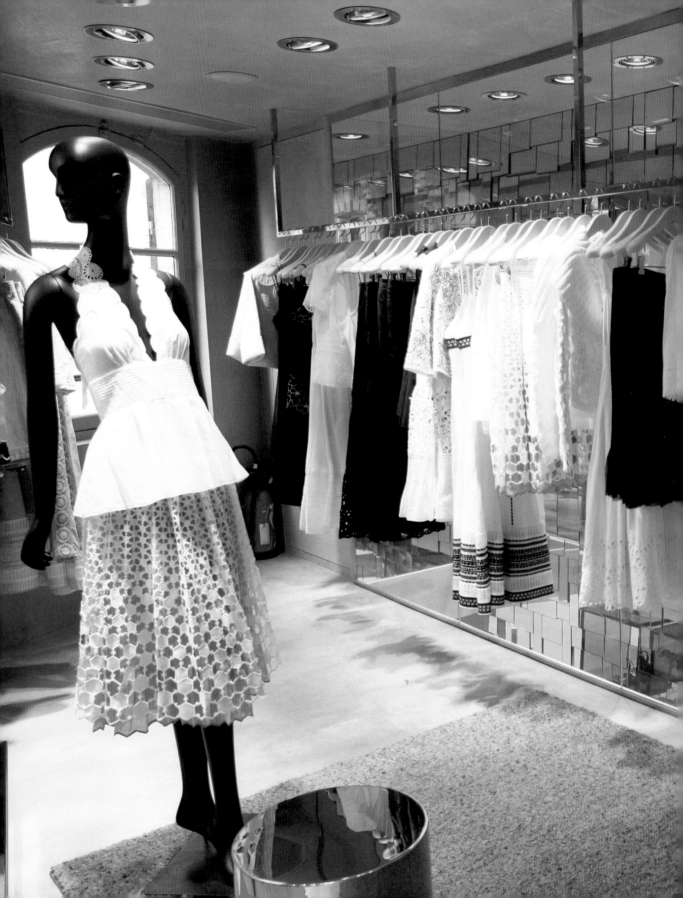

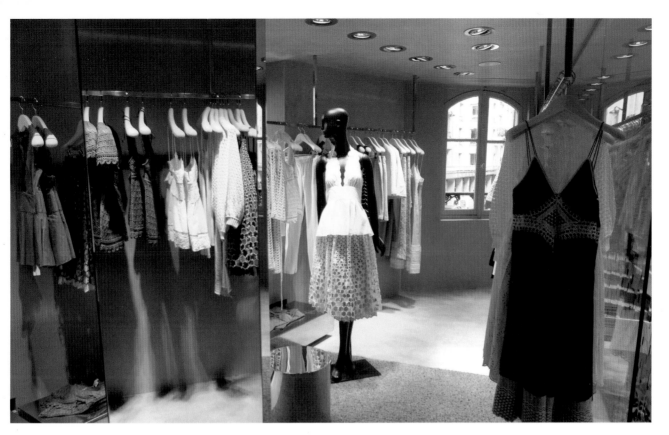

Boutique Rodolphe Menudier

Year: 2000
Photographs: © DR

This shop design was inspired by rock music, James Bond movies and Las Vegas hotels. Pillet knows how to express luxury in the language of contemporary design. The space becomes the perfect store window for the clever collections that shoe designer genius Rodolphe Menudier displays every season. The spot lighting and neutral colors truly put his creations in the limelight.

Dieses Shopdesign wurde inspiriert durch Rockmusik, James-Bond-Filme und Hotels in Las Vegas. Pillet hat es verstanden, Luxus in der Sprache des gegenwärtigen Designs auszudrücken. Der Raum verwandelt sich in das perfekte Schaufenster für die raffinierten Kollektionen, die der geniale Schuh-Designer Rodolphe Menudier in jeder Saison vorstellt. Die punktuelle Beleuchtung und die neutralen Farben des Raums lassen die Kreationen in den Vordergrund treten.

S'inspirant de la musique rock, les films de James Bond et les hôtels de Las Vegas, le design de cette boutique est le fruit de la quête de l'expression du luxe par le biais du langage actuel du design. L'espace se transforme en vitrine parfaite pour les collections que le génie des chaussures, Rodolphe Menudier, présente chaque saison sous l'étiquette de la sophistication. L'éclairage ponctuel et les couleurs neutres permettent aux créations d'être les véritables protagonistes.

Inspirada en la música rock, las películas de James Bond y los hoteles de Las Vegas, el diseño de esta tienda es el resultado de la búsqueda de la expresión del lujo a través del lenguaje actual del diseño. El espacio se convierte en el escaparate perfecto para las colecciones que el genio de los zapatos, Rodolphe Menudier, presenta cada temporada bajo la etiqueta de la sofisticación. La iluminación puntual y los colores neutros logran que las creaciones sean las auténticas protagonistas.

Ispirato alla musica rock, ai film di James Bond e agli hotel di Las Vegas, il design di questo negozio è il risultato della ricerca dell'espressione del lusso attraverso il linguaggio del design contemporaneo. Lo spazio si trasforma nella vetrina perfetta per le collezioni che il genio delle calzature, Rodolphe Menudier, presenta ad ogni stagione sotto il marchio della ricercatezza. L'illuminazione localizzata e i colori neutri fanno delle creazioni le autentiche protagoniste.

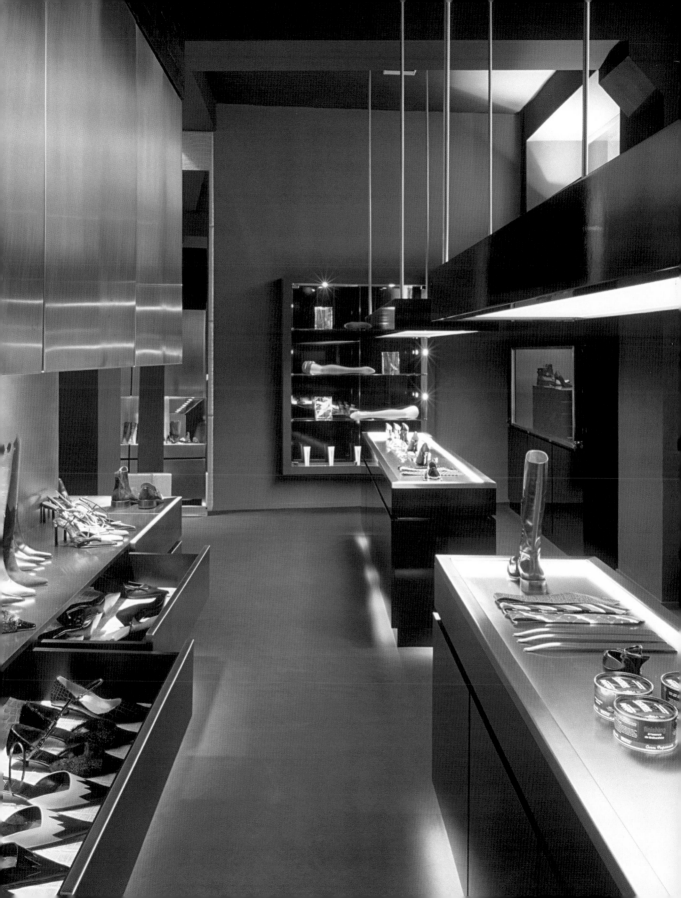

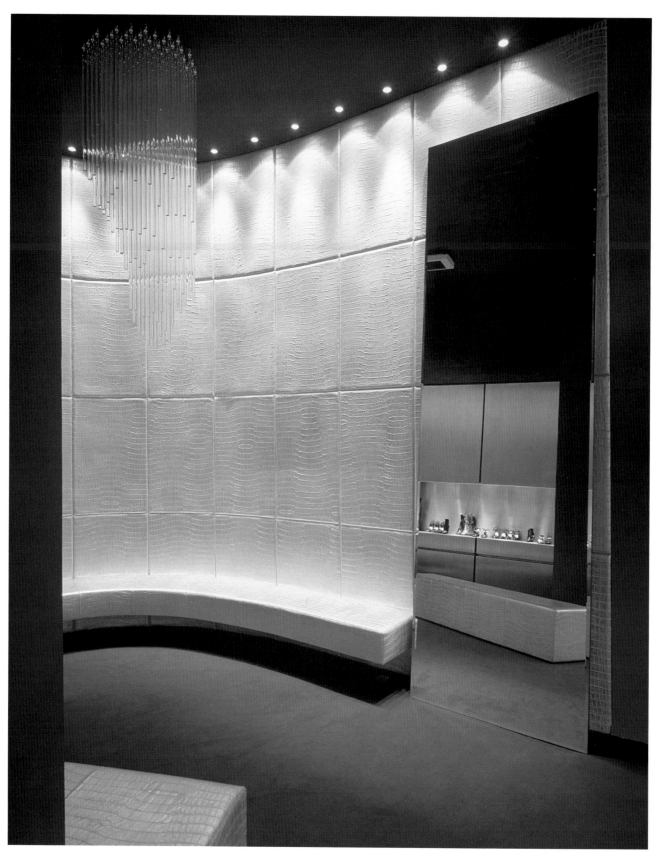

Agence Christophe Pillet

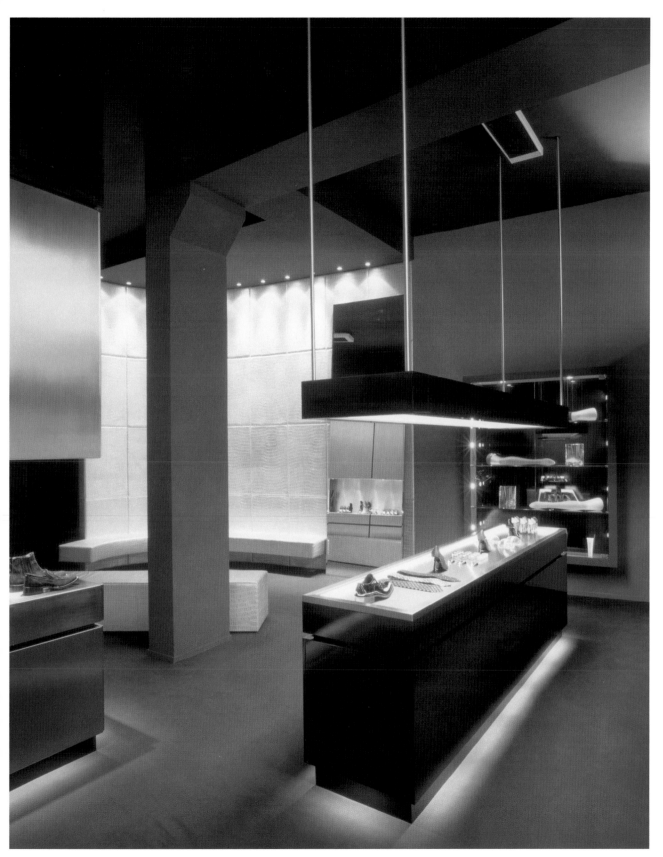

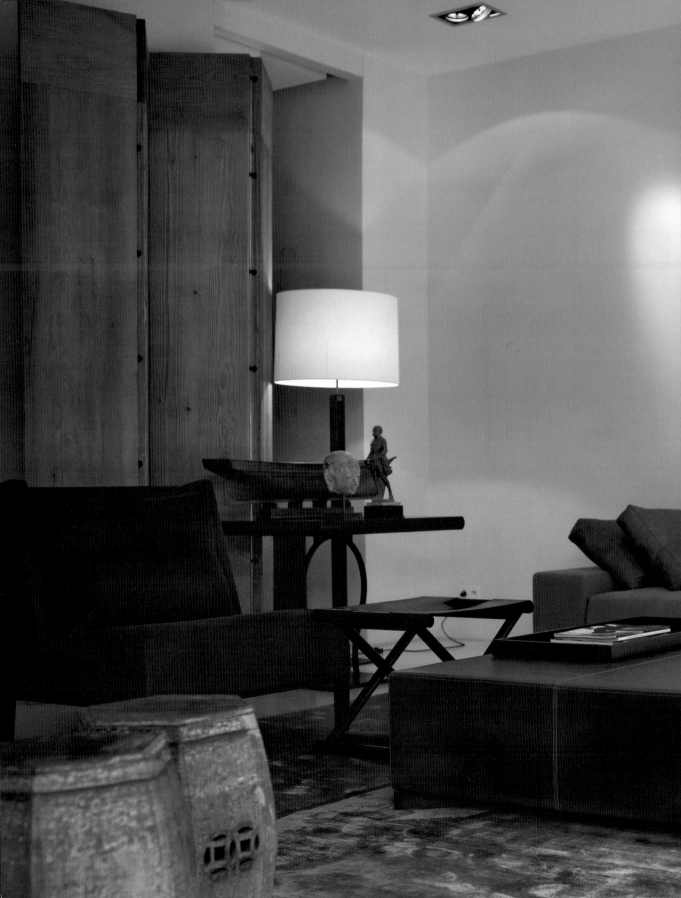

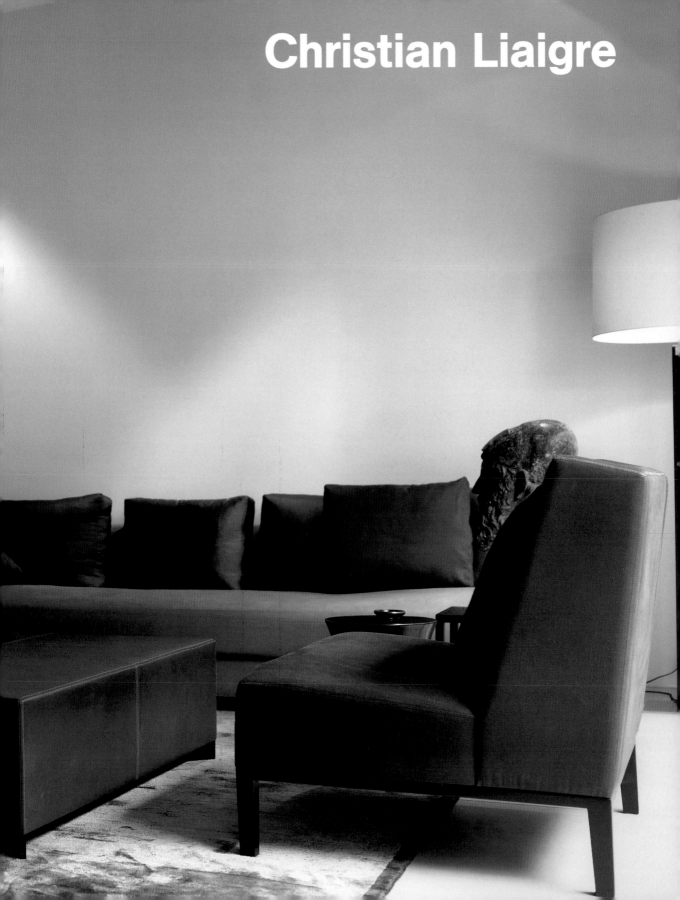

Christian Liaigre

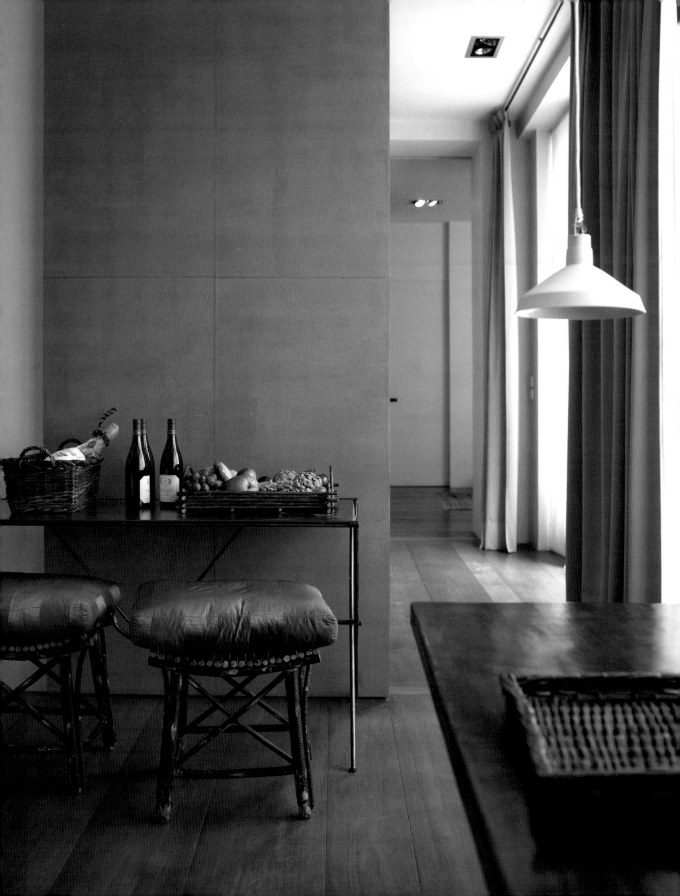

Christian Liaigre

122, rue de Grenelle, 75007 Paris

+33 145 56 16 42

+33 145 51 33 99

www.christian-liaigre.fr

etudes@christian-liaigre.fr

Christian Liaigre

1943
Born in Niort, France

1987
Starts his own label

2001
Designs the Market Restaurant and wins the prize for the best restaurant decoration, Paris, France

2002
D&AD Silver Award for the most outstanding environmental design for the Hakkasan, London, UK

2004
Becomes member of the Comité Colbert

Nature and craftsmanship are the sources of inspiration for the designs of Christian Liaigre. After studying at the École Nationale Supériore des Arts Décoratifs in Paris and the start of his professional career, he decided to take some time off from the rapid artistic development of the city. He returned ten years later, feeling the need to communicate the beauty of his life experiences through his creativity. In 1987, he started a business for interior and furniture design.

Die Entwürfe von Christian Liaigre werden von der Natur und der Handwerkskunst inspiriert. Nach seinem Studium an der École Nationale Supériore des Arts Décoratifs in Paris und den Anfängen seiner beruflichen Laufbahn, entschied er, sich für einige Zeit vom schnellen künstlerischen Wandel der Stadt zu entfernen. Zehn Jahre später kehrte er zurück mit dem Bedürfnis, die Schönheit seiner Lebenserfahrungen durch die Kreativität zu vermitteln. 1987 gründete er eine Firma für Interieur- und Möbeldesign.

La nature et l'artisanat inspirent les designs de Christian Liaigre. Après ses études à l'École des Arts Décoratifs de Paris et les débuts de sa trajectoire professionnelle, il décide de s'éloigner pour un temps du développement artistique rapide de la ville. Il y retourne dix ans plus tard, sentant la nécessité de communiquer la beauté de ses expériences vitales par le biais de la créativité. En 1987, il crée sa marque, consacrée au design d'intérieur et de mobilier.

La naturaleza y la artesanía inspiran los diseños de Christian Liaigre. Tras sus estudios en la École Nationale Supériore des Arts Décoratifs de París y los inicios de su trayectoria profesional, decidió alejarse por un tiempo del rápido desarrollo artístico de la ciudad. Regresó diez años más tarde, al sentir la necesidad de comunicar la belleza de sus experiencias vitales a través de la creatividad. En 1987 creó su marca, dedicada al diseño de interiores y de mobiliario.

Sono la natura e l'artigianato a ispirare i disegni di Christian Liaigre. Dopo gli studi presso l'École Nationale Supériore des Arts Décoratifs a Parigi e gli inizi della sua carriera, decide di allontanarsi per un periodo dalla rapida evoluzione artistica della città. Torna dieci anni dopo, sentendo la necessità di comunicare attraverso la creatività la bellezza delle esperienze di vita sperimentate. Nel 1987 crea la propria azienda di disegno d'interni e d'arredo.

Interview | Christian Liaigre

Which do you consider the most important work of your career? The most important project was also the most enjoyable: the one I did for Valentino, the fashion designer.

In what ways does Paris inspire your work? Sometimes there are places in Paris that are very inspiring. Unlike New York's stimulating, though tiring, hysteria, Paris is a city with style, which discloses itself without imposing. The places are never neutral. Paris is prone to luxury.

Does a typical Paris style exist, and if so, how does it show in your work? The advantage of being in Paris is that you can perceive the magical link among the remains of the past, which are destined to favor luxury. I try to transmit this to my furniture.

How do you imagine Paris in the future? Certain places seduce our contemporaries with their exoticism. Paris seduces with its culture and that's the future of our civilizations.

Welches Werk halten Sie für das wichtigste Ihrer Karriere? Das wichtigste Projekt war auch das angenehmste: Das, welches ich für Valentino, den Modeschöpfer, entworfen habe.

Wie inspiriert Paris Ihre Arbeit? Manchmal gibt es Plätze in Paris, die sehr inspirierend sind. Nicht so wie die Hysterie New Yorks, die, obwohl sie ermüdet, auch stimulierend ist. Paris ist eine Stadt mit Stil, der sich enthüllt, ohne sich aufzudrängen. Die Orte sind nie neutral. Paris neigt zum Luxus.

Gibt es einen typischen Pariser Stil, und wenn ja, wie macht dieser sich in Ihrer Arbeit bemerkbar? Der Vorteil davon, in Paris zu sein, ist, dass man die magische Verbindung wahrnehmen kann, die zwischen den Dingen besteht, die von der Vergangenheit übrig geblieben sind. Diese sind dazu bestimmt, den Luxus zu begünstigen. Das versuche ich, in meinen Möbeln zu vermitteln.

Wie stellen Sie sich Paris in der Zukunft vor? Bestimmte Orte verführen unsere Zeitgenossen mit ihrer Exotik. Paris verführt mit seiner Kultur und diese ist die Zukunft unserer Zivilisationen.

Etrier bench

Quelle est à vos yeux l'œuvre la plus importante de votre carrière ? Le projet le plus important était aussi le plus agréable : celui que j'ai réalisé pour Valentino, designer de mode.

Dans quelle mesure votre œuvre artistique s'inspire-t-elle de Paris ? Il y a parfois certains endroits à Paris qui vous inspirent vraiment. Contrairement à l'hystérie stimulante mais fatigante de New York, Paris est une ville qui a du style, qui se révèle sans s'imposer. Les endroits ne sont jamais neutres. Paris est enclin au luxe.

Existe-t-il un style typiquement parisien, et si oui, comment se manifeste-t-il dans votre œuvre ? L'avantage de vivre à Paris c'est de percevoir le lien magique entre les vestiges du passé, destiné à favoriser le luxe. C'est ce que j'essaie de transmettre à mes meubles.

Comment imaginez-vous le Paris du futur ? Certains endroits séduisent nos contemporains par leur exotisme. Paris séduit par sa culture et celle-ci est le futur de nos civilisations.

¿Cuál cree que es el trabajo más importante de su carrera? El proyecto más importante fue también el más divertido: el que hice para Valentino, el diseñador de moda.

¿Cómo le inspira París en su trabajo? En algunas ocasiones hay lugares en París que son realmente inspiradores. A diferencia de la histeria estimulante pero extenuante de Nueva York, París es una ciudad con estilo, que se revela a sí misma sin imponerse. Los lugares no son nunca neutros. París tiende al lujo.

¿Existe un estilo típico de París? Y si es así, ¿cómo se muestra éste en su obra? La ventaja de estar en París es que puedes percibir la conexión mágica entre las ruinas del pasado, destinadas a favorecer el lujo. Procuro transmitir esto a mi mobiliario.

¿Cómo se imagina París en un futuro? Algunos lugares seducen a nuestros contemporáneos por su exotismo. París seduce por su cultura, futuro de nuestras civilizaciones.

Quale ritiene sia l'opera più importante della sua carriera? Il progetto più importante è stato anche il più piacevole: quello che ho realizzato per lo stilista Valentino.

In che modo Parigi ispira il suo lavoro? In certi momenti ci sono luoghi di grande ispirazione a Parigi. A differenza di New York, con la sua stimolante, seppur stancante, isteria, Parigi è una città con stile, che si rivela senza imporsi. I luoghi non sono mai neutrali. Parigi è predisposta al lusso.

Esiste un tipico "stile parigino"? Se sì, come si manifesta nel suo lavoro? Il vantaggio di essere a Parigi consiste nel poter percepire il legame magico tra i resti del passato, destinati a favorire il lusso. Questo è ciò che cerco di trasmettere ai miei arredi.

Come immagina Parigi nel futuro? Alcuni luoghi seducono i nostri contemporanei con il loro esotismo. Parigi seduce con la sua cultura.

Bergére armchair

Apartment in Paris

Year: 2006
Photographs: © Mark Seelen

The fusion of classicism and modernism, together with a touch of the exotic is by and large the personal trademark of Christian Liaigre, as this Parisian apartment demonstrates so well. The furniture was created by Liaigre especially for this project and gives the apartment its very own individual touch. Natural wood with dark tones, such as wengué, and leather are his favorite materials.

Die Verschmelzung von Klassizismus und Modernität in Verbindung mit einer Prise Exotik, ist, im Großen und Ganzen, das persönliche Markenzeichen Christian Liaigres. Dies zeigt sich auch in diesem Pariser Apartment. Das Mobiliar wurde von Liaigre exklusiv für das Projekt entworfen und gibt der Wohnung dadurch ihre ganz individuelle Note. Naturholz in dunklen Tönen, wie zum Beispiel Wenge, und Leder sind seine Lieblingsmaterialien.

La fusion entre classicisme et modernité, ponctuée de légères touches d'exotisme, est dans son ensemble, le sceau personnel de Christian Liaigre, comme le démontre à la perfection cet appartement à Paris. Le mobilier, spécialement créé par Liaigre pour ce projet, lui confère son caractère particulier. Le bois naturel aux tons sombres, comme le wengué, et le cuir, sont ses matériaux de prédilection.

La fusión entre clasicismo y modernidad, mezclada con pequeñas pinceladas de exotismo es, a grandes rasgos, el sello personal de Christian Liaigre, como lo demuestra a la perfección este apartamento en París. El mobiliario fue creado especialmente por Liaigre para este proyecto y da al apartamento su peculiar carácter. La madera natural de tonos oscuros, como el wengué, y el cuero son sus materiales predilectos.

La fusione tra classicismo e modernità, mescolata con piccole pennellate d'esotismo è, a grandi linee, il marchio personale di Christian Liaigre, come dimostra alla perfezione questo appartamento a Parigi. L'arredamento è stato espressamente creato da Liaigre per questo progetto e conferisce all'appartamento il suo carattere peculiare. Il legno naturale dai toni scuri, come il wengè, ed il cuoio sono i suoi materiali prediletti.

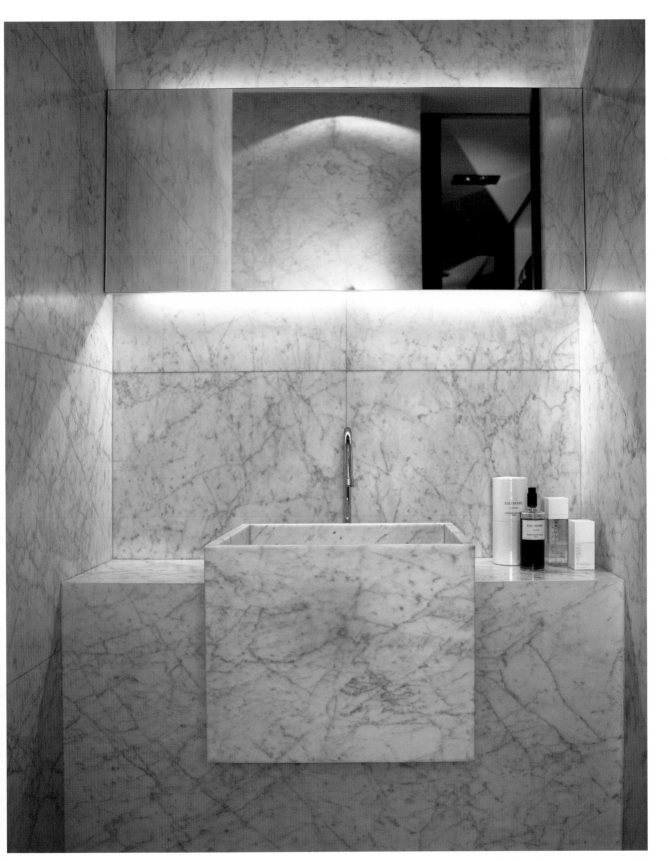

Furniture Collection 2006

Year: 2006
Photographs: © Luc Boegly

Although these furniture pieces draw on aesthetics from different eras and cultures, they nevertheless appear simple and modern. This is what makes them unique. Their forms suggest the colonial style in both ethnic and exotic terms. They are made of solid and elegant materials, such as wengué wood and aluminum.

Obwohl diese Möbelstücke von der Ästhetik anderer Epochen und Kulturen inspiriert wurden, wirken sie doch schlicht und modern. Dadurch werden sie zu etwas Einzigartigem. In den Formen dieser Stücke kann man den Kolonialstil, ethnisch und exotisch, erkennen. Sie bestehen aus solidem und elegantem Material, wie Wengeholz und Aluminium.

Tout en s'inspirant de l'esthétique d'époques et cultures différentes, ces meubles sont simples et modernes. C'est ce qui en fait l'unicité. Le style colonial, ethnique et exotique se reconnaît essentiellement dans les formes de ces meubles. Pour les réaliser, on a utilisé des matériaux robustes et élégants, comme le bois de wengué et l'aluminium.

Aunque los muebles están inspirados en la estética de épocas y culturas diferentes tienen un aire sencillo y moderno. Es esto lo que los hace únicos. El estilo colonial, étnico y exótico se reconoce fundamentalmente en las formas de estos muebles, para cuya realización se han utilizado materiales sólidos y elegantes, como la madera de wengué y el aluminio.

Anche se i mobili sono ispirati all'estetica di epoche e culture diverse, sono di aspetto semplice e linea moderna: ecco cosa li rende unici. Lo stile coloniale, etnico ed esotico si riconosce fondamentalmente nelle linee di questi mobili, per la cui realizzazione sono stati utilizzati materiali solidi ed eleganti, come il legno wengè e l'alluminio.

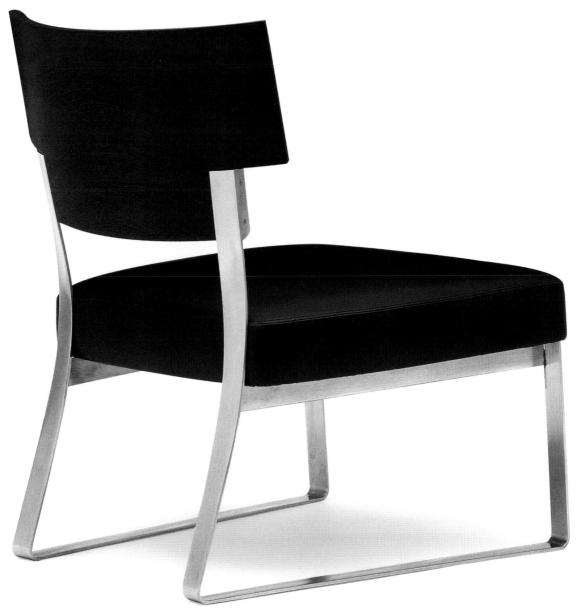

Malte Armchair

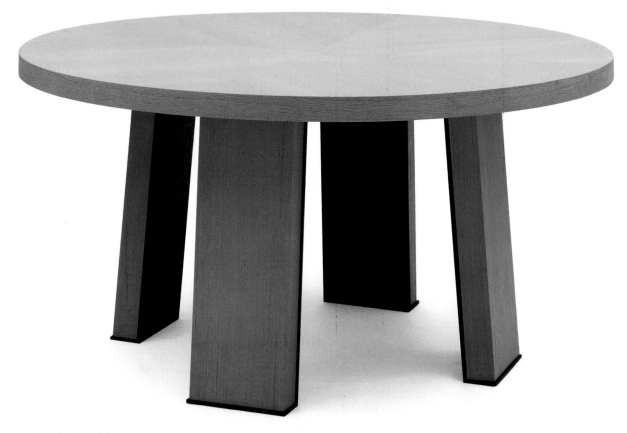

Artois Round Dining Table

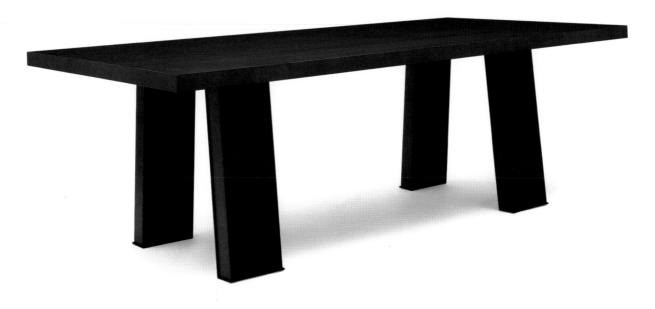

Artois Large Dining Table

Galion Console

Agustin Sofa

Opium Sofa

Spartane Chair

Latin Daybed

Calòptere Low Table

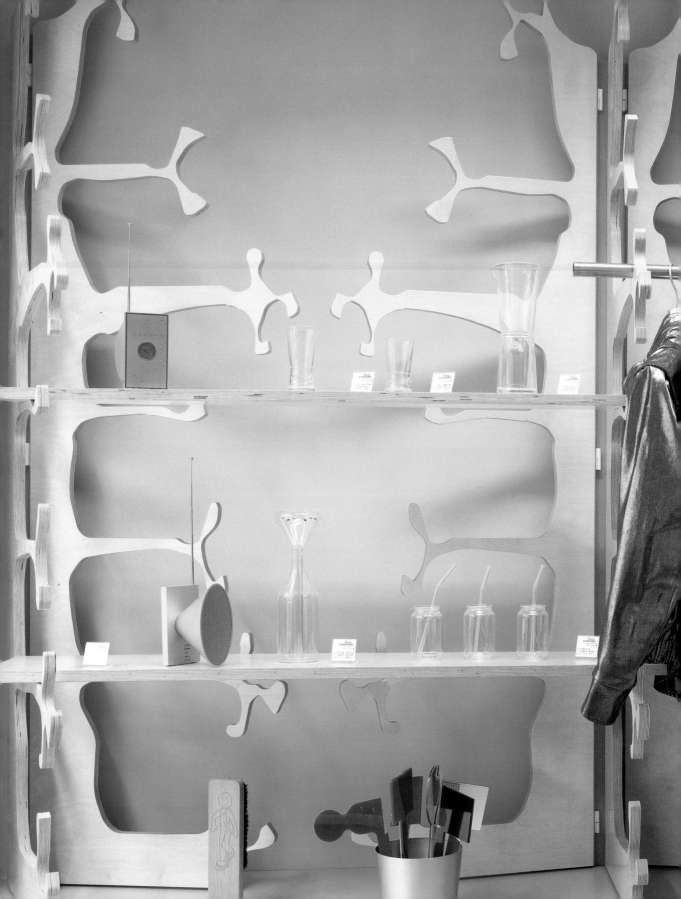

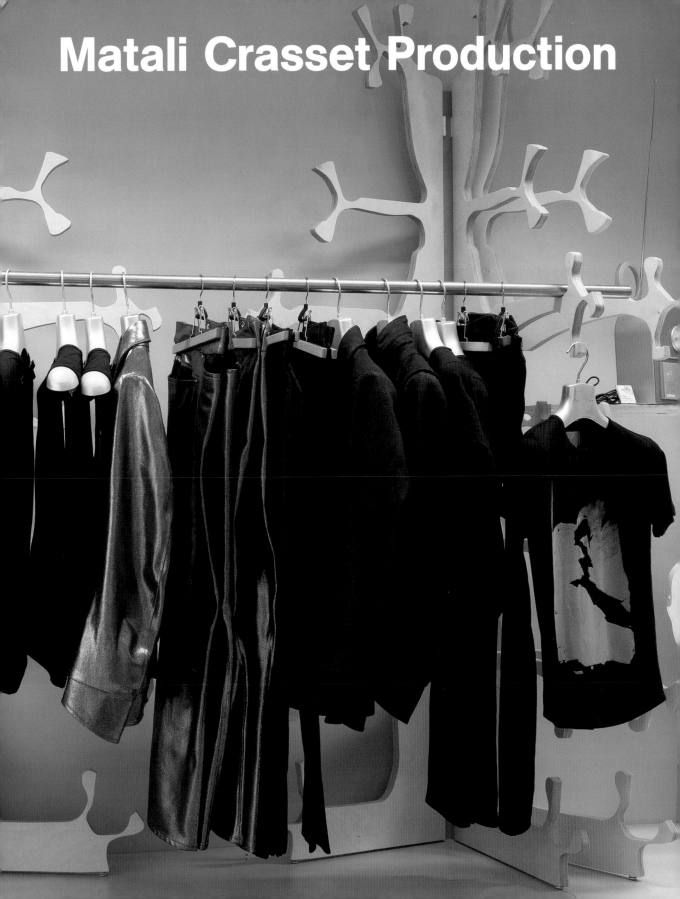

Matali Crasset Production

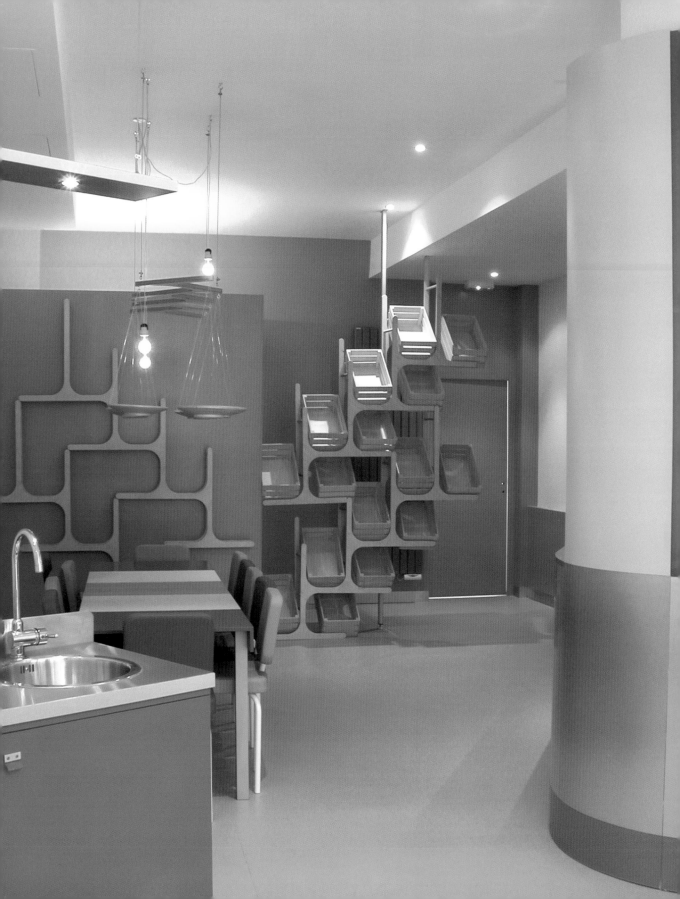

Matali Crasset Production

26, rue du Buisson Saint-Louis, 75010 Paris

+33 142 40 99 89

+33 142 40 99 98

www.matalicrasset.com

matali.crasset@wanadoo.fr

Matali Crasset

1965
Born in Charlons-en-Champagne, France

1991
Finished her studies at the École Nationale Supériore de Création Industrielle in Paris, France

1998
Creates her own studio

2001
First architecture project: the advertising company Red Cell in Paris, France

2002
Exhibition matali crasset: un pas de côté 1991/2002

2003
Hi hotel, Nice, France

Born in 1965 in a small village in the north of France, Matali Crasset studied in Paris and started out working for designer Denis Santachiara in Milan, before returning to Paris in 1993 to work for Philippe Starck. As an industrial designer, stage designer and interior architect, she is always on a quest, driven by hypotheses rather than principles. The Hi hotel, in Nice, is one of the large projects she has implemented from her studio, founded in 1998.

Matali Crasset wurde 1965 in einem kleinen Dorf im Norden Frankreichs geboren und war nach ihrem Studium in Paris zunächst in Mailand für den Designer Denis Santachiara tätig, bevor sie 1993 nach Paris zurückging, um für Philippe Starck zu arbeiten. Als Industriedesignerin, Bühnenbildnerin und Innenarchitektin befindet sie sich stets auf der Suche, getrieben eher von Hypothesen als von Prinzipien. Das Hotel Hi in Nizza ist eines der großen Projekte, das ihr Studio, gegründet 1998, realisiert hat.

Née en 1965 dans un petit village du nord de la France, Matali Crasset, à l'issue de ses études à Paris, travaille quelques temps à Milan pour le designer Denis Santachiara, avant de rentrer à Paris en 1993 sous la direction de Philippe Starck. Son œuvre, en tant que designer industriel, scénographe et architecte d'intérieur, présente une recherche en mouvement constant remplie d'hypothèse plus que de principes. L'hôtel Hi, à Nice, est un des grands projets sortis du studio qu'il fonde en 1998.

Nacida en 1965 en un pequeño pueblo del norte de Francia, Matali Crasset, tras finalizar sus estudios en París, trabajó una temporada en Milán para el diseñador Denis Santachiara, antes de regresar a París en 1993 bajo la dirección de Philippe Starck. Su trabajo, como diseñadora industrial, escenógrafa e interiorista, es una continua búsqueda en movimiento, llena de hipótesis más que de principios. El hotel Hi, en Niza, es uno de los grandes proyectos que ha llevado a cabo desde su estudio, fundado en 1998.

Nata nel 1965 in un paesino del nord della Francia, Matali Crasset lavora per un certo periodo a Milano per il designer Denis Santachiara al termine dei propri studi compiuti a Parigi prima di tornare a lavorare nella capitale sotto la direzione di Philippe Starck nel 1993. Il suo lavoro come designer industriale, scenografa e designer d'interni è una continua ricerca, mossa da ipotesi più che da principi. L'hotel Hi, a Nizza, è uno dei grandi progetti realizzato dal suo studio fondato nel 1998.

Interview | Matali Crasset

Which do you consider the most important work of your career? The Hi hotel in Nice.

In what ways does Paris inspire your work? I love Paris and I feel good in this city, which helps me work. There is a good cultural atmosphere, but there is a lack of energy.

Does a typical Paris style exist, and if so, how does it show in your work? My work isn't linked to a Parisian style. The only connection I could find is the mix between artificial and natural, as a park in the city for example.

How do you imagine Paris in the future? I hope that it won't become a museum city, a dead city. In the west, we are headed this way. Paris needs to change architecturally. Perhaps we need a new Baron Haussmann to breathe some new life into the city. Paris has changed over the past few years. We now have bike lanes, which were inconceivable a few years ago. But we need more, more utopia, more revolution.

Welches Werk halten Sie für das wichtigste Ihrer Karriere? Das Hi Hotel in Nizza.

Wie inspiriert Paris Ihre Arbeit? Ich liebe Paris und ich fühle mich gut in dieser Stadt. Das hilft mir bei meiner Arbeit. Es gibt hier eine gute kulturelle Atmosphäre, aber es fehlt auch an Energie.

Gibt es einen typischen Pariser Stil, und wenn ja, wie macht dieser sich in Ihrer Arbeit bemerkbar? Meine Arbeit steht nicht in Verbindung zu einem Pariser Stil. Die einzige Verbindung, die ich entdecken könnte, ist die Mischung aus Künstlichem und Natürlichem, wie zum Beispiel ein Park in der Stadt.

Wie stellen Sie sich Paris in der Zukunft vor? Ich hoffe, dass es sich nicht in eine Museums-Stadt, in eine tote Stadt, verwandelt. Das ist die Entwicklung im Westen. Paris braucht eine architektonische Wende. Vielleicht brauchen wir einen neuen Baron Haussmann, der der Stadt etwas neues Leben einhaucht. Paris hat sich während der letzten Jahre verändert. Jetzt haben wir Radwege, was bis vor wenigen Jahren noch unvorstellbar gewesen wäre. Aber wir brauchen mehr, mehr Utopia, mehr Revolution.

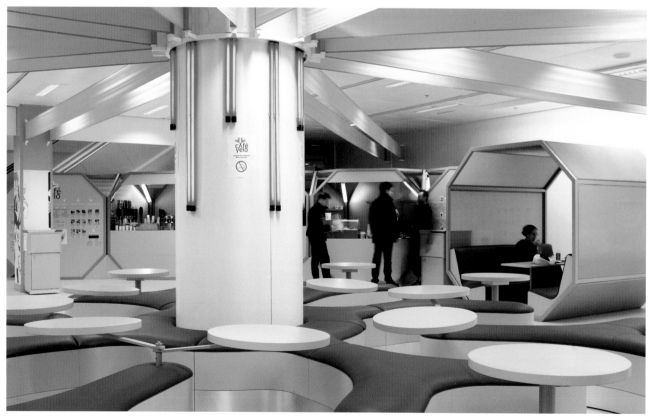

Quelle est à vos yeux l'œuvre la plus importante de votre carrière ? L'hôtel Hi à Nice.

Dans quelle mesure votre œuvre artistique s'inspire-t-elle de Paris ? J'adore Paris et je me sens bien dans cette ville, ce qui m'aide à travailler. Il y règne une bonne atmosphère culturelle, mais l'énergie y fait défaut.

Existe-t-il un style typiquement parisien, et si oui, comment se manifeste-t-il dans votre œuvre ? Mon œuvre n'est pas liée à un style parisien. Le seul lien que je puisse trouver c'est le mélange entre artificiel et naturel, à l'image d'un parc au cœur de la ville, par exemple.

Comment imaginez-vous le Paris du futur ? J'espère que Paris ne deviendra pas une ville musée, une ville morte. A l'ouest, c'est le chemin que l'on est en train de suivre. Paris a besoin de changer d'architecture. Peut-être qu'il nous faudrait un nouveau baron Haussmann pour insuffler une nouvelle vie à la ville. Certes, Paris a changé au cours des dernières années. Nous avons maintenant des pistes cyclables, chose inconcevable il y a quelques années à peine. Mais il faut encore plus, plus d'utopie, plus de révolution.

¿Cuál cree que es el trabajo más importante de su carrera? El hotel Hi en Niza.

¿Cómo le inspira París en su trabajo? Me encanta París y me siento a gusto en esta ciudad, lo que me ayuda a trabajar. Se respira una buena atmósfera cultural, pero falta energía.

¿Existe un estilo típico de París? Y si es así, ¿cómo se muestra éste en su obra? Mi trabajo no está conectado con un estilo parisino. La única conexión que podría encontrar es la mezcla de lo artificial con lo natural, como un parque en la ciudad por ejemplo.

¿Cómo se imagina París en un futuro? Espero que no se convierta en una ciudad-museo, una ciudad muerta. En el oeste vamos en esa dirección. París necesita un cambio desde el punto de vista arquitectónico. Quizás necesitemos un nuevo barón Haussmann para respirar una nueva vida en la ciudad. París ha cambiado en los últimos años. Ahora tenemos carril-bici, algo que era inconcebible hace unos pocos años. Necesitamos algo más, más utopía, más revolución.

Quale ritiene sia l'opera più importante della sua carriera? L'hotel Hi a Nizza.

In che modo Parigi ispira il suo lavoro? Amo Parigi e mi sento bene in questa città. Ciò contribuisce al mio lavoro. C'e una buona atmosfera culturale, ma manca energia.

Esiste un tipico "stile parigino"? Se sì, come si manifesta nel suo lavoro? Il mio lavoro non è collegato a uno stile parigino. L'unica relazione che potrei trovare è l'unione tra artificiale e naturale, come un parco in una città, per esempio.

Come immagina Parigi nel futuro? Spero che non diventerà una città-museo, una città morta. Nella parte ovest stiamo prendendo questa strada. Parigi ha bisogno di una svolta architettonica. Forse abbiamo bisogno di un nuovo barone Haussmann che infonda nuova vita alla città. Parigi è cambiata negli ultimi anni. Ora abbiamo le piste ciclabili, inconcepibili fino a pochi anni fa, ma c'è bisogno di molto di più: più utopia, più rivoluzione.

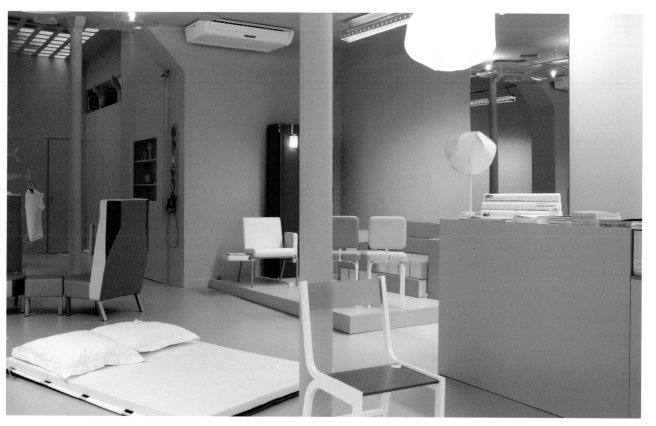

Lieu Commun

Year: 2006
Photographs: © Patrick Gries

This space is the result of a union of four artists: Eric Morand and Laurent Garnier with their brand F communications, stylist Ron Orb and Matali Crasset, in charge of design. In this establishment all their work is displayed and it's also a perfect place for coming up with new shared projects. Their three design worlds blend into one harmonic display with the goal of bringing their ideas together.

Dieser Raum ist das Ergebnis einer Union von vier Künstlern: Eric Morand und Laurent Garnier mit ihrer Marke F communications, dem Stylisten Ron Orb und, für das Design zuständig, Matali Crasset. In diesem Lokal werden all ihre Werke ausgestellt und es ist zudem ein perfekter Ort für die Entstehung neuer gemeinsamer Projekte. Die drei Designwelten vermischen sich in einer harmonischen Ausstellung mit dem Wunsch, eine Annäherung ihrer Ideen zu erreichen.

Cet espace est le fruit de l'association entre quatre créateurs indépendants : Eric Morand et Laurent Garnier avec leur marque F communications, le styliste Ron Orb et, chargée de leur design, Matali Crasset. Cette boutique où sont exposées toutes leurs créations est par ailleurs l'endroit idéal pour la prolifération des projets en commun. Les trois univers de création se mêlent pour être exposés harmonieusement, avec le désir de faire converger les idées.

Este espacio es el resultado de la unión de cuatro creadores independientes: Eric Morand y Laurent Garnier con su marca F communications, el estilista Ron Orb y, como encargada de su diseño, Matali Crasset. En esta tienda se exponen todas sus creaciones y es además un lugar idóneo para la prolifeación de los proyectos en común. Los tres mundos de creación se mezclan para ser expuestos en armonía, bajo el deseo de hacer que las ideas converjan.

Questo spazio è il risultato dell'unione di quattro creativi indipendenti: Eric Morand e Laurent Garnier, con il loro marchio F Communications, lo stilista Ron Orb e, come sua responsabile per il disegno, Matali Crasset. In questo negozio sono esposte tutte le loro creazioni, in un unico luogo che è altresì ideale per la proliferazione di progetti comuni. I tre mondi della creazione si mescolano per essere esposti in armonia, mossi da un forte desiderio di convergenza dei diversi stili creativi.

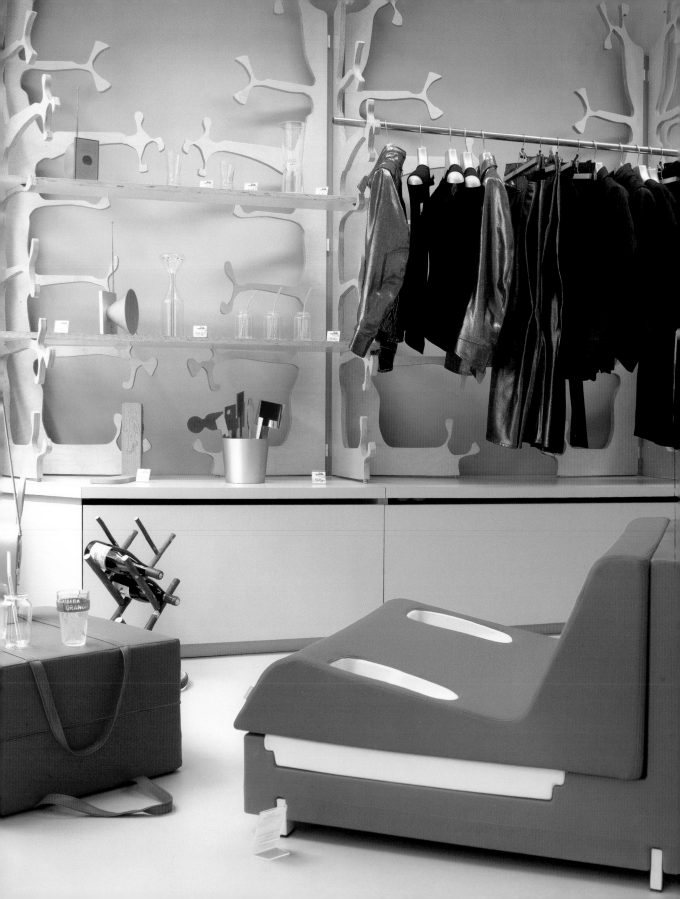

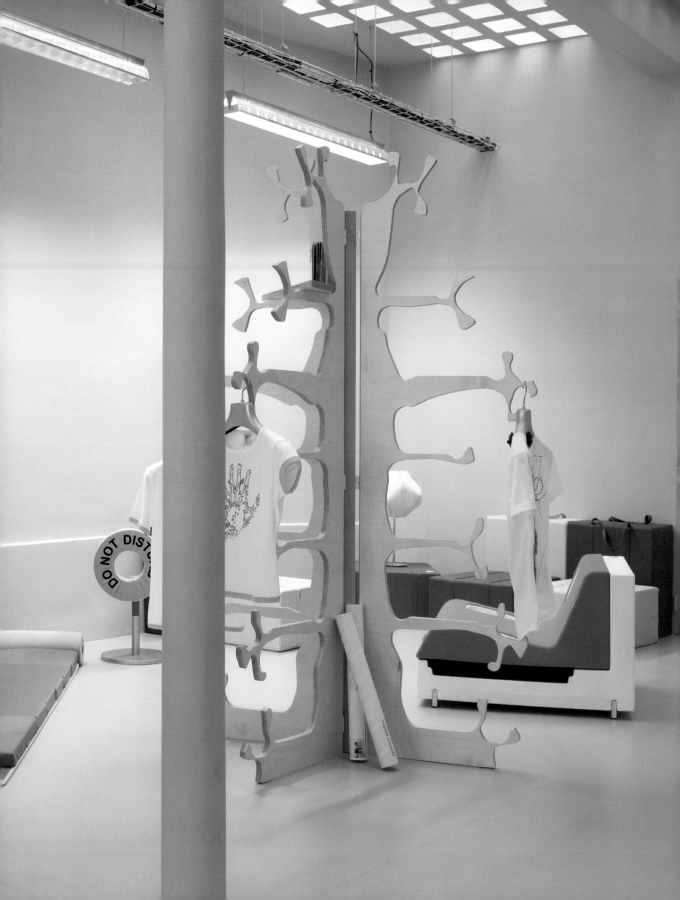

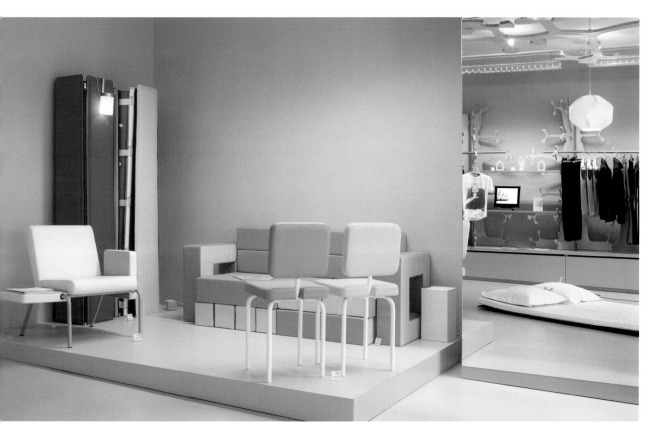

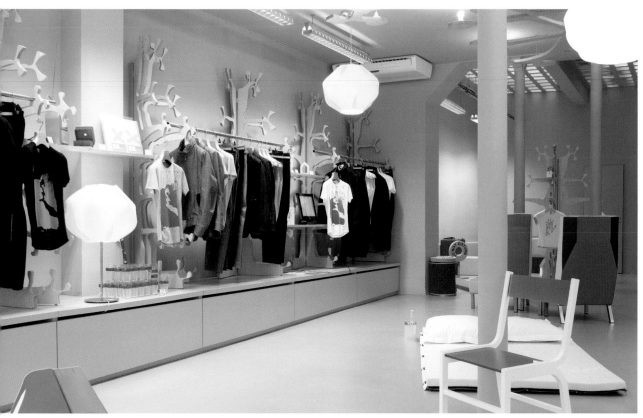

Cuisine Fraich'attitude

Year: 2006
Photographs: © Pf. Dufour

This center for job training and culinary creations in the catering industry gives emphasis to fruit and vegetables. Striking colors were chosen for its design: Green, yellow, pink and sky blue cover the walls, floor and furniture. The furnishings and decoration are of an organic design that evokes the shapes of trees and underlines the philosophy of this training center.

Dieses Zentrum für Berufsausbildung und kulinarische Schöpfung in der Gastronomie ist dem Schwerpunkt Obst und Gemüse gewidmet. Für sein Design wurden knallige Farben gewählt: Grün, Gelb, Pink und Himmelblau bedecken die Wände, den Boden und die Möbel. Das Mobiliar und die Dekorationselemente sind in einem organischen Design gestaltet, das an die Formen von Bäumen erinnert und die Ausrichtung dieses Zentrums unterstreicht.

Cet espace est consacré à la formation et la création culinaire, spécialement réalisée à base de fruits et légumes. Le design affiche un choix de couleurs vives : vert, jaune, rose et bleu ciel habillent les murs, le sol et le mobilier. Ces meubles et autres éléments décoratifs affichent un design organique qui évoque les formes des arbres et soulignent la philosophie de la nature de ce centre de formation.

Este espacio dedicado a la formación y la creación culinaria, especialmente con frutas y verduras. Para su diseño se optó por colores llamativos: verde, amarillo, rosa y azul celeste cubren las paredes, el suelo, y los muebles. Estos muebles y otros elementos decorativos poseen un diseño orgánico que evoca las formas de los árboles y subraya la filosofía natural de este centro de formación.

Questo spazio è destinato alla formazione e alla creazione culinaria, a base soprattutto di frutta e verdura. Per decorarlo sono stati scelti colori sgargianti: verde, giallo, rosa e celeste ricoprono le pareti, il pavimento e i mobili. L'arredo e gli altri elementi decorativi si ispirano al design organico, che evoca le forme degli alberi e sottolinea la filosofia di questo centro di formazione.

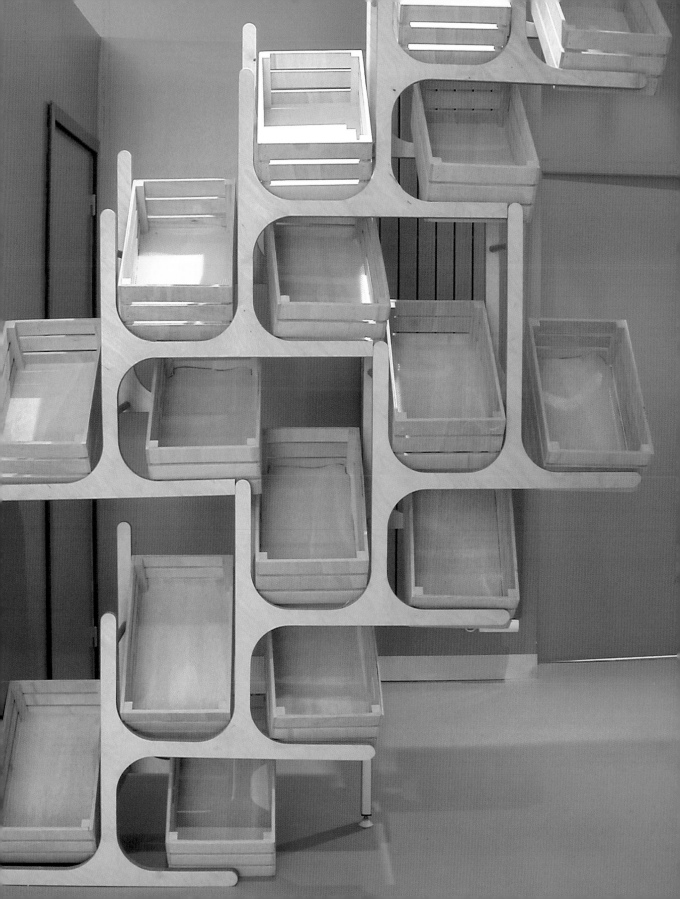

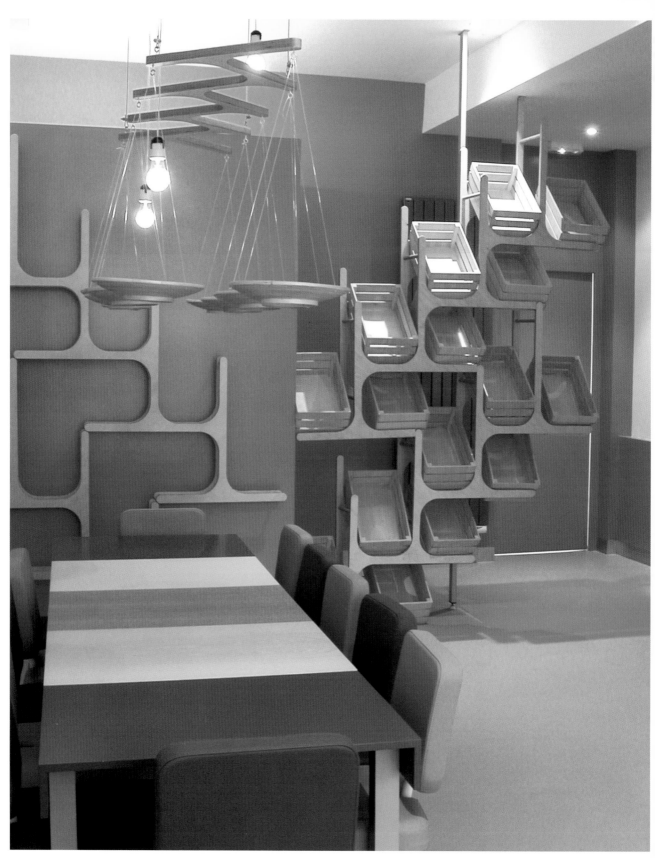

Matali Crasset Production

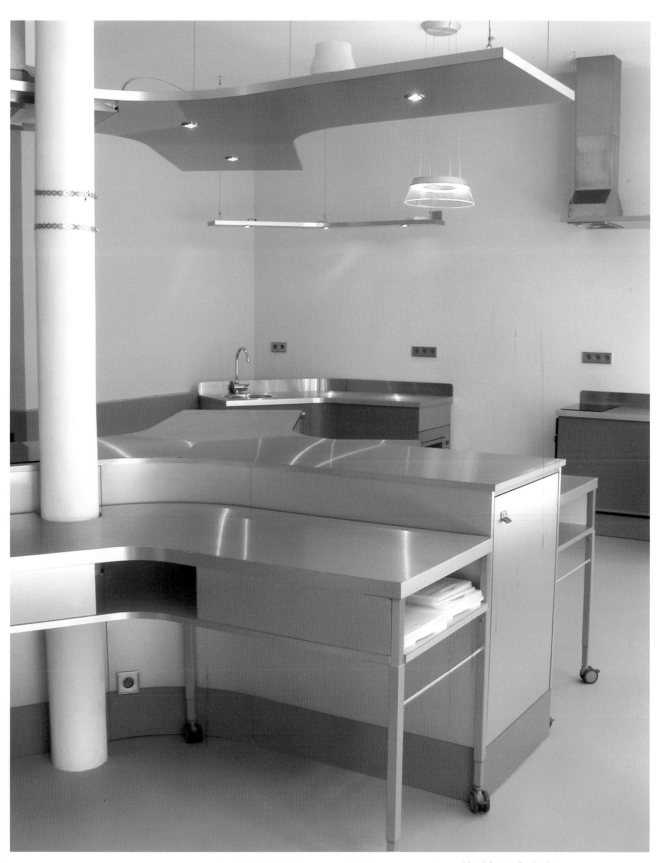

Annex for the BHV

Year: 2005
Photographs: © Patrick Gries

This space, located in the center of the Belle Epine shopping mall, is an initiative aimed at young people that has divided the annex into four areas: "agir" (act), "bouger" (move), "fashion" and "s'évader" (escape). It contains the elements necessary to awaken creativity and interest in young people and to acquaint them with fashion. There's also a place for get-togethers, the Café Yélo. The furnishings in the space present a dynamic, original and fresh design with vivid colors that invites interaction among people.

Dieser Raum, der sich mitten im Einkaufszentrum Belle Epine befindet, ist eine Initiative, die sich an junge Leute richtet. Der Anbau ist in vier Zonen aufgeteilt: „agir" (handeln), „bouger" (sich bewegen), „fashion" (Mode) und „s'évader" (sich zerstreuen). Er ist ausgestattet mit den nötigen Elementen, um die Kreativität und das Interesse der jungen Menschen zu wecken und ihnen die Mode nahe zu bringen. Außerdem verfügt er über einen Treffpunkt, das Café Yélo. Das Mobiliar wurde in einem dynamischen Design gestaltet, originell und frisch, mit lebhaften Farben, die dazu einladen, miteinander zu agieren.

Cet espace, situé dans le centre commercial Belle Epine, est une initiative destinée aux jeunes, divisant l'annexe en quatre zones : « agir », « bouger », « mode » et « s'évader ». Le lieu est doté des éléments nécessaires pour éveiller la créativité et l'intérêt des jeunes, et les rapprocher, au passage, de la mode. En outre, il comporte un point de rencontre, le Café Yélo. Le mobilier de l'espace affiche un design dynamique, original et rafraîchissant, aux couleurs vives, qui invite les jeunes à l'interaction.

Este espacio, un anexo ubicado en el centro comercial Belle Epine, es una iniciativa dirigida a los jóvenes que se ha dividido en cuatro áreas : "agir" (actuar), "bouger" (moverse), "fashion" (moda) y "s'évader" (evadirse). El lugar está dotado con los elementos necesarios para despertar la creatividad y el interés de los jóvenes, y acercarlos a la moda. Además cuenta con un punto de encuentro, el Café Yélo. El mobiliario del espacio presenta un diseño dinámico, original y fresco, de colores vivos que invita a los jóvenes a interactuar.

Questo spazio, ubicato nel centro commerciale Belle Epine, è un'iniziativa rivolta ai giovani. L'edificio annesso è stato diviso in quattro aree: "agir" (agire), "bouger" (muoversi), "fashion" e "s'évader" (evadere). Il luogo è dotato degli elementi necessari per risvegliare la creatività e l'interesse dei giovani, e per avvicinarli, nel contempo, alla moda. Inoltre, dispone di un punto d'incontro, il Café Yélo. L'arredamento presenta un design dinamico, originale e fresco dai colori vivi, che invita i giovani all'interazione.

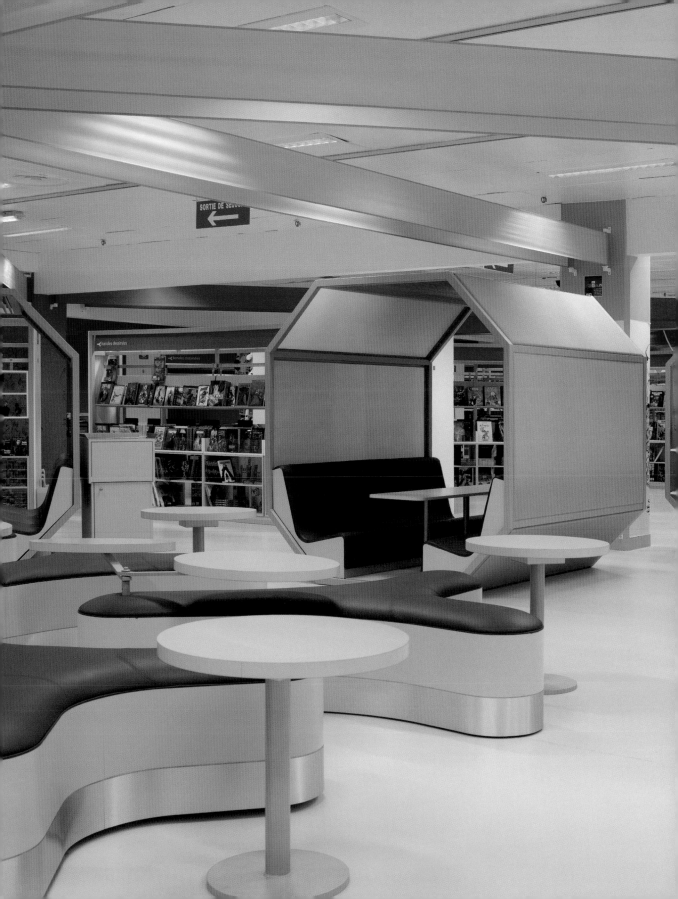

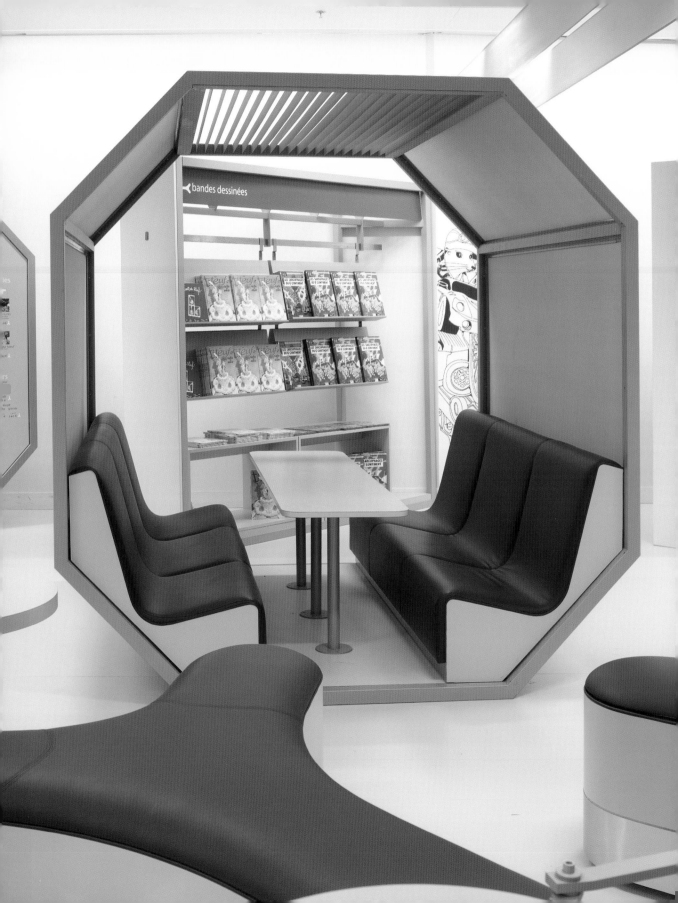

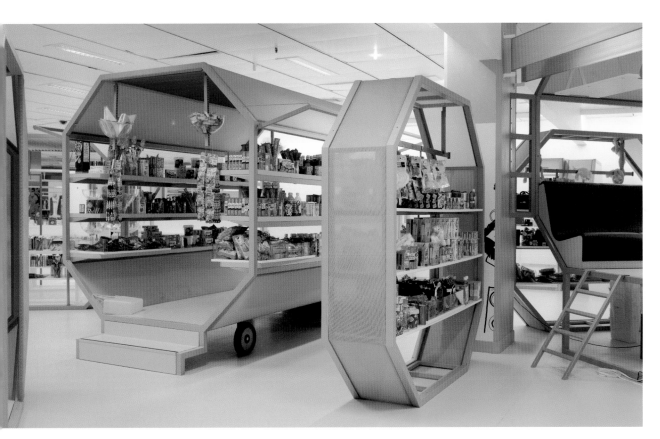

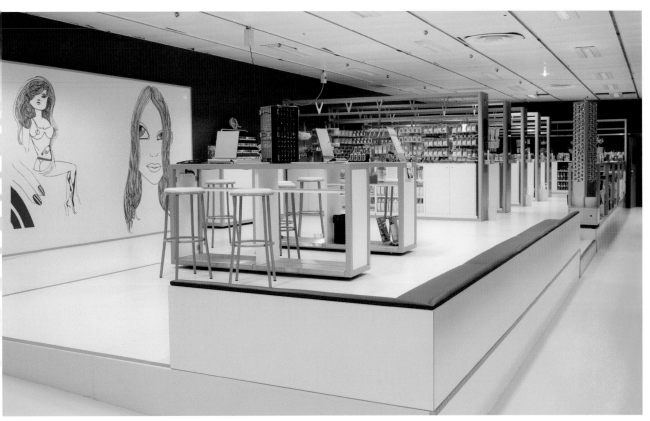

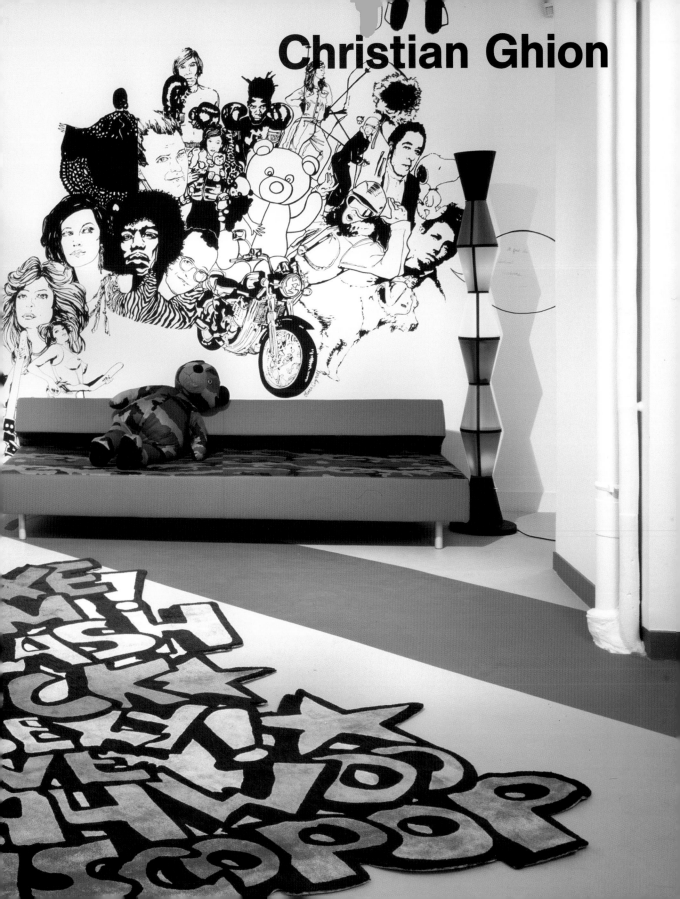

Christian Ghion

Christian Ghion

156, rue Oberkampf, 75011 Paris

+33 149 29 06 90

+33 149 29 06 89

www.christianghion.com

ghion@christianghion.com

Christian Ghion

After abandoning his career in law, Christian Ghion became a designer, stage designer and interior architect. He began his career as the partner of another great talent, Patrick Nadeau. His extensive portfolio of projects comprises everything from interiors of unmistakable design to creations for Cappellini, Driade, YSL, Christian Dior and others. Every year, he organizes the DesignLab at the Paris furniture show, where young designers can put their creations on display.

Nach dem Abbruch seiner Laufbahn als Anwalt wurde Christian Ghion zum Designer, Bühnenbildner und Innenarchitekten. Er begann seine Karriere als Partner eines weiteren großen Talents: Patrick Nadeau. Auf seiner umfassenden Projektliste finden sich sowohl Innenräume von unverwechselbarem Design als auch Kreationen für Cappellini, Driade, YSL, Christian Dior und andere. Jedes Jahr organisiert er das DesignLab auf der Pariser Möbelmesse, in dem junge Designer ihre Werke ausstellen können.

Après avoir abandonné sa trajectoire dans le domaine du droit, il devient designer, scénographe et architecte d'intérieur. Au début de sa carrière, il s'associe à un autre grand talent, Patrick Nadeau. Sa longue liste de projets va des intérieurs au design spécifique pour Cappellini, Driade, YSL et Christian Dior, pour ne citer qu'eux. Tous les ans, il organise le DesignLab au salon du Meuble de Paris, vitrine pour les créations de jeunes designers.

Tras abandonar su trayectoria en el mundo del derecho, se convirtió en diseñador, escenógrafo y arquitecto de interiores. Empezó su carrera como socio de con otro gran talento, Patrick Nadeau. Su extensa lista de proyectos abarca desde interiores con un inconfundible diseño hasta creaciones para Cappellini, Driade, YSL y Christian Dior, entre otros. Cada año organiza el DesignLab en la Feria del Mueble de París, un escaparate para las creaciones de jóvenes diseñadores.

Dopo aver abbandonato la carriera giuridica come avvocato, Christian Ghion diventa designer, scenografo e architetto d'interni, inizialmente in veste di associato al fianco di un altro grande talento, Patrick Nadeau. La lunga lista dei suoi progetti spazia dalla progettazione di interni dall'inconfondibile design alle creazioni per griffe fra cui Cappellini, Driade, YSL e Christian Dior. Ogni anno organizza il DesignLab presso il Salone del Mobile di Parigi, una vetrina per le creazioni dei giovani designer.

Christian Ghion

1958
Born in Montmorency, France

1982
Studies at the École d'Architecture de Charenton, Étude de Création de Mobilier

1987
Founds a studio with Patrick Nadeau

1990
Prix de la Création de la Ville de Paris, France

2002
Chaise longue Shadow for Cappellini, Milan

2004
Perfume bottle for Christian Dior, Paris, France
Showroom Jean-Charles de Castelbajac, Paris, France
Boutique Chantal Thomass, Paris, France

2006
Shop window Louis Vuitton, Paris, France

Interview | Christian Ghion

Which do you consider the most important work of your career? I don't consider one work more important than the other. I had the chance to work for Chantal Thomass, Castelbajac and Pierre Gagnaire and I am very happy to have shared their universe.

In what ways does Paris inspire your work? I move around Paris on my Vespa. The streets are a source of inspiration, especially the popular districts where all the cultures mix.

Does a typical Paris style exist, and if so, how does it show in your work? If there is a Parisian style in my work, it's a spirit of lightness: sexy, lazy, and free. I feel close to the Folies Bergères universe, Montmartre and the Parisian guys who speak the so-called Titi slang.

How do you imagine Paris in the future? As in the French animation movie "Renaissance," which is a vision of a Paris transformed into a megalopolis where old and new intertwine, retaining the city's charm.

Welches Werk halten Sie für das wichtigste Ihrer Karriere? Es gibt kein Werk, das ich für wichtiger als ein anderes halte. Ich hatte die Gelegenheit, für Chantal Thomass, Castelbajac und Pierre Gagnaire zu arbeiten und ich bin glücklich darüber, dass ich ihr Universum teilen konnte.

Wie inspiriert Paris Ihre Arbeit? Ich bewege mich durch Paris mit meiner Vespa. Die Straßen sind eine Quelle der Inspiration, besonders die populären Viertel, in denen sich die Kulturen vermischen.

Gibt es einen typischen Pariser Stil, und wenn ja, wie macht dieser sich in Ihrer Arbeit bemerkbar? Wenn es einen typischen Pariser Stil in meiner Arbeit gibt, dann ist es ein Geist der Leichtigkeit: sexy, müßig und frei. Ich fühle mich dem Folies Bergères Universum, Montmartre und den Parisern, die den sogenannten Titi-Slang sprechen, nah.

Wie stellen Sie sich Paris in der Zukunft vor? Wie in dem französischen Zeichentrickfilm „Renaissance", der eine Vision der Stadt Paris ist, die sich in eine Megapole verwandelt hat, in der das Alte und das Neue miteinander verflochten sind, wodurch der Charme der Stadt bewahrt wird.

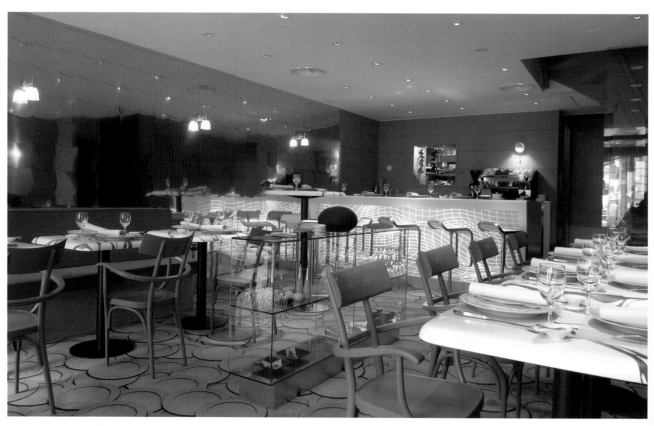

Quelle est à vos yeux l'œuvre la plus importante de votre carrière ? Je ne pense pas qu'une œuvre soit plus importante que l'autre. J'ai eu la chance de travailler pour Chantal Thomass, Castelbajac et Pierre Gagnaire et je suis extrêmement heureux d'avoir pu partager leur univers.

Dans quelle mesure votre œuvre artistique s'inspire-t-elle de Paris ? Je circule dans Paris sur ma Vespa. Les rues m'inspirent, surtout celles des quartiers populaires où il y a un brassage culturel.

Existe-t-il un style typiquement parisien, et si oui, comment se manifeste-t-il dans votre œuvre ? S'il y a un style parisien dans mon œuvre, c'est un esprit de légèreté : sexy, paresseux, et libre. Je me sens proche de l'univers des Folies Bergères, de Montmartre et des titis parisiens qui parlent l'argot.

Comment imaginez-vous le Paris du futur ? Comme dans le film français d'animation « Renaissance », une vision de Paris transformé en mégalopole ou l'ancien et le nouveau se mêlent, préservant le charme de la cité.

¿Cuál cree que es el trabajo más importante de su carrera? No considero un trabajo más importante que otro. Tuve la oportunidad de trabajar con Chantal Thomass, Castelbajac y Pierre Gagnaire y estoy muy contento de haber compartido sus universos.

¿Cómo le inspira París en su trabajo? Me muevo por París con mi Vespa. Las calles son una fuente de inspiración, especialmente los distritos populares donde se mezclan todas las culturas.

¿Existe un estilo típico de París? Y si es así, ¿cómo se muestra éste en su obra? Si hay un estilo parisino en mi trabajo, ése es el espíritu de la ligereza: sexy, perezoso y libre. Me siento cercano al universo del Folies Bergères, Montmartre y a los chicos parisinos que hablan lo que se conoce como el argot "Titi".

¿Cómo se imagina París en un futuro? Como en la película de animación francesa "Renaissance", que muestra una visión de un París transformado en una megápolis donde lo antiguo y lo nuevo se entremezclan, conservando el encanto de la ciudad.

Quale ritiene sia l'opera più importante della sua carriera? Non considero nessun lavoro più importante di un altro. Ho avuto la possibilità di lavorare per Chantal Thomass, Castelbajac e Pierre Gagnaire e sono molto felice di avere condiviso il loro universo.

In che modo Parigi ispira il suo lavoro? Mi muovo per Parigi sulla mia Vespa. Le strade sono una fonte di ispirazione, specialmente i quartieri popolari in cui le culture si mescolano.

Esiste un tipico "stile parigino"? Se sì, come si manifesta nel suo lavoro? Se esiste uni stile parigino nel mio lavoro, è uno spirito di leggerezza: sensuale, pigro e libero. Mi sento vicino all'universo delle Folies Bergères, di Montmartre e dei giovani parigini che parlano il cosiddetto "Titi" slang.

Come immagina Parigi nel futuro? Come nel film d'animazione francese "Renaissance", che è una visione di Parigi trasformata in una megalopoli in cui il vecchio e il nuovo si intrecciano, trattenendo il fascino della città.

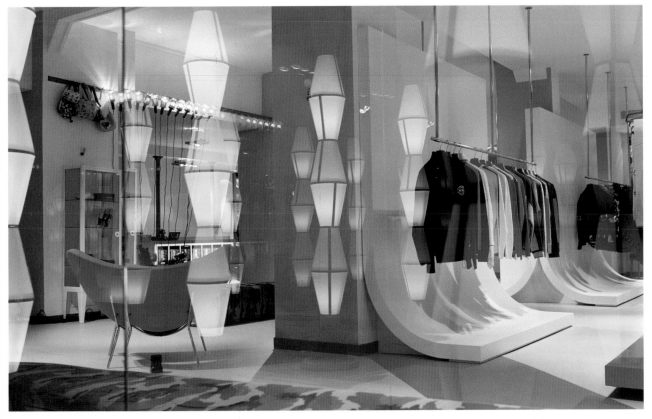

Christian Ghion 239

Jean-Charles de Castelbajac Concept Store

Year: 2004
Photographs: © Eric Baudelaire

Architect Philippe Proisy and his friend Christian Ghion set out to design a room that would compliment the designer's personality. The result is an open, colorful and artistic space, which draws attention to the collages, pictures and symbols that decorate the shop, as well as to the motorbikes, one of Castelbajac's great passions. A space that does justice to the ideas and talent of both creators.

Der Architekt Philippe Proisy und sein Freund Christian Ghion wollten einen Raum entwerfen, der zur Persönlichkeit des Designers passt. Das Ergebnis ist ein offener, bunt erleuchteter und künstlerischer Raum, der die Aufmerksamkeit auf die Collagen, die Bilder und Symbole lenkt, mit denen der Shop dekoriert ist, ebenso wie auf die Motorräder, eine der großen Leidenschaften Castelbajacs. Ein Raum, der den Wünschen und dem Talent der beiden Schöpfer entspricht.

Pour créer un lieu en accord avec la personnalité du designer, son ami Christian Ghion et l'architecte Philippe Proisy ont imaginé un espace dépouillé, coloré et artistique qui attire l'attention sur les collages, les images et les symboles qui décorent la boutique, comme sur les motos, une des grandes passions de Castelbajac. Un espace qui répond aux désirs et au talent des deux créateurs.

Para crear un lugar acorde con la personalidad del diseñador, el arquitecto Philippe Proisy y su amigo Christian Ghion imaginaron un espacio despejado, colorido y artístico, que atrajera la atención hacia los collages, las imágenes y los símbolos que decoran la tienda, al igual que hacia las motos, una de las grandes pasiones de Castelbajac. Un espacio que responde a los deseos y al talento de ambos creadores.

Per creare un luogo in sintonia con la personalità del designer, il suo amico Christian Ghion e l'architetto Philippe Proisy hanno immaginato uno spazio ampio, illuminato vivacemente e artistico, che attirasse l'attenzione verso i collages, i quadri e i simboli che decorano il negozio, così come verso le moto, una delle grandi passioni di Castelbajac. Un ambiente che risponde ai desideri e al talento di entrambi i creativi.

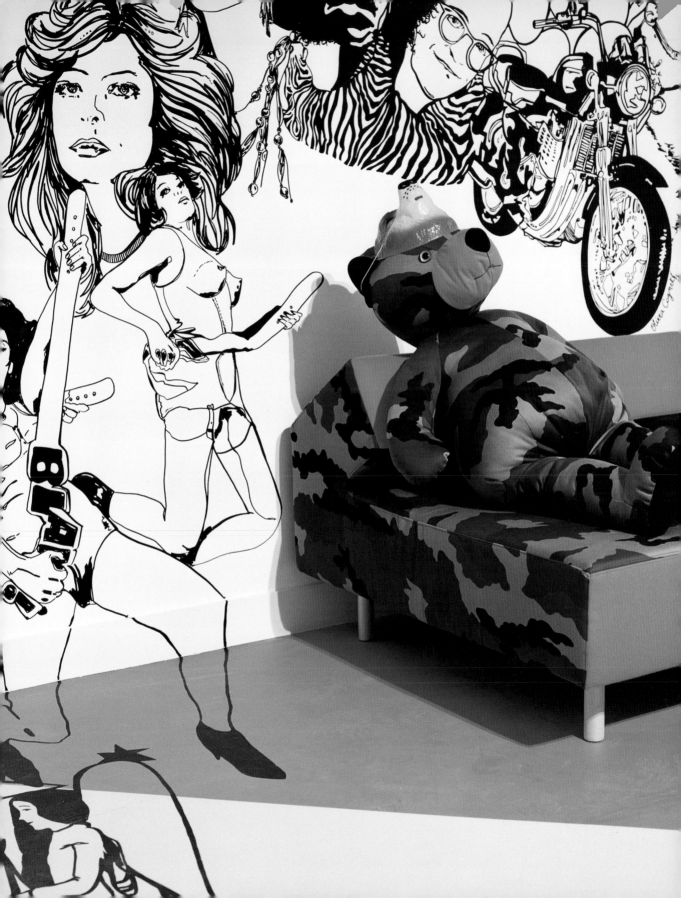

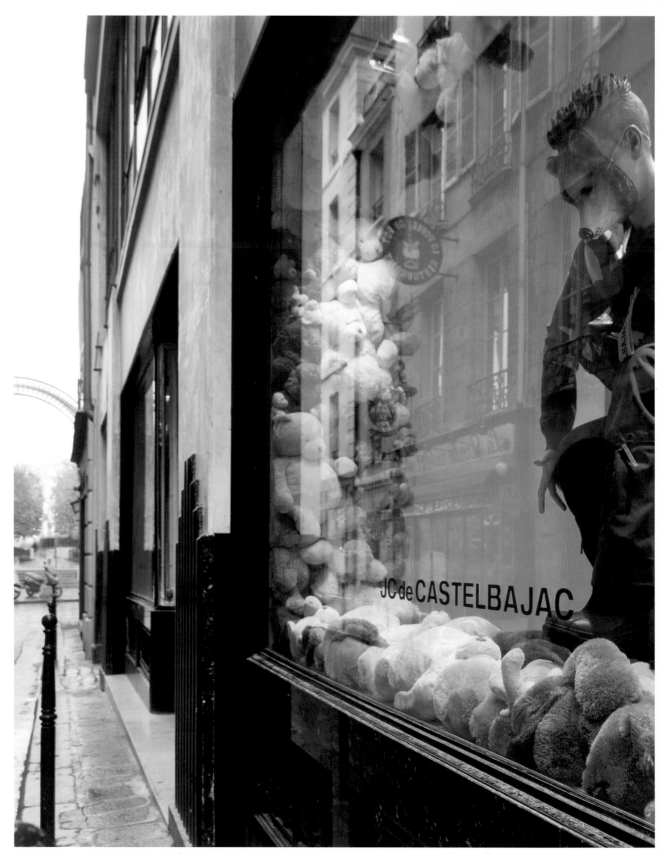

Christian Ghion

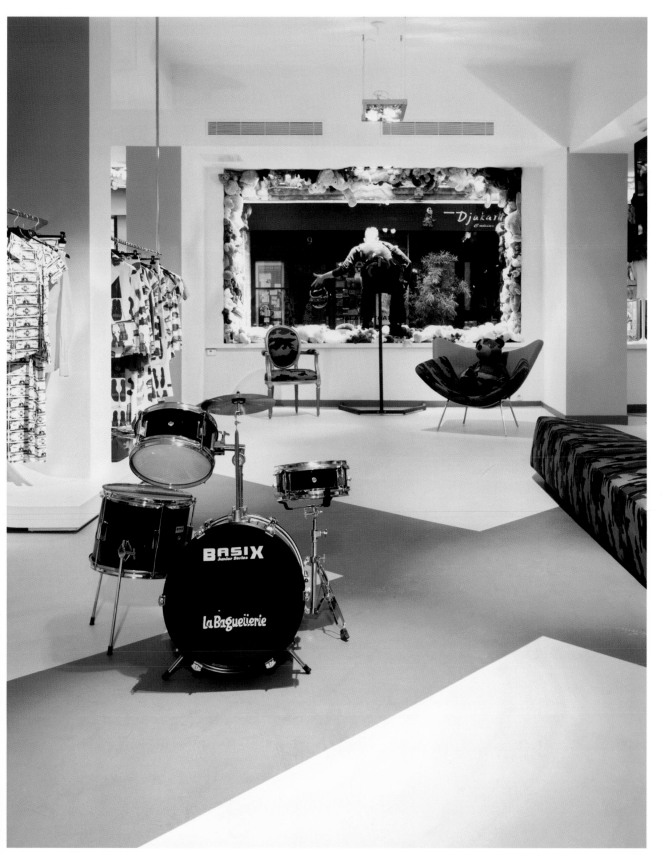

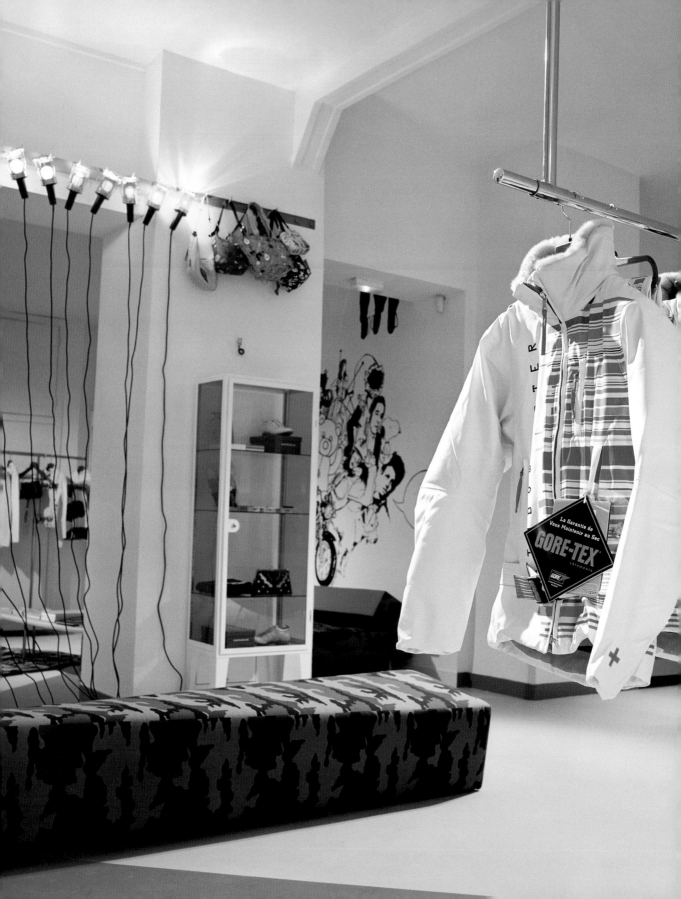

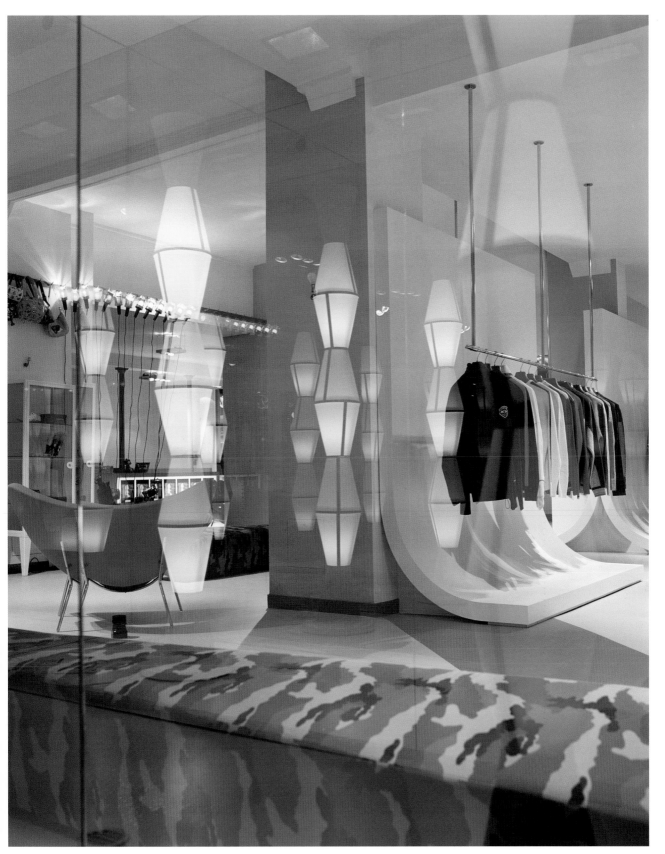

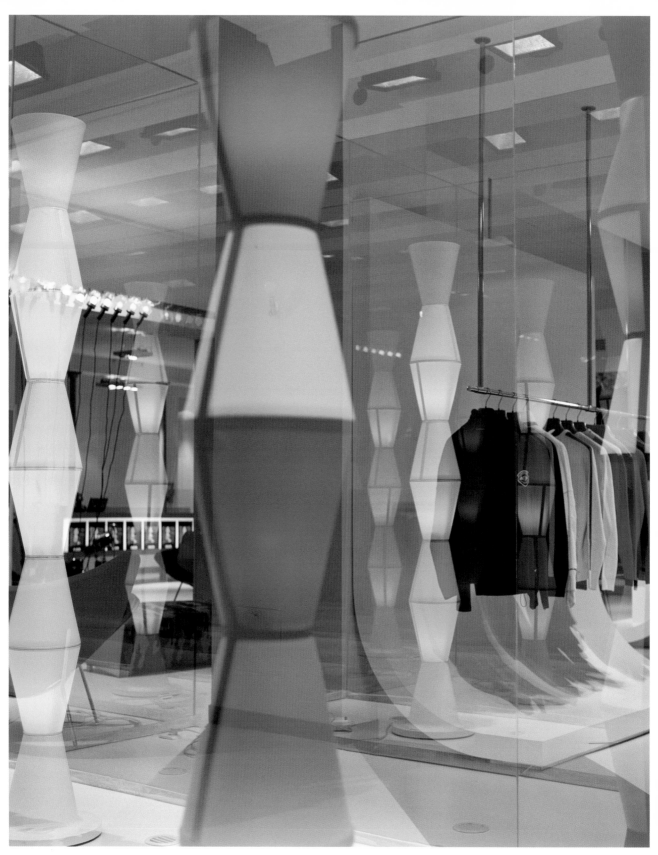

Christian Ghion

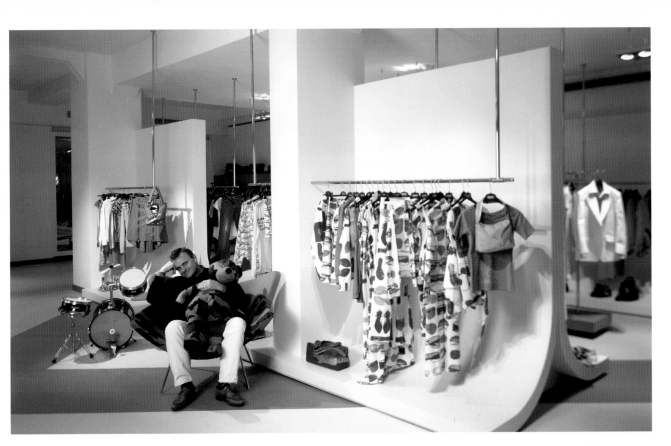

Chantal Thomass Shop

Year: 2004
Photographs: © Roger Casas

The challenge for this project was to capture the spirit of Chantal Thomass and to represent it in a modern and innovative way in her shop. Luxury and seduction, two of the elements that characterize her lingerie, are reflected in the infinite shades of pink and the cushions. The winding, baroque forms of the furnishings also add to the feminine character of the interior.

Bei der Planung dieses Projektes galt es, den Geist von Chantal Thomass einzufangen und ihn auf moderne und innovative Weise in ihrem Geschäft darzustellen. Luxus und Verführung, zwei Merkmale ihrer Dessous, spiegeln sich in den unendlichen Rosaschattierungen und den Polstern wider. Die kurvigen, barocken Formen des Mobiliars tragen zusätzlich zu dem femininen Charakter des Interieurs bei.

Le défi de ce projet est de capter l'esprit de Chantal Thomass et de le transposer d'une façon moderne et innovatrice dans sa boutique. Luxe et séduction, deux des éléments caractéristiques de sa lingerie, se reflètent dans les tonalités infinies de rose et dans les matelassés. Les formes sinueuses du style baroque du mobilier confèrent un caractère extrêmement féminin à la boutique.

El reto de este proyecto era captar el espíritu de Chantal Thomass y plasmarlo de una forma moderna e innovadora en su tienda. Lujo y seducción, dos de los elementos que caracterizan su lencería, se reflejan en las infinitas tonalidades de rosa y en los acolchados. Las formas sinuosas del estilo barroco del mobiliario otorgan un carácter si cabe más femenino a la tienda.

La sfida di questo progetto era captare lo spirito di Chantal Thomass e plasmarlo in forma moderna e innovativa nella sua boutique. Lusso e seduzione, due degli elementi che caratterizzano la sua biancheria intima, si riflettono nelle infinite tonalità di rosa e nelle imbottiture. Le forme sinuose dello stile barocco dell'arredo infondono un carattere, se possibile, ancora più femminile al negozio.

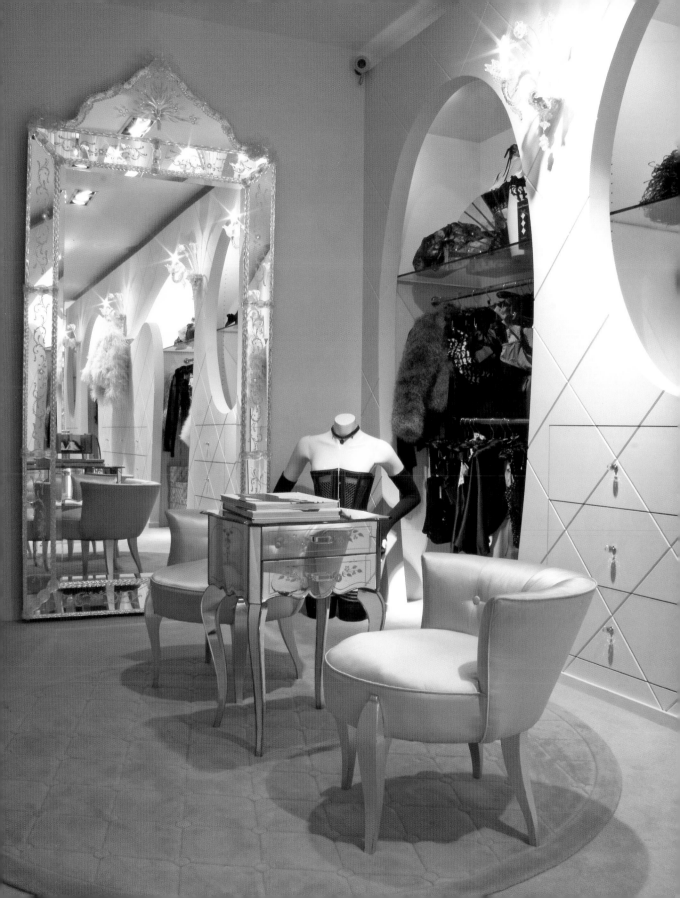

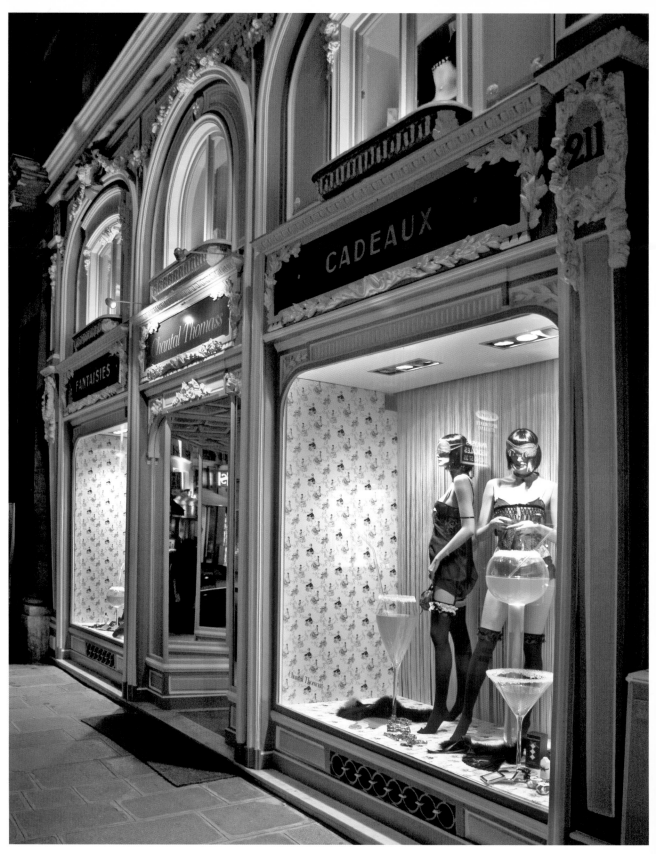

Christian Ghion

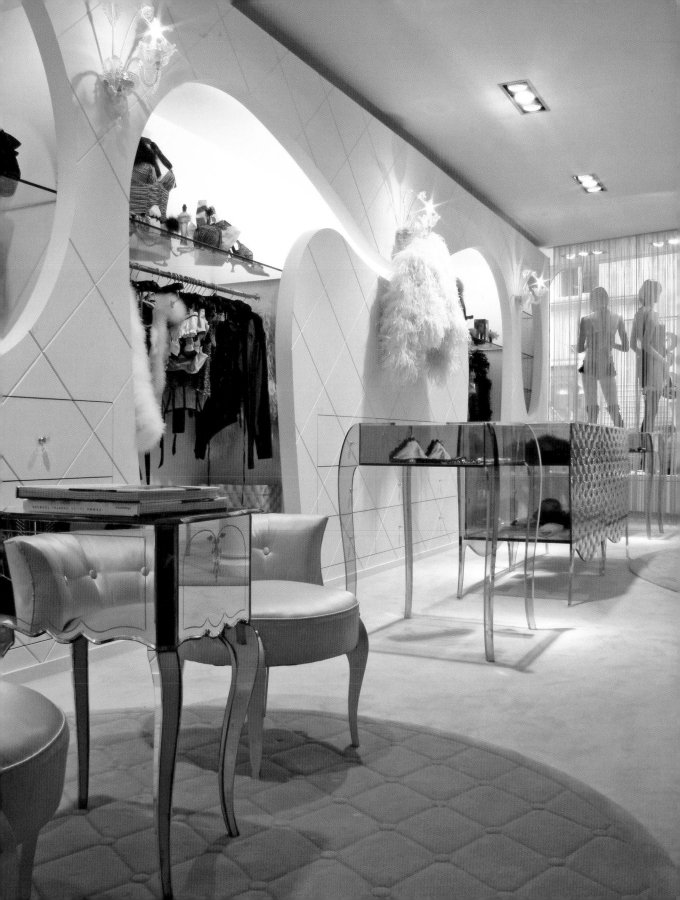

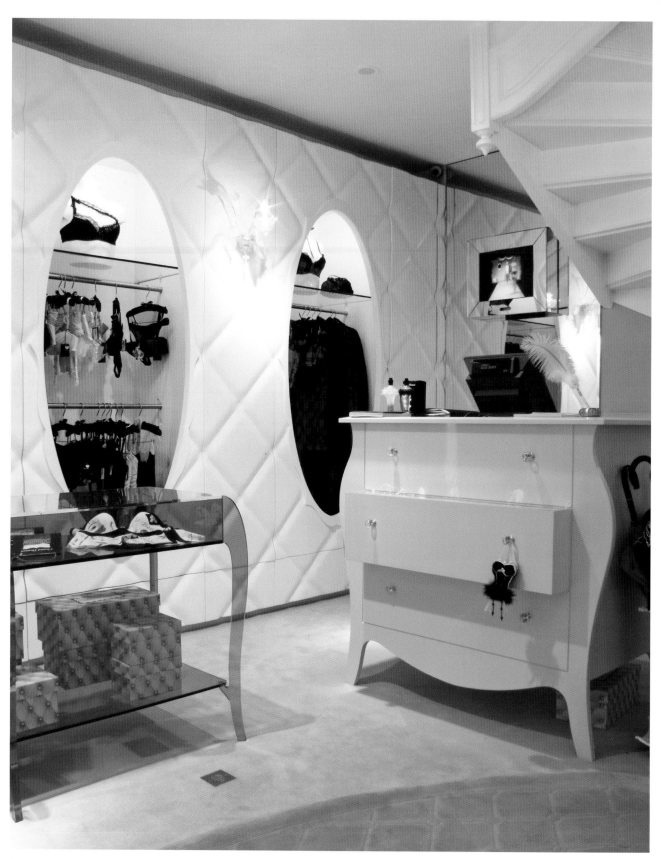

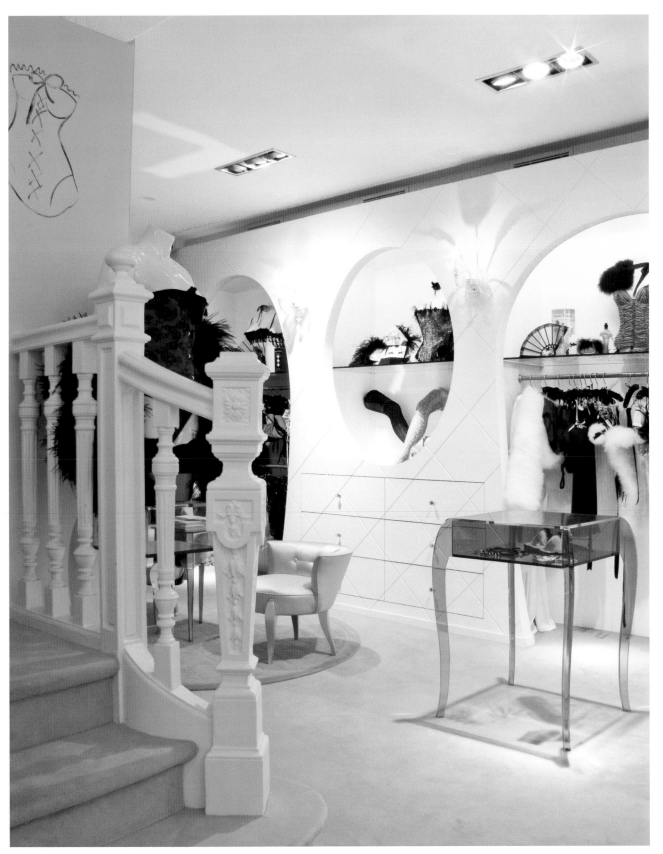

Gaya Restaurant

Year: 2005
Photographs: © Jacques Gavard

Fish is the specialty of this restaurant, which is why the designer chose blue as the dominant color. Add to this aquamarine green to represent the nuances of the ocean. One of the walls is made entirely of stainless steel, giving the room the depth and width of a mirror. The original Corian tables are decorated with shapes of seaweed . "Graceful, essential, simple and refined" this is how Christian Ghion describes this restaurant.

Die Spezialität dieses Restaurants ist Fisch, weswegen der Designer Blau als vorherrschende Farbe auswählte. Dazu kommt ein aquamarinfarbiges Grün, das die Nuancen des Ozeans darstellt. Eine der Wände besteht komplett aus Edelstahl und verleiht dem Raum damit die Tiefe und Weite eines Spiegels. Die originellen Tische aus Corian zieren Muster von Meeresalgen. „Elegant, essenziell, einfach und edel" ist dieses Restaurant in den Worten von Christian Ghion.

Le poisson étant la spécialité de ce restaurant, le designer a choisi le bleu comme couleur prédominante. Il lui a rajouté des touches de vert aigue-marine qui imitent la couleur de l'océan. Un des murs est entièrement réalisé en acier inoxydable, ce qui apporte la sensation de profondeur et l'amplitude d'un miroir. Les tables originales, réalisées en Corian, sont décorées de formes d'algues marines. « Elégant, substantiel, simple et raffiné » : telle est la vision de Christian Ghion de ce restaurant.

El pescado es la especialidad de este restaurante, motivo por el que el diseñador escogió el azul como color predominante. A éste se le añadieron toques de verde aguamarina que plasmaran el color del océano. Una de las paredes es totalmente de acero inoxidable, lo que aporta la sensación de profundidad y amplitud de un espejo. Las originales mesas, realizadas en Corian, están decoradas con formas de algas marinas. "Elegante, esencial, simple y refinado", así es como ve Christian Ghion este restaurante.

Il pesce è la specialità di questo ristorante, motivo per cui il designer ha scelto il blu come colore predominante. A questo si aggiungono tocchi di verde acquamarina, che rappresenta il colore dell'oceano. Una delle pareti è completamente realizzata in acciaio inox, in modo da conferire la sensazione di profondità e ampiezza di uno specchio. Gli originali tavoli, realizzati in Corian, presentano decorazioni a forma d'alga marina. "Elegante, essenziale, semplice e raffinato", ecco come Christian Ghion vede questo ristorante.

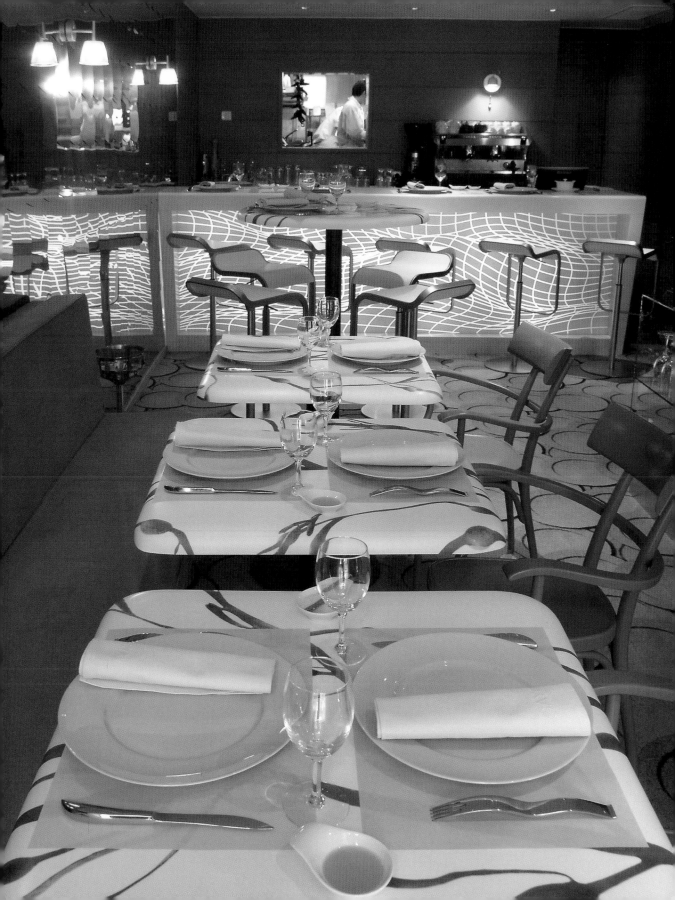

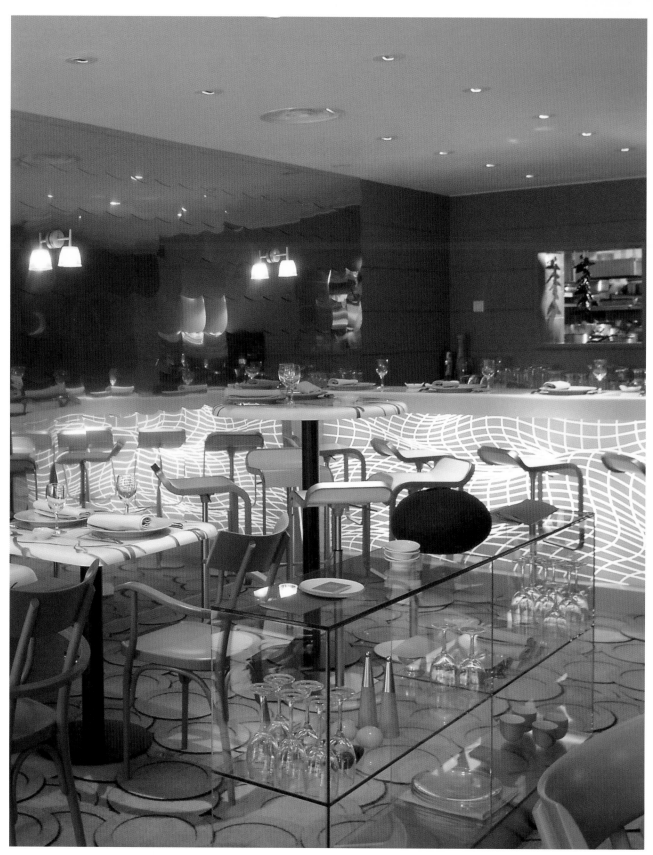

Christian Ghion

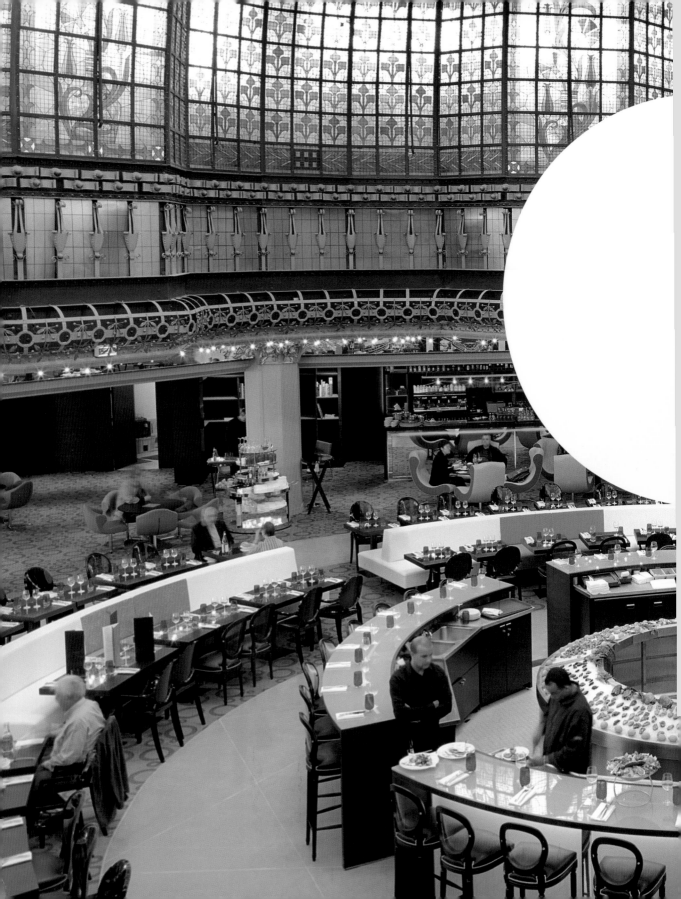

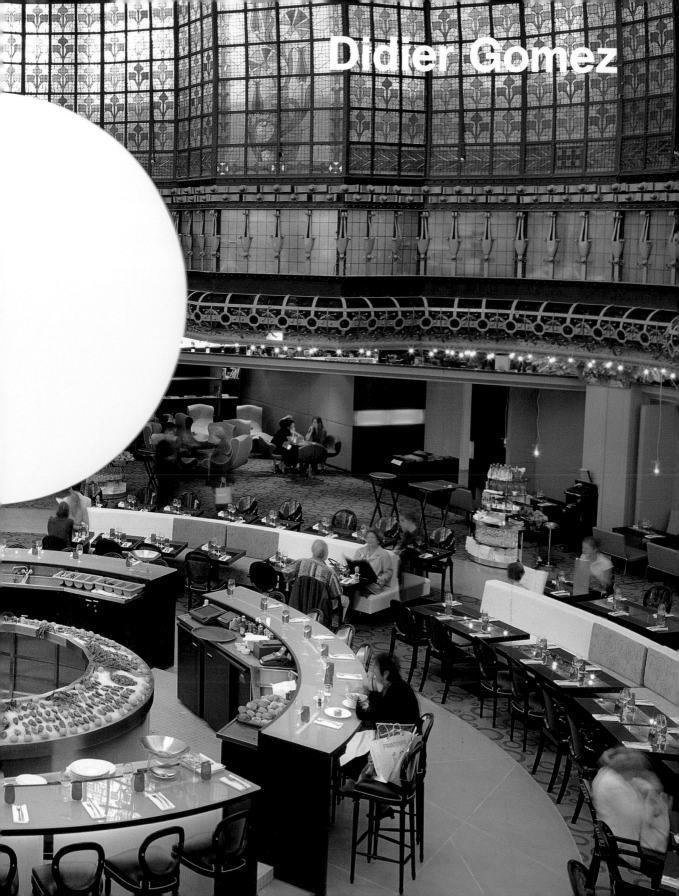

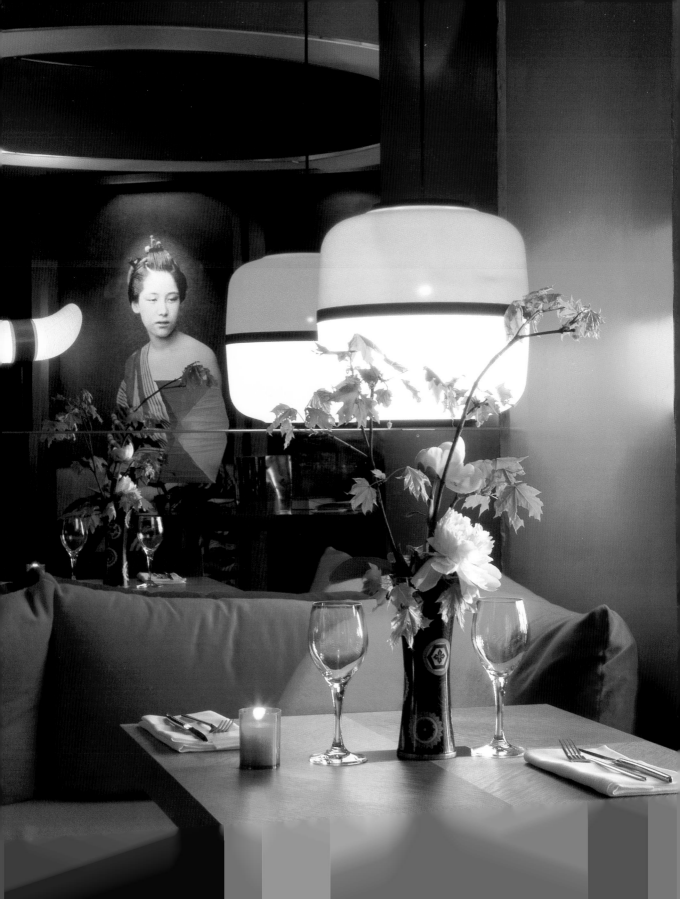

Didier Gomez

80, rue des Archives, 75003 Paris

+33 144 61 04 00

+33 144 61 04 00

www.didiergomez.com

dgidgabriel@yahoo.fr

Didier Gomez

This designer with Andalusian roots founded his design studio in 1978. Several years later, he joined forces with architect Jean-Jacques Ory, but in 2003 he went his own way again and founded two design and interior design studios. With these, he implemented numerous private projects, designed restaurants and boutiques for major fashion brands and furniture collections for prestigious international companies.

Dieser Designer mit andalusischen Wurzeln gründete 1978 sein eigenes Designstudio. Einige Jahre später schloss er sich mit dem Architekten Jean-Jacques Ory zusammen, aber 2003 machte er sich wieder selbständig mit der Gründung von zwei Design- und Innenarchitekturbüros. Mit ihnen verwirklichte er eine Vielzahl von privaten Projekten, entwarf Ladenlokale und Boutiquen für große Modemarken und Möbelkollektionen für angesehene internationale Firmen.

Ce designer aux racines andalouses fonde son studio de design en 1978. Des années plus tard, il décide de s'associer avec l'architecte Jean-Jacques Ory. Mais en 2003, il reprend son envol et crée ses studios de design et d'intérieur où il réalise de nombreux projets privés, conçoit des magasins et boutiques pour les grands noms du monde de la mode ainsi que des collections de mobilier pour de prestigieuses sociétés internationales.

Este diseñador de raíces andaluzas fundó su estudio de diseño en 1978. Años más tarde decidió asociarse con el arquitecto Jean-Jacques Ory, pero en el 2003 se independizó de nuevo y creó dos estudios de diseño e interiorismo con los que ha realizado numerosos proyectos privados, ha diseñado tiendas y boutiques para grandes nombres del mundo de la moda, y también colecciones de mobiliario para prestigiosas firmas de ámbito internacional.

Designer dalle radici andaluse, Didier Gomez fonda il suo studio di design nel 1978. Associatosi alcuni anni più tardi con l'architetto Jean-Jacques Ory, si rimette in proprio nel 2003, dando vita a due studi di design e progettazione d'interni con cui ha realizzato numerosi progetti privati nonché negozi e boutique per grandi nomi del mondo della moda e collezioni d'arredi per prestigiosi marchi internazionali.

1953
Born in Mougins, France

1978
Presents his first collections of furniture

1985
Founds his own interior design studio

1994-2002
He associates with the architect Jean-Jacques Ory

2003
Independent again creates two new studios: Didier Gomez Design and Didier Gomez Interior Design.

Interview | Didier Gomez

Which do you consider the most important work of your career? I don't consider any of my works as the most important. I have the same attitude toward, and give the same attention, to all my projects.

In what ways does Paris inspire your work? Paris can be an inspiration. For my next restaurant, in the Printemps Haussmann department store, Paris has inspired me unconsciously. Generally, I like the confrontation between modernity and memories from the past.

Does a typical Paris style exist, and if so, how does it show in your work? Paris style is something elegant, chic and subtle. I try to stay in within these lines, but I also like modernity, insolence, incoherence, and the mix with other cultures. The Parisian style includes the influences from Africa, Asia, etc.

How do you imagine Paris in the future? I imagine a big modern revolution in Paris, confronting old with new and accepting other cultures and heritages.

Welches Werk halten Sie für das wichtigste Ihrer Karriere? Ich halte keins meiner Werke für das wichtigste. Ich habe die gleiche Einstellung allen meinen Projekten gegenüber und widme allen die gleiche Aufmerksamkeit.

Wie inspiriert Paris Ihre Arbeit? Paris kann eine Inspiration sein. Für mein nächstes Restaurant, im Printemps Haussmann, hat mich Paris unbewusst inspiriert. Im Allgemeinen mag ich den Kontrast zwischen Modernität und Erinnerungen aus der Vergangenheit.

Gibt es einen typischen Pariser Stil, und wenn ja, wie macht dieser sich in Ihrer Arbeit bemerkbar? Der Pariser Stil ist etwas Elegantes, Schickes und Subtiles. Ich versuche, mich an diese Prinzipien zu halten, aber ich mag auch Modernität, Frechheit, Zusammenhanglosigkeit und die Vermischung mit anderen Kulturen. Der Pariser Stil ist auch beeinflusst von Afrika, Asien etc.

Wie stellen Sie sich Paris in der Zukunft vor? Ich stelle mir eine große moderne Revolution in Paris vor, die das Alte dem Neuen gegenüberstellt und andere Kulturen akzeptiert.

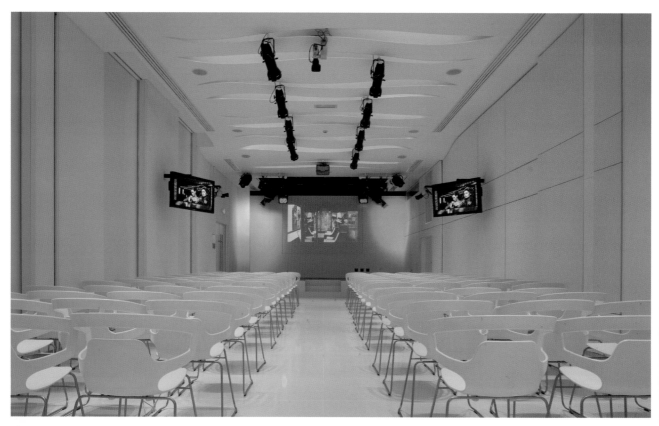

Quelle est à vos yeux l'œuvre la plus importante de votre carrière ? Je ne considère aucune de mes œuvres comme étant la plus importante. J'ai la même attitude envers tous mes projets et leur accorde la même attention.

Dans quelle mesure votre œuvre artistique s'inspire-t-elle de Paris ? Paris peut être une source d'inspiration. Pour mon prochain restaurant, au Printemps Haussmann, Paris m'a inspiré de manière inconsciente. En général, j'aime la confrontation entre modernité et mémoires du passé.

Existe-t-il un style typiquement parisien, et si oui, comment se manifeste-t-il dans votre œuvre ? Le style parisien, c'est quelque chose d'élégant, chic et subtil. J'essaie de rester dans ces lignes, mais j'aime aussi la modernité, l'insolence, l'incohérence et le mélange des cultures. Le style parisien englobe les influences venant d'Afrique, d'Asie, etc.

Comment imaginez-vous le Paris du futur ? J'imagine une grande révolution moderne à Paris, confrontant l'ancien et le nouveau et acceptant d'autres cultures et héritages.

¿Cuál cree que es el trabajo más importante de su carrera? No considero ninguno de mis trabajos como el más importante. Siempre tengo la misma actitud y presto la misma atención a todos mis proyectos.

¿Cómo le inspira París en su trabajo? París puede servir de inspiración. Para mi próximo restaurante, en unos grandes almacenes de Printemps Haussmann, París me ha inspirado inconscientemente. Por lo general, me gusta la confrontación entre la modernidad y los recuerdos del pasado.

¿Existe un estilo típico de París? Y si es así, ¿cómo se muestra éste en su obra? El estilo de París es elegante, chic y sutil. Procuro quedarme dentro de estos parámetros, pero también me gusta lo moderno, lo insolente, lo incoherente y la mezcla con otras culturas. El estilo parisino abarca influencias procedentes de África, Asia, etc.

¿Cómo se imagina París en un futuro? Me imagino una gran revolución moderna en París, que confronte lo antiguo con lo nuevo y acepte otras culturas y herencias.

Quale ritiene sia l'opera più importante della sua carriera? Non considero nessuno dei miei lavori come il più importante. Ho la stessa considerazione e dedico la stessa attenzione a tutti i miei progetti.

In che modo Parigi ispira il suo lavoro? Parigi può essere un'ispirazione. Per il mio prossimo ristorante, in un grande magazzino Printemps Haussmann, Parigi mi ha ispirato a livello subliminale. Generalmente, mi piace la contrapposizione tra la modernità e i ricordi del passato.

Esiste un tipico "stile parigino"? Se sì, come si manifesta nel suo lavoro? Lo stile parigino è elegante, chic e impercettibile. Cerco di seguire queste linee ma mi piacciono anche la modernità, l'insolenza, l'incoerenza e il mix con altre culture. Lo stile parigino subisce positivamente anche l'influsso di Africa, Asia, ecc.

Come immagina Parigi nel futuro? Immagino una grande rivoluzione moderna a Parigi, che contrapponga il vecchio e il nuovo e implichi l'accettazione di altri patrimoni culturali.

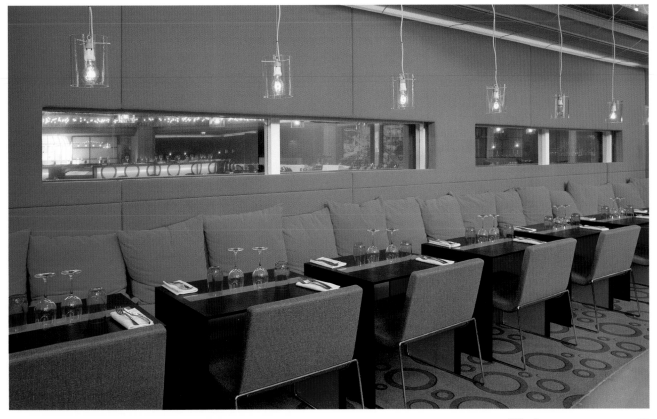

Brasserie Printemps

Year: 2006
Photographs: © Xavier Béjot

This restaurant is situated on the sixth floor of Printemps Haussmann, just below the spectacular dome that crowns this historic building. The color range of its glass is repeated in the design of the space, filled with striking colors that delineate the different sections of the restaurant. The luxurious and original interior of the room combines a classical structure with a modern design.

Dieses Restaurant befindet sich im sechsten Stockwerk des Printemps Haussmann unter der spektakulären Kuppel, welche dieses historische Gebäude krönt. Die Farbpalette des Glases wiederholt sich im Design des Raums, dessen auffällige Farben die verschiedenen Zonen des Restaurants abgrenzen. Der luxuriös und originell ausgestattete Raum verbindet eine klassische Struktur mit einem modernen Design.

Ce restaurant est situé au sixième étage du Printemps Haussmann, juste en dessous de la coupole spectaculaire qui couronne cet édifice historique. La gamme chromatique de la grande verrière supérieure se répète dans le design de l'espace, doté de couleurs criardes qui délimitent les différentes zones du restaurant. Le luxe revisité est visible dans cet espace au design original qui allie la modernité à une structure classique.

Este restaurante se sitúa en la sexta planta del Printemps Haussmann, justo bajo la espectacular cúpula que corona este edificio histórico. La gama cromática de la gran cristalera superior se repite en el diseño del espacio, dotado de llamativos colores que delimitan las distintas zonas del restaurante. La reinvención del lujo se hace visible en este espacio de original diseño que aúna lo moderno con una estructura clásica.

Questo ristorante si trova al sesto piano del Printemps Haussmann, proprio sotto la spettacolare cupola che corona questo edificio storico. La gamma cromatica della grande vetrata superiore è replicata all'interno dal design dell'ambiente, caratterizzato da colori appariscenti che delimitano le diverse zone del ristorante. La reinvenzione del lusso è resa visibile in questo locale dall'originale design, che riunisce la modernità con una struttura classica.

Didier Gomez

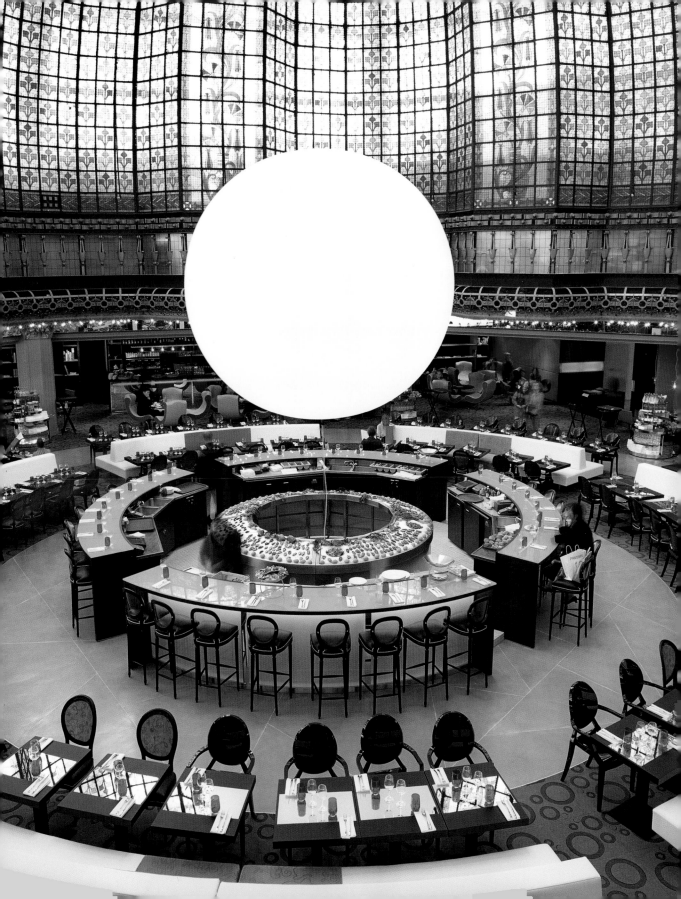

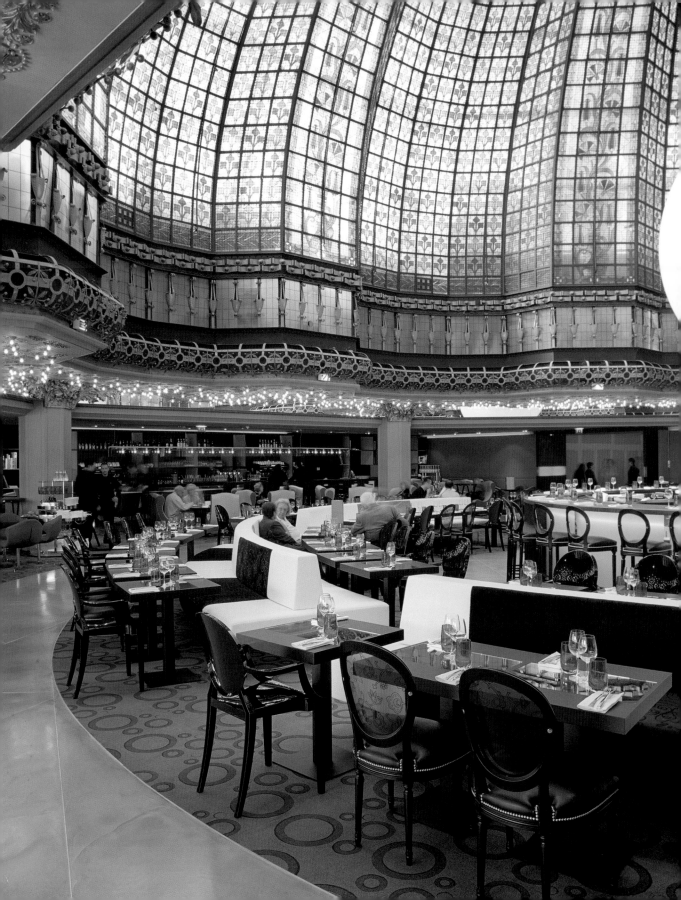

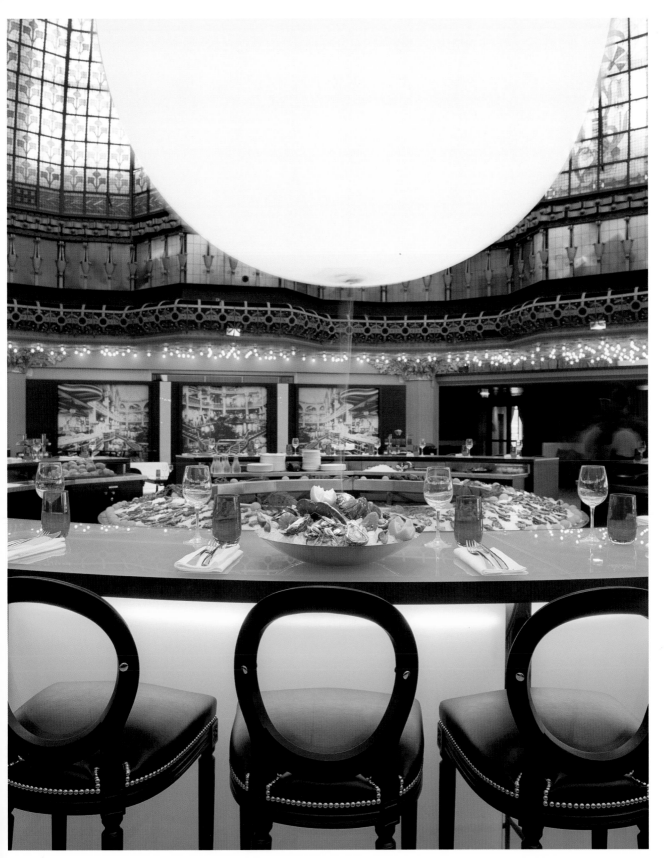

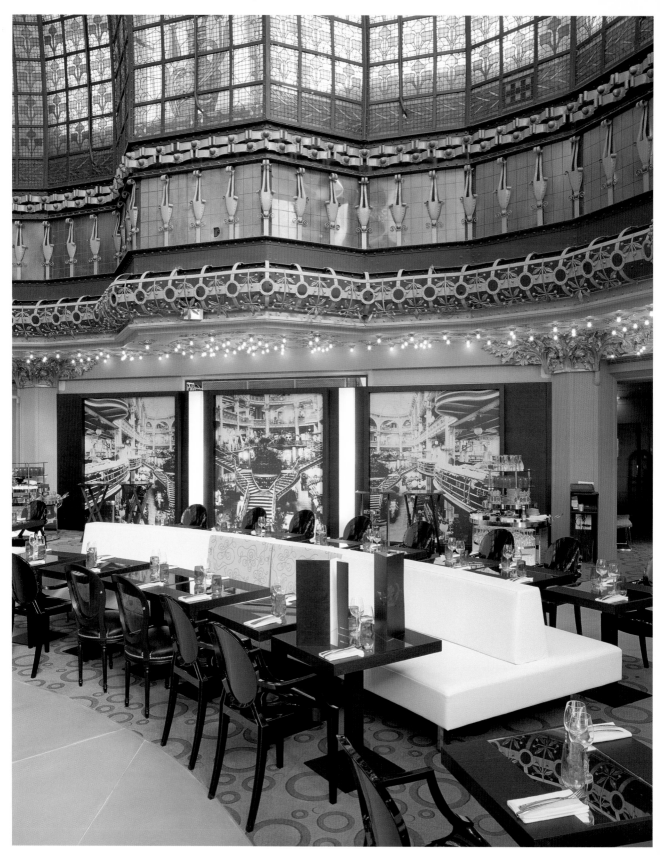

Didier Gomez

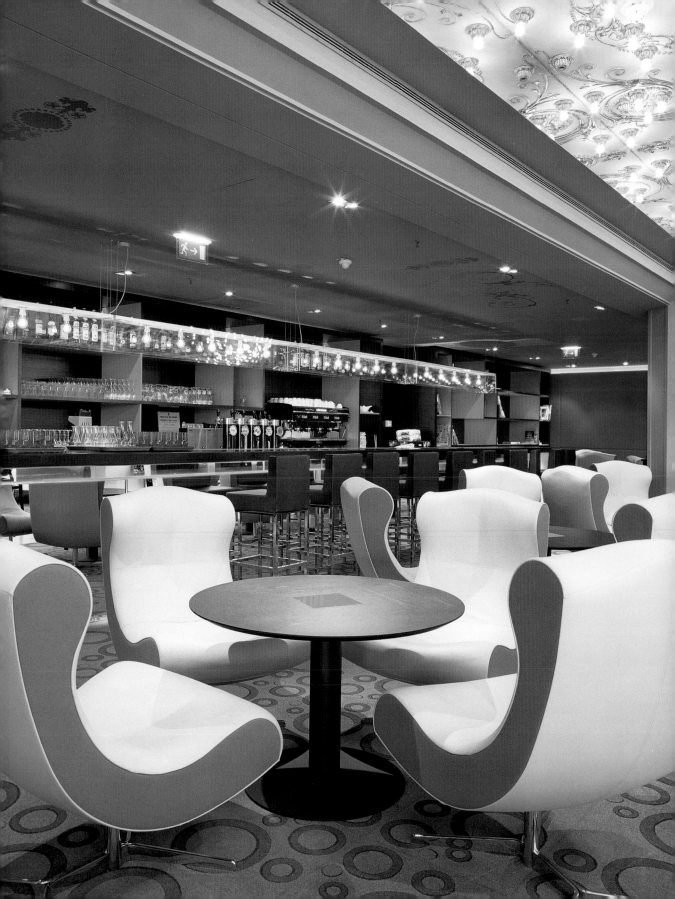

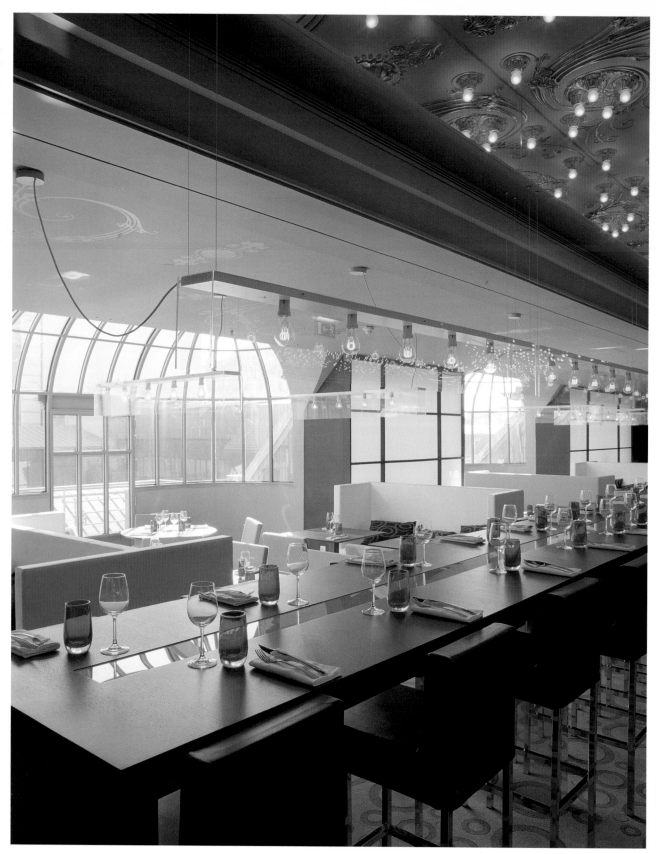

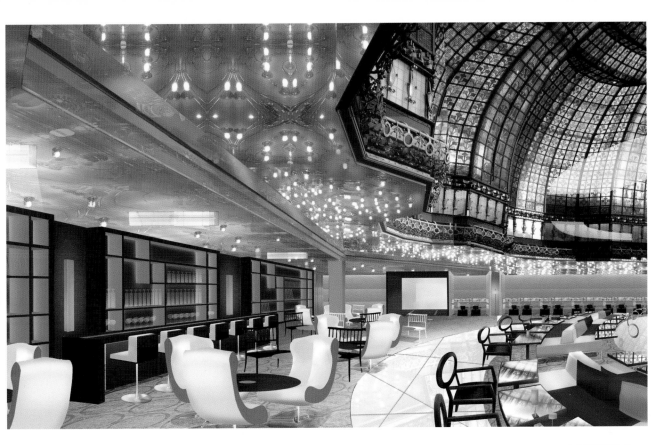

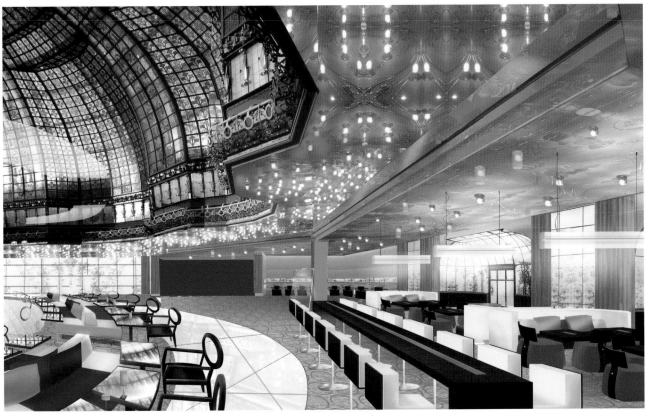

L'Oréal Academy

Year: 2005

Photographs: © Didier Boy de la Tour

Pureness and light are the key ingredients in the design of this 10,800 ft² training facility for hair stylists. Given the ongoing change and dynamism of this profession, Didier Gomez designed a large loft space for the practice area and mobile furnishings in the classrooms, making the facility adaptable to future changes and needs. The auditorium is a multi-purpose room, whose colors change with the chosen lights (blue, green or red) and which allows the use of technology as a teaching tool.

Reinheit und Helligkeit sind die Schlüsselmerkmale des Designs dieses 1.000 m² großen Raums, welcher der Berufsausbildung von Friseuren dient. Da dieser Beruf durch permanenten Wandel und Dynamik gekennzeichnet ist, entwarf Didier Gomez ein weitläufiges Loft für den Bereich, der für die praktischen Übungen vorgesehen ist, und mobiles Mobiliar in den Lehrräumen. So können die Räumlichkeiten den zukünftigen Änderungen und Bedürfnissen angepasst werden. Der Hörsaal ist ein Mehrzweckraum, der sich je nach dem ausgewählten Licht (Blau, Grün, Rot) farblich verwandelt und den Gebrauch von Technologie als pädagogisches Lehrmittel ermöglicht.

La pureté et la luminosité sont les clés du nouveau design de ces 1.000 m² dédiés à la formation de professionnels de la coiffure. Vu la constante évolution et le dynamisme de la profession, Didier Gomez a suggéré un vaste espace type loft pour la zone de formation et un mobilier amovible dans les salles, adaptable à des changements et besoins futurs. L'auditorium est une salle polyvalente qui permet de transformer ses couleurs en fonction de la lumière choisie (bleue, verte ou rouge), utilisant des moyens technologiques en guise d'outils pédagogiques.

La pureza y la luminosidad son las claves del nuevo diseño de estos 1.000 m² dedicados a la formación de profesionales de la peluquería. Basándose en la constante evolución y dinamismo de la profesión, Didier Gomez propuso un amplio espacio tipo loft para la zona de prácticas y un mobiliario móvil en las aulas, adaptable a futuros cambios y necesidades. El auditorio es una sala polivalente que permite transformar sus colores según la luz escogida (azul, verde o roja) y que utiliza medios tecnológicos como herramienta pedagógica.

La purezza e la luminosità sono la chiave della nuova veste in cui si propone la superficie di 1.000 m² destinata alla formazione di professionisti dell'acconciatura. Data la costante evoluzione e il dinamismo della professione, Didier Gomez ha proposto un ampio spazio, simile ad un loft, per la zona d'esercitazioni pratiche, e un arredamento mobile nelle aule. Gli ambienti sono stati creati in funzione della loro adattabilità futura a modifiche e necessità diverse. L'auditorio è una sala polivalente i cui colori possono trasformarsi secondo la luce scelta (blu, verde o rossa), dotata di accorgimenti per l'utilizzo pedagogico di mezzi tecnologici.

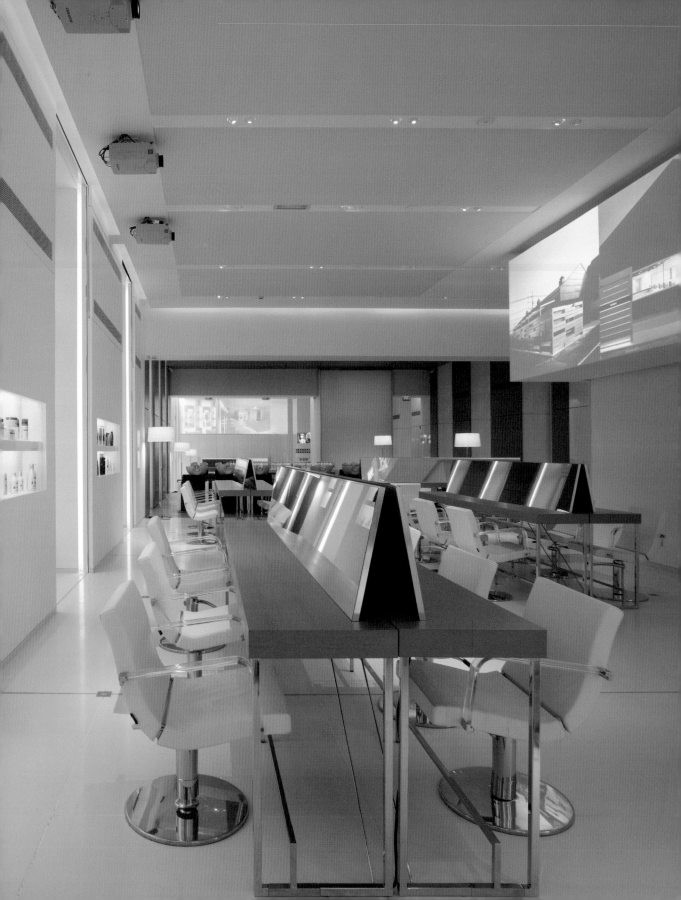

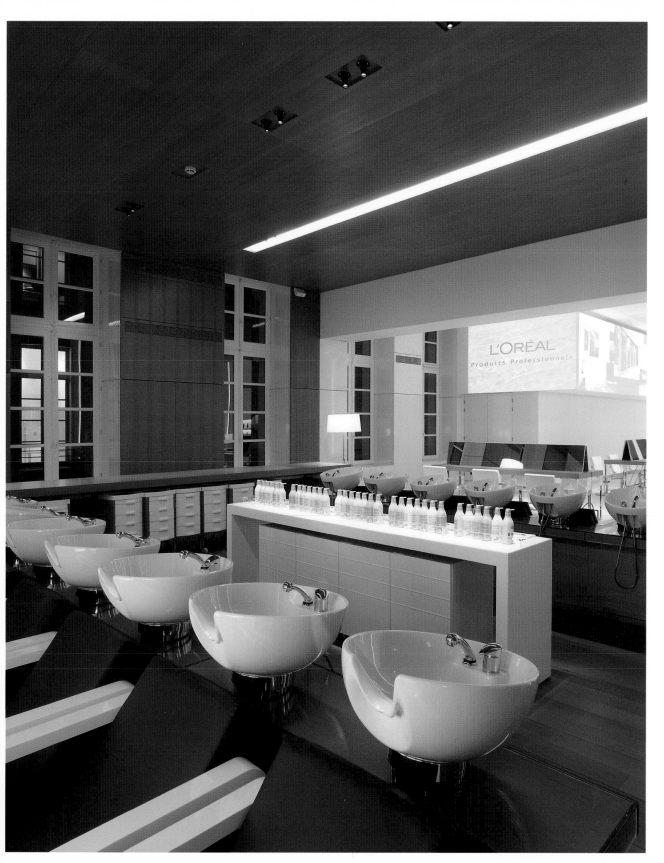

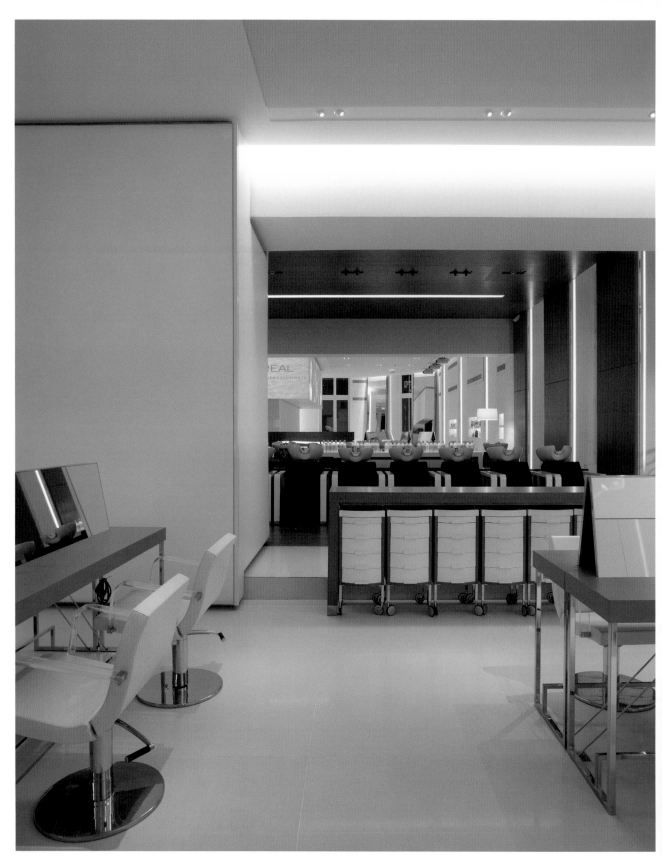

Didier Gomez

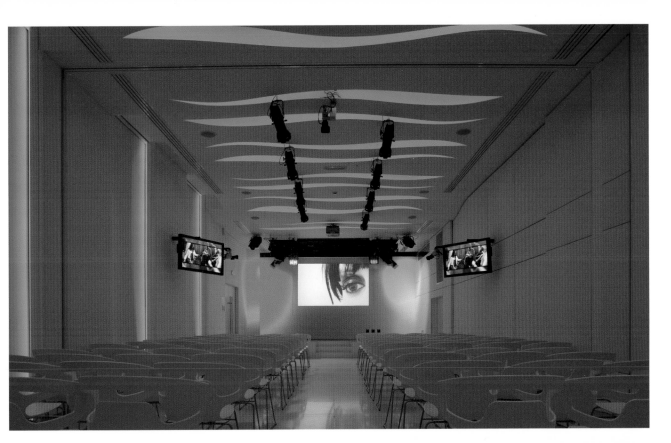

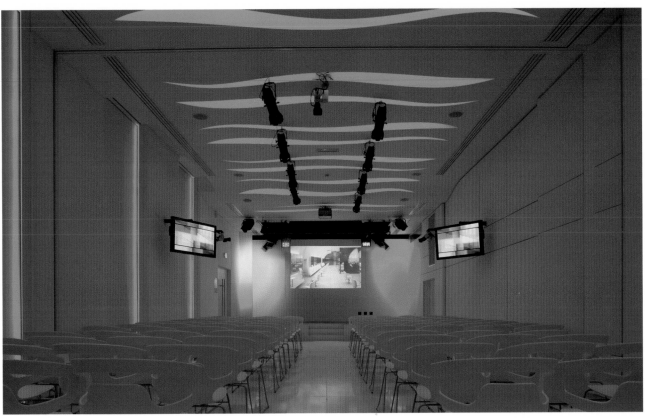

Le Mood

Year: 2006

Photographs: © Xavier Bejot

Situated right in the heart of the Champs-Élysées, the restaurant-bar-lounge Le Mood is a place where Asia and the West come together, designed with a mysterious oriental style. Each of the three levels is decorated differently, allowing patrons to switch visual environments several times within a single restaurant. According to Didier Gomez, it is an "illusory vision of Asia" inspired by the movie "In the Mood for Love".

Im Herzen der Champs-Élysées gelegen, ist das Restaurant-Bar-Lounge Le Mood ein Treffpunkt von Asien und dem Westen, gestaltet in einem orientalischen, geheimnisvoll anmutenden Stil. Jede der drei Ebenen ist anders dekoriert; so kann man innerhalb eines einzigen Lokals mehrfach die visuelle Umgebung wechseln. Laut Didier Gomez handelt es sich um eine „trügerische Vision Asiens", inspiriert von dem Film „In the Mood for Love".

Situé en plein cœur des Champs-Élysées, le restaurant-bar-lounge Le Mood est un lieu ou s'unissent l'Asie et l'Occident, conçu dans un style oriental revisité et mystérieux. Chacun de ses trois niveaux est décoré différemment pour offrir la possibilité de varier l'environnement visuel au sein d'un même espace. D'après Didier Gomez lui-même, il s'agit d'une « vision illusoire de l'Asie » inspirée du film « In the Mood for Love ».

Situado en pleno corazón de los Campos Elíseos, el restaurante-bar-lounge Le Mood es un lugar de unión entre Asia y Occidente, diseñado con un estilo oriental reinventado y misterioso. Cada uno de sus tres niveles está decorado de forma distinta, para ofrecer la posibilidad de ir variando el entorno visual dentro de un mismo espacio. Según el propio Didier Gomez, se trata de una "visión ilusoria de Asia" inspirada en la película *Deseando amar*.

Situato nel cuore degli Champs-Élysées, il ristorante-bar-lounge Le Mood è un luogo d'unione tra Asia e Occidente, progettato con uno stile orientale reinventato e misterioso. Ognuno dei suoi tre livelli è decorato in modo diverso, per offrire la possibilità di variare il contesto visivo nell'ambito di un unico spazio. Secondo lo stesso Didier Gomez, si tratta di una "visione illusoria dell'Asia", ispirata al film *In the Mood for Love*.

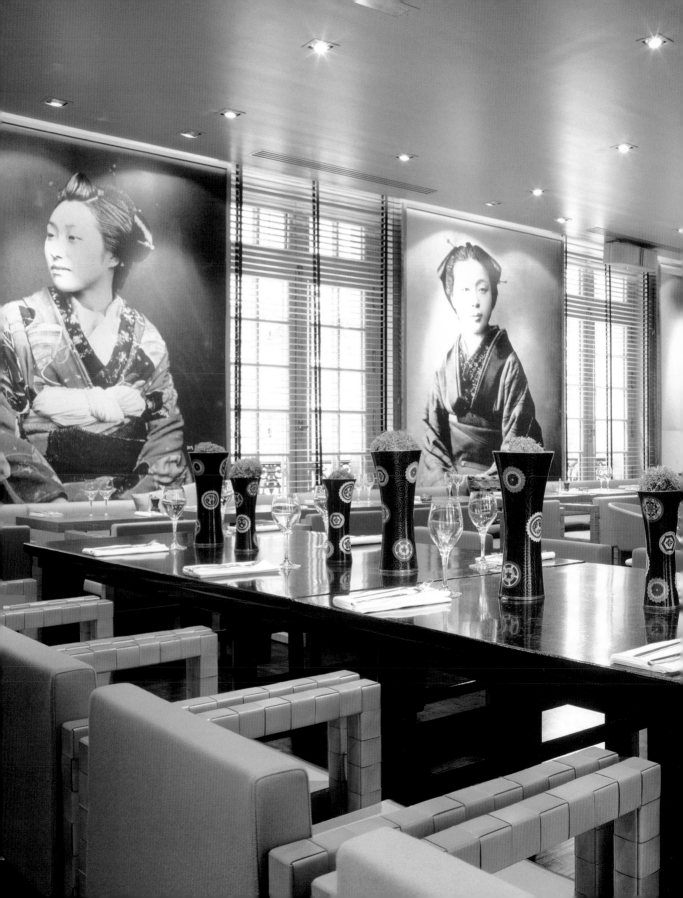

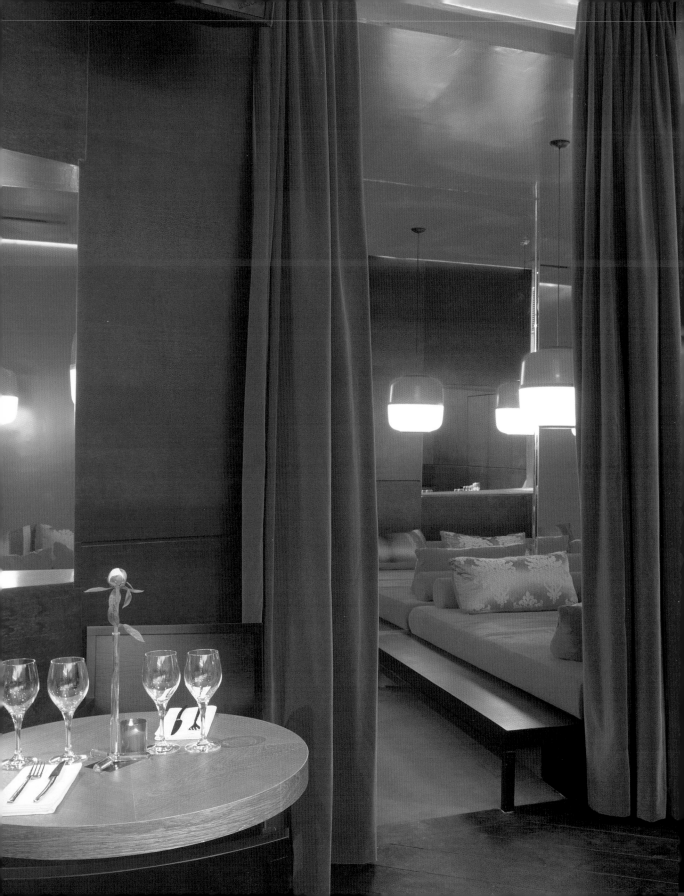

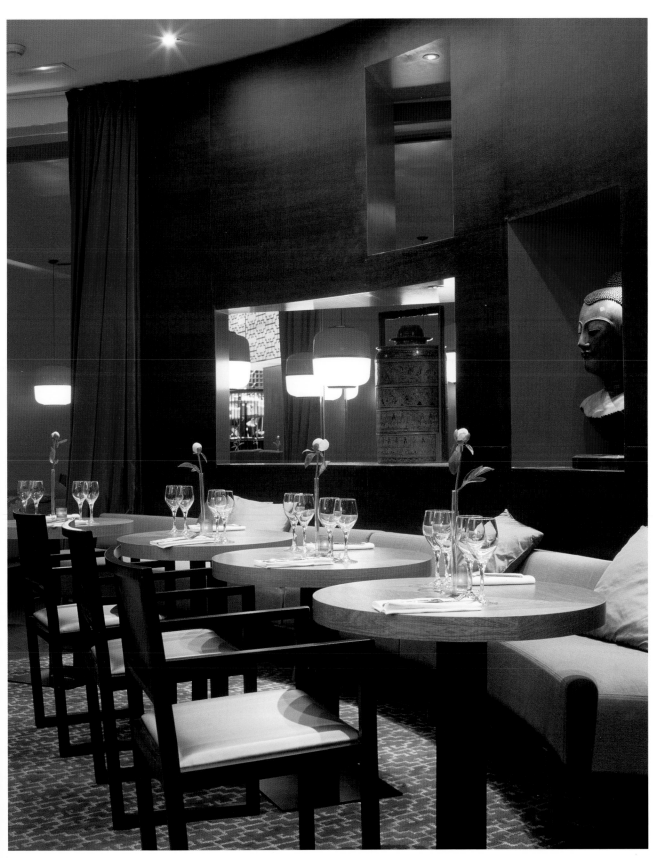

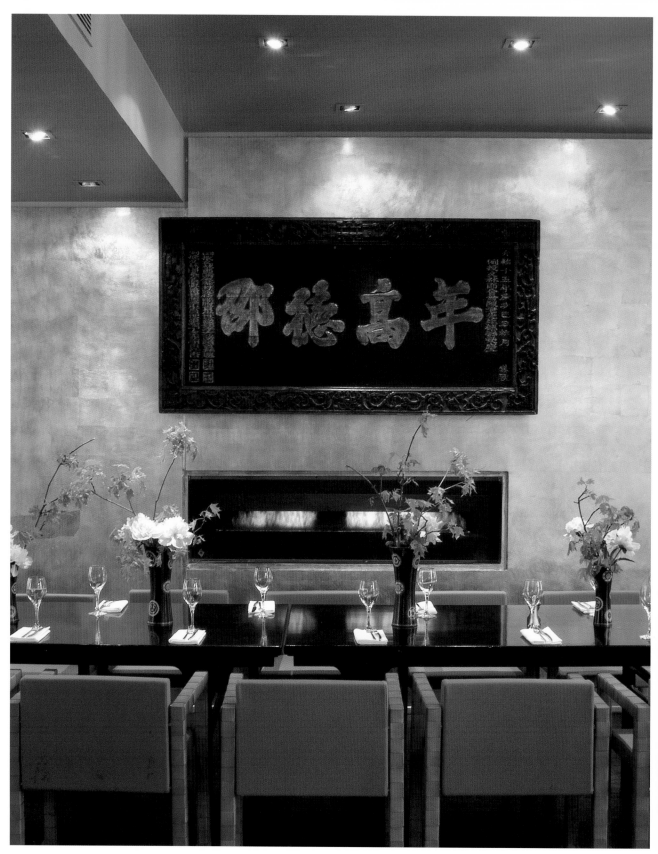

Didier Gomez

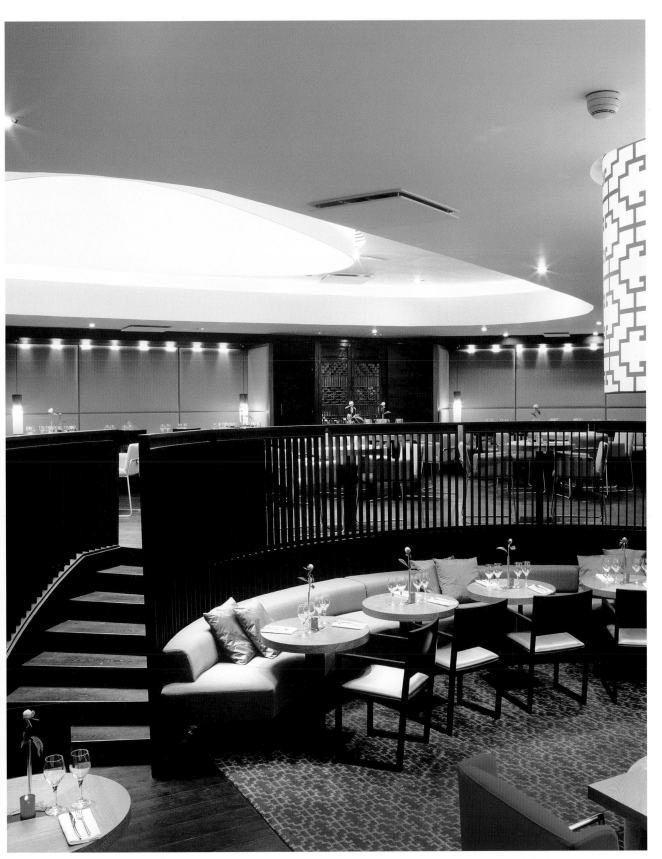

Imaad Rahmouni

Imaad Rahmouni

8, passage de la Bonne Graine, 75017 Paris

+33 140 21 01 05

+33 140 21 01 07

www.imaadrahmouni.com

Imaad Rahmouni

1967
Born in Algiers, Algeria

1990
Degree from the École Polytechnique
d'Architecture et d'Urbanisme (EPAU), Alger

1997-2000
Works for Philippe Starck

2000
Maison Blanche, Paris, France

2002
Maison Rouge, Paris, France
Stand Renault, Madrid, Lisbon and Mexico
Deli's Café, Paris, France

2003
La Suite, Paris, France

2005-2006
Scenography exhibition John Lennon cité de la
musique Paris, France

Born in Algiers, Imaad Rahmouni is one of the most popular interior designers in the French capital and designed numerous well-known bars and restaurants in Paris. His neo-modernist style defines all of his work, such as the restaurant Maison Rouge in the popular Marais district, La Suite or the Pink Paradise club. Today, he works between Paris and Marrakesh, participating in various projects.

Imaad Rahmouni, geboren in Algier, ist einer der beliebtesten Innenarchitekten der französischen Hauptstadt und gestaltete zahlreiche Pariser Bars und bekannte Restaurants. Sein neo-moderner Stil prägt alle seine Werke, wie das Restaurant Maison Rouge im beliebten Stadtviertel Marais, La Suite oder der Club Pink Paradise. Zurzeit arbeitet er zwischen Paris und Marrakesch an verschiedenen Projekten.

Né à Alger, Imaad Rahmouni est un des designers d'intérieur les plus populaires de la capitale française et l'artisan de nombreux bars et restaurants très connus de la ville. Le style néo moderne de sa société imprègne toutes ses créations, comme le restaurant Maison Rouge dans le quartier très couru du Marais, la Suite ou le club Pink Paradise. A l'heure actuelle, il travaille entre Paris et Marrakech où il participe à divers projets.

Nacido en Argel, Imaad Rahmouni es uno de los diseñadores de interiores más populares de la capital francesa y el artífice de numerosos bares y restaurantes muy conocidos de la ciudad. El estilo neomoderno de su firma impregna todas sus creaciones, como el restaurante Maison Rouge en el concurrido barrio de Marais, La Suite o el club Pink Paradise. Actualmente trabaja entre París y Marrakech, donde participa en varios proyectos.

Nato ad Algeri, Imaad Rahmouni è uno dei disegnatori d'interni più popolari della capitale francese e il creatore di numerosi bar e ristoranti molto noti della città. Lo stile neomoderno è la cifra di tutte le sue creazioni, come il ristorante Maison Rouge nel frequentato quartiere del Marais, La Suite o il Club Pink Paradise. Attualmente lavora a vari progetti dividendosi tra Parigi e Marrakech.

Interview | Imaad Rahmouni

Which do you consider the most important work of your career? This is very difficult to answer because, like with my kids, I am fond of each project for something. However, the first one is always different, so it has to be the Maison Blanche in Paris.

In what ways does Paris inspire your work? Of course, Paris is more than an inspiration: it is a spirit. I mean, Paris always moves in a subtle way, which you can't see if you don't love this city.

Does a typical Paris style exist, and if so, how does it show in your work? We can't say that Paris has its own style. Paris gives you power, an "open mind".

How do you imagine Paris in the future? Paris is struggle. You are always fighting to move even the smallest things. Still, I can't imagine Paris as a harum-scarum city.

Welches Werk halten Sie für das wichtigste Ihrer Karriere? Das ist sehr schwer zu sagen, denn, ähnlich wie bei meinen Kindern, mag ich jedes meiner Projekte aus einem bestimmten Grund. Das erste ist allerdings immer etwas Außergewöhnliches, so muss es also das Maison Blanche in Paris sein.

Wie inspiriert Paris Ihre Arbeit? Paris ist natürlich mehr als eine Inspiration: Es ist eine Stimmung. Ich meine, Paris bewegt sich immer auf eine subtile Art und Weise, die man nicht sehen kann, wenn man diese Stadt nicht liebt.

Gibt es einen typischen Pariser Stil, und wenn ja, wie macht dieser sich in Ihrer Arbeit bemerkbar? Man kann nicht sagen, dass Paris seinen eigenen Stil hat. Paris gibt dir Kraft, einen „offenen Geist".

Wie stellen Sie sich Paris in der Zukunft vor? Paris ist anstrengend. Man muss immerzu kämpfen, um auch nur die geringste Sache zu bewegen. Dennoch kann ich mir Paris nach wie vor nicht als ausgeflippte Stadt vorstellen.

Quelle est à vos yeux l'œuvre la plus importante de votre carrière ? Il est difficile de répondre à cette question, car comme pour mes enfants, j'aime chacun de mes projets pour quelque chose. Néanmoins, le premier est toujours insolite, donc ce doit être la Maison Blanche à Paris.

Dans quelle mesure votre œuvre artistique s'inspire-t-elle de Paris ? Il est évident que Paris, c'est plus qu'une source d'inspiration : c'est un esprit. Je veux dire par là que Paris évolue toujours avec subtilité, ce que vous ne verrez pas si vous n'aimez pas la ville.

Existe-t-il un style typiquement parisien, et si oui, comment se manifeste-t-il dans votre œuvre ? On ne peut pas dire que Paris ait son propre style. Paris vous donne de la force, une « ouverture d'esprit ».

Comment imaginez-vous le Paris du futur ? Paris est éreintante. Il faut toujours s'y battre, même pour faire bouger les plus petites choses. Néanmoins, je ne peux pas vraiment pas m'imaginer Paris comme une ville exubérante.

¿Cuál cree que es el trabajo más importante de su carrera? Esto es muy difícil de responder porque, como me ocurre con mis hijos, siento cariño por cada proyecto por algún motivo. Sin embargo, el primero es siempre diferente, así que en ese caso destacaría la Maison Blanche de París.

¿Cómo le inspira París en su trabajo? Naturalmente, París es más que una inspiración: es un espíritu. Con esto quiero decir que París siempre se mueve de un modo sutil, que no puedes apreciar si no amas esta ciudad.

¿Existe un estilo típico de París? Y si es así, ¿cómo se muestra éste en su obra? No se puede decir que París tenga su estilo propio. París te da poder, una "mente abierta".

¿Cómo se imagina París en un futuro? París te reclama mucha energía. Siempre estás luchando para mover incluso las cosas más pequeñas. Aun no me puedo imaginar París como una ciudad frenética.

Quale ritiene sia l'opera più importante della sua carriera? È molto difficile rispondere perché, come con i miei figli, amo ognuno dei miei progetti per qualche ragione particolare. Tuttavia, il primo è sempre speciale, quindi deve essere la Maison Blanche a Parigi.

In che modo Parigi ispira il suo lavoro? Certo, Parigi è più di una ispirazione: è un'atmosfera. Voglio dire che Parigi si evolve sempre in un modo sottile, che non si sa cogliere se non si ama questa città.

Esiste un tipico "stile parigino"? Se sì, come si manifesta nel suo lavoro? Parigi ha uno stile proprio. Parigi ti dà forza, ti apre la mente.

Come immagina Parigi nel futuro? Parigi ti richiede molta energia. È una lotta continua per spostare persino le cose più piccole. Ancora non riesco ad immaginare Parigi come una città frenetica.

La Suite

Year: 2003

Photographs: © Alexandre Tabaste

Pink in all kinds of shading dominates this design from the year 2003. A style with a baroque air and futuristic touches impregnate each of the areas that form this massive 10,000 ft² space. Since the glazed roof can be opened, patrons can enjoy their breakfast, tea or dinner in the open air. The cushioned, "capitonée" walls give the room an extravagant and sophisticated touch.

Rosa in allen Schattierungen dominiert dieses Design aus dem Jahre 2003. Ein barock angehauchter Stil mit futuristischen Akzenten kennzeichnet alle Bereiche des 1.000 m² großen Raums. Da das Glasdach geöffnet werden kann, kann man hier das Frühstück, den Tee oder das Abendessen unter freiem Himmel einnehmen. Die gepolsterten Wände aus *Capitonée* im Loungebereich verleihen dem Raum eine extravagante und raffinierte Note.

Les tons roses prédominent le design de cet espace revisité en 2003. Un style aux allures baroques et touches futuristes imprègne chacune des zones qui forment ce grand espace de 1.000 m². Grâce au toit en verre ouvrant, il est possible de déjeuner, prendre l'air ou dîner sous les étoiles. Les murs rembourrés et capitonnés créent un espace unique, dont la personnalité nous enveloppe dans un monde de magie et sophistication.

Los tonos rosas predominan en el nuevo diseño de este espacio en 2003. Un estilo con aires barrocos y toques futuristas impregna cada una de las zonas que forman este gran espacio de 1.000 m². Gracias a que el techo acristalado puede abrirse, es posible comer o tomar algo al aire libre o cenar bajo las estrellas. Las paredes acolchadas y en *capitonée* logran un espacio único, cuya personalidad envuelve en un mundo de magia y sofisticación.

Le tonalità del rosa predominano dopo la ristrutturazione realizzata nel 2003. Uno stile di lieve reminiscenza barocca dai tocchi futuristici pervade ognuna delle zone che si estendono, formando un unico ambiente, su una superficie di 1.000 m². Grazie al tetto in vetro apribile è possibile fare colazione, gustare un tè o la cena direttamente sotto le stelle. Nella lounge le pareti imbottite in *capitonné* conferiscono all'ambiente una nota di raffinata stravaganza.

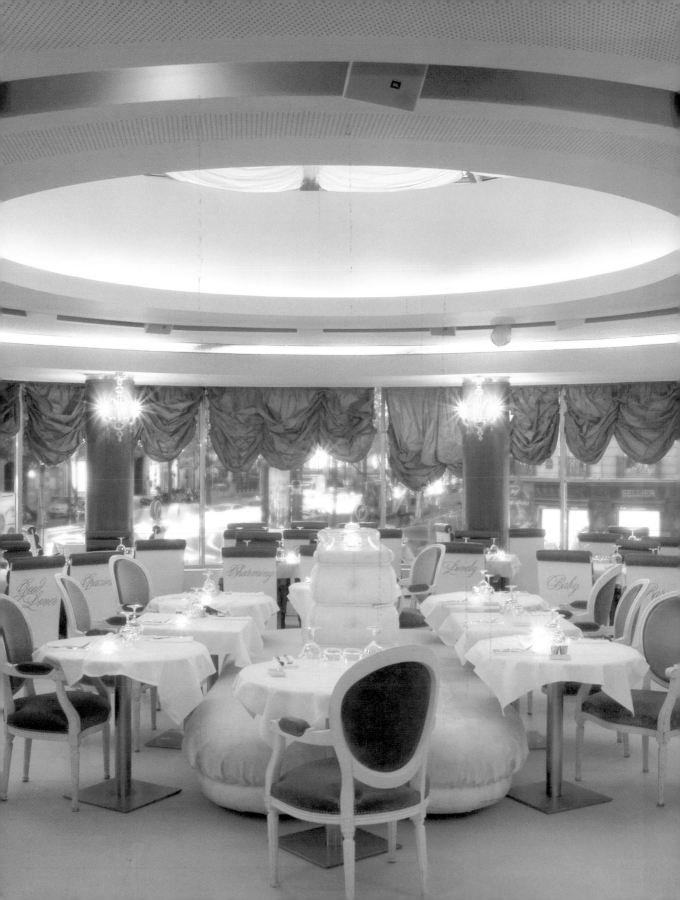

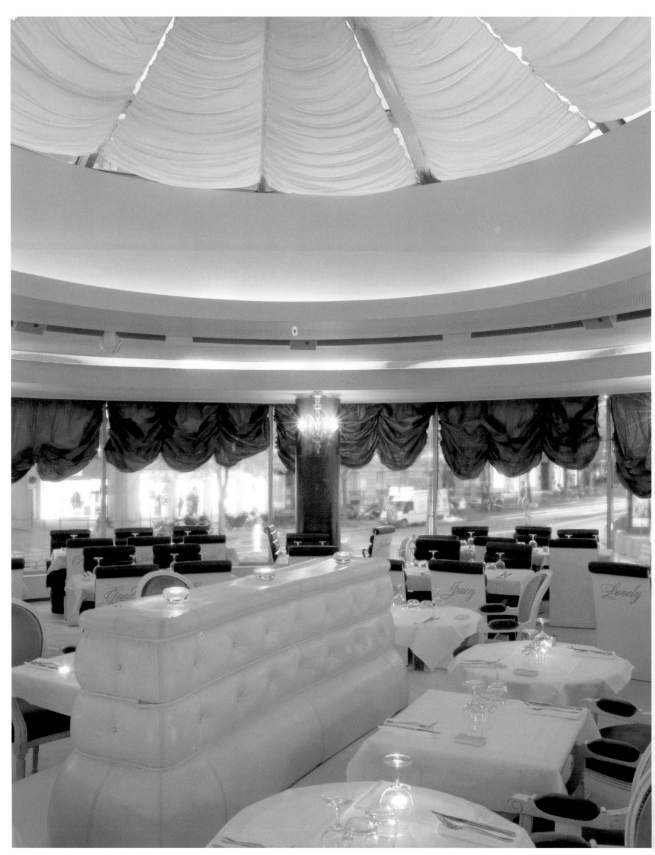

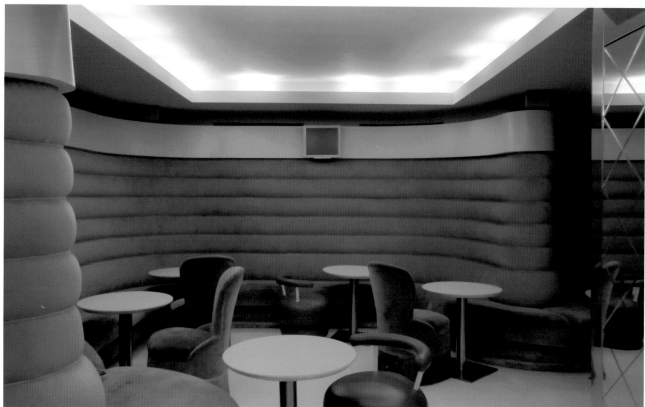

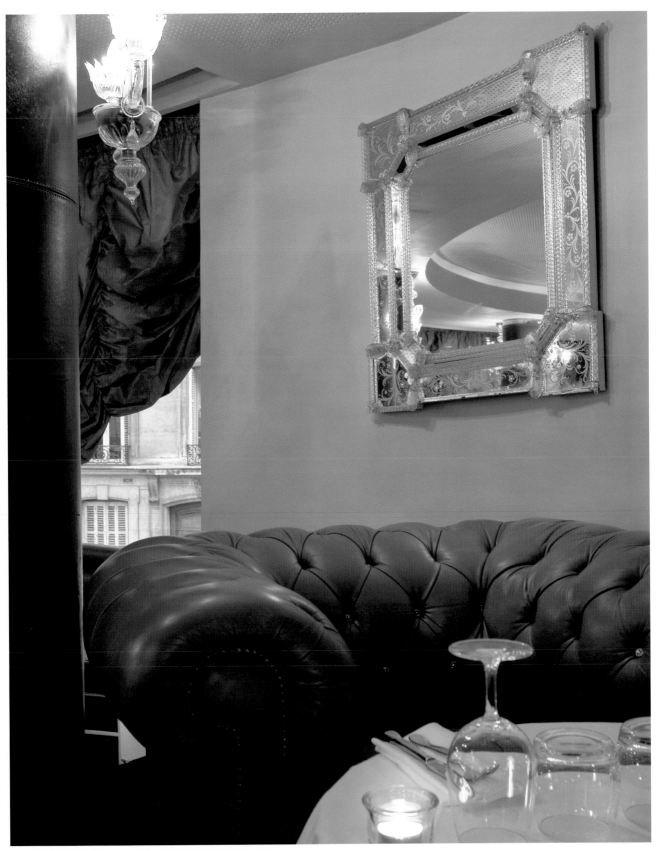

Le Pershing Hall Bar and Restaurant

Year: 2004
Photographs: © Benjamin Geminell

Imaad Rahmouni was the architect commissioned with the redesign of the restaurant and lounge of this hotel, situated in one of the most exclusive areas of the city. The Murano glass, silk cushions and pearls give the entire room an elegant flair. At the same time, the contemporary furniture, wall carpets and the magnificent mirrors provide a soft and warm atmosphere. Green, carmine and gold are the prevailing colors in these two relaxing surroundings.

Imaad Rahmouni war der Architekt, der mit der Neugestaltung des Restaurants und der Lounge dieses Hotels betraut wurde, das sich in der exklusivsten Zone der Stadt befindet. Durch das Muranoglas, die Seidenkissen und die Perlen erhält der gesamte Raum eine elegante Note und gleichzeitig wird mit dem modernen Mobiliar, den Wandteppichen und den pracht-vollen Spiegeln eine zarte und warme Atmosphäre geschaffen. Grün, Karminrot und Gold sind die vorherrschenden Farben in diesen zwei Ambienten, die zum Relaxen einladen.

Imaad Rahmouni est l'architecte chargé de restaurer le restaurant et le salon de cet hôtel, situé dans une des zones les plus exclusives de la ville. Rahmouni est parvenu à lui insuffler un air d'élégance grâce aux verres de Murano, coussins de soie et perles, tout en créant une atmosphère chaleureuse et subtile par le biais de mobilier contemporain, tapis et miroirs magnifiques. Le vert, le carmin et l'or habillent de couleurs ces deux univers qui invitent à la détente.

Imaad Rahmouni ha sido el arquitecto encargado de revisar el restaurante y el lounge de este hotel, situado en una de las zonas más exclusivas de la ciudad. Rahmouni ha logrado insuflarle un aire de elegancia merced a los cristales de Mura-no, los cojines de seda y las perlas, a la vez que ha creado un delicado y caluroso ambiente gracias al mobiliario contem-poráneo, tapices y magníficos espejos. El verde, el carmín y el dorado tintan estos dos ambientes que invitan al relax.

Imaad Rahmouni è stato l'architetto incaricato di rinnovare ristorante e lounge di questo hotel, situato in una delle zone più esclusive della città. Rahmouni è riuscito ad infondere loro eleganza grazie ai dettagli in cristallo di Murano, ai cusci-ni di seta e alle perle, creando allo stesso tempo una delicata e calda atmosfera, grazie agli arredi contemporanei, agli arazzi e ai magnifici specchi. Il verde, il carminio e il dorato sono le note cromatiche predominanti di questi due ambien-ti che invitano al relax.

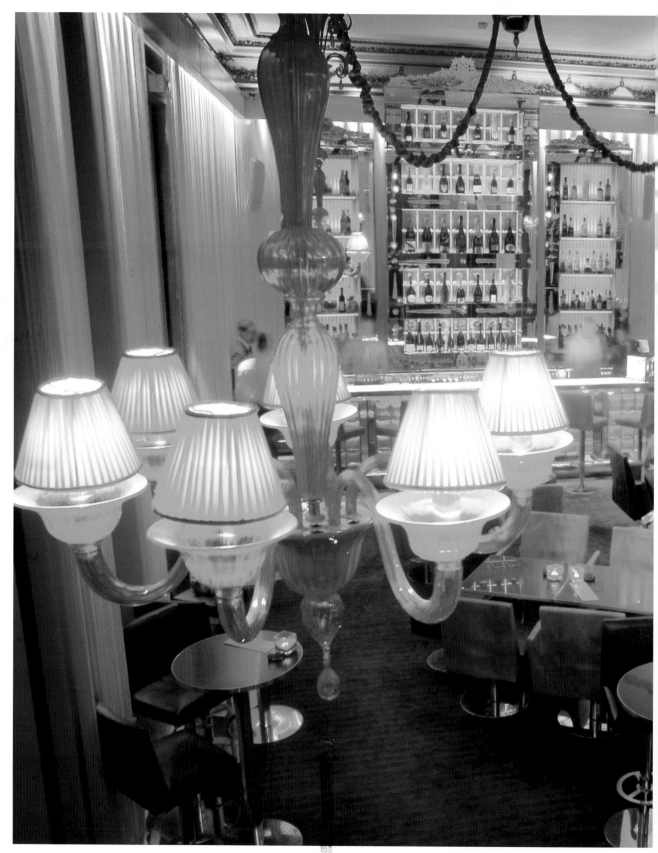

Imaad Rahmouni

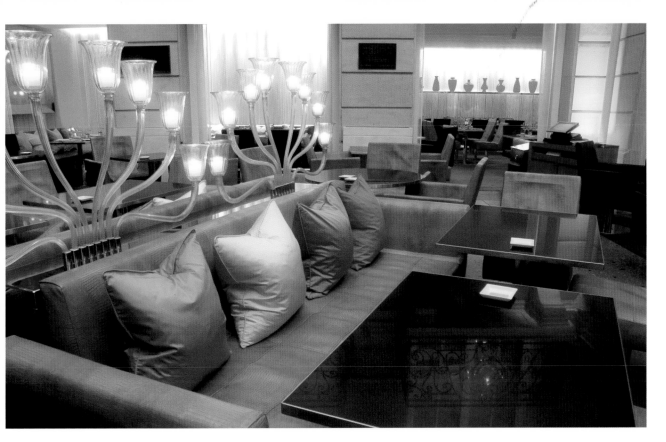

Imaad Rahmouni 299

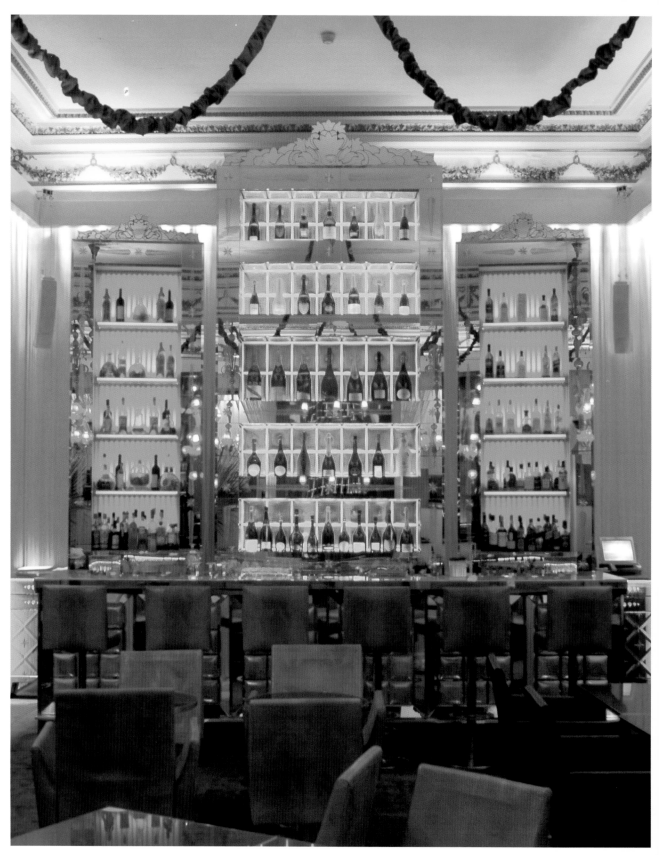

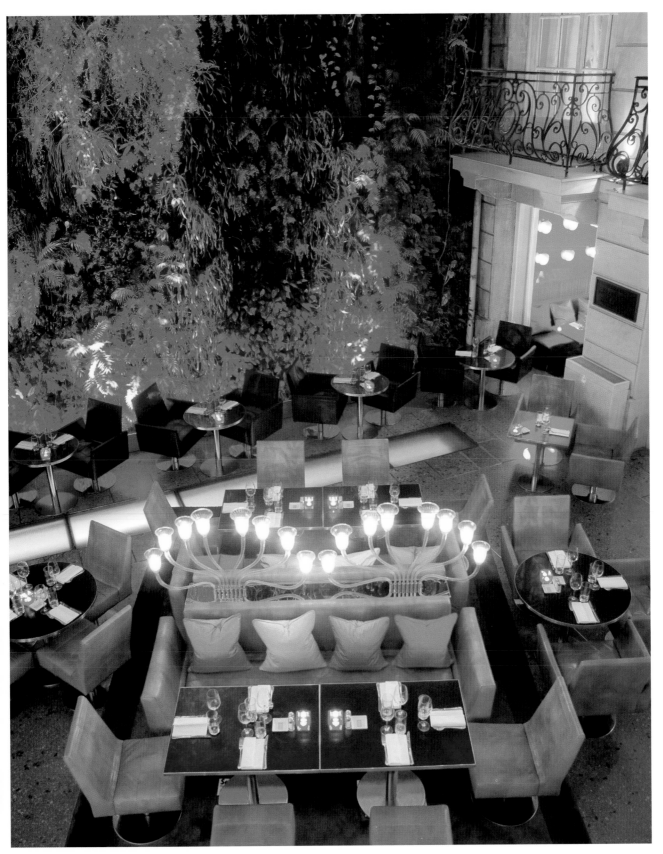

Pink Paradise

Year: 2002
Photographs: © Alexandre Tabaste

The design of this erotic bar absorbs the sensual atmosphere inside in a subtle, elegant and modern way. The subdued light is softly reflected in the pearl curtains, shiny wall-to-wall carpeting and cushioned walls of the more private zones, while the stage draws attention with its illuminated floor. The lighting was chosen with care to create an intimate and sensual atmosphere.

Das Design dieser erotischen Bar nimmt die sinnliche Atmosphäre auf eine raffinierte, elegante und moderne Weise auf. Das gedämpfte Licht wird in den Perlenvorhängen, dem schillernden Teppichboden und den gepolsterten Wänden der Privatzonen sanft reflektiert, während die Bühne mit ihrem beleuchteten Boden die Aufmerksamkeit auf sich lenkt. Die Beleuchtung wurde sorgfältig ausgesucht, um ein intimes und sinnliches Ambiente zu schaffen.

Le design de ce bar érotique parvient à transmettre toute la force de la sensualité et sexualité de manière sophistiquée, élégante et moderne. La faible lumière se reflète doucement dans les rideaux de perles, la moquette brillante et les murs capitonnés des zones plus intimes, tandis que la scène attire l'attention grâce à son sol illuminé. D'une manière générale, l'éclairage a été soigneusement choisi pour créer une ambiance intime et sensuelle, d'une façon très ponctuelle et précise.

El diseño de este bar erótico logra transmitir toda la fuerza de la sensualidad y la sexualidad de un modo sofisticado, elegante y moderno. La luz tenue se refleja suavemente en las cortinas de perlas, la moqueta brillante y las paredes acolchadas de las zonas más privadas, mientras que el escenario acapara la atención gracias a su suelo iluminado. La iluminación ha sido escogida cuidadosamente para crear un ambiente íntimo y sensual, de una manera muy puntual y precisa.

Il design di questo club erotico riesce a trasmettere tutta la forza della sensualità in modo sofisticato, elegante e moderno. La luce soffusa si riflette tenuemente sulle tende di perle, sulla moquette cangiante e sulle pareti imbottite delle zone più appartate, mentre il palco attrae l'attenzione verso di sé grazie al suo pavimento illuminato. In generale, l'illuminazione è stata scelta attentamente per creare un ambiente intimo e sensuale.

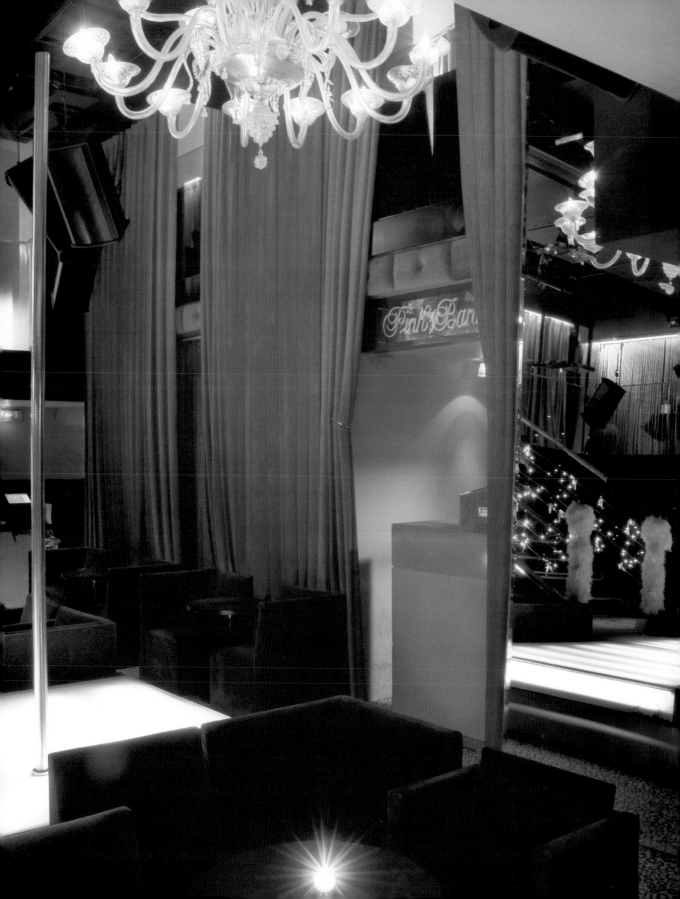

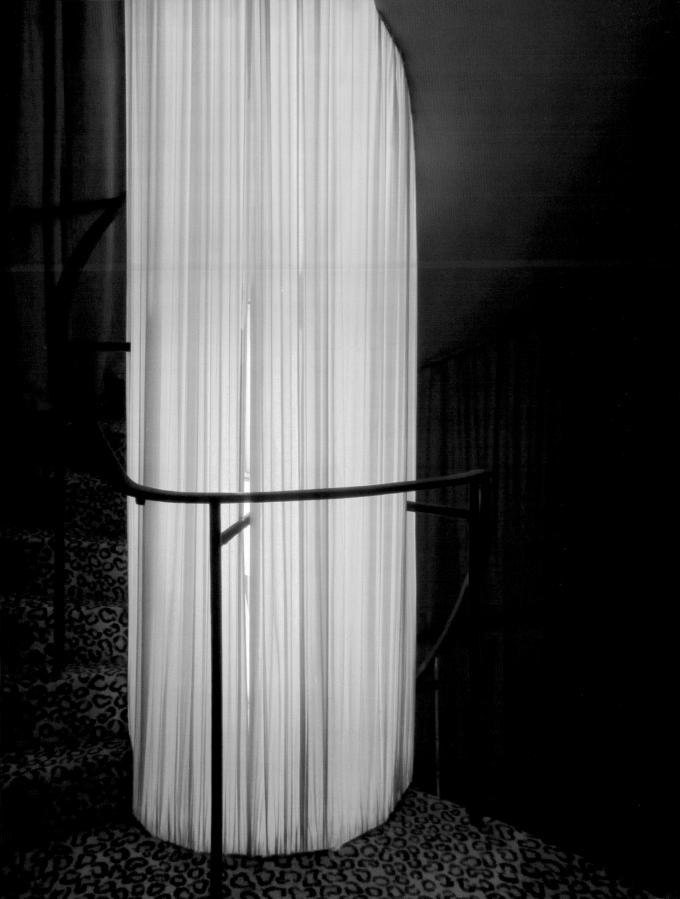

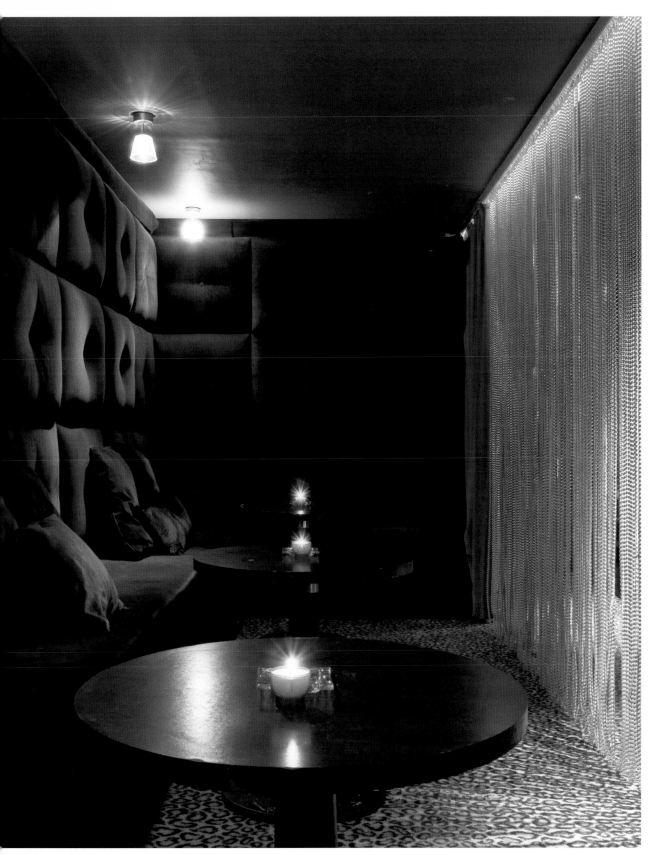

Product Design

Ito Morabito

India Mahdavi imh

Andrée Putman

Philippe Starck

Ronan & Erwan Bouroullec

Ito Morabito

Paco Bottle (2002)

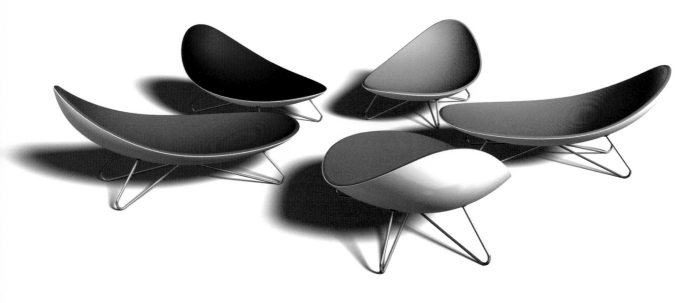

Petal Lounge Chair (2002)

Ito Morabito

58, rue Charlot, 75003 Paris

+33 142 46 00 09

+33 142 46 03 09

www.ora-ito.com

info@ora-ito.com

Ito Morabito

1977
Born in Marseille, France

1998
Starts creating fake products for real brands

1999
Design of watches for Swatch

2001
Receives the "Oscar for the best packaging"
for the aluminum bottle for Heineken

2003
Oxygen water bottle for Ogo

2005
Architecture and product-design of a brand
flagship for Thierry Mugler Perfumes

2006
Product-design and visual identity of the first
psycho-active perfume, the Smiley

Ora-Ïto is the brand name of Ito Morabito, a young iconoclastic designer whose boldness has made him the shooting star in the design community. He became famous when he designed fictitious products for real brands and presented their prototypes on the Internet without being requested–it was a success. Various art galleries displayed his creations. He began receiving orders from such well-known brands as Nike, Swatch, L'Oréal and Heineken.

Ora-Ïto ist der Markenname von Ito Morabito, ein junger, ikonoklastischer Designer, der durch seine Dreistigkeit zum Shootingstar der Designszene wurde. Bekannt wurde er durch das Design von fiktiven Produkten für echte Marken, deren Prototypen er ungefragt im Internet präsentierte – mit Erfolg. Seine Werke wurden in verschiedenen Kunstgalerien ausgestellt. Er erhielt Aufträge von bekannten Marken wie Nike, Swatch, L'Oréal oder Heineken.

Ora-Ïto est le nom d'enseigne de Ito Morabito, un jeune designer iconoclaste dont l'insolence l'a porté au sommet. Il se fait connaître par ses designs de produits fictifs pour des marques réelles, dont il a mis les prototypes sur la toile, en créant son propre site avec grand succès. Diverses galeries d'art ont exposé ses créations. Cela lui vaudra d'être engagé par des marques aussi connues que Nike, Swatch, l'Oréal ou Heineken, entre autres.

Ora-Ïto es el nombre de marca de Ito Morabito, un joven diseñador iconoclasta cuyo descaro lo ha llevado a lo más alto. Se dio a conocer con sus diseños de productos ficticios para marcas reales, cuyos prototipos colgó, por su propia cuenta y con enorme éxito, en la red. Varias galerías de arte expusieron sus creaciones. Así fue propulsado hasta llegar a ser contratado por marcas tan reconocidas como Nike, Swatch, L'Oréal o Heineken.

Ora-Ïto è il nome della marca di Ito Morabito, un giovane designer iconoclasta che con la sfacciataggine ha raggiunto la vetta imponendosi all'attenzione degli ambienti del design come talento-rivelazione. La sua fama è dovuta al disegno di prodotti fittizi per marchi reali, i cui prototipi, diffusi in rete per esclusiva iniziativa del designer, hanno riscosso grande successo. Varie gallerie d'arte hanno esposto le sue creazioni. L'esplosione di successo gli ha valso la commissione di progetti reali da parte di marchi rinomati tra cui Nike, Swatch, L'Oréal o Heineken.

Interview | Ito Morabito

Which do you consider the most important work of your career? I always want to make each work better. I may be proud of what I did when I look back in the future, but for now I just feel like a lucky kid playing with amazing tools.

In what ways does Paris inspire your work? The city's *art de vivre* saturates me. In terms of architecture, it's a very well-preserved city and it would be interesting to interact with its historical side, adding modern pieces.

Does a typical Paris style exist, and if so, how does it show in your work? I don't think it exists in contemporary creations. The style of current designers is more international than Parisian.

How do you imagine Paris in the future? I conceived a pirate campaign of Paris in 2010, a parody of the consumer society. Famous monuments were bought by big companies: you could see the McDonald's logo on Notre-Dame. Seriously, I see Paris becoming more and more lively.

Welches Werk halten Sie für das wichtigste Ihrer Karriere? Ich habe schon immer danach gestrebt, jedes neue Werk besser zu machen. Wenn ich eines Tages zurückschaue, werde ich vielleicht stolz auf das sein, was ich gemacht habe, aber im Moment fühle ich mich nur wie ein glückliches Kind, das mit unglaublichem Werkzeug spielt.

Wie inspiriert Paris Ihre Arbeit? Die *art de vivre* der Stadt durchdringt mich. Was die Architektur angeht, so ist es eine sehr gut erhaltene Stadt, und es wäre interessant, mit ihrer geschichtlichen Seite zu interagieren und moderne Gebäude hinzuzufügen.

Gibt es einen typischen Pariser Stil, und wenn ja, wie macht dieser sich in Ihrer Arbeit bemerkbar? Ich glaube, in gegenwärtigen Kreationen gibt es ihn nicht. Der Stil der heutigen Designer ist eher international als pariserisch.

Wie stellen Sie sich Paris in der Zukunft vor? Ich habe eine fiktive Werbekampagne für Paris im Jahre 2010 konzipiert, eine Parodie auf die Konsumgesellschaft. Berühmte Monumente sind von großen Konzernen gekauft worden: Man konnte das McDonald's-Logo an der Notre-Dame sehen. Aber im Ernst: Ich glaube, Paris wird immer lebendiger werden.

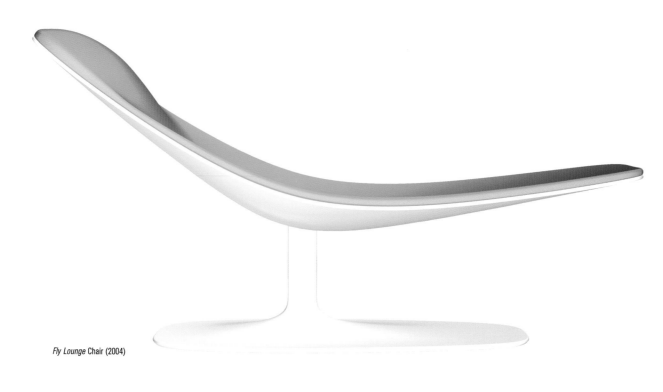

Fly Lounge Chair (2004)

Quelle est à vos yeux l'œuvre la plus importante de votre carrière ? J'ai toujours voulu faire mieux à chaque nouvelle œuvre. Peut-être serai-je fière de ce que j'ai fait plus tard, mais pour l'heure je me sens comme un gosse heureux en train de jouer avec des outils extraordinaires.

Dans quelle mesure votre œuvre artistique s'inspire-t-elle de Paris ? L'art de vivre de la ville me remplit. En termes d'architecture, c'est une cité très bien conservée et ce serait intéressant d'agir en interaction avec son aspect historique, en ajoutant des pièces modernes.

Existe-t-il un style typiquement parisien, et si oui, comment se manifeste-t-il dans votre œuvre ? Je ne crois pas qu'il existe dans les créations contemporaines. Le style des designers actuels est plus international que parisien.

Comment imaginez-vous le Paris du futur ? J'ai conçu une campagne pirate de Paris en 2010, une parodie de la société de consommation. Les monuments célèbres ont été achetés par de grandes compagnies: vous pouviez voir le logo de McDonald's sur Notre-Dame. Sérieusement, je vois Paris devenir de plus en plus vivant.

¿Cuál cree que es el trabajo más importante de su carrera? Siempre quiero hacer mejor mi trabajo. Puede que esté orgulloso de lo que he realizado cuando en el futuro mire hacia atrás, pero por ahora me siento como un niño afortunado jugando con unas herramientas increíbles.

¿Cómo le inspira París en su trabajo? El *art de vivre* de la ciudad me satura. En términos de arquitectura, es una ciudad que está muy bien preservada, y sería interesante interactuar con su parte histórica, añadiendo partes modernas.

¿Existe un estilo típico de París? Y si es así, ¿cómo se muestra éste en su obra? No creo que lo haya en las creaciones contemporáneas. El estilo de los diseñadores actuales es más internacional que parisino.

¿Cómo se imagina París en un futuro? Me imagino una campaña pirata en el París del año 2010, una parodia de la sociedad de consumo. Los monumentos famosos los habrán comprado las grandes compañías: el logo de McDonald's se podrá ver en Notre-Dame. En serio, veo que París será una ciudad cada vez mucho más animada.

Quale ritiene sia l'opera più importante della sua carriera? Voglio sempre migliorare ogni mio lavoro. Forse nel futuro sarò orgoglioso di quello che ho fatto quando mi guarderò alle spalle ma, per adesso, mi sento solo come un bambino fortunato che gioca con strumenti straordinari.

In che modo Parigi ispira il suo lavoro? L'*art de vivre* della città è ciò che mi permea. In termini architettonici, è una città molto ben preservata e sarebbe interessante interagire con la sua parte storica, aggiungendo parti moderne.

Esiste un tipico "stile parigino"? Se sì, come si manifesta nel suo lavoro? Non credo che esista nelle creazioni contemporanee. Lo stile dei designer attuali è più internazionale che parigino.

Come immagina Parigi nel futuro? Ho realizzato una pubblicità "pirata" su Parigi nel 2010, una parodia della società dei consumi. I monumenti celebri erano comprati dai grandi gruppi industriali: il logo di McDonald's appariva su Notre-Dame. A parte gli scherzi, vedo una Parigi sempre più vivace.

Gervita Spoon (2006)

Product Collection

Photographs: © Ora-ïto Studio

Ora-ïto himself has on occasion defined his creations as "simple-complicated"; in other words, a mix between the extreme simplicity of the design and the complexity involved in the creative process before arriving at the desired final result. His futuristic, modern, organic and pure style fits with any product, and he has designed everything from lamps and mobile phones to armchairs. His creations include Heineken's aluminum bottles, whose design was critically acclaimed and won an award in 2002.

Er selbst hat seine Werke als „einfachkompliziert" bezeichnet, das heißt, eine Mischung aus der höchsten Einfachheit des Designs und der Kompliziertheit des kreativen Prozesses bis zum gewünschten Ergebnis. Sein futuristischer, moderner, organischer und reiner Stil passt zu jedem Produkt und so hat er von Lampen über Mobiltelefone bis hin zu Sesseln alles designt. Zu seinen Werken zählt auch die Aluminiumflasche für Heineken, ein gefeiertes Design, das im Jahre 2002 ausgezeichnet wurde.

Il a lui-même défini ses créations, à un moment donné, comme quelque chose de « simple complexe », à savoir, un mélange entre la simplicité maximale du design et la complexité du processus créatif pour parvenir au résultat désiré. Son style futuriste, moderne, organique et pur parvient à s'adapter à n'importe quel produit, allant de la conception de lampes et mobiles jusqu'aux fauteuils. Parmi ses créations, on trouve également des bouteilles d'aluminium pour Heineken, un design très prisé, récompensé en 2002.

En alguna ocasión, él mismo ha definido sus creaciones como algo "simplecomplejo", es decir, una mezcla entre la máxima simplicidad del diseño y la complejidad que supone el proceso creativo hasta llegar al resultado deseado. Su estilo futurista, moderno, orgánico y puro consigue encajar con cualquier producto y ha llegado a diseñar desde lámparas y móviles hasta butacas. Entre sus creaciones se encuentran también las botellas de aluminio para Heineken, un diseño aclamado y que fue premiado en el año 2002.

Egli stesso ha definito le sue creazioni come qualcosa di "semplicecomplesso"; in altre parole, un mix tra la massima semplicità del design e la complessità che presuppone il processo creativo fino al raggiungimento del risultato desiderato. Il suo stile futuristico, moderno, organico e puro si sposa bene con qualunque prodotto e gli ha permesso di progettare da lampade a cellulari e persino poltrone. Tra le sue creazioni si trovano anche le bottiglie d'alluminio per Heineken, un design acclamato premiato nel 2002.

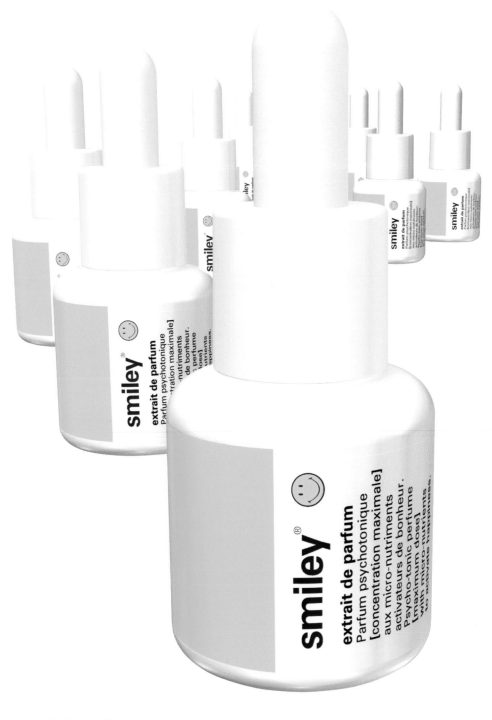

Happy Therapy Psycho-Active Perfume (2006)

Huby (2006)

Ogo Oxygen Water Bottle (2003)

My X-8 Cell-Phone (2004)

Brick External Hard-Disk (2005)

One-Line Table Lamp (2004)

Le Cab

Year: 2003
Photographs: © Ora-ïto Studio

This aesthetically futuristic space with its fascinating lighting has become one of the most frequented places in Paris. Along with the restaurant, the bar and discotheque of Le Cab constitute a meeting point for all types of people, but especially for young modern people who enjoy hanging out in fashionable places. The atmosphere is a successful combination of design and lighting with shifting contrasts between warm and cold colors.

Dieser futuristisch anmutende Raum mit seiner faszinierenden Beleuchtung ist zu einem der meistbesuchten Orte in Paris geworden. Neben dem Restaurant sind auch die Bar und die Diskothek von Le Cab ein Treffpunkt für alle Arten von Besuchern, besonders jedoch für junge, moderne Menschen, die sich gerne in Modelokalen aufhalten. Das Ambiente ist eine gelungene Kombination aus Design und Beleuchtung mit wechselnden Kontrasten von warmen und kalten Farbtönen.

Cet espace à l'esthétique futuriste et éclairage fascinant s'est converti en l'un des lieux les plus fréquentés de Paris. En plus de son restaurant, le bar et la discothèque du Cab sont un point de rencontre pour toutes sortes de gens, notamment des jeunes modernes, adeptes des endroits branchés, qui apprécient l'ambiance réussie en combinant design et éclairage dans un jeu de contrastes entre tons chauds et froids.

Este espacio de estética futurista e iluminación fascinante se ha convertido en uno de los lugares más frecuentados de París. Además de su restaurante, el bar y la discoteca de Le Cab son un punto de encuentro para todo tipo de gente, en especial jóvenes modernos, adeptos a los sitios de moda y que disfrutan con el ambiente logrado al combinar el diseño y la iluminación en un juego de contrastes entre tonos cálidos y fríos.

Questo spazio dall'estetica futuristica e dall'illuminazione affascinante si è trasformato in uno dei luoghi più frequentati di Parigi. Oltre al suo ristorante, il bar e la discoteca di Le Cab sono un punto d'incontro per gente di ogni tipo, specialmente giovani moderni, adepti dei locali alla moda, che godono dell'ambiente creato combinando il design e la luce, in un gioco di contrasti tra toni caldi e freddi.

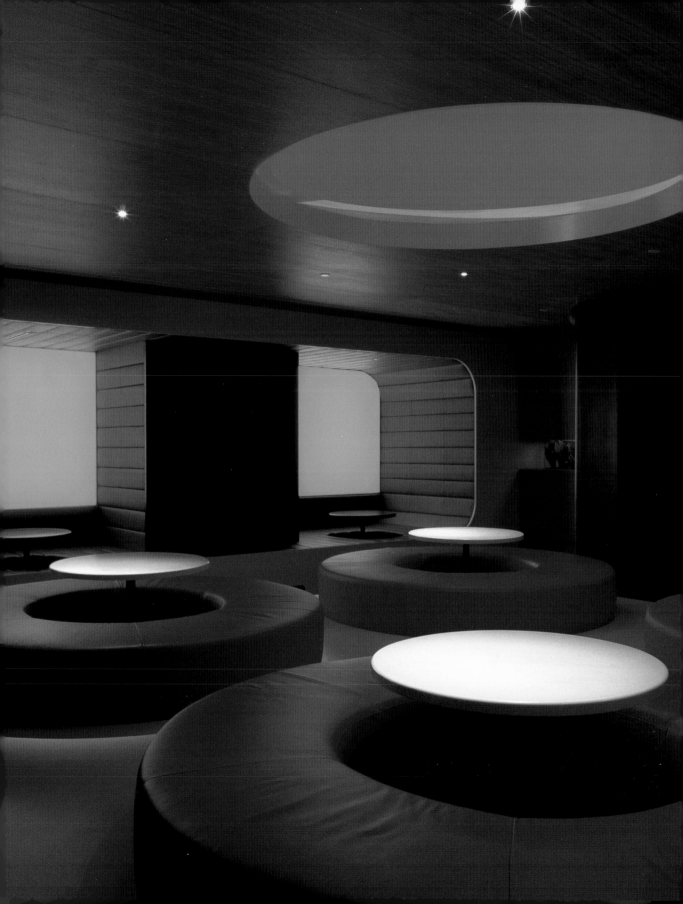

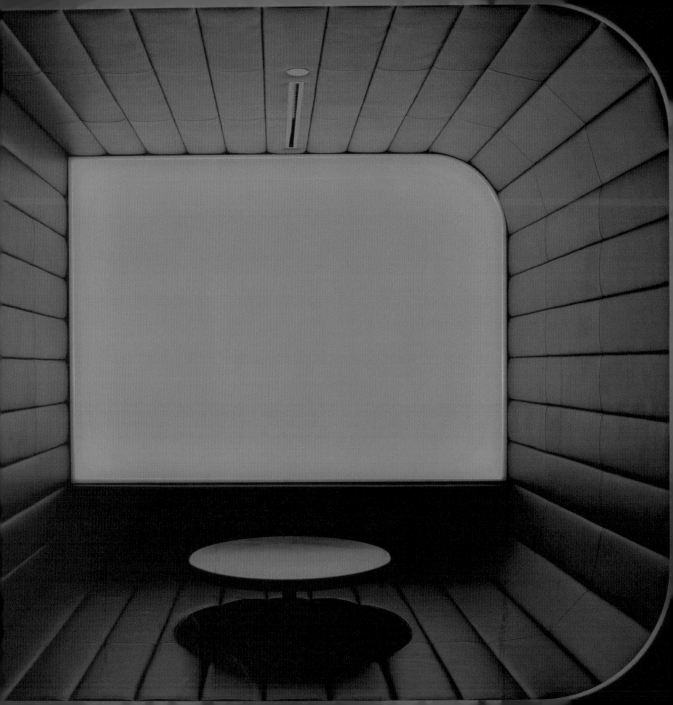

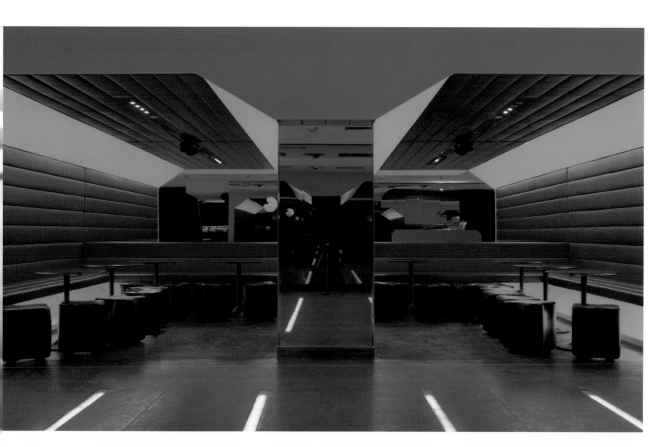

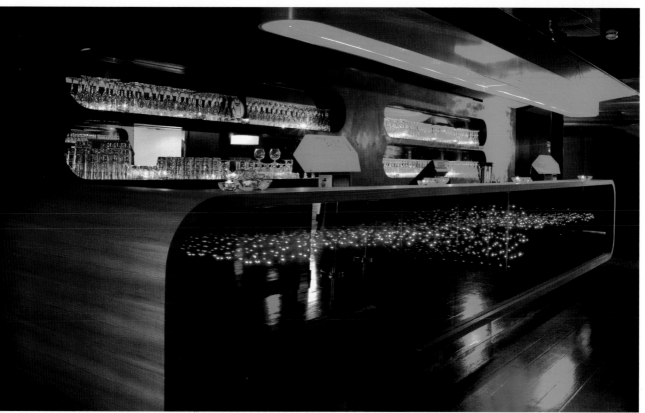

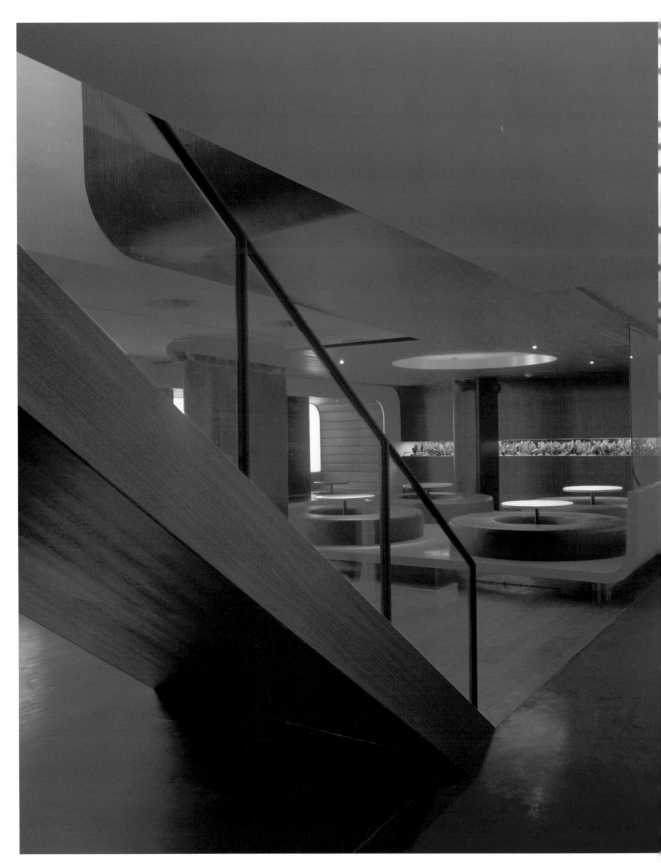

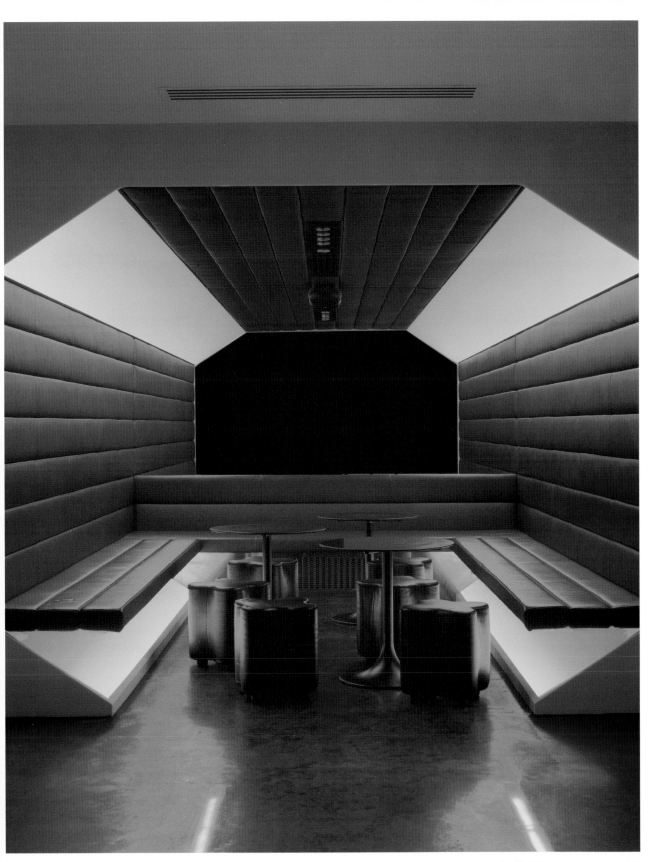

Rendez-Vous Toyota

Year: 2006
Photographs: © Luc Boegly

Right in the heart of Paris, at number 79 on the Champs-Élysées, you'll find Toyota's Rendez-Vous, a flagship store that offers visitors a high-tech experience of this brand. When preparing for the project, Ora-Ïto drew on Toyota's strong points–quality, design and innovation–and on their design philosophy of "Vibrant Clarity". The result is an entirely white room where the vehicles solely take center stage.

Im Herzen von Paris, auf den Champs-Élysées Nr. 79, befindet sich das Rendez-Vous von Toyota, ein Flagship-Store, der den Besuchern eine Hightech-Erfahrung dieser Marke bietet. Für den Entwurf ließ sich Ora-Ïto einerseits von den starken Seiten Toyotas inspirieren – Qualität, Design und Innovation – und andererseits von der Design-Philosophie „Vibrant Clarity". Das Ergebnis ist ein Raum komplett in Weiß, in dem einzig und allein die Fahrzeuge im Vordergrund stehen.

En plein cœur de Paris, au 79 de l'avenue des Champs-Élysées, vous trouverez le Rendez-Vous de Toyota, un Flagship-Store qui offre aux visiteurs une expression *high-tech* de cette enseigne. Pour réaliser le projet, Ora-Ïto s'est inspiré des points forts de Toyota – qualité, design et innovation – et de sa philosophie de design, « Clarté Vibrante », pour créer un espace entièrement blanc où les véhicules sont les protagonistes exclusifs.

En pleno corazón de París, en el 79 de la avenida de los Campos Elíseos, se encuentra el Rendez-Vous de Toyota, una flagship store que ofrece a los visitantes una experiencia *high-tech* de esta marca. Para confeccionar el proyecto, Ora-Ïto se inspiró en los puntos fuertes de Toyota –la calidad, el diseño y la innovación– y en su filosofía de diseño "Claridad Vibrante" para crear un espacio de colores completamente blancos donde los vehículos sean los únicos protagonistas exclusivos.

Nel cuore di Parigi, al 79 del viale degli Champs-Élysées, si trova il Rendez-Vous di Toyota, un *flagship store* che offre ai visitatori un'esperienza altamente tecnologica di questo marchio. Per creare il progetto, Ora-Ïto si è ispirato ai punti forti di Toyota – qualità, design e innovazione – e alla propria filosofia del design, "Chiarezza Vibrante", per creare uno spazio completamente in bianco dove i veicoli sono i protagonisti esclusivi.

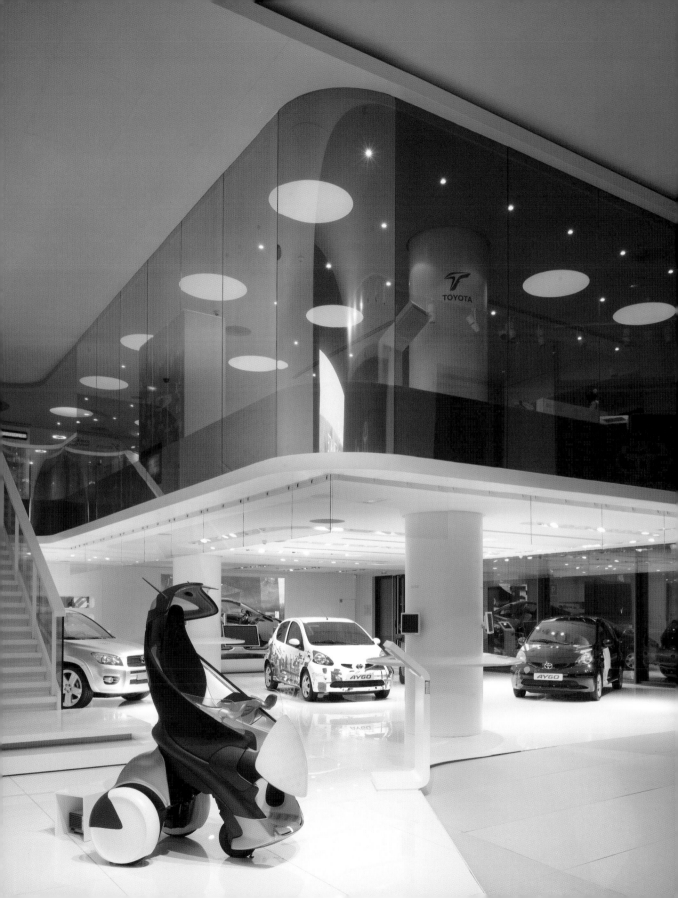

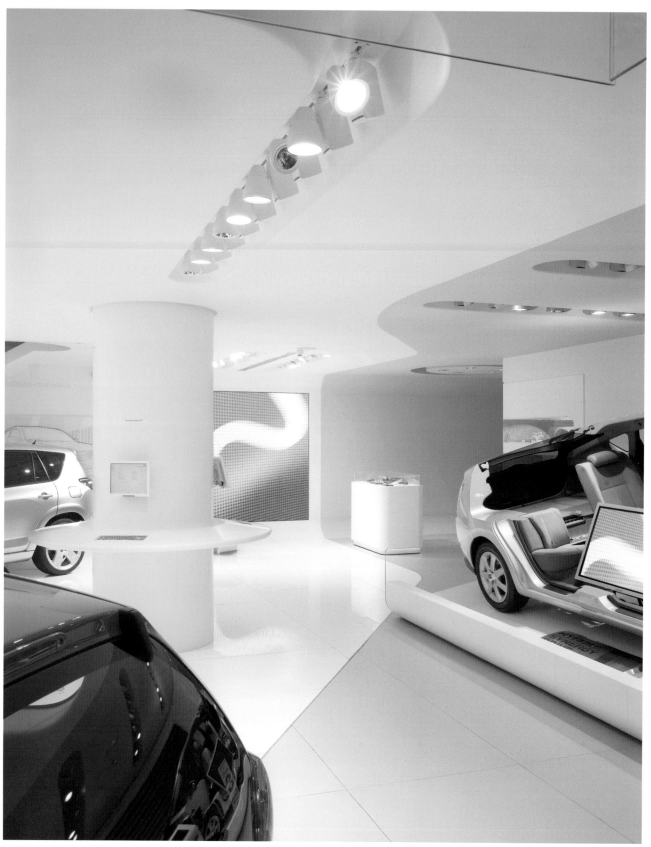

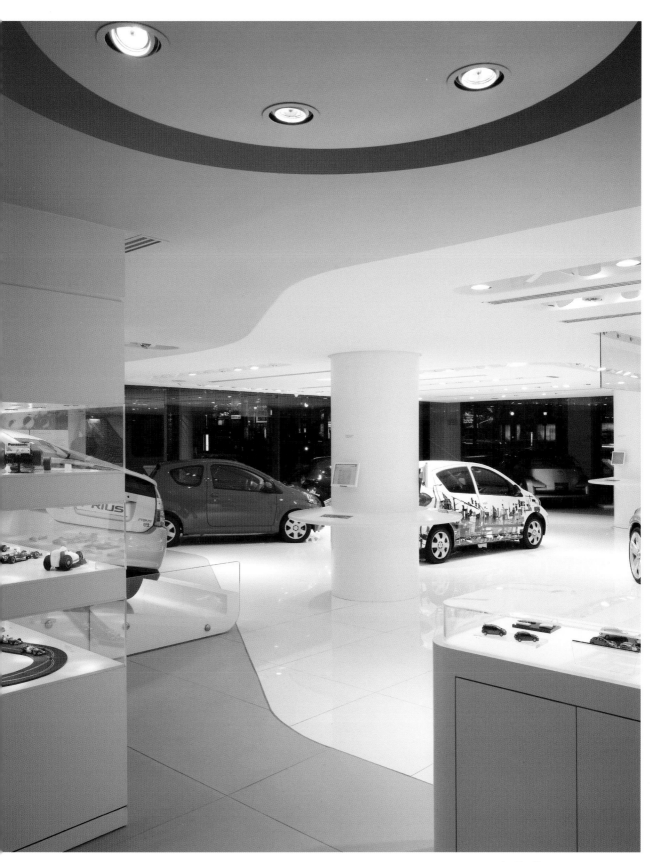

Trèfle Table (2006)

India Mahdavi imh

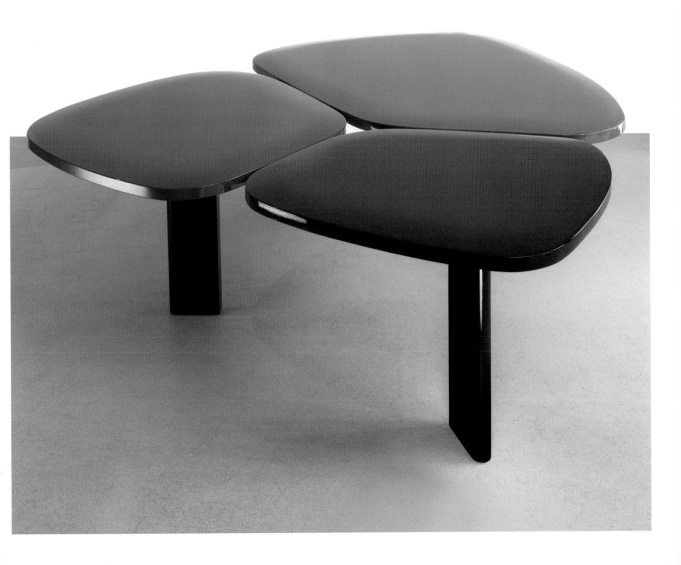

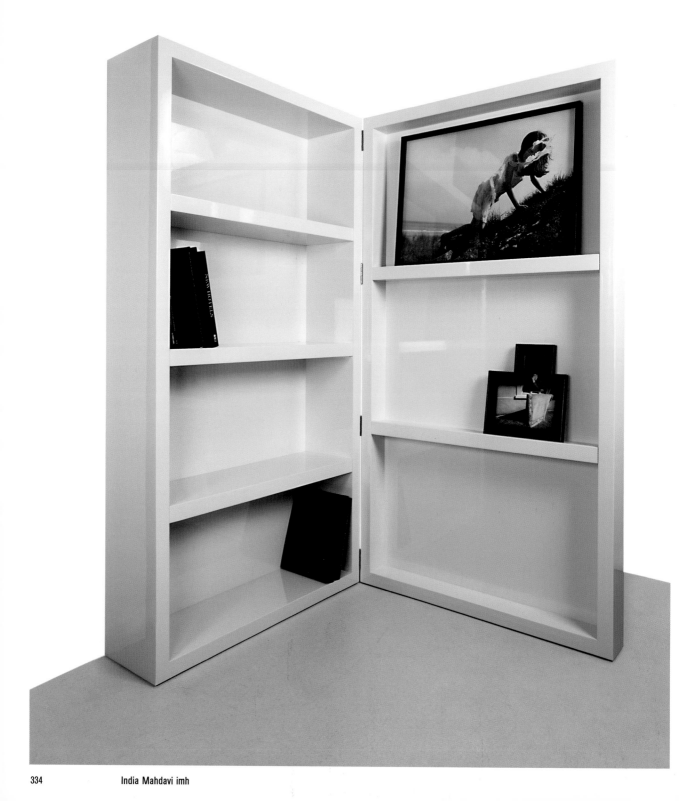

India Mahdavi imh

5, rue Las Cases, 75007 Paris

+33 145 51 63 89

+33 145 51 38 16

www.india-mahdavi.com

studio@indiamahdavi.com

India Mahdavi

The imagination of this architect and designer knows no limits. Her studio, imh, based in Paris, is famous for the diversity of its international projects. India Mahdavi has been active in all kinds of fields, from architecture to stage decoration and object, furniture and interior design. Her creations are characterized by sensuality, modernity and elegance. She was nominated Artist of the Year at the international exposition "Maison&Objet" 2004.

Die Vorstellungskraft dieser Architektin und Designerin ist unerschöpflich. Ihr Studio imh in Paris ist bekannt für die Vielfalt seiner internationalen Projekte. India Mahdavi hat in den verschiedensten Bereichen gewirkt, von der Architektur bis zur Bühnendekoration, über Möbel-, Objekt- und Interieurdesign. Sinnlichkeit, Modernität und Eleganz kennzeichnen ihre Werke. Auf der internationalen Messe „Maison&Objet" 2004 wurde sie zur Künstlerin des Jahres ernannt.

L'imagination de cette architecte et designer est sans bornes. Son bureau imh, basé à Paris, est réputé pour la diversité de ses projets internationaux, dans lesquels elle exploite tant l'architecture que la scénographie, en passant par le design d'intérieur, de mobilier et d'objets. La sensualité, la modernité et l'élégance caractérisent ses créations, pour lesquelles elle a été nommée Créatrice de l'année pour l'exposition internationale « Maison&Objet » en 2004.

La imaginación de esta arquitecta y diseñadora no tiene límite. Su oficina imh, con sede en París, es conocida por la diversidad de sus proyectos internacionales, en los que ha explorado desde la arquitectura hasta la escenografía, pasando por el diseño de interiores, de mobiliario y de objetos. La sensualidad, la modernidad y la elegancia caracterizan sus creaciones, que la han llevado a ser nombrada Creadora del Año por la exposición internacional "Maison&Objet" en 2004.

La forza creativa di India Mahdavi, architetto e designer, non conosce limiti. Il suo studio imh, con base a Parigi, è conosciuto per la varietà dei progetti internazionali con cui Mahdavi ha esplorato svariati campi, dall'architettura alla scenografia, passando per il disegno d'interni, d'arredo e di oggetti di complemento arredo. Sensualità, modernità ed eleganza caratterizzano le sue creazioni. Nell'ambito del Salone internazionale "Maison&Objet" del 2004 è stata nominata Creativa dell'anno.

1967
Born in Iran

1999
Creates her office imh in Paris, France

2000
Townhouse hotel, Miami, USA
APT, bar lounge, New York, USA

2001
Givenchy's boutiques concept, Paris, France

2002
Dragon-i restaurant in Hong Kong

2004
Elected designer of the year by Salon Maison&Objet

2005
Condesa df hotel in Mexico City, Mexico
Collection of crockery for Bernardaud, Paris, France

2006
John Frieda Salon, London, UK

Interview | India Mahdavi

Which do you consider the most important work of your career? The Condesa DF hotel is probably my most encompassing project, as I was involved in every aspect of it: architecture (with Javier Sánchez), program, interiors, furniture, graphics (Ich&Kar), menu (Jonathan Morr), landscape, etc. It's also the most personal project I have completed.

In what ways does Paris inspire your work? Paris's elegance and *art de vivre* have always been an inspiration.

Does a typical Paris style exist, and if so, how does it show in your work? There is a typical French style, which does not translate directly into an aesthetic as much as the fact that there is always a story behind a successful space. A story gives a certain authenticity and, therefore, a sense of luxury.

How do you imagine Paris in the future? I Paris, the museum-city…

Welches Werk halten Sie für das wichtigste Ihrer Karriere? Das Condesa DF Hotel ist wahrscheinlich mein allumfassendstes Projekt, da ich an jedem seiner Aspekte beteiligt war: Architektur (mit Javier Sánchez), Programm, Innenausstattung, Mobiliar, grafische Gestaltung (Ich&Kar), Speisekarte (Jonathan Morr), Gartenarchitektur etc. Es ist zudem das persönlichste meiner Projekte.

Wie inspiriert Paris Ihre Arbeit? Die Pariser Eleganz und *art de vivre* sind schon immer eine Inspiration gewesen.

Gibt es einen typischen Pariser Stil, und wenn ja, wie macht dieser sich in Ihrer Arbeit bemerkbar? Es gibt einen typischen französischen Stil, der aber nicht direkt mit Ästhetik gleichzusetzen ist. Zu einem erfolgreichen Raumdesign gibt es immer eine Geschichte. Eine Geschichte verleiht eine gewisse Authentizität, und damit eine Art Luxus.

Wie stellen Sie sich Paris in der Zukunft vor? Paris, die Museums-Stadt …

Bishops (2000/2003)

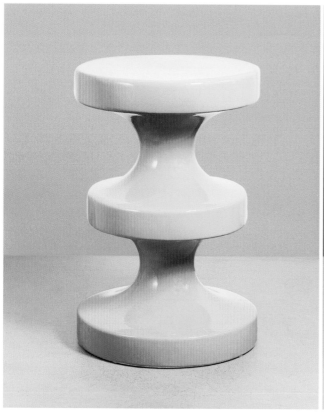

Quelle est à vos yeux l'œuvre la plus importante de votre carrière ? Le Condesa DF hôtel est probablement mon projet le plus universel, puisque j'étais impliquée dans tous ses aspects : architecture (avec Javier Sánchez), programme, intérieurs, mobilier, graphiques (Ich&Kar), menu (Jonathan Morr), paysage, etc. C'est aussi le plus personnel de mes projets réalisés.

Dans quelle mesure votre œuvre artistique s'inspire-t-elle de Paris ? L'élégance et l'art de vivre de Paris ont toujours été une source d'inspiration.

Existe-t-il un style typiquement parisien, et si oui, comment se manifeste-t-il dans votre œuvre ? Il y a un style typiquement parisien, qui ne se traduit pas directement en esthétique d'autant plus qu'il y a toujours une histoire derrière un espace réussi. Une histoire confère une certaine authenticité et, par conséquent, un sens de luxe.

Comment imaginez-vous le Paris du futur ? Paris, la ville musée…

¿Cuál cree que es el trabajo más importante de su carrera? El hotel Condesa DF es probablemente mi proyecto más global en el sentido de que me involucré en todos los aspectos: la arquitectura (con Javier Sánchez), los programas, los interiores, el mobiliario, los gráficos (Ich&Kar), los menús (Jonathan Morr), el diseño de los jardines, etc. Es también el proyecto más personal que he realizado.

¿Cómo le inspira París en su trabajo? La elegancia y el *art de vivre* de París han sido siempre mi inspiración.

¿Existe un estilo típico de París? Y si es así, ¿cómo se muestra éste en su obra? Hay un estilo típico francés, que no se traduce tanto directamente en una estética, como en el hecho de que siempre existe una historia detrás de un espacio logrado. Toda historia aporta cierta autenticidad y, por lo tanto, un sentido de lujo.

¿Cómo se imagina París en un futuro? París, la ciudad-museo…

Quale ritiene sia l'opera più importante della sua carriera? L' hotel Condesa DF è, probabilmente, il mio progetto più completo, dato che sono stata coinvolta in ogni suo aspetto: architettura (con Javier Sánchez), programma, interni, arredo, grafica (Ich&Kar), menù (Jonathan Morr), paesaggi, ecc. Inoltre si tratta del progetto più personale che ho portato a termine.

In che modo Parigi ispira il suo lavoro? L'eleganza e l'*art de vivre* di Parigi sono sempre state un'ispirazione per me.

Esiste un tipico "stile parigino"? Se sì, come si manifesta nel suo lavoro? Esiste un tipico stile francese che non si traduce direttamente in un'estetica parigina, al di là del fatto che c'è sempre una storia dietro un luogo di successo. Una storia dà una certa autenticità e, di conseguenza, un senso di lusso.

Come immagina Parigi nel futuro? Parigi, la città-museo…

Product Collection

Photographs: © Philippe Chancel, Thierry Depagne, Dominique Cohas

Nature is the source of inspiration for the latest collection of India Mahdavi, displayed in her Parisian showroom together with her previous designs, whose essence exudes from a fusion of sensuality, elegance and imagination. From the origin of a line to the finishing touches on a piece, all that is organic finds its place in this new collection, which includes creations such as the Diamond Library. A clear challenge to equilibrium.

Die Natur ist die Inspirationsquelle der letzten Kollektion von India Mahdavi, die sie in ihrem Pariser Showroom ausstellt. Wie auch ihre vorherigen Entwürfe, sind diese Designs das Ergebnis einer Verschmelzung von Sinnlichkeit, Eleganz und Vorstellungskraft. Die organischen Elemente finden ihren Platz vom Beginn einer Linie bis zur Vollendung eines Stücks in dieser neuen Kollektion, die Kreationen wie die Diamond-Bibliothek umfasst. Eine klare Herausforderung an das Gleichgewicht.

La nature est la source d'inspiration de la dernière collection d'India Mahdavi, exposée dans son *showroom* parisien à côté des ses designs antérieurs dont l'essence est le fruit de l'union entre sensualité, élégance et imagination. De l'origine d'une ligne à l'épanouissement d'une œuvre, l'organique trouve sa place dans cette nouvelle collection qui propose des créations comme la bibliothèque Diamond, véritable défi à l'équilibre.

La naturaleza ha sido la fuente de inspiración de la última colección de India Mahdavi, expuesta en su *showroom* parisino junto con sus diseños anteriores, cuya esencia resulta del concierto entre la sensualidad, la elegancia y la imaginación. Del origen de una línea, al florecimiento de una pieza, lo orgánico encuentra su sitio en esta nueva colección que propone creaciones como la biblioteca Diamond, un claro desafío al equilibrio.

La natura è la fonte d'ispirazione dell'ultima collezione di India Mahdavi, esposta nel suo *showroom* parigino. Come per i suoi progetti precedenti, anche questa volta è l'accordo tra sensualità, eleganza e forza creativa l'essenza di questi disegni. Dall'origine di una linea al fiorire di un elemento, l'organicità trova spazio in questa nuova collezione che propone creazioni come la libreria Diamond, una chiara sfida ai principi dell'equilibrio.

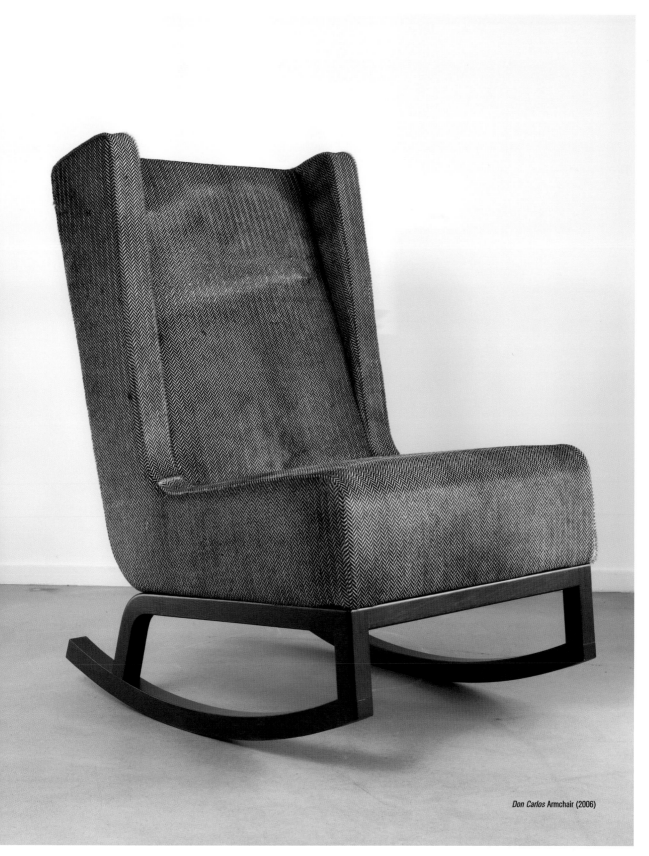

Don Carlos Armchair (2006)

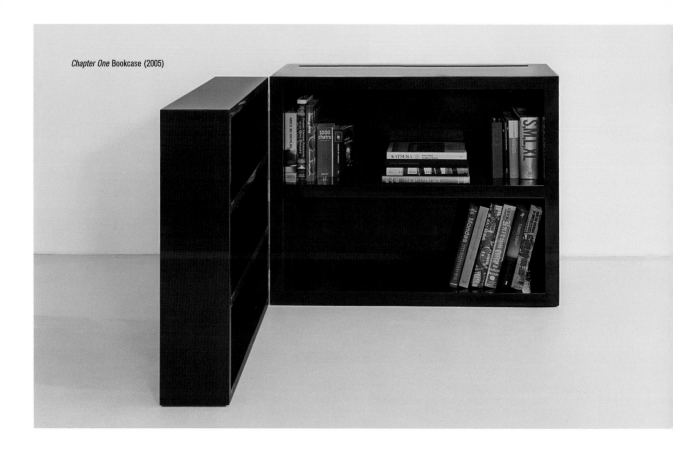

Chapter One Bookcase (2005)

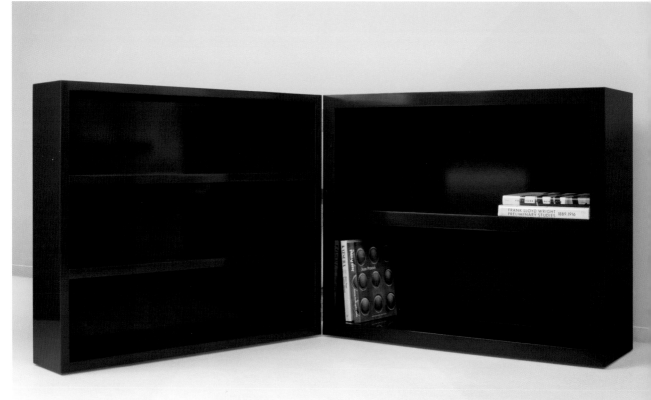

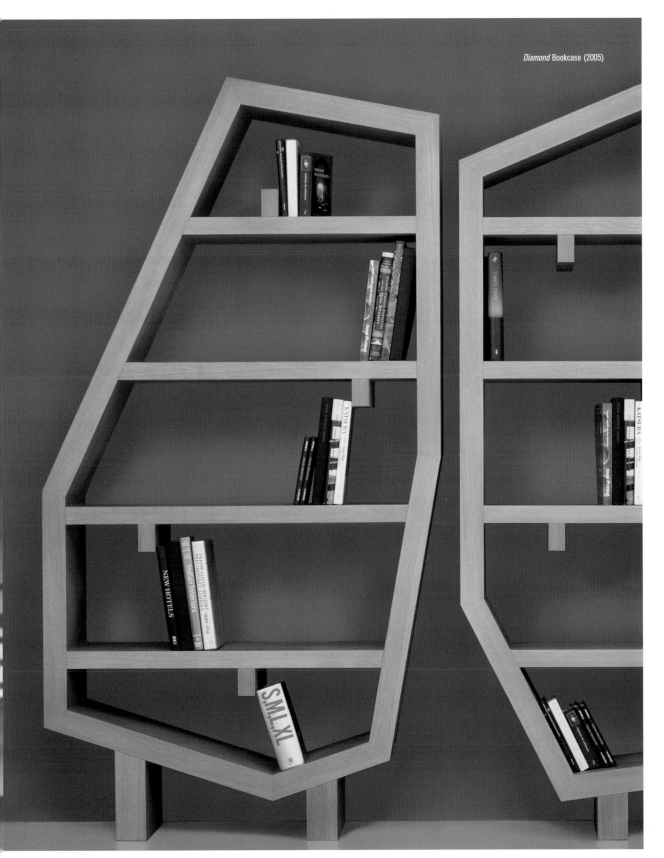

Diamond Bookcase (2005)

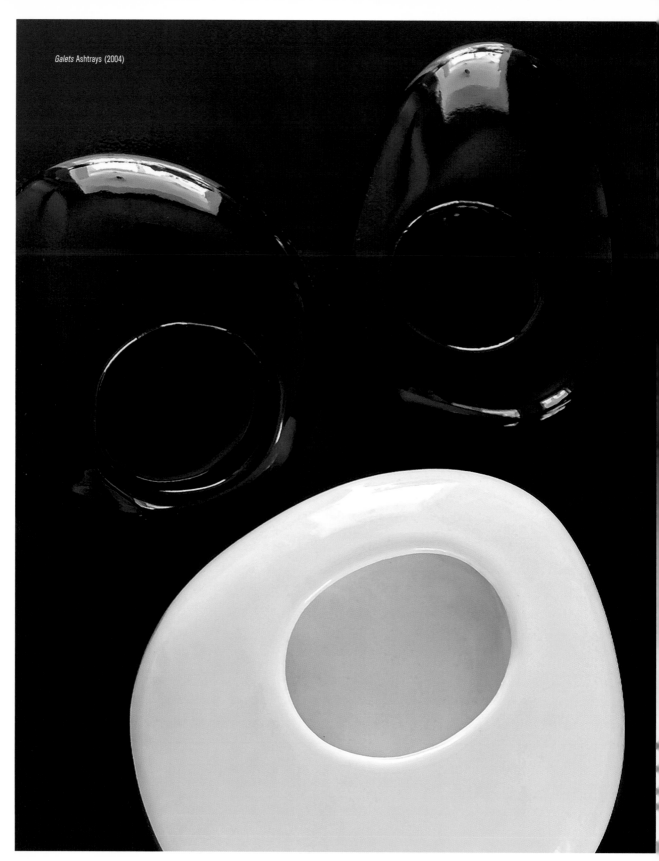

Galets Ashtrays (2004)

India Mahdavi imh

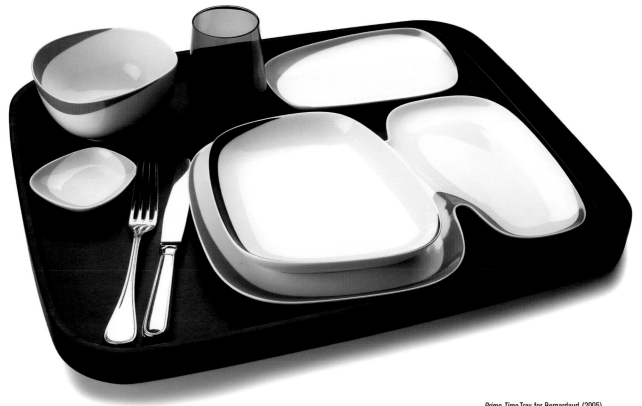

Prime Time Tray for Bernardaud (2005)

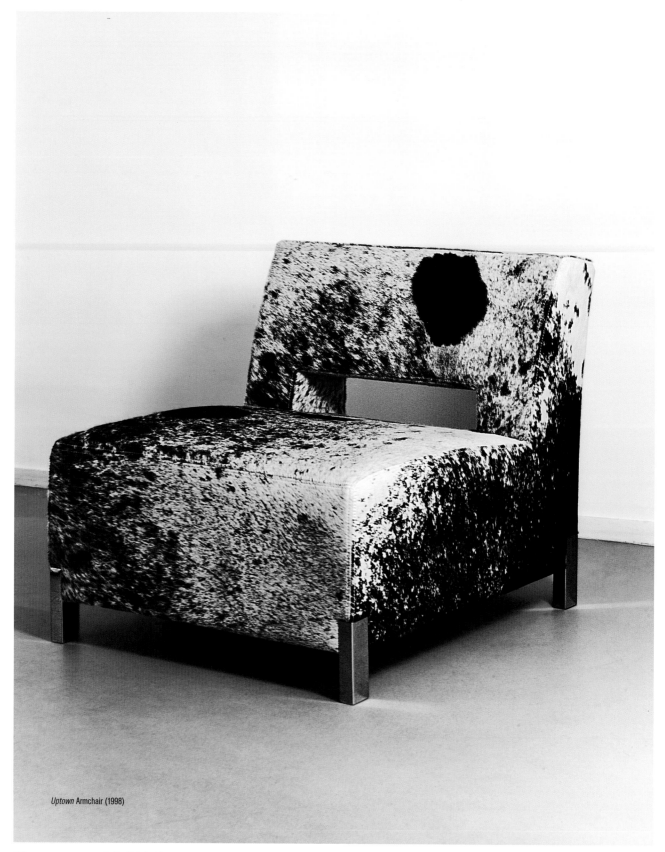

Uptown Armchair (1998)

Butterfly Table (2004)

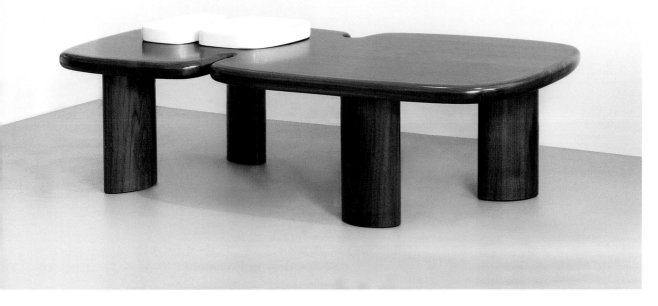

Bluff Table

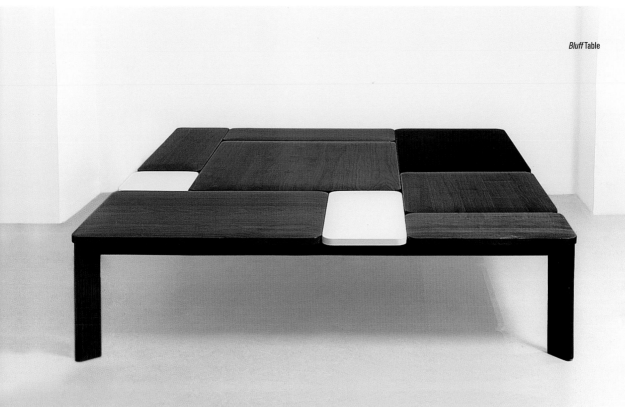

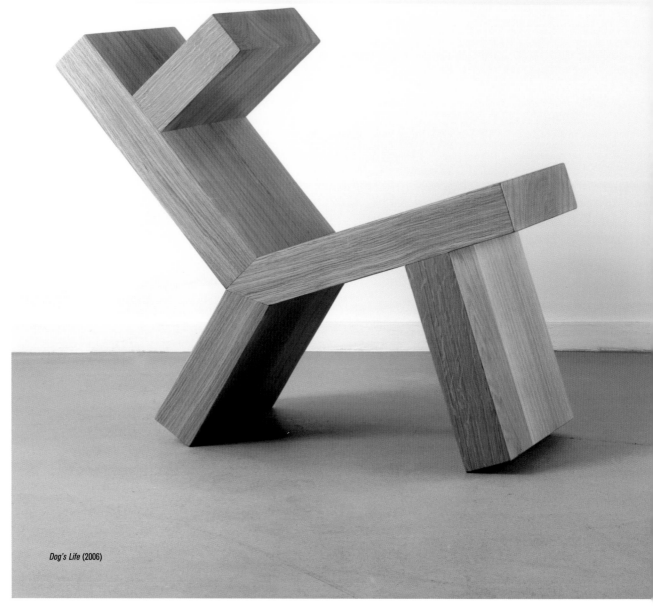

Dog's Life (2006)

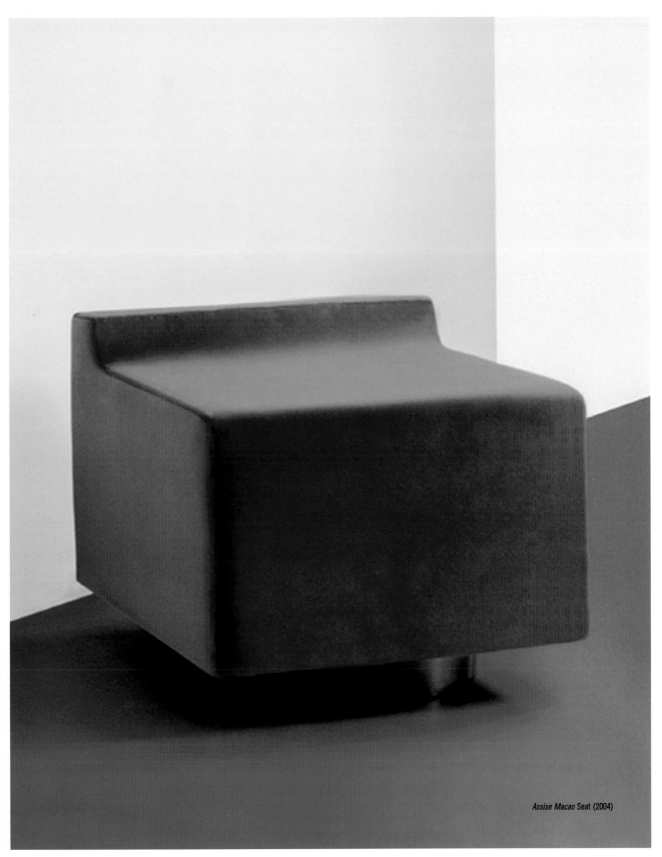

Assise Macao Seat (2004)

Jewelry Collection *926* for Christofle 2005

Andrée Putman

Rond sur Carré Table

Andrée Putman

Andrée Putman

83, avenue Denfert-Rochereau, 75014 Paris

+33 155 42 88 55

+33 155 42 88 50

www.andreeputman.com

archi@andreeputman.com

Andrée Putman

1925
Born in Paris, France

1978
Founds Ecart International

1984
Morgans Hotel, New York, USA

1997
Founds the new firm with her name, Andrée Putman

1998
Lagerfeld Gallery, Paris, France

2001
Pershing Hall hotel, Paris, France
Launches the fragance Préparation Parfumée Andrée Putman

2002
The Wolfsburg Ritz Carlton receives the Best Hotel in Germany Award

2003
Hotel Particulier, Paris, France

This internationally acclaimed designer began her career as a journalist for the magazines "L'œil" and "Les cahiers de Elle". Her brilliant idea of reproducing modern furnishings of the 20th century with her company Ecart International and thus reviving forgotten designs has made her an icon in the field of design. She also helped define the concept of the boutique hotel with her design of the Morgans Hotel in New York.

Diese international gefeierte Designerin begann ihre Laufbahn als Journalistin für die Zeitschriften „L'œil" und „Les cahiers de Elle". Durch ihre brillante Idee, mit ihrer Firma Ecart International moderne Einrichtungsgegenstände des 20. Jahrhunderts nachzubilden und damit vergessene Designs wiederzubeleben, wurde sie zu einer Referenz im Bereich Design. Mit der Gestaltung des Morgans Hotel in New York prägte sie auch das Konzept des Boutique-Hotels.

Cette femme designer, à la renommée internationale, commence à travailler en tant que journaliste pour les revues « L'œil » et « Les cahiers de Elle ». Grâce à son idée géniale de reproduire, avec sa société Ecart International, des œuvres modernes du XXe siècle, sauvant ainsi certains designs de l'oubli, elle devient une référence dans le secteur du design. Elle a également signé le concept de boutique hôtel avec le design du Morgans Hotel à New York.

Esta diseñadora aclamada internacionalmente empezó trabajando como periodista para las revistas "L'œil" y "Les cahiers de Elle". Su brillante idea de reproducir con su firma Ecart International piezas modernas del siglo XX con las que rescata diseños olvidados la ha convertido en un referente en el sector del diseño. También acuñó el concepto de hotel boutique con el diseño del Morgans Hotel en Nueva York.

Ora designer acclamata a livello internazionale, Andrée Putman ha cominciato lavorando come giornalista per le riviste "L'œil" e "Les cahiers de Elle". La brillante idea di far riprodurre nella propria azienda, Ecart International, complementi d'arredo moderni del XX secolo, riscattando design dimenticati, l'ha trasformata in punto di riferimento importante del settore. Con la progettazione del Morgans Hotel di New York Putman ha coniato la formula boutique-hotel.

Interview | Andrée Putman

Which do you consider the most important work of your career? My most interesting work is the Morgans Hotel in New York, designed at the end of the 1970's.

In what ways does Paris inspire your work? It has taken me a lifetime to become a fan of my city. I am deeply-rooted in this city, which makes me emotional and happy every time I return.

Does a typical PAris style exist, and if so, how does it show in your work? The only thing that might make Paris different from the rest of the world is the disparity between life in Paris and life in the province. Life in the province is more refined, because people there celebrate wonderful traditions. What links my work to Paris is the celebration of the strange and unknown, the hospitality to strangers. Parisians are unpredictable.

How do you imagine Paris in the future? Paris has finally understood that some of its appeal lies in the small restaurants and bistros where the food is often outstanding. I will not speak about the future, lest I make a mistake, but I suspect that those places that seem to have been disappearing are destined to revive.

Welches Werk halten Sie für das wichtigste Ihrer Karriere? Mein interessantestes Werk ist das Morgans Hotel in New York, das Ende der siebziger Jahre entworfen wurde.

Wie inspiriert Paris Ihre Arbeit? Es hat mich mein ganzes Leben gekostet, ein Fan meiner Stadt zu werden. Ich bin tief verwurzelt in dieser Stadt, was mich emotional und glücklich werden lässt, wann immer ich hierher zurückkehre.

Gibt es einen typischen Pariser Stil, und wenn ja, wie macht dieser sich in Ihrer Arbeit bemerkbar? Das Einzige, was Paris vom Rest der Welt unterscheidet, ist die Ungleichheit zwischen dem Leben in Paris und dem Leben in der Provinz. Das Leben in der Provinz ist kultivierter, weil die Menschen dort wundervolle Traditionen feiern. Was meine Arbeit mit Paris verbindet ist das Feiern des Ungewöhnlichen, des Unbekannten, die Gastfreundschaft Fremden gegenüber. Pariser sind unberechenbar.

Wie stellen Sie sich Paris in der Zukunft vor? Paris hat endlich verstanden, dass ein Teil des Reizes dieser Stadt in den kleinen Restaurants und Bistros liegt, in denen das Essen oft hervorragend ist. Ich möchte nicht über die Zukunft sprechen, um keinen Fehler zu begehen, aber ich vermute, dass die Orte, die dabei waren zu verschwinden, wiederaufleben werden.

Quelle est à vos yeux l'œuvre la plus importante de votre carrière ? Mon œuvre la plus intéressante, c'est le Morgans Hotel à New York, conçu à la fin des années 70.

Dans quelle mesure votre œuvre artistique s'inspire-t-elle de Paris ? Cela m'a pris toute une vie pour devenir fan de ma cité. Je suis profondément enracinée dans cette ville, qui m'émeut et me rend heureuse chaque fois que j'y reviens.

Existe-t-il un style typiquement parisien, et si oui, comment se manifeste-t-il dans votre œuvre ? La seule chose qui fait que Paris est différent du reste du monde, c'est la disparité entre la vie à Paris et en province. La vie en province est plus raffinée, car les gens y célèbrent de merveilleuses traditions. Ce qui relie mon œuvre à Paris, c'est la célébration de l'étrange et de l'inconnu, l'hospitalité envers les étrangers. Les Parisiens sont imprévisibles.

Comment imaginez-vous le Paris du futur ? Paris a finalement compris qu'une part de son charme réside dans les petits restaurants et bistrots où la cuisine est souvent excellente. Je ne parlerai pas du futur, de peur de commettre une erreur, mais j'imagine que les endroits qui ont tendance à disparaître sont destinés à revivre.

¿Cuál cree que es el trabajo más importante de su carrera? Mi trabajo más interesante es el Morgans Hotel en Nueva York, diseñado a finales de los setenta.

¿Cómo le inspira París en su trabajo? Me ha costado toda la vida convertirme en fan de mi ciudad. Estoy profundamente arraigada a esta ciudad, lo que me hace sentir emocionada y feliz cada vez que regreso.

¿Existe un estilo típico de París? Y si es así, ¿cómo se muestra éste en su obra? La única cosa que puede que haga a París diferente del resto del mundo es la disparidad entre la vida en París y la vida en la provincia. La vida en la provincia es más refinada porque la gente allí celebra unas tradiciones maravillosas. Lo que conecta mi trabajo con París es la celebración de lo extraño y lo desconocido, la hospitalidad a los forasteros. Los parisinos son impredecibles.

¿Cómo se imagina París en un futuro? París por fin ha comprendido que parte de su atractivo reside en los pequeños restaurantes y *bistrots* donde a menudo la comida resulta excepcional. No voy a hablar del futuro, no sea que me equivoque, pero sospecho que estos lugares que parecen ir desapareciendo, están destinados a revivir.

Quale ritiene sia l'opera più importante della sua carriera? Il mio lavoro più interessante è il Morgans Hotel a New York, progettato alla fine degli anni '70.

In che modo Parigi ispira il suo lavoro? Mi c'è voluta una vita per diventare un fan della mia città. Ho delle radici profonde in questa città, e ciò mi emoziona e mi fa felice ogni volta che ci torno.

Esiste un tipico "stile parigino"? Se sì, come si manifesta nel suo lavoro? Probabilmente, l'unica cosa che differenzia Parigi dal resto del mondo è la disparità tra la vita della città e quella della provincia. La vita della provincia è più raffinata, perché lì la gente celebra meravigliose tradizioni. Il mio lavoro è legato a Parigi dalla celebrazione di ciò che è estraneo e sconosciuto, dall'accoglienza ospitale della diversità. I parigini sono imprevedibili.

Come immagina Parigi nel futuro? Alla fine, Parigi ha capito che parte del suo fascino risiede nei piccoli ristoranti e bistro in cui il cibo è spesso eccellente. Non dirò niente del futuro, per non rischiare di sbagliarmi, ma ho la sensazione che quei luoghi che sembrano essere scomparsi siano destinati a rinascere.

Crescent Moon Sofa

Product Collection

The starting points which Andrée Putman considers when contemplating her designs are key to understanding the care and dedication with which she pampers and tends to the conceptual evolution of all her creations. Durability, not only of the material used, but also of the aesthetics of her designs, is the central aspect, which all the pieces of jewelry and furniture of her Préparation Meublée collection share.

Die Ansatzpunkte, von denen Andrée Putman für den Entwurf ihrer Designs ausgeht, sind wichtig um die Sorgfalt und die Hingabe zu verstehen, mit denen sie die konzeptuelle Evolution ihrer Kreationen betreut. Beständigkeit, nicht nur des verwendeten Materials, sondern auch der Ästhetik ihrer Entwürfe, ist der zentrale Aspekt, den alle Schmuckstücke und Möbel ihrer Préparation Meublée gemein haben.

Les questions que se pose Andrée Putman à l'heure d'élaborer ses designs sont essentielles pour comprendre le soin et l'engagement qu'elle consacre à l'évolution conceptuelle de toutes les créations. La pérennité, non pas sur le plan matériel mais plutôt esthétique, est l'aspect central de chacune de ses pièces de joaillerie et de mobilier de sa Préparation Meublée.

Las cuestiones que se plantea Andrée Putman a la hora de elaborar sus diseños son claves para entender el cuidado y la dedicación con que mima y atiende la evolución conceptual de todas las creaciones. Su perdurabilidad, ya no material, sino en términos de estética, es el aspecto principal de cada una de sus piezas de joyería y mobiliario de su Préparation Meublée.

Le questioni che si pone Andrée Putman nel momento di elaborare i suoi progetti sono fondamentali per comprendere l'attenzione e la dedizione con cui cura e segue l'evoluzione concettuale di tutte le sue creazioni. La durevolezza, non solo materiale bensì in termini d'estetica come proporzione adeguata è aspetto essenziale di ciascuna delle opere di oreficeria e arredo della sua Préparation Meublée.

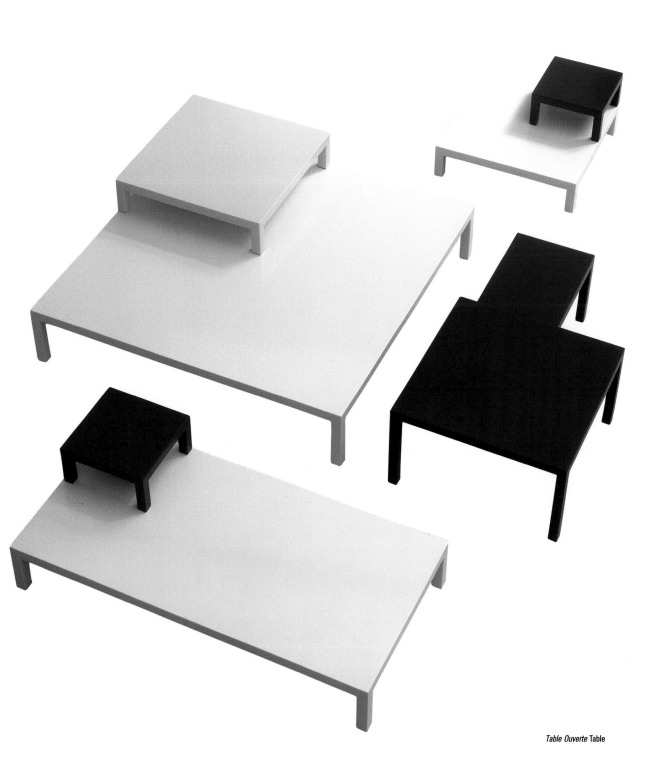

Table Ouverte Table

Andrée Putman 355

Clair de Jour Armchair

Towel Caddy Chair

Croqueuse de Diamants Chair

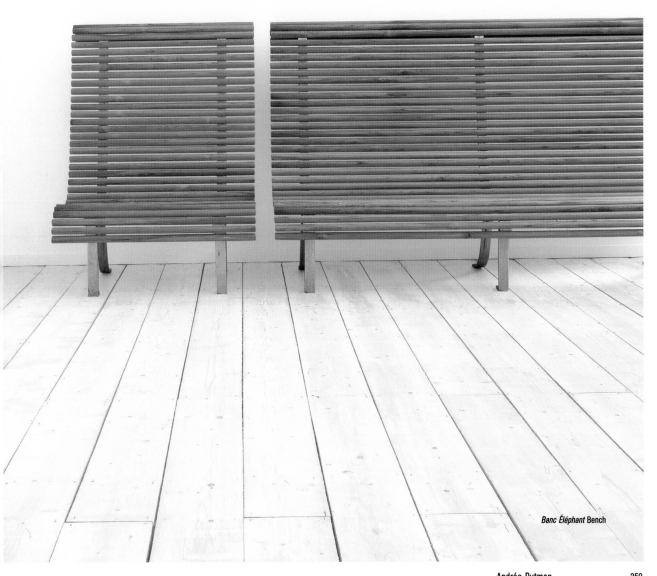

Banc Éléphant Bench

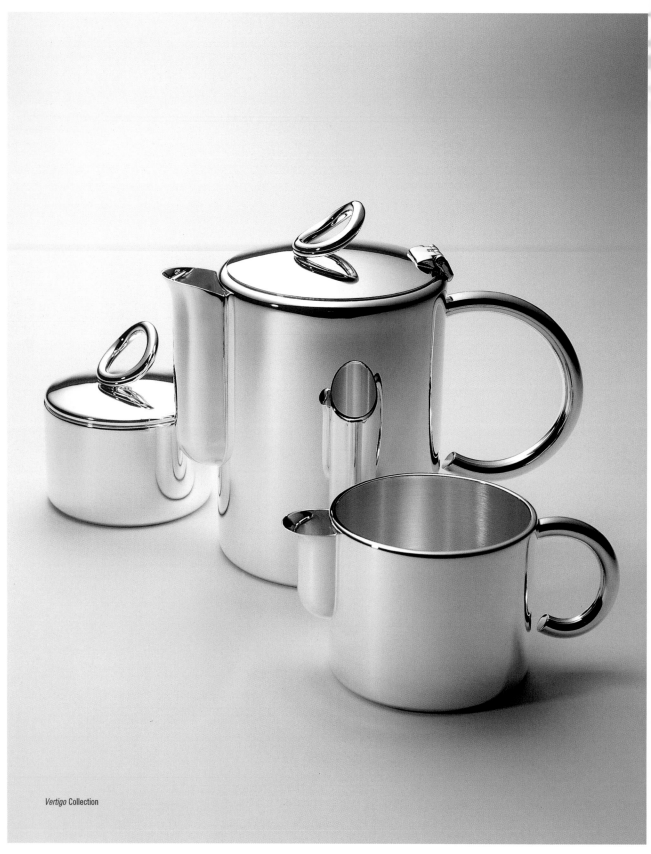

Vertigo Collection

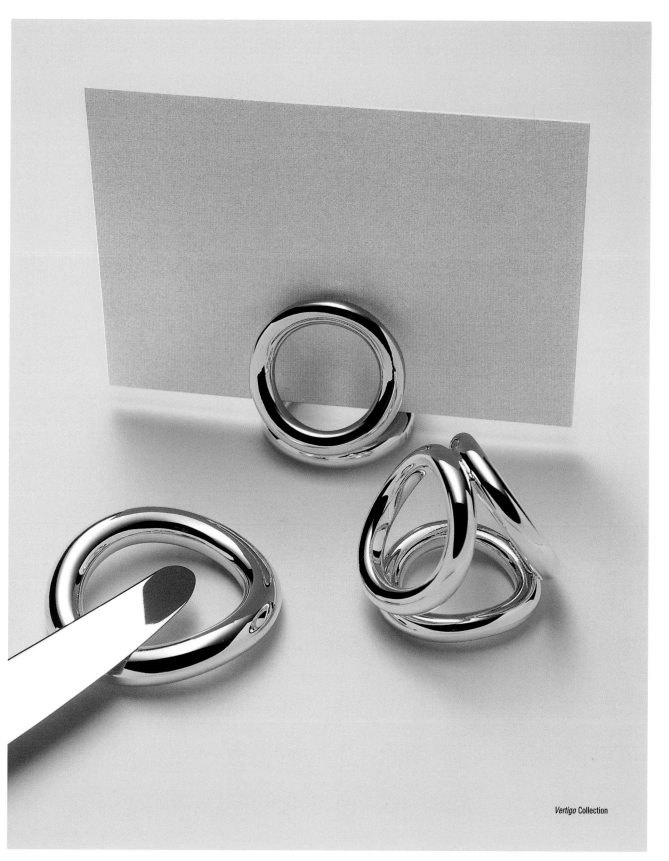

Vertigo Collection

La Maison Guerlain

Year: 2004
Photographs: © Guerlain

Founded in 1914, La Maison Guerlain reopened its doors in June 2005 with an innovative design by Andrée Putman. Since the marble of the floor below had to be preserved, the designer decided to hide it by covering the counters with oak wood with large illuminated displays. In the store window, glass bead curtains hang like delicate drops of perfume and the beauty salon on the first floor boasts a somber, elegant and modern design.

Das 1914 gegründete La Maison Guerlain wurde im Juni 2005 in neuem Design von Andrée Putman wiedereröffnet. Da der Marmor des unteren Stockwerks erhalten bleiben musste, entschloss sich die Designerin dazu, es zu verbergen, indem sie die Ladentische mit Eichenholz und die Wände mit großen beleuchteten Werbekästen bedeckte. In den Schaufenstern hängen Glasperlen wie zarte Parfumtropfen von den Decken und das Design des Schönheitszentrums im ersten Stock ist schlicht, elegant und modern.

Fondée en 1914, la Maison Guerlain ouvre à nouveau ses portes en juin 2005, avec un design revisité par Andrée Putman. Obligée de conserver le marbre de l'étage inférieur, la designer a choisi de le dissimuler et pour le faire, elle a habillé les comptoirs de bois de hêtre et les murs de grandes boites d'enseignes lumineuses publicitaires. Dans la vitrine, les rideaux de perles de verre tombent comme de délicates gouttes de parfum, et le centre de beauté du premier étage affiche un design sobre, élégant et moderne.

Fundada en 1914, La Maison Guerlain abrió de nuevo sus puertas en junio del 2005 con un diseño renovado por Andrée Putman. Al tener que respetar el mármol del piso inferior, la diseñadora optó por disimularlo y para ello cubrió los mostradores con madera de roble y las paredes con grandes porta-anuncios iluminados. En el escaparate, las cortinas de abalorios cuelgan como delicadas gotas de perfume, y el centro de belleza del primer piso muestra un diseño sobrio, elegante y moderno.

Fondata nel 1914, La Maison Guerlain ha aperto di nuovo le porte a giugno 2005 con un design rinnovato firmato Andrée Putman. Dovendo mantenere il marmo del piano inferiore, la designer ha scelto di mimetizzarlo ricoprendo i banconi con legno di rovere e le pareti con grandi cornici luminose promozionali. In vetrina, tende di perle di vetro scendono dal soffitto come delicate gocce di profumo. Il centro di bellezza al primo piano si contraddistingue per un design sobrio, elegante e moderno.

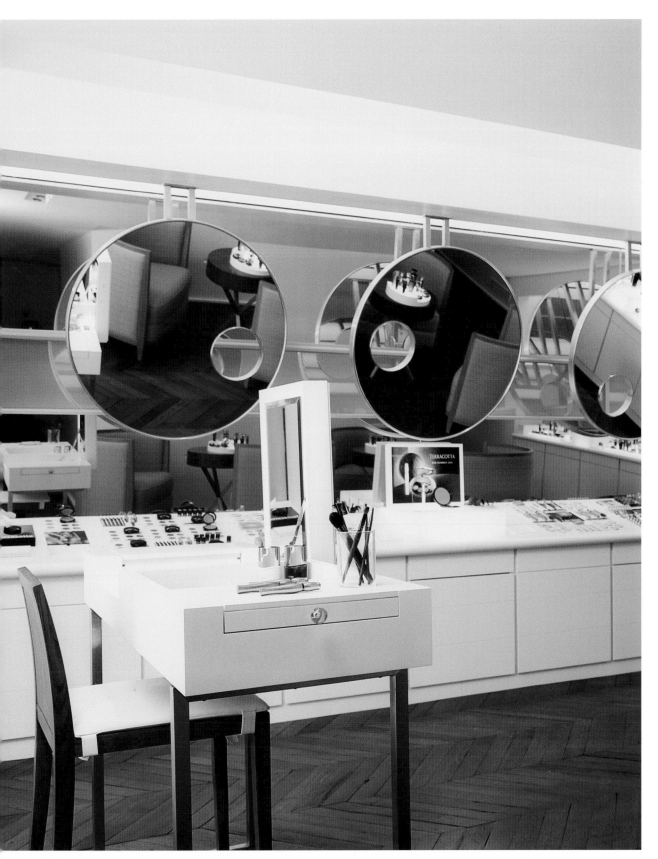

Andrée Putman

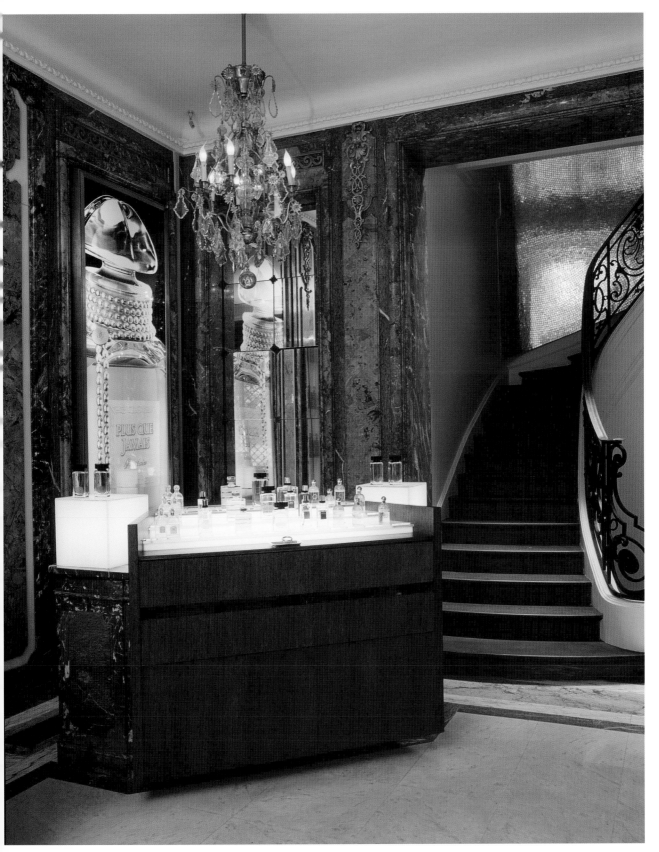

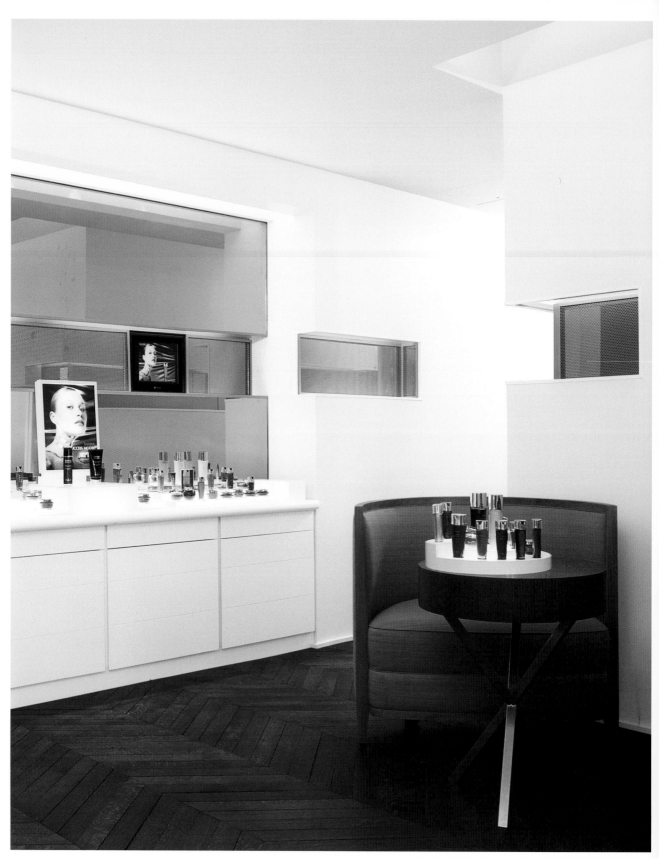

Andrée Putman

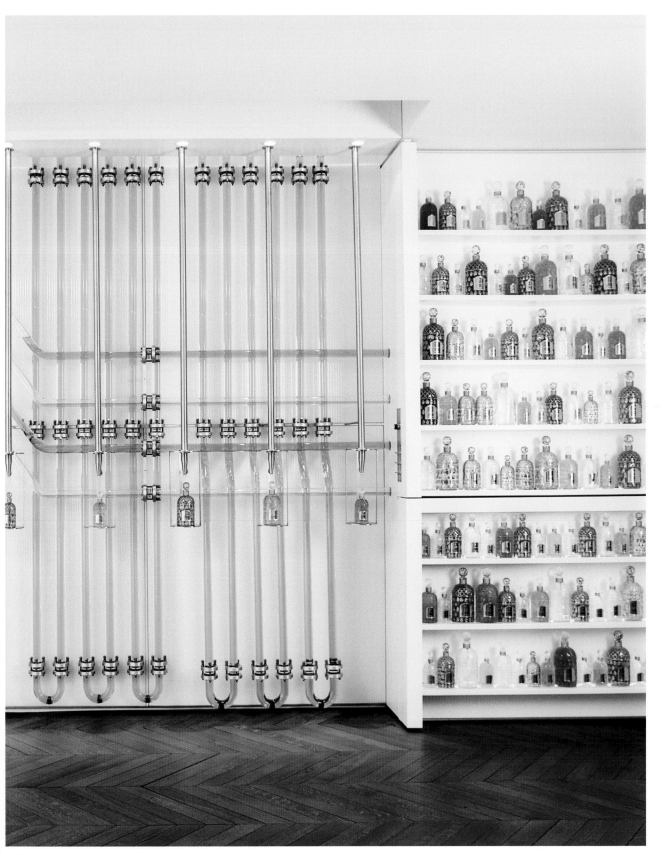

Top Top tables (2006)

Philippe Starck

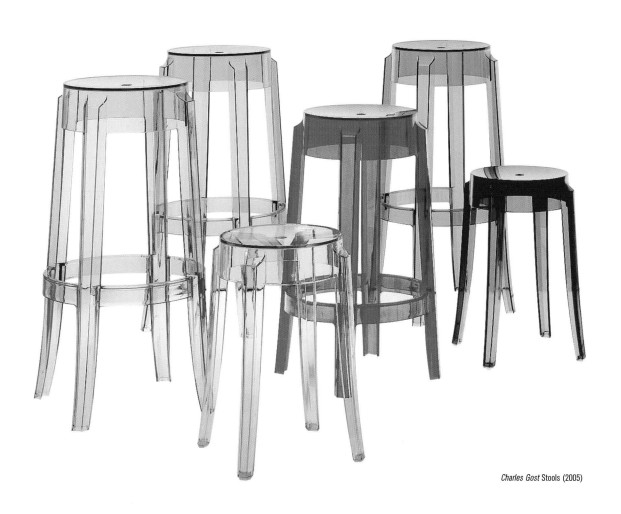

Charles Gost Stools (2005)

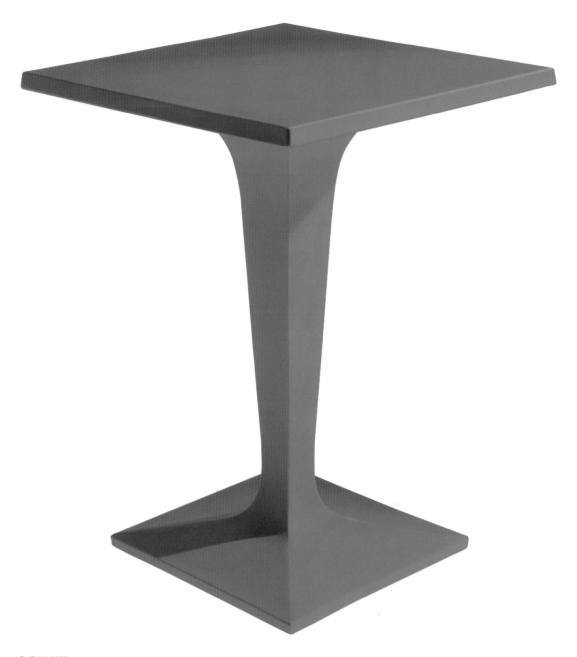

Toy Table (2006)

Philippe Starck

18/20, rue du Faubourg du Temple, 75011 Paris

+33 148 07 54 54

+33 148 07 54 64

www.philippe-starck.com

info@philippe-starck.com

Philippe Starck

He may be an eccentric rebel, but Philippe Starck is without a doubt a genius of contemporary design. Even as a child, he dedicated himself to drawing and design, together with his father. In 1979, he founded his company, Starck Products, and began to excel in the design of Parisian nightclubs. In 1982, François Mitterrand entrusted him with the redecoration of the Élysée Palace. His inventiveness and imagination are limitless and his company is internationally renowned.

Philippe Starck ist ein exzentrischer Regelübertreter, aber zweifelsfrei ein Genie des zeitgenössischen Designs. Bereits während seiner Kindheit widmete er sich dem Zeichnen und dem Design, zusammen mit seinem Vater. 1979 gründet er seine Firma Starck Products und begann, sich mit der Gestaltung von Pariser Nachtclubs hervorzutun. 1982 betraut ihn François Mitterrand mit der Neudekoration des Élysée-Palastes. Seine Erfindungsgabe und seine Vorstellungskraft sind grenzenlos und seine Firma ist international renommiert.

Excentrique et hors normes, mais sans aucun doute un génie du design contemporain, Philippe Starck passe son enfance à dessiner et créer aux côtés de son père. En 1979, Il fonde sa société, Starck Products, et commence à se distinguer par le design de boîtes de nuits de Paris. En 1982, François Mitterrand lui confie la restauration du Palais de l'Élysée. Son ingéniosité et imagination sont sans limites et sa société est désormais reconnue sur le plan international.

Excéntrico y transgresor, pero sin duda un genio del diseño contemporáneo, Philippe Starck pasó su infancia dibujando y creando junto a su padre. En 1979, funda su firma, Starck Products, y empieza a despuntar con el diseño de clubs nocturnos de París. En 1982, François Mitterrand le confía la redecoración del Palacio de los Elíseos. Su ingenio e imaginación no tienen límites y su firma es reconocida ya internacionalmente.

Eccentrico e trasgressivo ma allo stesso tempo genio indiscusso del design contemporaneo, Philippe Starck disegna e crea insieme al padre già durante l'infanzia. Nel 1979 dà vita alla propria azienda, Starck Products, e comincia a farsi notare con la progettazione di alcuni locali notturni di Parigi. Nel 1982 François Mitterrand gli commissiona l'arredamento dei suoi appartamenti privati nel Palazzo dell'Eliseo. Il suo ingegno e la sua creatività non hanno limiti, la sua azienda è rinomata a livello internazionale.

Philippe Starck

1949
Born in Paris, France

1965
Start his studies at École Nissim de Camodo, Paris, France

1968
Founds his first business producing inflatable objects

1969
Becomes artistic director for Cardin

1979
Creates the society Starck Products

1984
Designs the interior of the Café Costes in Paris, France

1988
Grand Prix National de la Création Industrielle, France

2000
Designs Chez Bon, Paris, France; Sanderson Hotel, London, UK; Hudson Hotel, New York, USA

2006
Restaurant Bon, Moscow, Russia

Interview | Philippe Starck

Which do you consider the most important work of your career? The next one. Everything you do must be done with the best quality and intelligence.

In what ways does Paris inspire your work? The fact is I am incredibly French, obviously European, absolutely worldly and, finally, totally stateless.

Does a typical Paris style exist, and if so, how does it show in your work? I think that Paris has some powerful assets, including great creators and industrial know-how, but it needs to develop faster. Sometimes I feel Paris needs to have more desire.

How do you imagine Paris in the future? Paris has an extraordinary potential, but it has been asleep for such a long time. It's dangerous because being hot is not only a media phenomenon. It's a vicious cycle: energy brings even more energy.

Welches Werk halten Sie für das wichtigste Ihrer Karriere? Das nächste. Alles muss mit der höchsten Qualität und Intelligenz geschaffen werden.

Wie inspiriert Paris Ihre Arbeit? Die Wahrheit ist: Ich bin unglaublich französisch, offensichtlich europäisch, absolut irdisch und, letzten Endes, total staatenlos.

Gibt es einen typischen Pariser Stil, und wenn ja, wie macht dieser sich in Ihrer Arbeit bemerkbar? Ich glaube, dass Paris über einige starke Pluspunkte verfügt, einschließlich großer Künstler und industriellen Know-hows, aber es müsste sich schneller entwickeln. Manchmal habe ich das Gefühl, Paris brauche mehr Sehnsucht.

Wie stellen Sie sich Paris in der Zukunft vor? Paris hat ein außergewöhnliches Potenzial, aber es hat für so lange Zeit geschlafen. Das ist gefährlich, denn cool zu sein ist nicht nur ein Medienphänomen. Es ist ein Teufelskreis: Energie bringt noch mehr Energie.

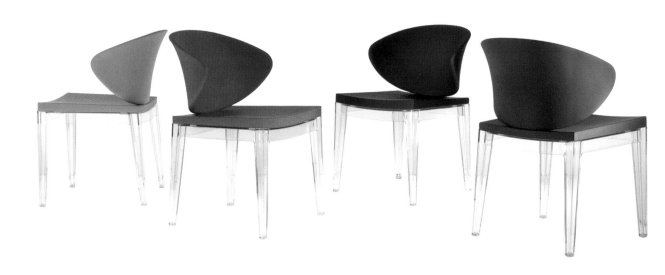

Madame Pol Chairs (2005)

Quelle est à vos yeux l'œuvre la plus importante de votre carrière ? La prochaine. Tout ce que vous réalisez doit être d'une qualité extrême et fait le plus intelligemment possible.

Dans quelle mesure votre œuvre artistique s'inspire-t-elle de Paris ? En fait, je suis incroyablement français, européen de toute évidence, un homme de la planète, et, en fin de compte, pas du tout national.

Existe-t-il un style typiquement parisien, et si oui, comment se manifeste-t-il dans votre œuvre ? Je crois que Paris a des acquis énormes, y compris de grands créateurs et un important savoir-faire industriel, mais il doit se développer plus vite. J'ai parfois l'impression que Paris devrait exprimer davantage de désirs.

Comment imaginez-vous le Paris du futur ? Paris a un potentiel extraordinaire, mais il est resté endormi pendant longtemps. C'est dangereux parce qu'être à la mode n'est pas seulement un phénomène de média. C'est un cercle vicieux : l'énergie engendre encore plus d'énergie.

¿Cuál cree que es el trabajo más importante de su carrera? El próximo. Todo lo que hagas debe estar realizado con la mejor calidad e inteligencia.

¿Cómo le inspira París en su trabajo? El hecho es que, por increíble que parezca, soy francés, obviamente europeo, absolutamente ciudadano del mundo y, finalmente, totalmente apátrida.

¿Existe un estilo típico de París? Y si es así, ¿cómo se muestra éste en su obra? Creo que París cuenta con unos valores realmente poderosos, lo que incluye a grandes creadores y conocimientos industriales, pero necesita desarrollarse más rápido. En algunas ocasiones siento que París necesita tener más deseo.

¿Cómo se imagina París en un futuro? París tiene un potencial extraordinario, pero ha estado dormida durante mucho tiempo. Esto resulta peligroso porque estar de moda no es sólo un fenómeno mediático. Es un círculo vicioso: la energía atrae aún más energía.

Quale ritiene sia l'opera più importante della sua carriera? La prossima. Tutto quello che si fa deve essere realizzato con la massima qualità e intelligenza.

In che modo Parigi ispira il suo lavoro? Il fatto è che sono incredibilmente francese, ovviamente europeo, assolutamente mortale e, per finire, totalmente apolide.

Esiste un tipico "stile parigino"? Se sì, come si manifesta nel suo lavoro? Credo che Parigi abbia alcuni importanti pregi, tra cui grandi creativi e un know-how industriale, ma ha bisogno di evolversi più in fretta. A volte, ho la sensazione che Parigi abbia bisogno di più desiderio.

Come immagina Parigi nel futuro? Parigi ha uno straordinario potenziale ma è rimasta addormentata per moltissimo tempo. È pericoloso perché la popolarità non è solo un fenomeno mediatico. È un circolo vizioso: l'energia genera energia.

Top Cut Chairs (2005)

Product Collection

Philippe Starck has managed to revolutionize the world of product design. He has re-examined the predominant aesthetics, created playful and original forms and demonstrated that design does not have run counter to functionality, the ultimate purpose of every object. This is the guiding principle of Philippe Starck, who has a unique talent in transforming any material into a work of art.

Philippe Starck hat die Welt des Produktdesigns revolutioniert: Er hat die vorherrschende Ästhetik überprüft, witzige und originelle Formen gestaltet und bewiesen, dass Design nicht im Widerspruch zur Funktionalität stehen muss, dem letztendlichen Zweck jeden Objekts. Dies ist der Leitgedanke des Designers, der über die Gabe verfügt, jedes Material in ein Kunstwerk verwandeln zu können.

Philippe Starck est parvenu à révolutionner le monde du design industriel en revisitant l'esthétique, innovant avec des formes amusantes et originales et démontrant que cette philosophie de l'image ne doit absolument pas renoncer à la fonctionnalité, but ultime de tout objet. C'est le principe directeur de ce designer doué : transformer tout matériau en œuvre d'art.

Philippe Starck ha logrado revolucionar el mundo del diseño de producto al plantear una revisión de la estética, innovar con formas divertidas y originales y demostrar que esta filosofía de la imagen no debe en absoluto reñir con la funcionalidad, el fin de cualquier objeto. Éste es el principio rector de este diseñador y su don: transformar cualquier material en una obra de arte.

Philippe Starck è riuscito a rivoluzionare il mondo del design industriale mediante una revisione dei canoni estetici predominanti che ha innovato introducendo forme divertenti e originali, dimostrando che design e funzionalità (il fine ultimo di qualsiasi oggetto) non debbano necessariamente escludersi a vicenda. Ecco il principio guida di questo designer e il segreto del suo dono naturale: saper trasformare qualsiasi materiale in un'opera d'arte.

Bo Chair (2006)

Lord Yo Chair (2006)

Royal T (2006)

Philippe Starck

LA Oil Tin (2006)

Travel Cot (2006)

Travel High Chair (2006)

Icon Stools (2006)

Maison Baccarat

Year: 2004
Photographs: © Claude Weber

Philippe Starck was commissioned with the decoration of this building, which was built in 1895 and today houses the crystal manufacturer Baccarat. He turned it into a magical glass palace in the Baroque style with majestic candelabras hanging from the ceiling. In the boutique, a large table-mirror displays the delicate pieces as if they were jewels, while the four display cases of the gallery enclose the most beautiful and oldest creations of the house. The interaction of mirrors and glass is repeated in the restaurant run by chef Thierry Burlot.

Philippe Starck wurde mit der Dekoration dieses Gebäudes betraut, das 1895 errichtet wurde und heute Sitz des Kristallherstellers Baccarat ist. Er machte es zu einem magischen Kristallpalast im barocken Stil mit majestätischen Kandelabern, die von den Decken hängen. In der Boutique werden die zerbrechlichen Stücke wie Juwelen auf einem großen Spiegeltisch ausgestellt und die vier Vitrinen der Galerie zeigen die schönsten und ältesten Kreationen des Hauses. Das Zusammenspiel von Spiegeln und Kristall wird im Restaurant fortgesetzt, dessen Chefkoch Thierry Burlot ist.

Philippe Starck a été chargé de la décoration de cet édifice, construit en 1895 et actuellement siège de Baccarat. Il en résulte un palais de verre magique, à l'esthétique baroque et aux lustres majestueux qui tombent du plafond. Dans la boutique, une grande table-miroir permet d'exposer les pièces délicates, comme s'il s'agissait de bijoux tandis que les quatre vitrines de la galerie-musée contiennent les créations les plus belles et anciennes de la maison. Le jeu de miroirs et de verre se retrouve dans le restaurant, dirigé par le chef Thierry Burlot.

Philippe Starck ha sido el encargado de la decoración de este edificio, construido en 1895 y actualmente sede de Baccarat. El resultado es un mágico palacio de cristal de estética barroca y candelabros majestuosos que penden del techo. En la boutique, una gran mesa-espejo permite mostrar las delicadas piezas como si de joyas se tratara, mientras que las cuatro vitrinas de la galería-museo encierran las creaciones más bellas y antiguas de la casa. El juego de espejos y cristal se repite en el restaurante, a cargo del chef Thierry Burlot.

Philippe Starck è stato incaricato della decorazione di questo edificio, costruito nel 1895 e oggi sede di Baccarat. Il risultato è un magico palazzo di cristallo dall'estetica barocca, con candelabri maestosi che pendono dal soffitto. Nella boutique, un grande tavolo a specchio permette di mostrare i delicati pezzi come se si trattasse di gioielli, mentre le quattro vetrine della galleria-museo racchiudono le creazioni più belle e antiche della maison. Il gioco di specchi e cristalli si ripete nel ristorante, diretto dallo chef Thierry Burlot.

Philippe Starck

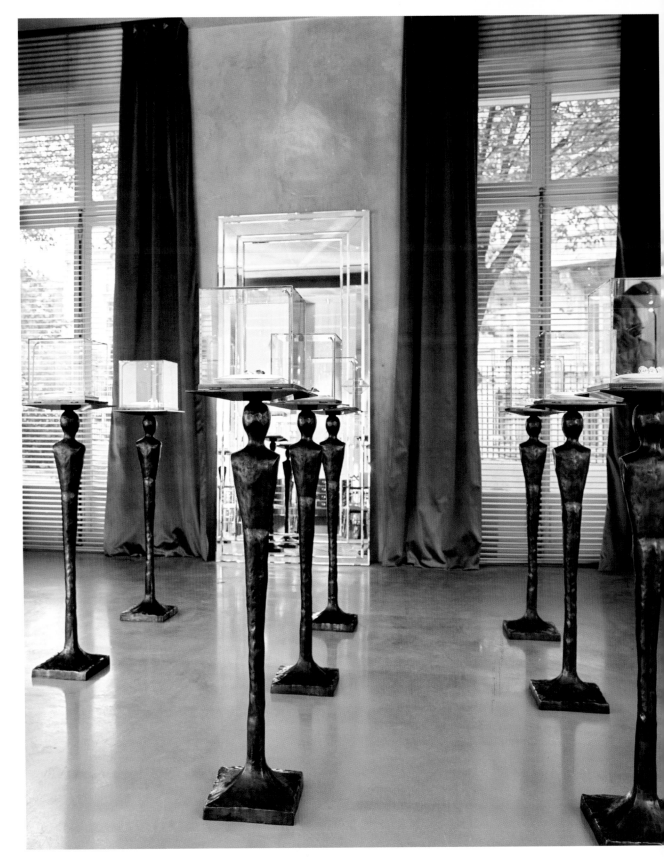

Philippe Starck

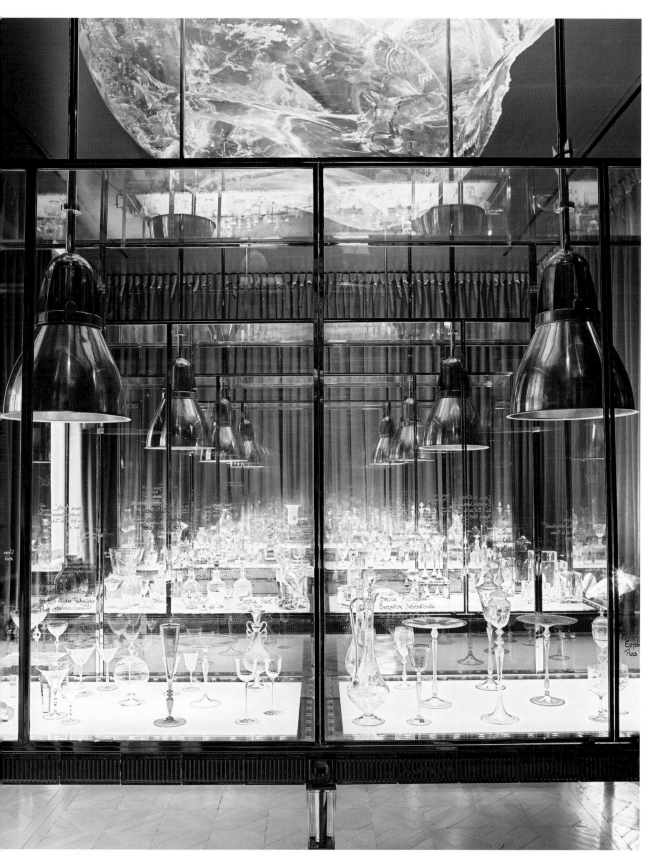

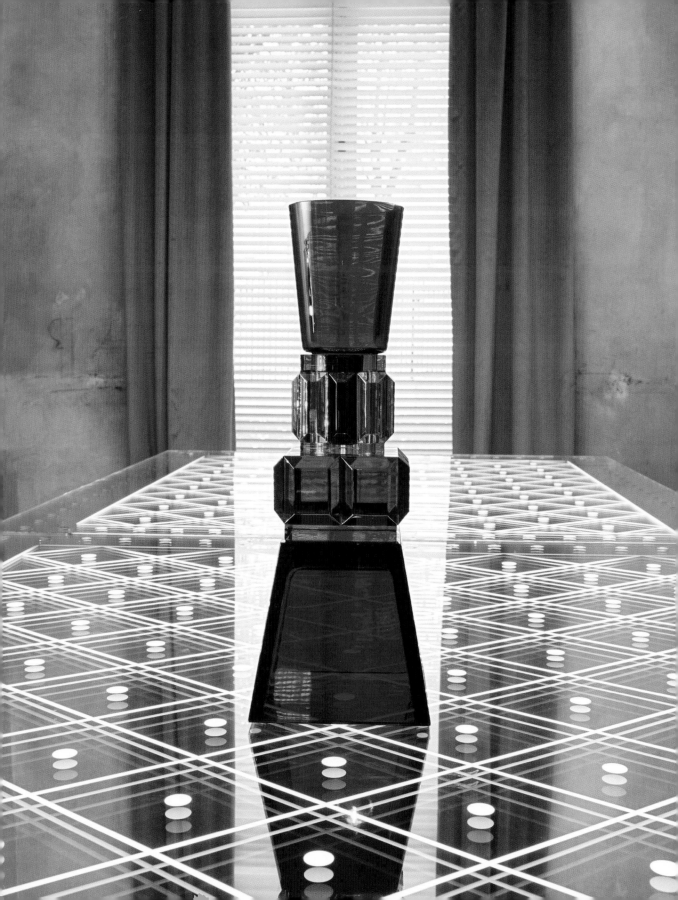

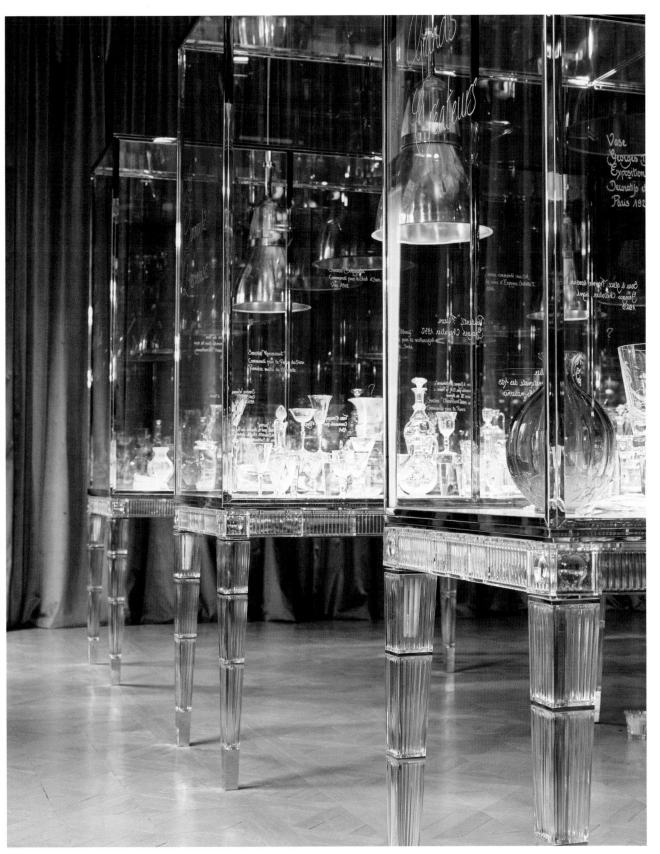

Ronan & Erwan Bouroullec

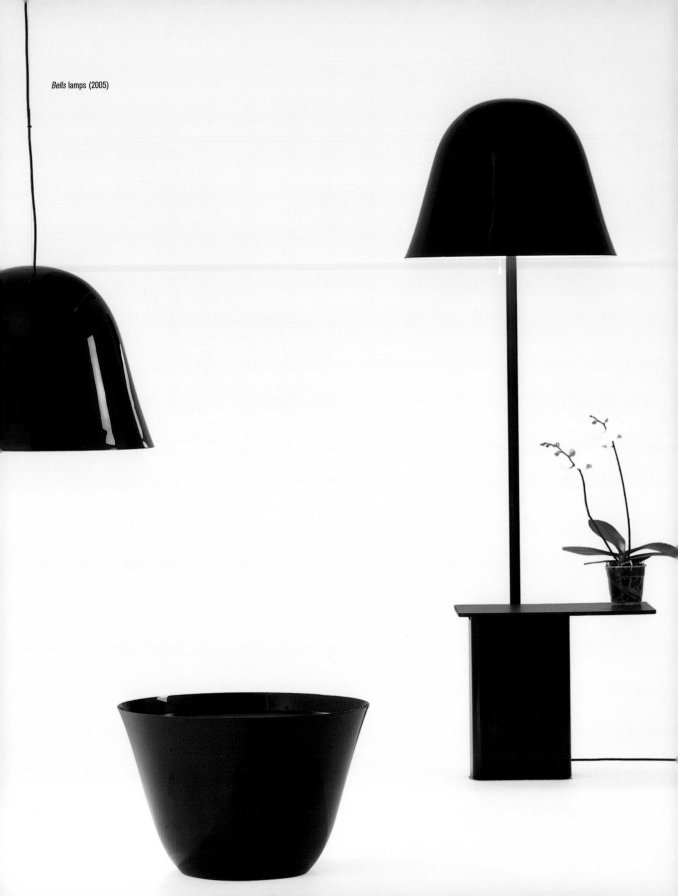

Bells lamps (2005)

Ronan & Erwan Bouroullec

23, rue du Buisson Saint-Louis, 75010 Paris

+33 142 00 52 11 (fax)

www.bouroullec.com

info@bouroullec.com

Ronan & Erwan Bouroullec

These two brothers are not only bonded by family, but also by their vocation for design. Erwan began collaborating with Ronan while he was still studying, and in 1999 this collaboration became a permanent work relationship. Despite their brief professional history, they have already been chosen for prestigious design awards. They have worked for numerous well-known furniture brands and their designs have been displayed in museums throughout the world.

Diese zwei Brüder verbindet nicht nur die Familie, sondern auch ihre Berufung für das Design. Erwan begann noch während des Studiums mit Ronan zusammenzuarbeiten und 1999 wurde diese Kooperation zu einer dauerhaften Arbeitsbeziehung. Trotz ihrer kurzen beruflichen Laufbahn wurden sie bereits mit angesehenen Design-Preisen ausgezeichnet. Sie haben für viele bekannte Möbelmarken gearbeitet und ihre Werke wurden in Museen auf der ganzen Welt ausgestellt.

Ces frères sont unis, outre la parenté, par la vocation du design. Erwan commence à collaborer avec Ronan alors qu'il étudie encore, et, en 1999, cette collaboration devient permanente. Dès lors, malgré leur courte trajectoire professionnelle, ils se sont déjà vu décernés de prestigieux prix de design. Ils créent pour de nombreuses marques renommées de mobilier et leurs designs sont exposés dans des musées du monde entier.

A estos hermanos los une, además del parentesco, su vocación para el diseño. Erwan empezó colaborando con Ronan mientras estudiaba y en 1999 esta colaboración se hizo permanente. Desde entonces, pese a su corta trayectoria profesional, ya han sido reconocidos con prestigiosos premios al diseño, han creado para numerosas y conocidas marcas de mobiliario y sus diseños han sido expuestos en museos de todo el mundo.

Questi fratelli, oltre che dal legame di sangue, sono uniti dalla vocazione per il design. Erwan comincia a collaborare con Ronan ancora durante gli studi, nel 1999 poi questa collaborazione diventa permanente. Da allora, nonostante la loro breve traiettoria professionale, sono già stati premiati con prestigiosi riconoscimenti del mondo del design, hanno creato per numerosi e conosciuti marchi d'arredamento e i loro progetti sono stati esposti nei musei di tutto il mondo.

1971
Ronan born in Quimper, France

1976
Erwan born in Quimper, France

1999
Permanent collaboration between Ronan and Erwan

1999
Best New Designer Awards, International Contemporary Furniture Fair (IFCC), New York, USA

2002
Start collaborating with Vitra

2003
Voted Designer of the Year by Elle Decoration, Japan

2004
Exhibition at the Museum of Contemporary Art in Los Angeles, USA
Exhibition at Museum Boijmans van Beuningen in Rotterdam, The Netherlands

2006
Floating House in Paris, France

Interview | Ronan & Erwan Bouroullec

Which do you consider the most important work of your career? We do not have a "most important work." We value all the projects we have made and have had great pleasure in doing them. Each one is a specific answer to the question and inspirations. Every project is a complex alchemy including various factors… and there is none we prefer.

In what ways does Paris inspire your work? Pfffffffff!

Does a typical Paris style exist, and if so, how does it show in your work? We don't believe there is a typical Paris style in design today. Parisian designers have very diverse styles, moreso than anywhere else in the world.

How do you imagine Paris in the future? "Paris will always be Paris…" In fact, Paris is a already a built-up city that may not evolve too much more, architecturally speaking. We find it a more or less stiff city.

Welches Werk halten Sie für das wichtigste Ihrer Karriere? Wir haben kein „wichtigstes Werk". Wir schätzen alle Projekte, die wir realisiert haben, und es hat uns großen Spaß gemacht, sie zu schaffen. Jedes für sich ist eine spezifische Antwort auf eine Frage und Inspirationen. Jedes Projekt ist eine komplexe Alchemie, die verschiedene Faktoren enthält … und es gibt keins, das wir bevorzugen.

Wie inspiriert Paris Ihre Arbeit? Pfffffffff!

Gibt es einen typischen Pariser Stil, und wenn ja, wie macht dieser sich in Ihrer Arbeit bemerkbar? Wir glauben nicht, dass es einen typischen Pariser Stil im heutigen Design gibt. Die Pariser Designer haben sehr verschiedene Stile, noch mehr als anderenorts auf der Welt.

Wie stellen Sie sich Paris in der Zukunft vor? „Paris wird immer Paris sein …" Genau genommen ist Paris bereits eine fertig gebaute Stadt, die sich architektonisch vielleicht nicht wesentlich weiter entwickeln wird. Wir finden, dass Paris eine eher steife Stadt ist.

Assemblage Collection (2004)

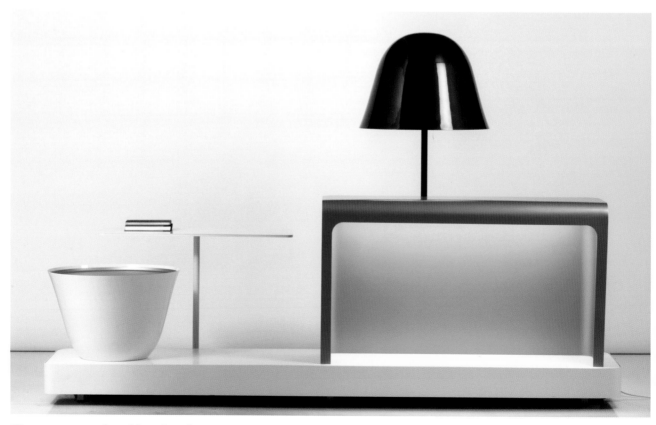

Quelle est à vos yeux l'œuvre la plus importante de votre carrière ? Aucune de nos œuvres n'est « la plus importante ». Pour nous, tous les projets réalisés ont de la valeur et nous éprouvons un grand plaisir à les faire. Chacun d'eux est la réponse spécifique à des questions et inspirations. Chaque projet est une alchimie composée de divers facteurs…et nous n'en préférons aucun.

Dans quelle mesure votre œuvre artistique s'inspire-t-elle de Paris ? Pffffffff !

Existe-t-il un style typiquement parisien, et si oui, comment se manifeste-t-il dans votre œuvre ? Nous ne pensons pas que dans le design d'aujourd'hui, il y ait un style typique. Les designers parisiens ont des styles très divers, plus que partout ailleurs dans le monde.

Comment imaginez-vous le Paris du futur ? « Paris sera toujours Paris… ». En fait, Paris est une ville déjà construite qui n'évoluera sans doute pas beaucoup, sur le plan architectural. C'est une ville que nous trouvons assez rigide.

¿Cuál cree que es el trabajo más importante de su carrera? No tenemos un trabajo que sea "el más importante". Damos un valor especial a todos los proyectos que hemos realizado y hemos disfrutado mucho durante su elaboración. Cada uno resulta una respuesta específica a diversas preguntas e inspiraciones. Todo proyecto es una compleja alquimia que abarca varios factores… y no hay uno que prefiramos ante los demás.

¿Cómo le inspira París en su trabajo? ¡Puuuffffffff!

¿Existe un estilo típico de París? Y si es así, ¿cómo se muestra éste en su obra? No creemos que haya un estilo típico de París en el mundo del diseño actual. Los diseñadores parisinos poseen estilos muy diversos, incluso más que en cualquier otro lugar del mundo.

¿Cómo se imagina París en un futuro? "París será siempre París…". En realidad París es ya una ciudad muy edificada que puede que no evolucione demasiado, desde el punto de vista arquitectónico. Consideramos París una ciudad más bien rígida.

Quale ritiene sia l'opera più importante della sua carriera? Non esiste "l'opera più importante". Valorizziamo tutti i progetti che abbiamo realizzato e da tutti abbiamo tratto grande soddisfazione. Ognuno di essi è una risposta specifica a diverse domande e ispirazioni. Ogni progetto è un'alchimia complessa che implica vari fattori… e non ne preferiamo nessuno.

In che modo Parigi ispira il suo lavoro? Uff!!

Esiste un tipico "stile parigino"? Se sì, come si manifesta nel suo lavoro? Non crediamo che attualmente esista un tipico stile parigino nel design. I designer parigini hanno stili molto diversi, qui ancora di più che in altre parti del mondo.

Come immagina Parigi nel futuro? "Parigi sarà sempre Parigi…" Di fatto, Parigi è una città già strutturata che non potrà evolversi ancora molto dal punto di vista architettonico. La riteniamo una città piuttosto rigida.

Faccett Sofa (2005)

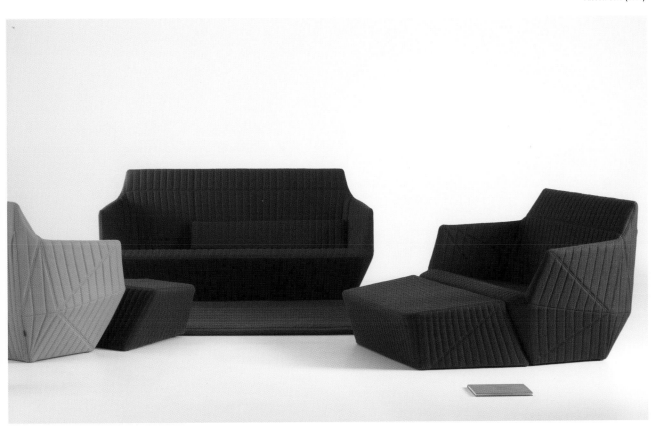

Product Collection

Photographs: © Paul Tahon, Ronan & Erwan Bouroullec, Vitra

Pureness of execution characterizes the designs of these two brothers. The two designers complement each other perfectly: Ronan is responsible for the design and Erwan for the art. Their creations are original, yet functional, and push the limits of conventional design. In other words: They are bold and original concepts with a striking design for everyday use.

Die Entwürfe dieser zwei Brüder sind gekennzeichnet von einer tadellosen Ausführung. Die beiden Designer ergänzen sich perfekt: Ronan ist für das Design zuständig und Erwan für die Kunst. Ihre Kreationen sind originell und doch funktionell und stellen eine Herausforderung für die Beschränkungen des konventionellen Designs dar. Kurzum: Es sind kühne und originelle Entwürfe mit einem auffälligen Design für den alltäglichen Gebrauch.

La pureté de l'exécution se reflète dans chacun des designs de ces deux frères dont la collaboration répond à un effort parfaitement complémentaire : Ronan pour le design et Erwan pour l'art. Leurs créations originales ne sont pas pour le moins fonctionnelles, fortes de la particularité de défier les limites du design conventionnel. En d'autres termes : ce sont des propositions osées et originales, dotées d'une esthétique affichée, destinées à l'usage quotidien.

La pureza en la ejecución se revela en cada uno de los diseños de estos dos hermanos que colaboran de forma complementaria: Ronan en el diseño y Erwan en el arte. Sus originales creaciones no dejan de ser piezas funcionales con la particularidad de desafiar las limitaciones del diseño convencional. Dicho de otro modo: son propuestas atrevidas y originales, con una estética llamativa, para el uso diario.

La purezza nell'esecuzione si rivela in ognuno dei disegni di questi due fratelli, la cui collaborazione risponde ad uno sforzo totalmente complementare: Ronan nel design ed Erwan nell'arte. Le loro originali creazioni sono, al tempo stesso, oggetti funzionali, con la particolarità di sfidare i limiti del design convenzionale. In altre parole: proposte da usare nel quotidiano, audaci, originali e dall'estetica appariscente.

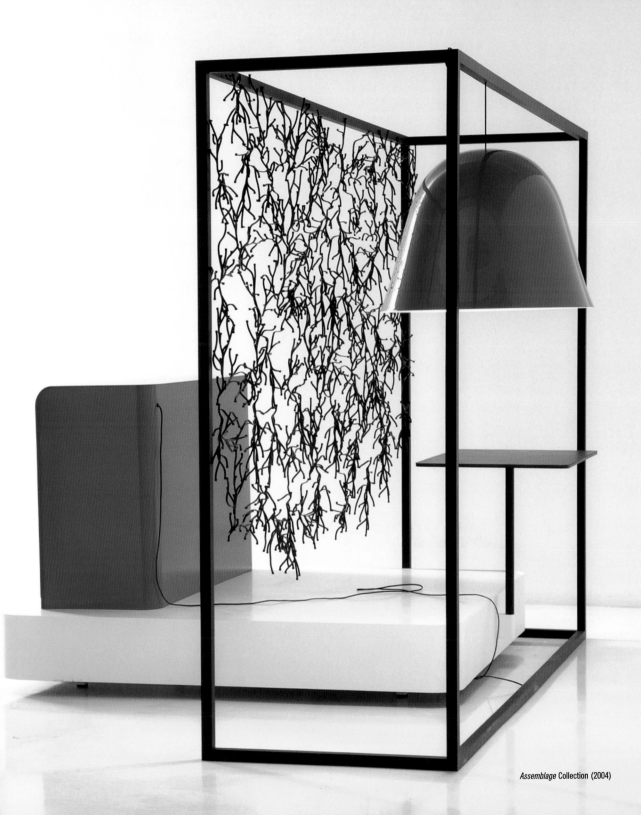

Assemblage Collection (2004)

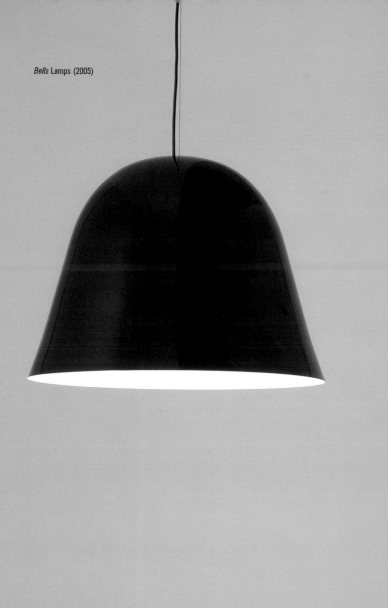

Bells Lamps (2005)

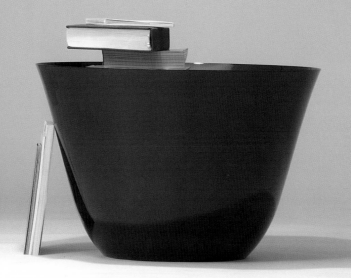

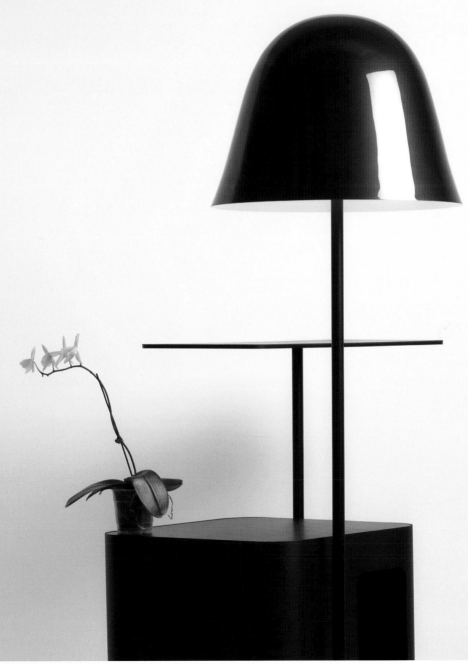

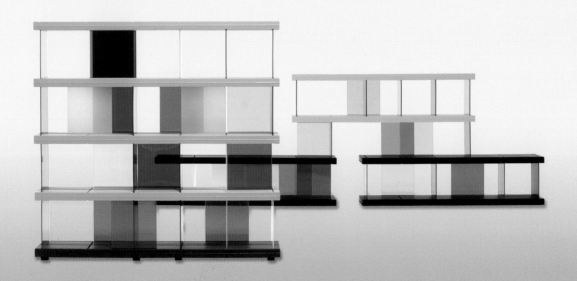

Self Shelf (2004)

Ronan & Erwan Bouroullec

Self Shelf (2004)

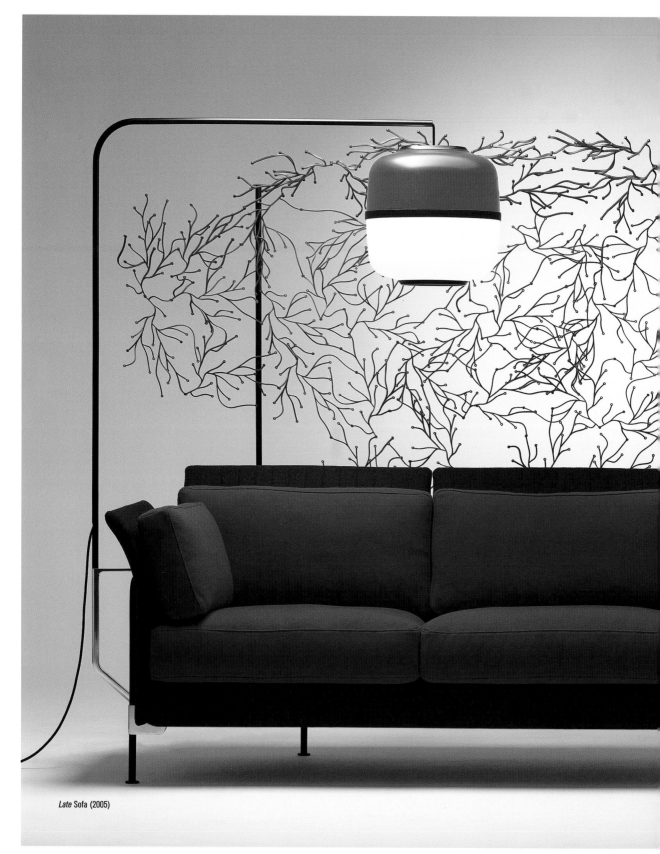

Late Sofa (2005)

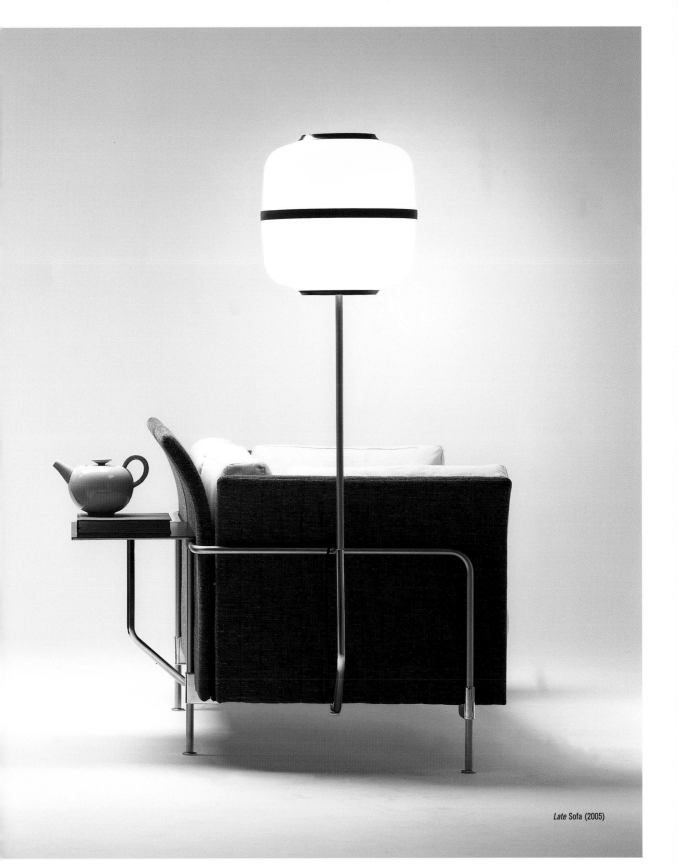

Late Sofa (2005)

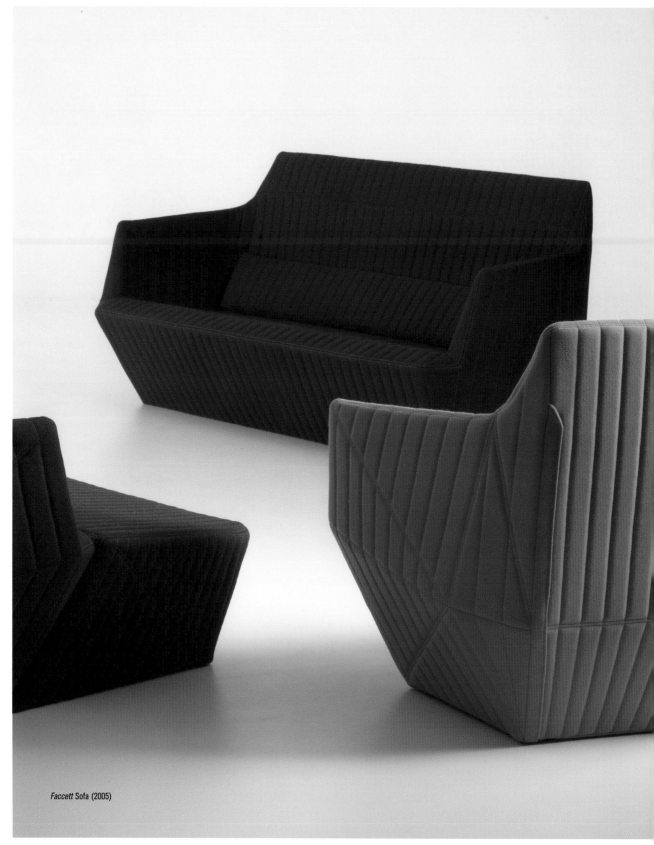

Faccett Sofa (2005)

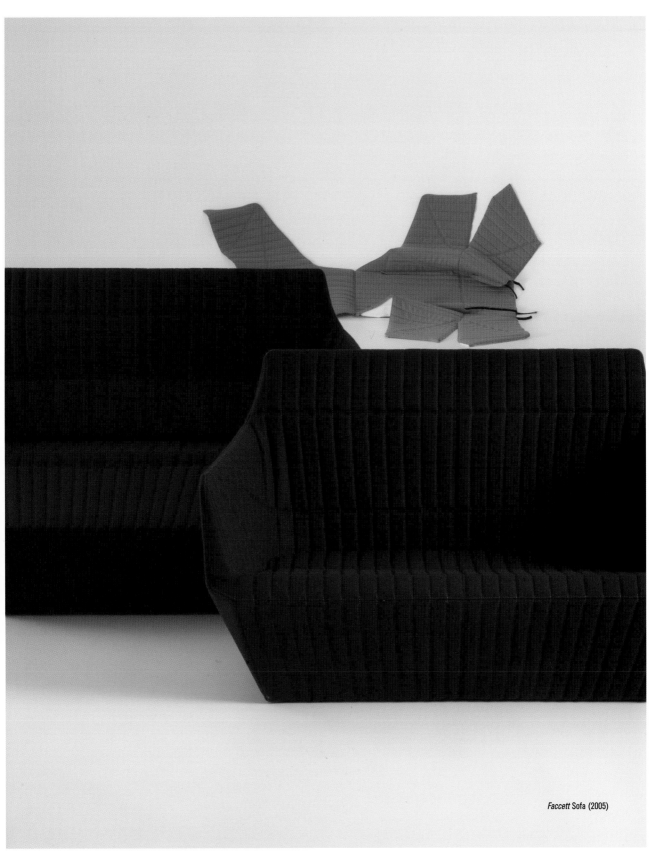

Faccett Sofa (2005)

Faccett Sofa (2005)

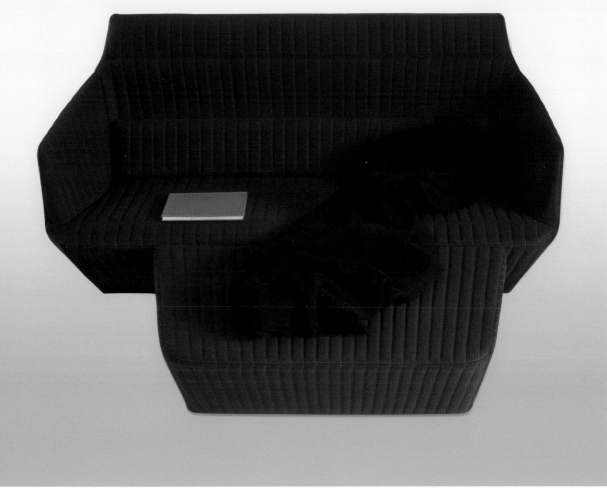

Slow Chair (2006)

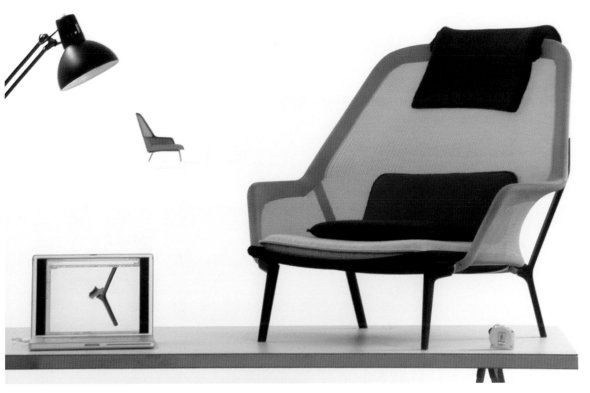

Slow Chair (2006)

Floating House

Year: 2006

Photographs: © Paul Tahon, Ronan & Erwan Bouroullec

The Floating House on the River Seine is a houseboat moored to the "Island of the Impressionists" in Chatou and was designed together with architects Jean-Marie Finot and Denis Daversin. Its aluminum skin offers 1,200 ft² of habitable space and is surrounded by a wooden frame. The line between working space and living space has been left undefined. Climbers planted on the terraces will gradually cover the exterior, visually merging the boat with its surroundings and protecting the privacy of the residents.

Das schwimmende Haus auf der Seine ist ein Hausboot, das an der „Insel der Impressionisten" in Chatou festgemacht ist und mit den Architekten Jean-Marie Finot und Denis Daversin gemeinsam konzipiert wurde. Seine Aluminiumhaut birgt 110 m² Wohnfläche und ist von einem Holzgestell umschlossen. Die Grenze zwischen Arbeits- und Wohnbereich bleibt undefiniert. Die Schlingpflanzen, die auf der Terrasse gepflanzt sind, bedecken nach und nach die Außenseiten und lassen so das Boot mit der Umgebung optisch verschmelzen, die Intimsphäre der Bewohner schützend.

La maison Flottante sur la Seine est une péniche habitable amarrée à l'« Ile » des Impressionnistes, à Chatou, réalisée en collaboration avec les architectes Jean-Marie Finot et Denis Daversin. Une peau d'aluminium habille les 110 m² d'espace habitable, recouvert à son tour d'une ossature de bois. Les limites entre les zones de travail et d'habitation demeurent indéfinies. Les plantes grimpantes des terrasses, recouvriront peu à peu l'extérieur, l'intégrant visuellement à l'environnement tout en préservant l'intimité des habitants.

La casa Flotante sobre el río Sena es una barca habitable amarrada a la "Isla de los Impresionistas", en Chatou, construida junto con los arquitectos Jean-Marie Finot y Denis Daversin. Una piel de aluminio reviste los 110 m² de espacio habitable, que a su vez está cubierta por un armazón de madera. Las fronteras entre la zona de trabajo y de vivienda quedan indefinidas. Las enredaderas, plantadas en las terrazas, van cubriendo poco a poco el exterior, integrándolo visualmente con el entorno al tiempo que preservarán la intimidad de los habitantes.

La casa galleggiante sulla Senna è una barca abitabile attraccata presso "l'Isola degli impressionisti", a Chatou, realizzata insieme agli architetti Jean-Marie Finot e Denis Daversin. Un rivestimento in alluminio copre come una seconda pelle i 110 m² di spazio abitabile, ed è a sua volta ricoperto da un telaio in legno. La delimitazione tra la zona di lavoro e l'abitazione resta indefinita. I rampicanti, piantati sulla terrazza, copriranno poco a poco l'esterno e lo integreranno visivamente con il contesto, preservando allo stesso tempo l'intimità degli abitanti.

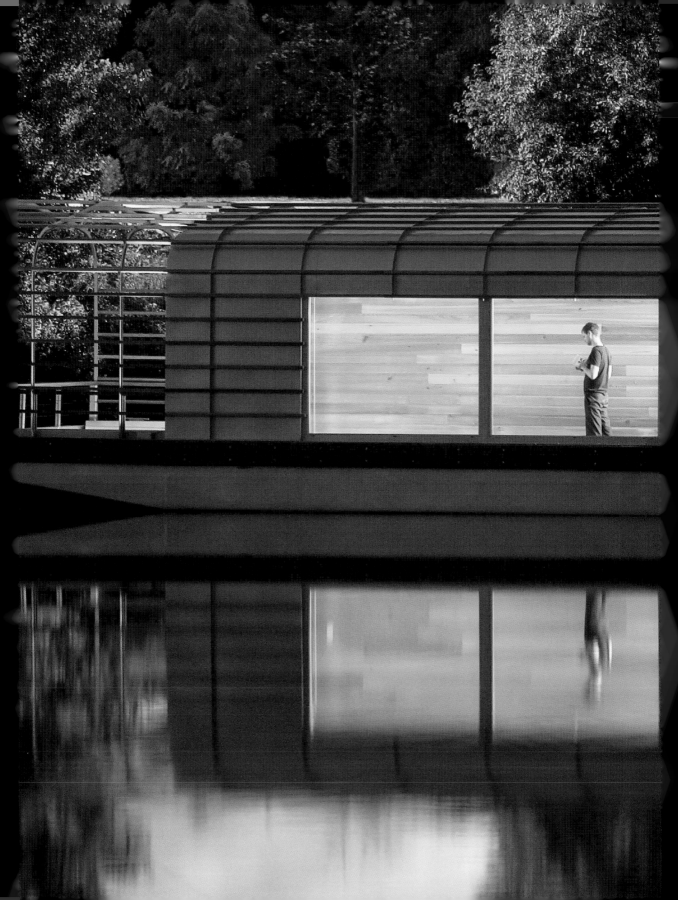

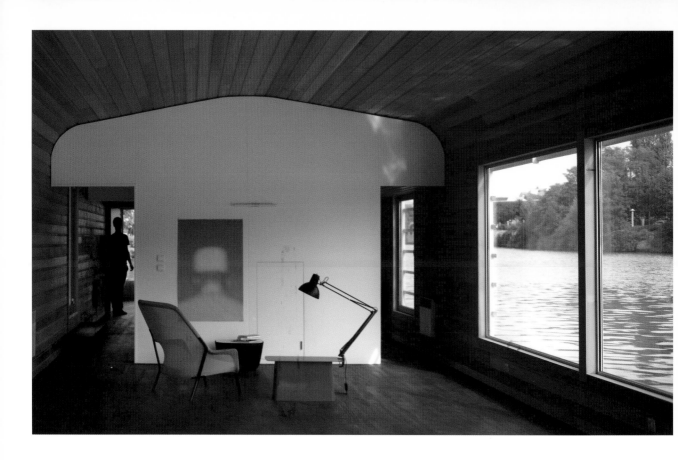

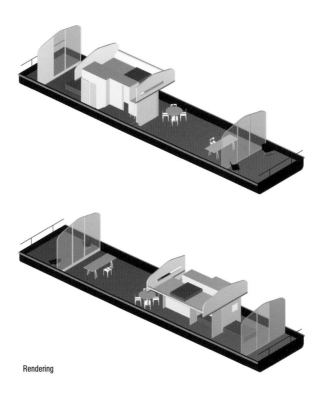

Rendering

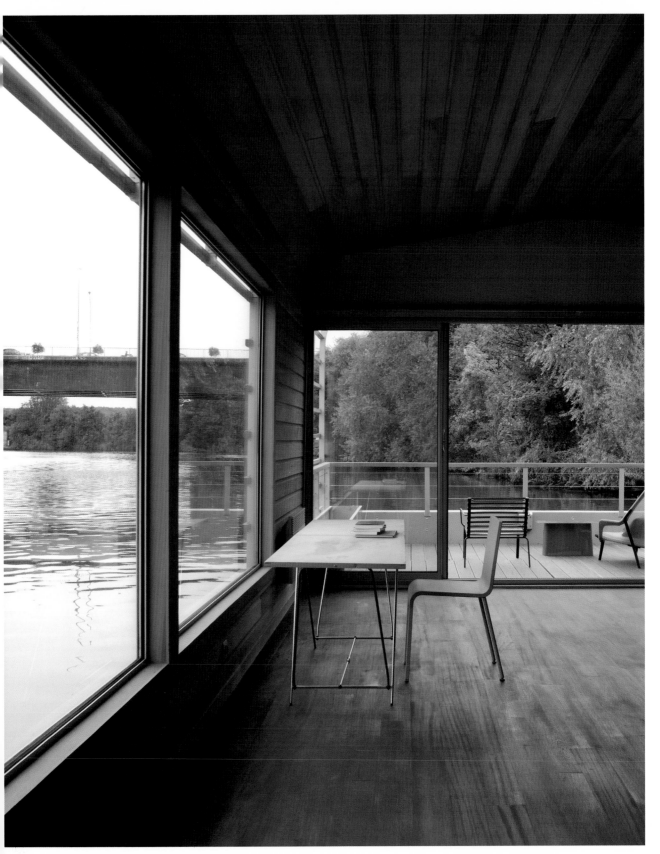

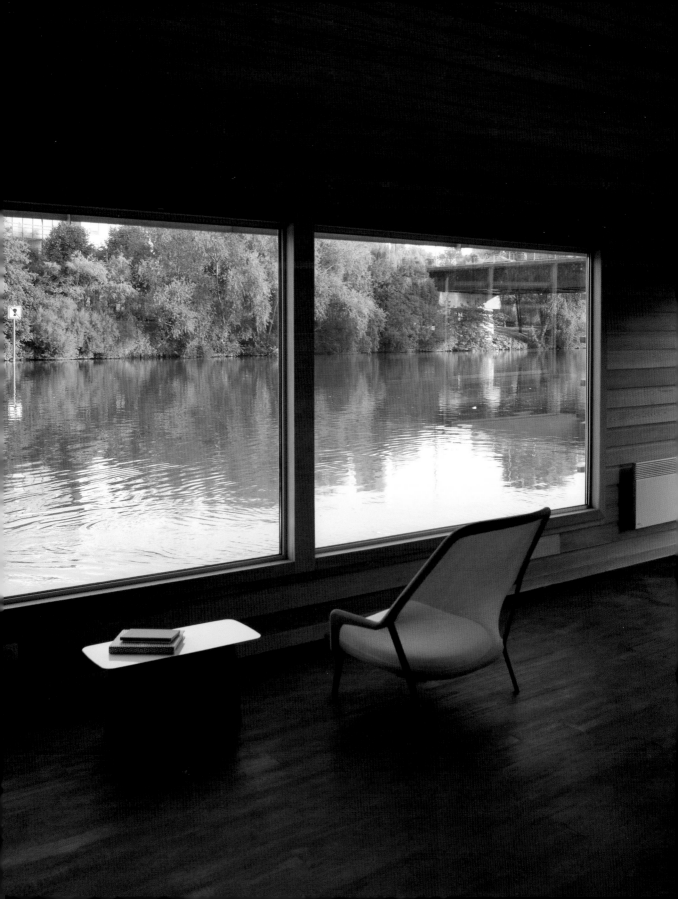

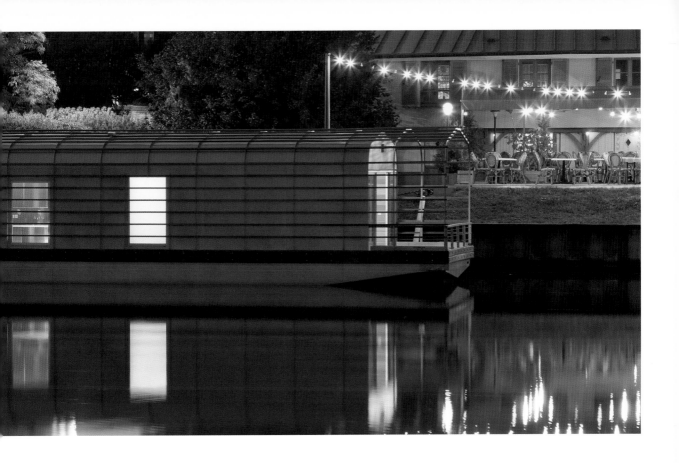

Sketch

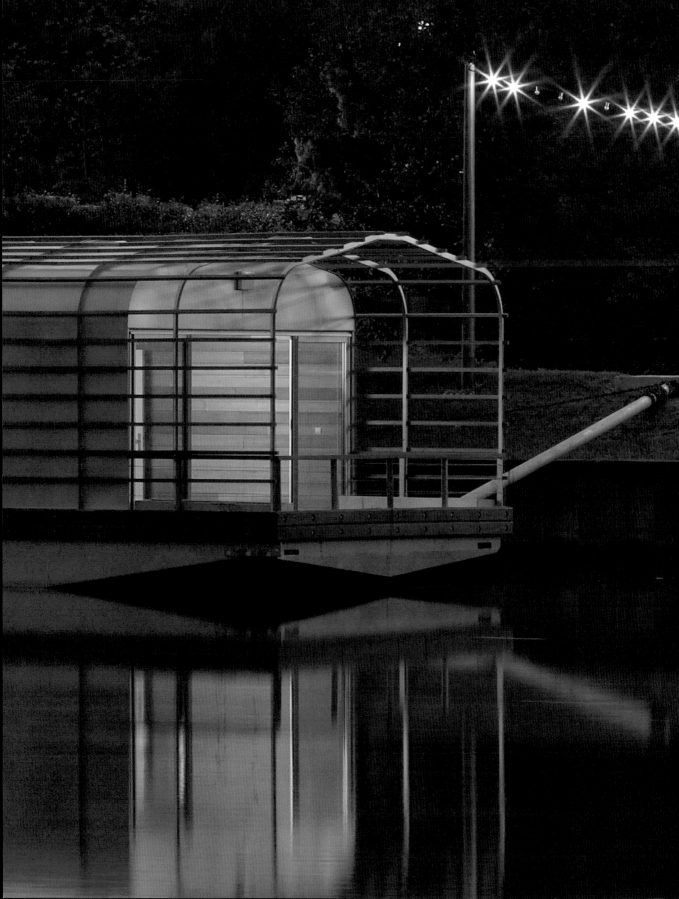

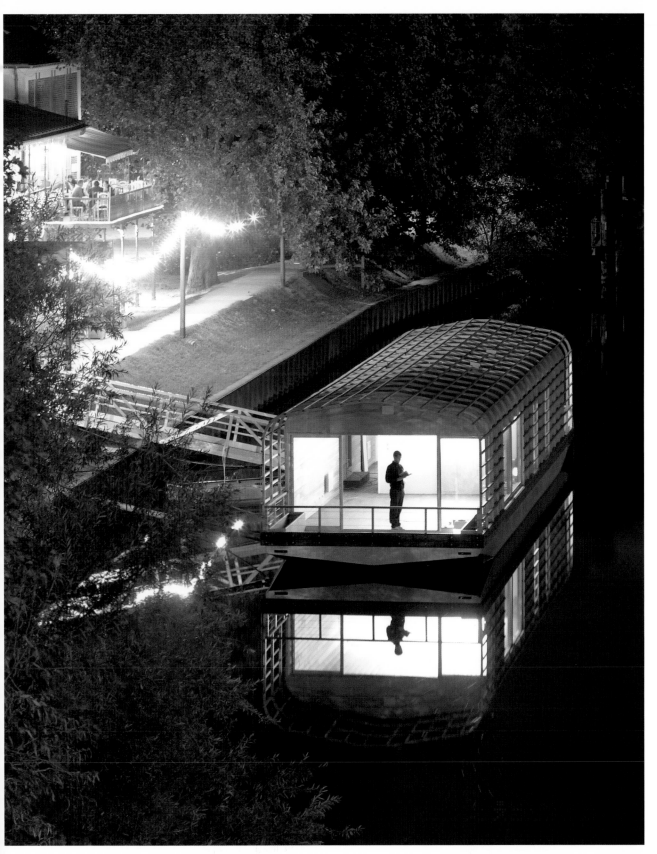

Fashion Design

Elie Saab France S.A.R.L

Marithé & François Girbaud

Junko Shimada

Jitrois Studio

Karl Lagerfeld

Anne Fontaine

Dior Homme

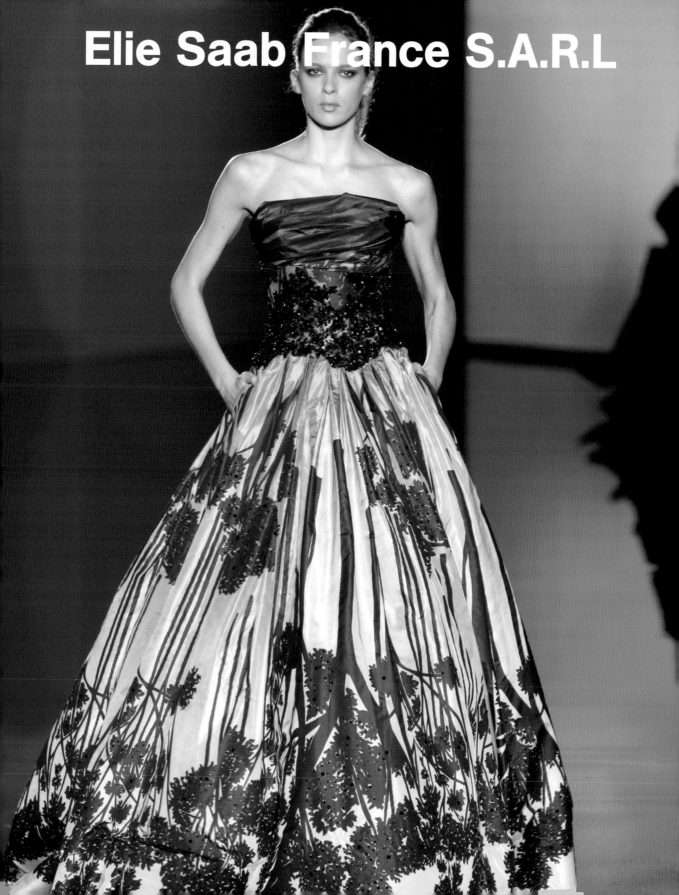

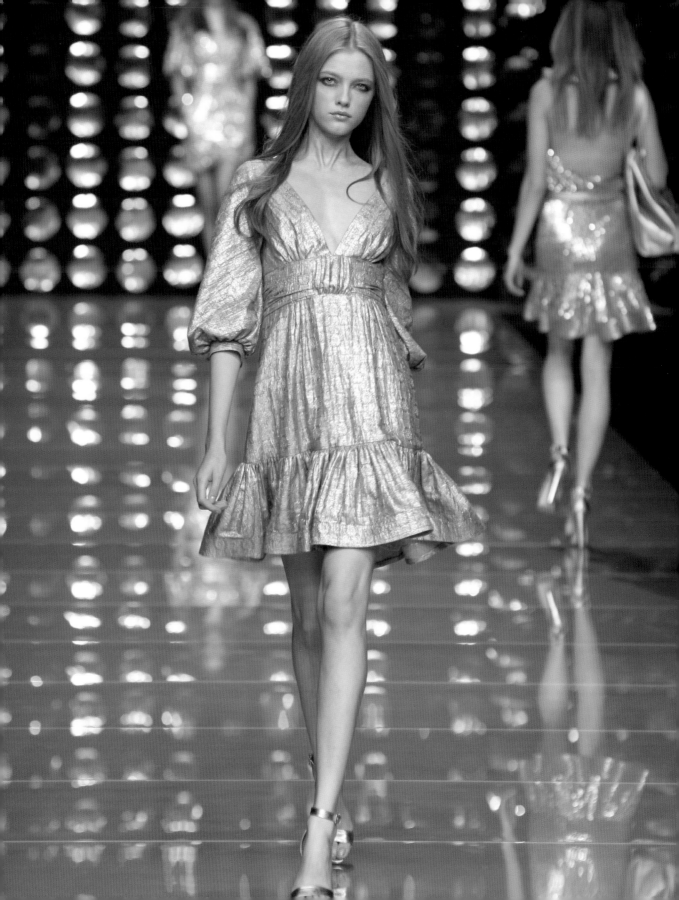

Elie Saab France S.A.R.L

47, rue Pierre Charron, 75008 Paris

+33 142 56 77 77

+33 142 56 77 76

www.eliesaab.com

info@eliesaab.com

Elie Saab

Born in Beirut, Elie Saab opened his first tailor shop at age eighteen. At that time, this young designer had no way of knowing that his creations would be worn by prominent members of society and even by Hollywood stars. The glamour and sophistication of his night robes took him to the catwalks of Milan and Paris. Today, he lives and works in both Beirut and Paris.

Elie Saab, geboren in Beirut, eröffnete seine erste Schneiderwerkstatt im Alter von achtzehn Jahren, ohne zu ahnen, dass seine Designs von führenden Kreisen der Gesellschaft und sogar von Hollywoodstars getragen werden würden. Seine Abendroben zeichnen sich durch Glamour und Raffinesse aus und werden auf den Laufstegen von Mailand und Paris gezeigt. Zurzeit lebt und arbeitet er zwischen Beirut und Paris.

Né à Beyrouth, Elie Saab ouvre son premier atelier de couture à dix-huit ans. A cette époque, ce designer précoce ignorait que la haute société y compris les stars les plus brillantes d'Hollywood porteraient un jour ses designs. Le glamour et la sophistication de ses vête-ments de nuit l'ont porté jusqu'aux podiums de Milan et, plus tard, de Paris, ville qui devient sa résidence secondaire. A l'heure actuelle, sa carrière se déroule à cheval entre Beyrouth et la capitale française.

Nacido en Beirut, Elie Saab abrió su primer taller de costura a los dieciocho años. En aquel entonces, este precoz diseñador no sabía que la alta sociedad e incluso las estrellas más bri-llantes de Hollywood vestirían sus diseños. El *glamour* y la sofisticación de sus vestidos de noche lo llevaron hasta las pasarelas de Milán y, más tarde, de París, ciudad que convirtió en su segunda residencia. Actualmente, su carrera se desarrolla a caballo entre Beirut y la capital francesa.

Nato a Beirut, Elie Saab apre il suo primo atelier di sartoria a diciotto anni, ancora ignaro del fatto che un giorno l'alta società e persino le stelle di Hollywood avrebbero indossato le sue creazioni. Il *glamour* e la ricercatezza dei suoi abiti da sera lo portano fino alle passerelle di Milano e di Parigi, sua seconda residenza. Al momento la sua carriera si svolge a cavallo tra Beirut e la capitale francese.

1964
Born in Beirut, Lebanon

1982
Opens his first atelier in Beirut, Lebanon

1997
First foreign designer taking part in Camera Nazionale della Moda, Italy

1998
Launches his first ready-to-wear collection

2000
Opens salon and showroom in Paris, France

2003
Invited to be a member of the Chambre Syndicale de la Couture Parisienne

2005
Opens his first boutique in Beirut, Lebanon

Interview | Elie Saab

Which do you consider the most important work of your career? The fact that I am able to fulfill my dream through my work and make women look elegant and beautiful.

In what ways does Paris inspire your work? Paris is my second home. It's a great source of inspiration, from its architecture to its museums. The homogeneity of different aspects makes it so inspirational. Paris is the capital of fashion and of *haute couture* in particular.

Does a typical Paris style exist, and if so, how does it show in your work? It has a charm that exists nowhere else. The lifestyle says it all. Parisian women are known for their elegance and grace. That is where the driving force of fashion lies.

How do you imagine Paris in the future? Paris will always be Paris. Each town has its ups and downs but Paris has eternal values. It's a meeting point for architecture, fashion, gastronomy…

Welches Werk halten Sie für das wichtigste Ihrer Karriere? Die Tatsache, dass ich mir meinen Traum durch meine Arbeit erfüllen und Frauen elegant und schön aussehen lassen kann.

Wie inspiriert Paris Ihre Arbeit? Die Stadt Paris ist meine zweite Heimat. Sie ist eine große Inspirationsquelle, von ihrer Architektur bis zu ihren Museen. Die Homogenität ihrer verschiedenen Aspekte macht sie so inspirierend. Paris ist die Modehauptstadt, und insbesondere die Hauptstadt der Haute Couture.

Gibt es einen typischen Pariser Stil, und wenn ja, wie macht dieser sich in Ihrer Arbeit bemerkbar? Paris verfügt über einen Charme, den es nirgendwo sonst gibt. Der Lebensstil sagt alles. Die Pariserinnen sind bekannt für ihre Eleganz und Grazie. Hierin liegt die treibende Kraft der Mode.

Wie stellen Sie sich Paris in der Zukunft vor? Paris wird immer Paris sein. Jede Stadt hat ihre Höhen und Tiefen, aber Paris hat dauerhafte, immer währende Werte. Diese Metropole ist ein Treffpunkt für Architektur, Mode, Gastronomie …

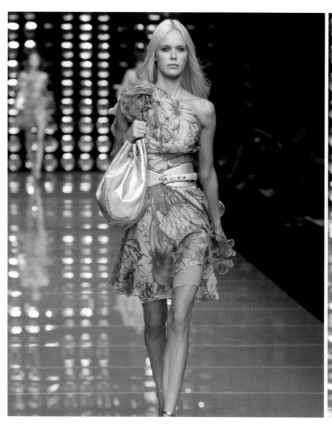
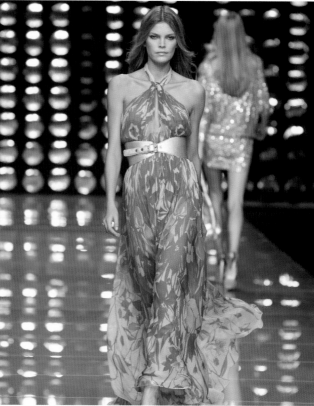

Quelle est à vos yeux l'œuvre la plus importante de votre carrière ? C'est le fait que je puisse réaliser mon rêve grâce à mon œuvre et rendre la femme élégante et belle.

Dans quelle mesure votre œuvre artistique s'inspire-t-elle de Paris ? Paris est ma deuxième patrie. C'est une grande source d'inspiration, de son architecture à ses musées. L'homogénéité de différents aspects fait d'elle une telle source d'inspiration. Paris est la capitale de la mode et de la haute couture en particulier.

Existe-t-il un style typiquement parisien, et si oui, comment se manifeste-t-il dans votre œuvre ? C'est un charme qui n'existe nulle part ailleurs. Tout est dans le style de vie. Les Parisiennes sont connues pour leur élégance et grâce. C'est là que se trouve la force motrice de la mode.

Comment imaginez-vous le Paris du futur ? Paris restera toujours Paris. Toute ville a des hauts et des bas, mais Paris possède des valeurs éternelles. C'est le rendez-vous de l'architecture, la mode, la gastronomie…

¿Cuál cree que es el trabajo más importante de su carrera? El hecho de que pueda realizar mi sueño a través de mi trabajo y conseguir que las mujeres estén guapas y elegantes.

¿Cómo le inspira París en su trabajo? París es mi segunda casa. Es una increíble fuente de inspiración, desde su arquitectura hasta sus museos. La homogeneidad de diferentes aspectos la hace tan inspiradora. París es la capital de la moda y de la alta costura en especial.

¿Existe un estilo típico de París? Y si es así, ¿cómo se muestra éste en su obra? Tiene un encanto que no hay en ningún otro lugar. El estilo de vida lo dice todo. Las mujeres parisinas son conocidas por su elegancia y gracia. Es ahí donde reside la fuerza impulsora de la moda.

¿Cómo se imagina París en un futuro? París siempre será París. Cada ciudad tiene sus altibajos pero París goza de valores eternos. Es un lugar de encuentro para la arquitectura, la moda, la gastronomía…

Quale ritiene sia l'opera più importante della sua carriera? Il fatto che io sia in grado di realizzare il mio sogno attraverso la mia professione e di far apparire le donne eleganti e bellissime.

In che modo Parigi ispira il suo lavoro? Parigi è la mia seconda casa. È una grande fonte d'ispirazione, dalla sua architettura ai suoi musei. L'omogeneità di aspetti differenti la rende così ispiratrice. Parigi è la capitale della moda e, in particolare, dell'*haute couture*.

Esiste un tipico "stile parigino"? Se sì, come si manifesta nel suo lavoro? Parigi ha un fascino che non esiste in nessun altro luogo. Lo stile di vita ne è la prova. Le donne parigine sono note per la loro eleganza e grazia. In questo risiede la forza propulsiva della moda.

Come immagina Parigi nel futuro? Parigi sarà sempre Parigi. Qualunque città ha i suoi alti e bassi ma Parigi ha valori eterni. È un punto d'incontro per l'architettura, la moda, la gastronomia…

Collection Autumn/Winter 2006/2007

Photographs: © Fréderique du Moulin, Patrice Stable

The gothic elegance of this collection gives the female figure a mysterious and majestic appearance, enchanting all the senses. The high-neck dresses with bows, asymmetrical sleeves or pronounced cuts are dyed with shades of aubergine, petrol or emerald that complement the black in a harmonious fusion. The taffeta of silk or organza combine with laces and details, which give these creations a form somewhat reminiscent of the modern designs of the Sixties.

Die gotische Eleganz dieser Kollektion lässt die weibliche Figur geheimnisvoll und majestätisch wirken und verzaubert alle Sinne. Die hochgeschlossenen Kleider im Empirestil, mit Schleifen oder mit asymmetrischen Ärmeln, sind in Schattierungen von Aubergine, Petrol oder Smaragdgrün gefärbt, die mit dem Schwarzen eine harmonische Fusion eingehen. Taft aus Seide oder Organza wird kombiniert mit Spitze und Details, welche diesen Kreationen eine Form geben, die bisweilen an moderne Designs der sechziger Jahre erinnert.

L'élégance gothique de cette collection dote la silhouette féminine d'une apparence à la fois mystérieuse et majestueuse qui fascine les sens. Les vêtements au col élancé avec laçage, manches asymétriques ou coupe impériale se teignent d'ombres de couleur aubergine, pétrole ou émeraude, complétant la couleur noire en une fusion harmonieuse. Le taffetas de soie et l'organdi s'allient à des empiècements de dentelle et détails qui sculptent ces créations, dont la forme évoque parfois les designs modernes des années soixante.

La elegancia gótica de esta colección dota a la figura femenina de una apariencia misteriosa y majestuosa, que fascina los sentidos. Los vestidos de cuellos altos con lazadas, mangas asimétricas o corte imperio se tiñen con sombras de color berenjena, petróleo o esmeralda que complementan al color negro en su armónica fusión. El tafetán de seda y la organza combinan con encajes y detalles que esculpen estas creaciones, cuya forma a veces evoca modernos diseños de los años sesenta.

L'eleganza gotica di questa collezione dota la figura femminile di un aspetto misterioso e maestoso che affascina i sensi. I vestiti a collo alto stile Impero, con fiocchi o maniche asimmetriche, si tingono di sfumature color melanzana, petrolio o smeraldo, che accompagnano il colore nero fondendosi armoniosamente. Il taffettà di seta e l'organza si abbinano a pizzi e dettagli che scolpiscono queste creazioni, la cui forma evoca talvolta moderni design anni '60.

Elie Saab France S.A.R.L

430 Elie Saab France S.A.R.L

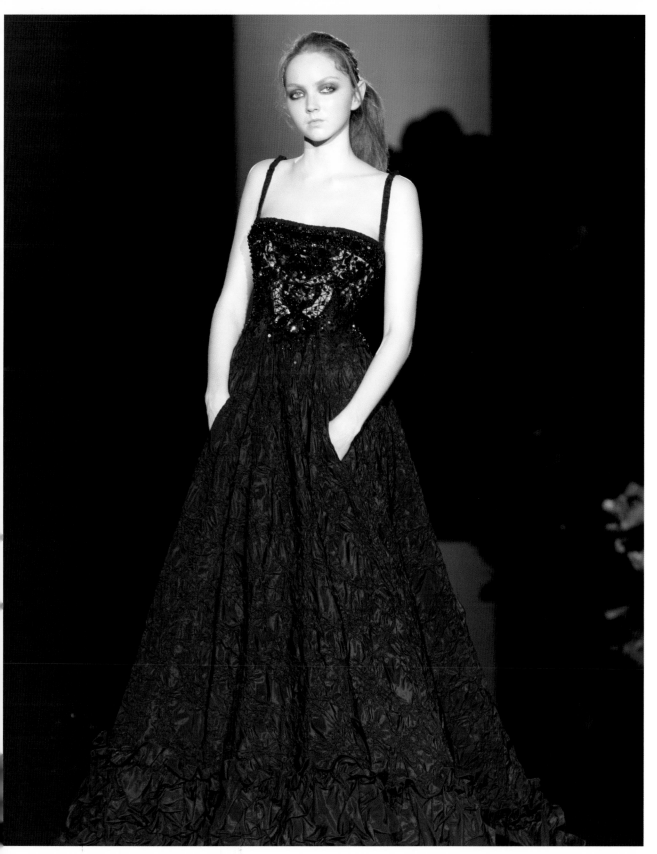

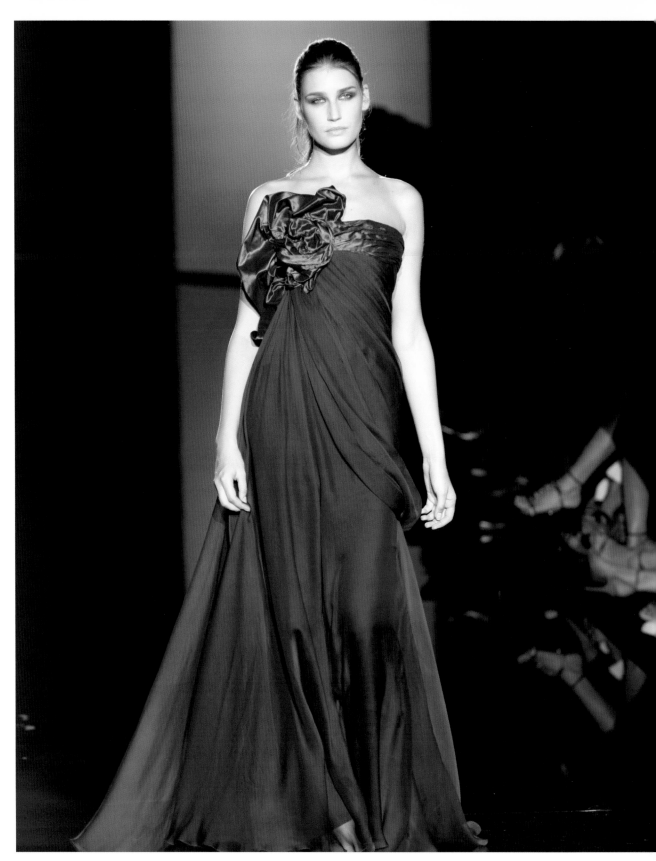

Elie Saab France S.A.R.L

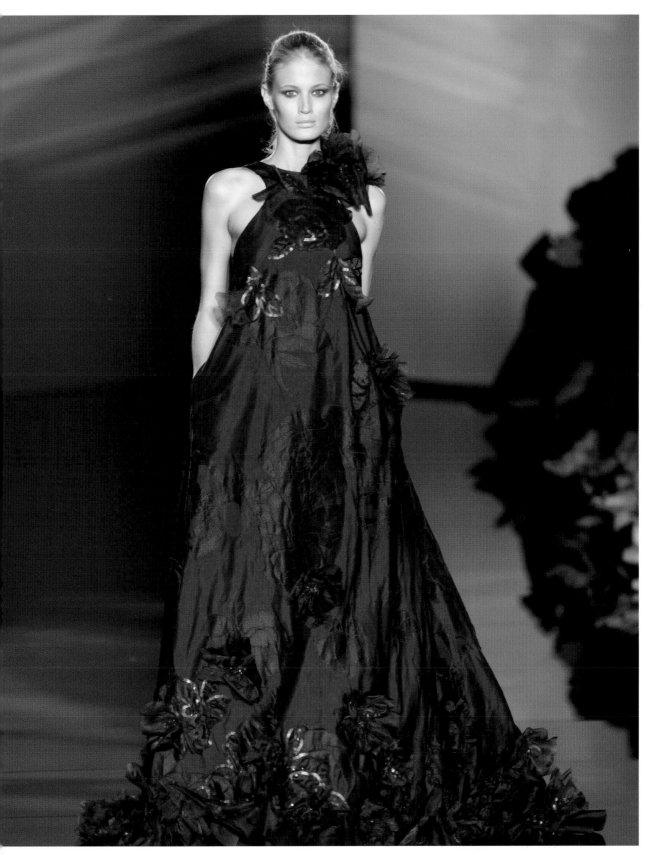

Collection Spring/Summer 2007

Photographs: © Fréderique du Moulin, Patrice Stable

The Beirut sun has been the inspiration for this collection where silhouettes are wrapped in glittering silk, satin or lamé, with pleats embroidered with sequins. The loose and light fit shows a woman seemingly reborn as a chrysalis, wrapped in glamorous dresses and tunics that are flimsy, yet tight around the waist. The definitive materialization of an eternal vision of femininity, bathed in an incandescent light.

Die Sonne über Beirut diente als Inspirationsquelle für diese Kollektion, in der die Silhouetten in glänzendes Seidenlamé oder Satin gehüllt werden, deren Falten mit Pailletten bestickt sind. Der weite und leichte Schnitt zeigt eine Frau, die wie eine Puppe aus einem Kokon schlüpft, eingehüllt in glamouröse Kleider und luftige, doch eng taillierte Tunikas. Die Verkörperung einer ewigen Sichtweise der Weiblichkeit, in gleißendes Licht getaucht.

Le soleil de Beyrouth a inspiré cette collection où les silhouettes s'enveloppent de vêtements de lamé, soie ou satin resplendissants, aux plis ourlés de paillettes. La coupe ample et légère dévoile une femme qui, à l'image d'une chrysalide, s'est enveloppée de tuniques vaporeuses, serrées à la ceinture et d'habits glamoureux. C'est en fait, la matérialisation, d'une vision éternelle de la féminité, baignée de lumière incandescente.

El sol de Beirut ha inspirado esta colección en la que las siluetas se envuelven en resplandecientes vestidos de lamé de seda o satén, con pliegues bordados con lentejuelas. El corte holgado y ligero muestra una mujer que resurge como una crisálida, envuelta en túnicas vaporosas, pero ceñidas a la cintura y en vestidos glamurosos. La materialización, en definitiva, de una una eterna visión de la feminidad, bañada en luz incandescente.

Il sole di Beirut ha ispirato questa collezione in cui le siluette sono avvolte in splendente lamé di seta o satin, con pieghe ricamate con paillette. Il taglio ampio e leggero mostra una donna che risorge come una crisalide, avvolta in tuniche vaporose ma strette in cintura, e in vestiti glamour. La materializzazione, in definitiva, di un'eterna visione della femminilità, immersa in un riverbero luminoso.

Elie Saab France S.A.R.L

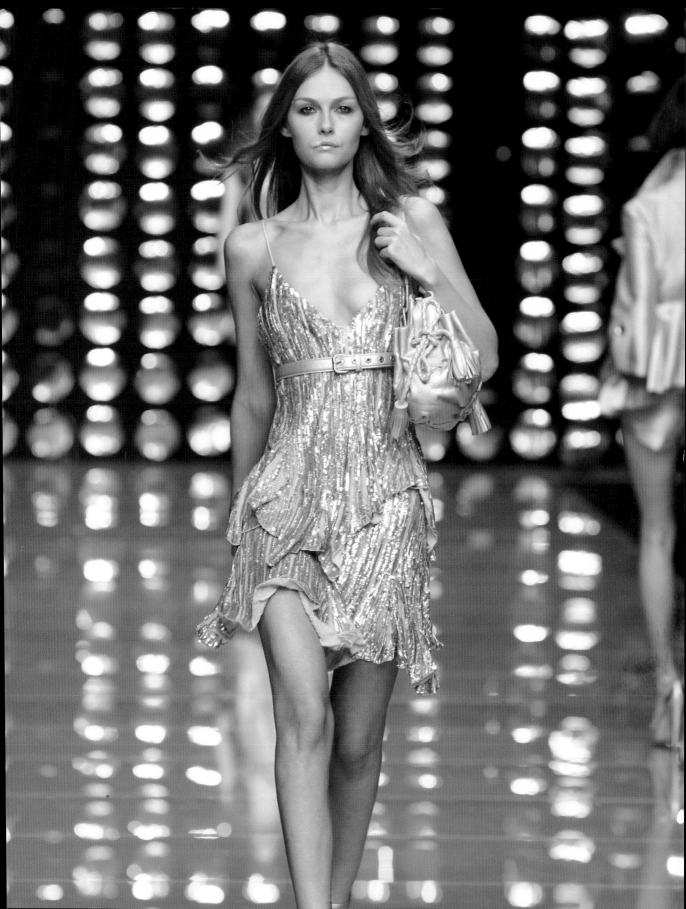

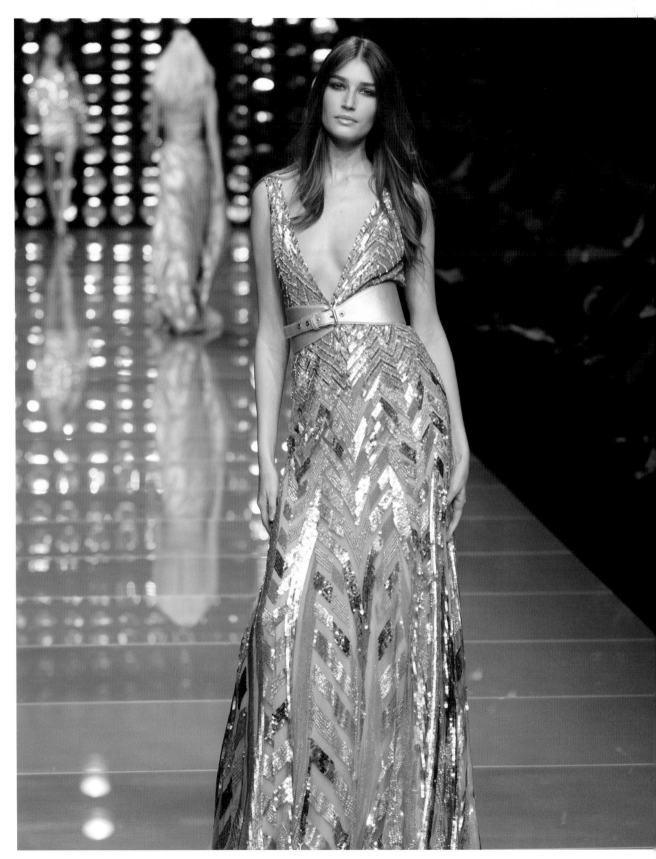

Elie Saab France S.A.R.L

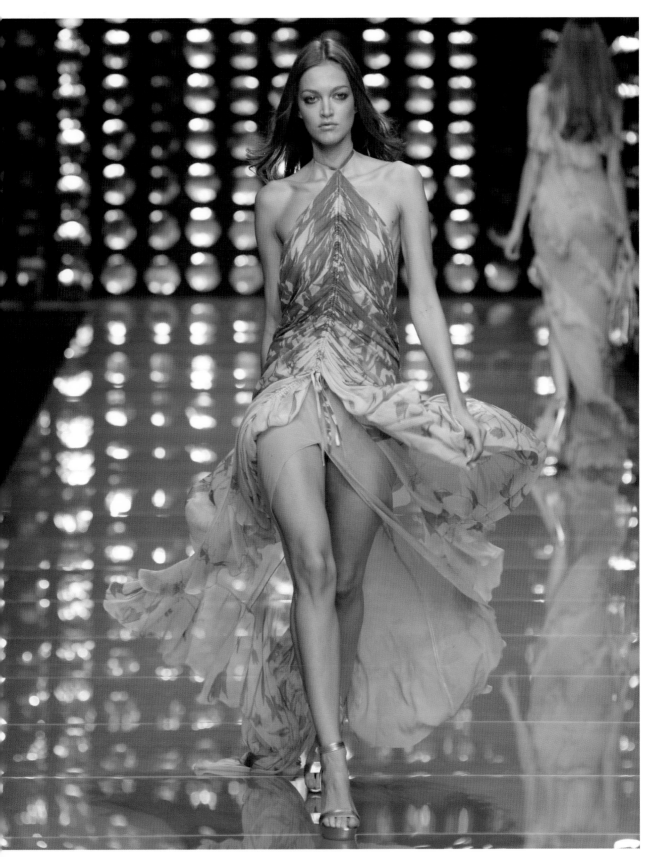

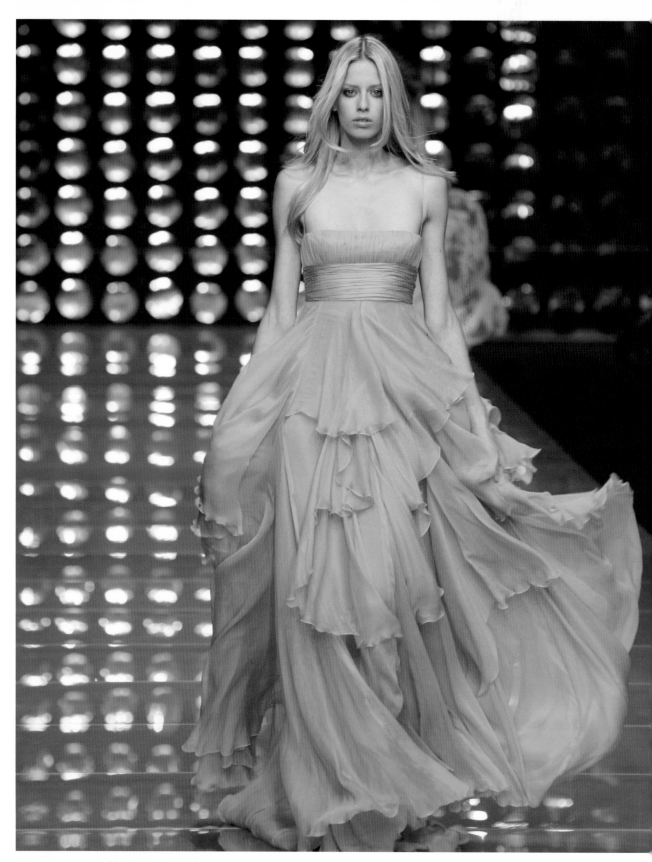

Elie Saab France S.A.R.L

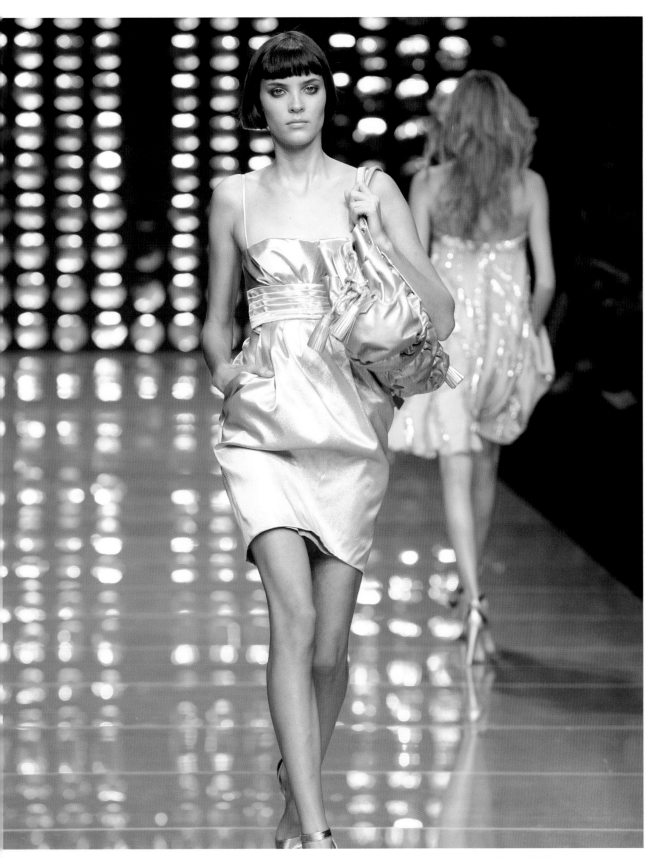

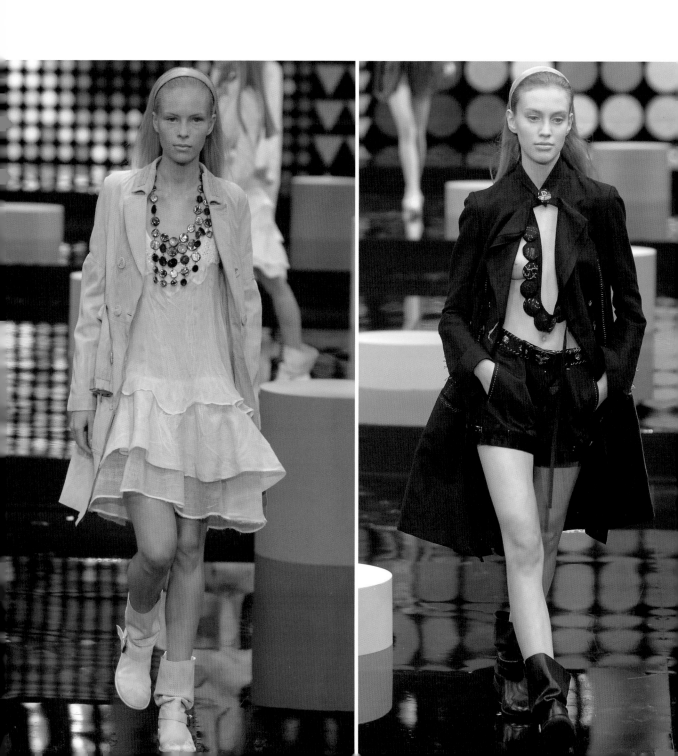

Marithé & François Girbaud

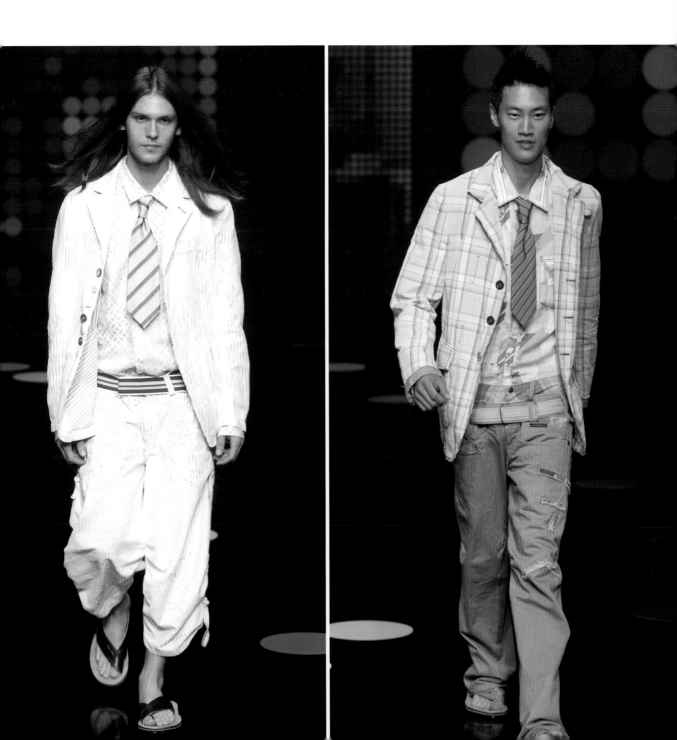

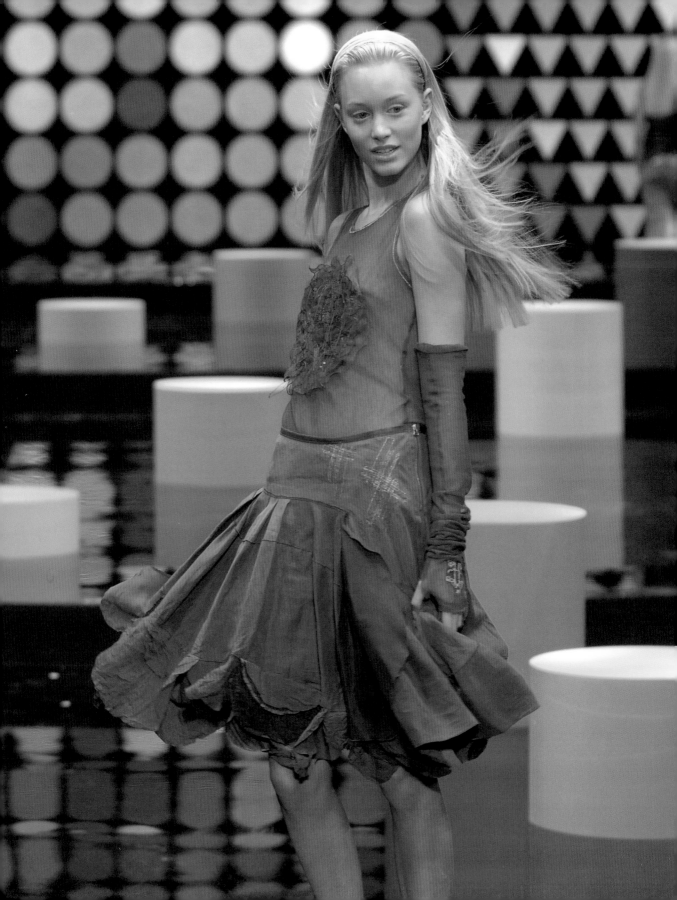

Marithé & François Girbaud

15 rue Louis Blanc, 75010 Paris

+33 155 35 11 08

www.girbaud.com

Marithé & François Girbaud

These two designers met in the 1960s. François imported jeans from the United States and Marithé sold hand-made ponchos. Their shared fascination of the "American Dream" drove them to work for brands like Closed, Maillaparty or Complete Look. In the end, they decided to start their own brand—Marithé et François Girbaud.

Dieses Designerpaar lernte sich in den sechziger Jahren kennen. François importierte Jeanshosen aus den Vereinigten Staaten, während Marithé handgefertigte Ponchos verkaufte. Ihre gemeinsame Faszination für den „amerikanischen Traum" ließ sie anfangen, für Marken wie Closed, Maillaparty oder Complete Look zu arbeiten. Schließlich entschlossen sie sich zur Gründung ihrer eigenen Marke Marithé et François Girbaud.

Ce couple de designers s'est rencontré dans les années 60. François importait des jeans des Etats Unis et Marithé faisait des ponchos à la main. Partageant la même fascination du « rêve américain », ils commencent à travailler pour des marques comme Closed, Maillaparty ou Complete Look. Après cette étape, ils décident de retourner à l'idée du « créateur », date de naissance de leur enseigne Marithé et François Girbaud.

Esta pareja de diseñadores se conoció en la década de los 60. François importaba pantalones vaqueros de los Estados Unidos y Marithé hacía ponchos a mano. Gracias a la fascinación compartida por el "sueño americano" empezaron a trabajar para marcas como Closed, Maillaparty o Complete Look. Tras esta etapa, decidieron volver a la idea de ser "creadores", momento en el que nació su marca Marithé et François Girbaud.

Questa coppia di stilisti si è conosciuta negli anni '60. All'epoca François importava jeans dagli Stati Uniti e Marithé vendeva poncho fatti a mano. Accomunati dallo stesso fascino nutrito nei confronti del "sogno americano", il duo comincia lavorando per griffe come Closed, Maillaparty e Complete Look fino ad arrivare a fondare il proprio marchio Marithé et François Girbaud.

1942
Marithé born in Lyon, France

1945
François born in Mazamet, France

1965
Start their joint career

1967
Invented the stone washed jeans look

1969
First boutique selling Girbaud-designed jeans opened in Paris, France

1999
Introduced denim tool belts

Interview | Marithé & François Girbaud

Which do you consider the most important work of your career? The stonewash we invented during the 60's and the Metamorphojean in 1988, when the big jeans companies were exclusively concerned with acid and snow wash.

In what ways does Paris inspire your work? Paris doesn't inspire our work. We don't spend much time there because of our travels. We are more inspired by art forms such as music or movies.

Does a typical Paris style exist, and if so, how does it show in your work? Paris is synonymous with *haute couture* in people's minds. Our line is in a constant state of development. We create products, not just fashion, and these products aren't associated with Paris alone.

How do you imagine Paris in the future? The problem is that fashion people think Paris is the center of the world. We see fashion as traveling and we would like to be able to choose among the big capitals every season.

Welches Werk halten Sie für das wichtigste Ihrer Karriere? Das Stonewash, das wir in den sechziger Jahren erfunden haben, und die Metamorphojean aus dem Jahre 1988, als die großen Jeans-Hersteller ausschließlich Acid- und Snowwash anwandten.

Wie inspiriert Paris Ihre Arbeit? Paris inspiriert unsere Arbeit nicht. Wegen unserer Reisen verbringen wir nicht viel Zeit dort. Wir werden mehr von Kunstformen wie Musik und Kino inspiriert.

Gibt es einen typischen Pariser Stil, und wenn ja, wie macht dieser sich in Ihrer Arbeit bemerkbar? Paris ist gleichbedeutend mit Haute Couture in den Köpfen der Menschen. Unsere Kleidung befindet sich in einem ständigen Zustand der Entwicklung. Wir schaffen Produkte, nicht nur Mode, und diese Produkte stehen nicht allein in Verbindung mit Paris.

Wie stellen Sie sich Paris in der Zukunft vor? Das Problem ist, dass die Leute aus der Modebranche denken, Paris sei das Zentrum der Welt. Für mich ist Mode eine Reise und mir würde es gefallen, wenn ich in jeder Saison unter den großen Hauptstädten der Welt auswählen könnte.

Quelle est à vos yeux l'œuvre la plus importante de votre carrière ? Le jean « stonewash » inventé pendant les années soixante et le « Metamorphojean » en 1988, alors que les grandes compagnies de jeans étaient uniquement concernées par « l'acide et le snow wash ».

Dans quelle mesure votre œuvre artistique s'inspire-t-elle de Paris ? Notre œuvre ne s'inspire pas de Paris. Nous n'y passons pas beaucoup de temps à cause des voyages. C'est plutôt l'art qui nous inspire, comme la musique ou les films.

Existe-t-il un style typiquement parisien, et si oui, comment se manifeste-t-il dans votre œuvre ? Dans l'esprit des gens, Paris est synonyme de haute couture. Nos créations sont en constante évolution. Nous créons des produits, pas seulement de la mode, et ceux-ci ne sont pas uniquement liés à Paris.

Comment imaginez-vous le Paris du futur ? Le problème, c'est que les gens de la mode pensent que Paris est le centre du monde. Pour nous, la mode est un voyage, et nous aimons pouvoir choisir à chaque saison parmi les grandes capitales.

¿Cuál cree que es el trabajo más importante de su carrera? El lavado a piedra que inventamos en los años sesenta y el Metamorphojean en 1988, momento en el que las grandes compañías de vaqueros únicamente estaban interesadas en el lavado con ácido y nieve.

¿Cómo le inspira París en su trabajo? París no inspira nuestro trabajo. No pasamos mucho tiempo ahí porque estamos de viaje. Nos sentimos más inspirados por el arte como la música o el cine.

¿Existe un estilo típico de París? Y si es así, ¿cómo se muestra éste en su obra? París es sinónimo de alta costura en la mente de las personas. Nuestra ropa está en continua evolución; creamos productos, no sólo moda, y éstos no están relacionados únicamente con París.

¿Cómo se imagina París en un futuro? El problema es que la gente fashion cree que París es el centro del mundo. Consideramos moda como viajar y nos gustaría poder elegir entre las grandes capitales para cada estación del año.

Quale ritiene sia l'opera più importante della sua carriera? Lo stonewash che abbiamo inventato negli anni '60 e il Metamorphojean del 1988, periodo in cui i grandi jeanserie impiegavano esclusivamente la scoloritura e la sbiancatura.

In che modo Parigi ispira il suo lavoro? Parigi non ispira il nostro lavoro. Non ci passiamo molto tempo a causa dei nostri continui viaggi. Siamo più ispirati dall'arte, per esempio dalla musica o dai film.

Esiste un tipico "stile parigino"? Se sì, come si manifesta nel suo lavoro? Parigi è sinonimo di *haute couture* nell'immaginario collettivo. I nostri vestiti sono in continua evoluzione. Creiamo prodotti, non solo moda, e questi prodotti non hanno un legame solo con Parigi.

Come immagina Parigi nel futuro? Il problema è che chi lavora nella moda pensa che Parigi sia il centro del mondo. Consideriamo la moda come sinonimo di viaggio e vorremmo poter scegliere tra le grandi capitali mondiali ad ogni stagione.

Marithé & François Girbaud 445

Women's Collection Spring/Summer 2007

Year: 2007
Photographs: © mfg

Light fabrics and the colors khaki, crème and white, laced with bronze and gold, dominate this collection. Wide skirts with folds, capes and pockets combine with tops and silk blouses, creating the perfect look for urban women as well as for women who love the outdoors. Leather belts emphasize the bodice while suggesting a masculine touch at the same time.

In dieser Kollektion herrschen leichte Stoffe und die Farben Khaki, Creme und Weiß, besprenkelt mit Bronze und Gold, vor. Die Röcke sind weit, mehrlagig und haben Taschen. Mit Tops und Seidenblusen werden sie zu einem perfekten Look kombiniert, sowohl für urbane als auch für abenteuerlustige Frauen. Die Taille wird feminin durch Ledergürtel betont, welche zugleich einen maskulinen Touch einbringen.

Les tissus légers sont le pari de MFG pour cette collection où prédominent le vert kaki et les tons blancs crémeux saupoudrés de bronze et d'or. Les jupes retournées sur elles-mêmes, larges, en forme de cape et dotées de poches sont assorties de tops et blouses de soie, un *look* parfait tant pour la femme citadine que pour les plus aventurières. Les ceintures de cuir accentuent la taille dans une collection qui associe des pièces d'inspiration masculine à des habits comme les jupes et les robes.

Las telas ligeras son la apuesta de MFG para esta colección en la que predominan el caqui y los tonos blancos cremosos salpicados por el bronce y el oro. Las faldas amplias, capeadas y con bolsillos combinan con tops y blusas de seda, un *look* perfecto tanto para la mujer urbana como para la aventurera. Los cinturones de cuero realzan la cintura en una colección que combina piezas de inspiración masculina con prendas como faldas y vestidos.

I tessuti leggeri sono la scommessa di MFG per questa collezione in cui predominano il colore cachi e i toni bianchi cremosi, picchiettati di bronzo e oro. Le gonne ampie, a più strati e ricche di tasche, si abbinano a top e camicette di seta: un look perfetto sia per la donna metropolitana sia per la più avventurosa. Le cinture di cuoio mettono in risalto la vita sottile conferendo allo stesso tempo un tocco maschile.

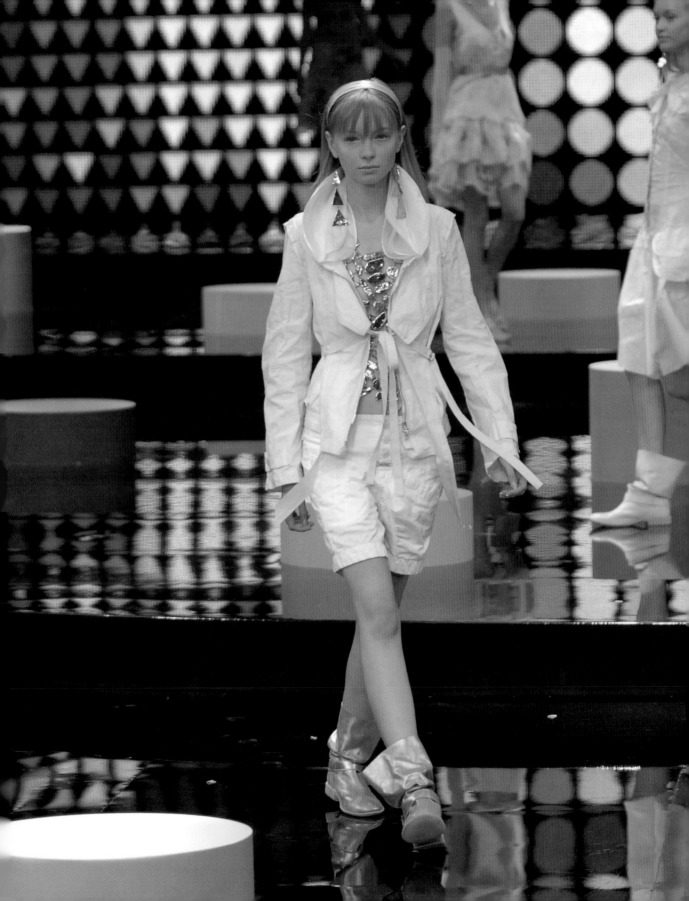

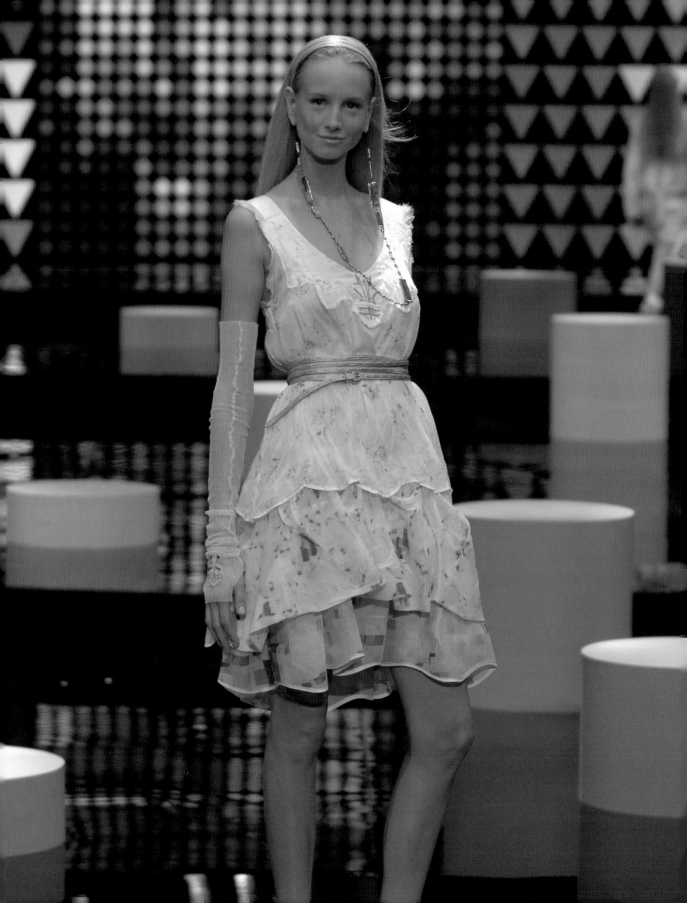

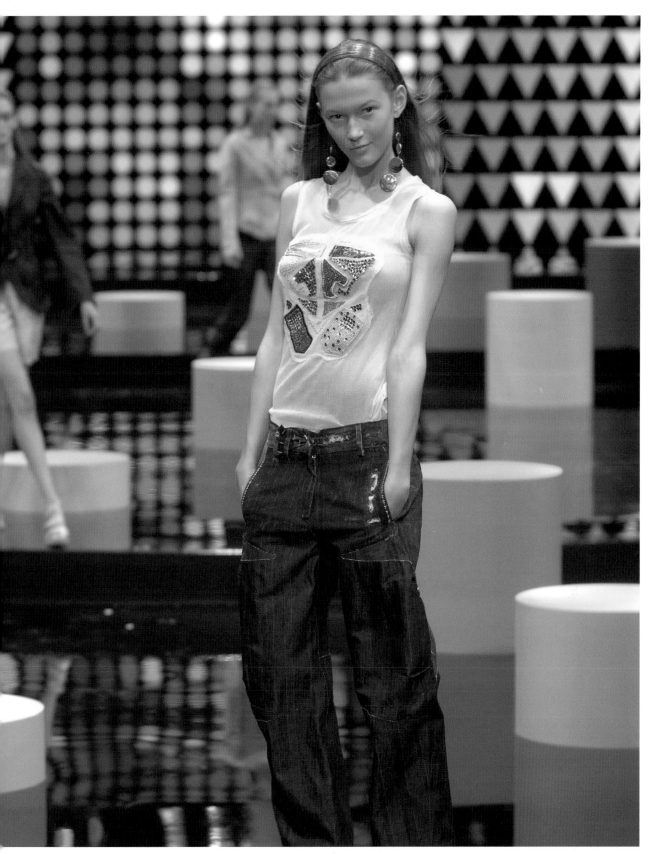

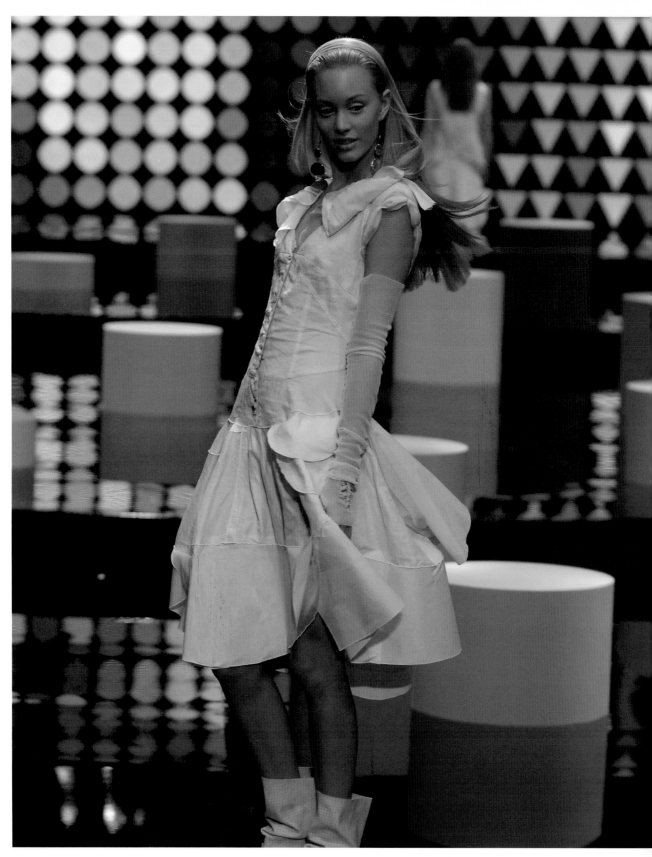

Marithé & François Girbaud

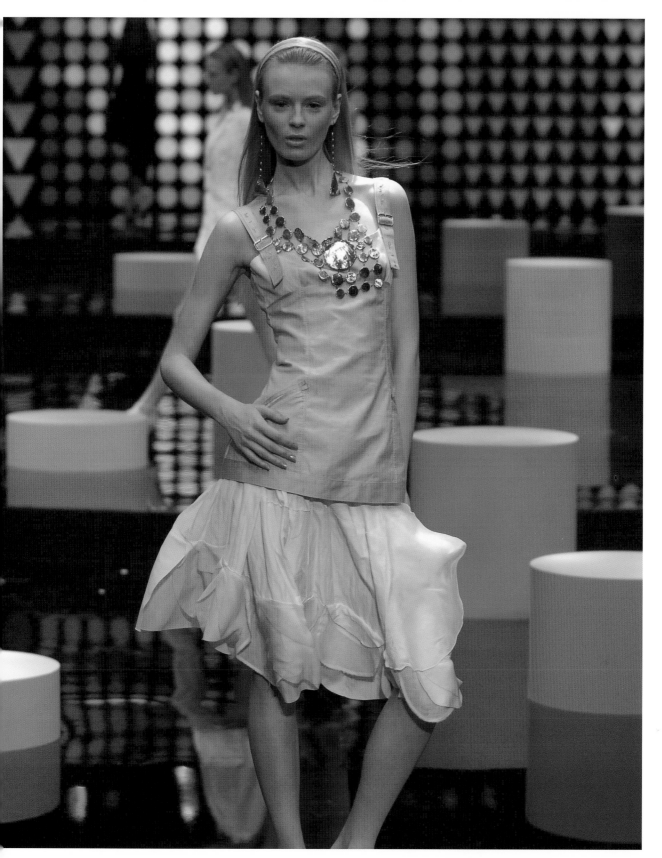

Men's Collection Spring/Summer 2007

Year: 2007
Photographs: © mfg

Technology and avant-garde are the concepts that define the revolutionary men's collection of Marithé and François Girbaud for spring/summer 2007. At the center of the collection are undoubtedly the jackets with button lines that flow into the various shapes. Straps, suspenders, eye-catching seams, hems and irregular patterns are stylistic elements, which always allow new combinations. Gray, earthy and black tones contrast with vivid blues, yellows and whites.

Moderne Technologie und avantgardistische Ideen kennzeichnen die revolutionäre Herrenkollektion von Marithé und François Girbaud für den Frühling/Sommer 2007. Im Mittelpunkt dieser Kollektion stehen zweifelsfrei Jacken mit Knopflinien, die sich in die verschiedenen Lagen einfügen. Bänder, Hosenträger, auffällige Nähte, Säume und ungleiche Muster sind Stilmittel, die immer neue Kombinationen erlauben. Die verschiedenen Töne in Grau, Umbra und Schwarz stehen im Kontrast zu lebhaften Farben wie Blau, Gelb und Weiß.

Technologie et avant-garde sont les concepts qui définissent la ligne révolutionnaire masculine de printemps/été 2007, signée Marithé François Girbaud. Les vestes sont l'élément phare de la collection, utilisant des capes voluptueuses brochées de rangées de boutons. Les ceintures, les tirants, les coutures voyantes, les ourlets et les imprimés irréguliers sont les éléments stylistiques qui se conjuguent pour créer de multiples combinaisons. Les tons gris, terre et le noir contrastent avec les bleus vifs, jaunes et blancs.

Tecnología y vanguardia son los conceptos que definen la revolucionaria línea masculina de primavera/verano 2007 diseñada por Marithé y François Girbaud. El elemento más destacado de la colección son las chaquetas, que utilizan voluptuosas capas y se entretejen con líneas de botones. Las cintas, los tirantes, las costuras llamativas, los dobladillos y los estampados desiguales son los elementos estilísticos que se conjugan para producir múltiples combinaciones. Los tonos grises, tierra y el negro contrastan con los vivos azules, amarillos y blancos.

Tecnologia e avanguardia sono i concetti che definiscono la rivoluzionaria linea maschile primavera/estate 2007 disegnata da Marithé e François Girbaud. L'elemento più rilevante della collezione sono senza dubbio le giacche con linee di bottoni asimmetriche. Nastri, bretelle, cuciture appariscenti, orli e stampati irregolari sono gli elementi stilistici che si coniugano per produrre molteplici combinazioni. I toni grigi, terra e neri contrastano con i vivi blu, gialli e bianchi.

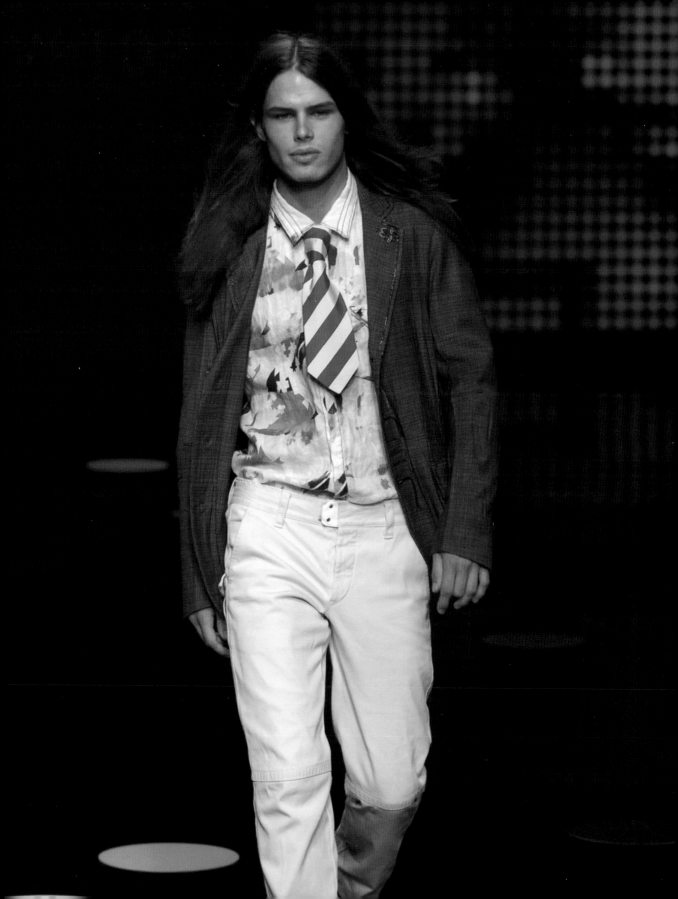

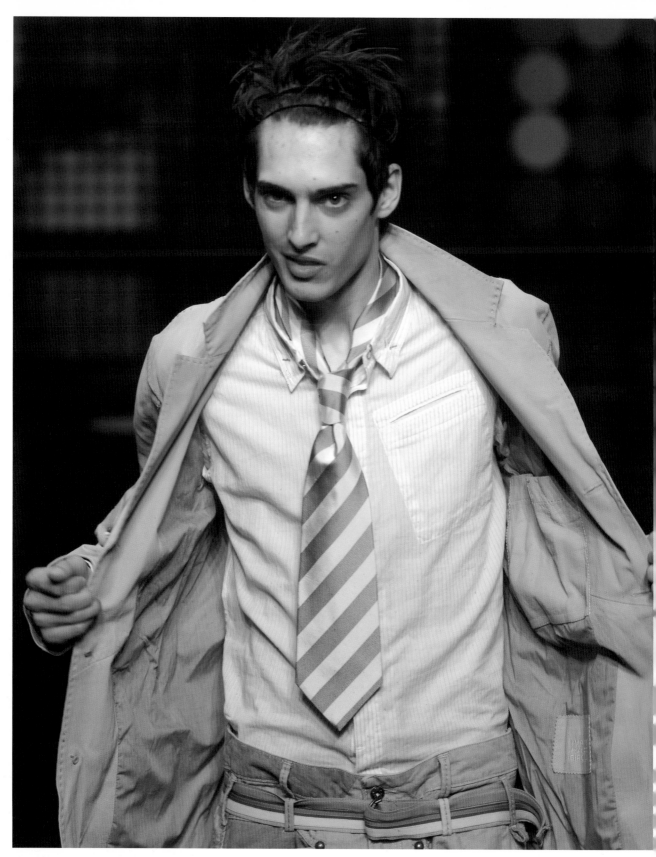

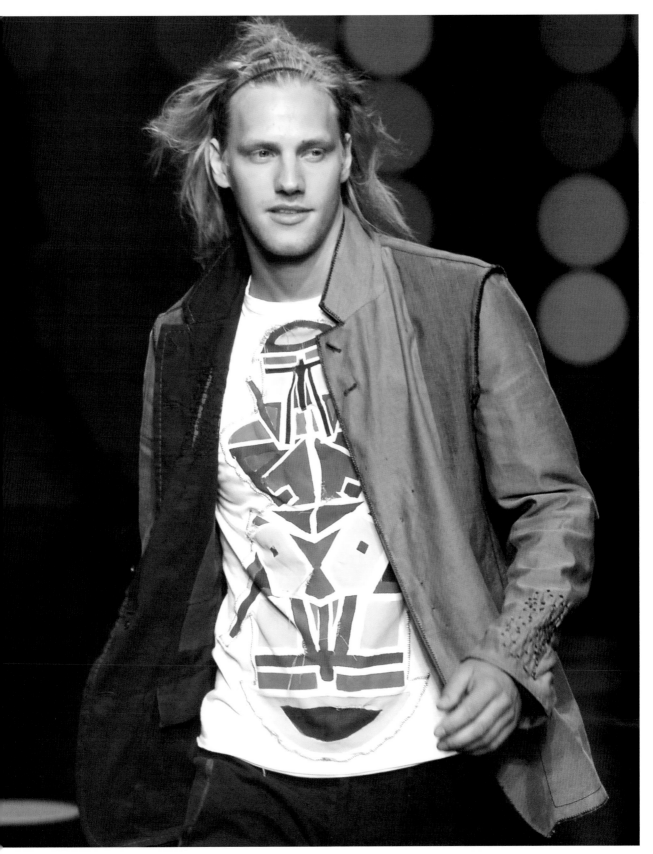

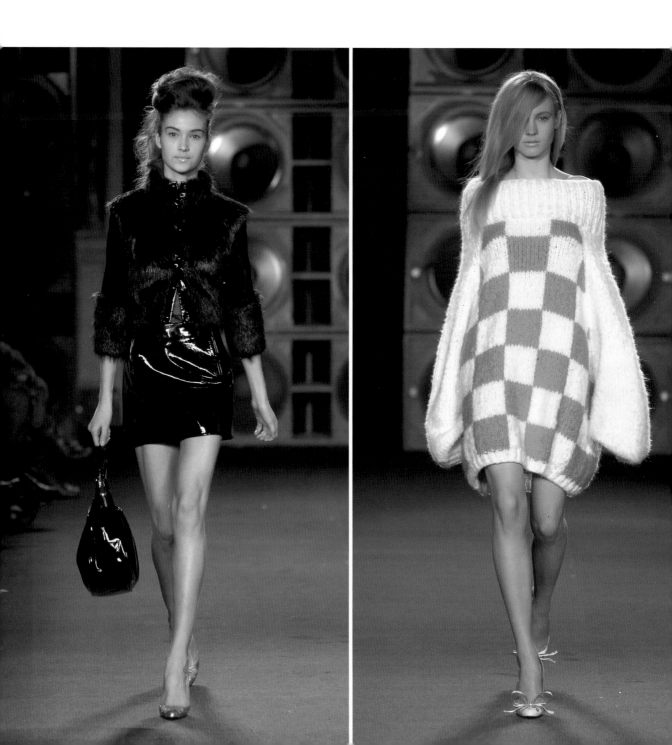

Junko Shimada

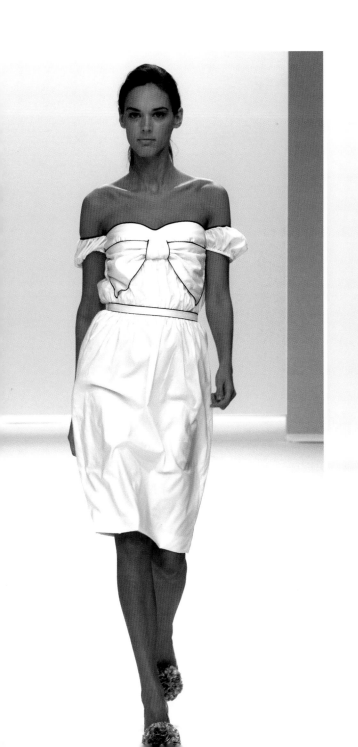

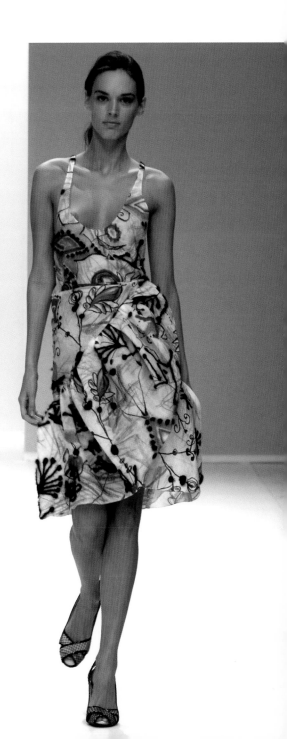

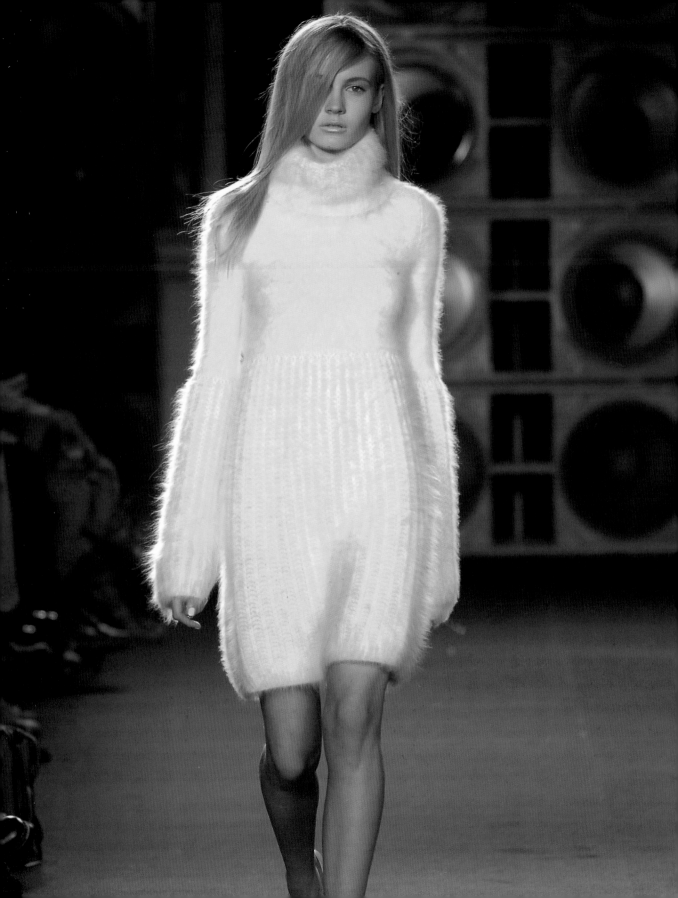

Junko Shimada

84, rue Beaubourg, 75003 Paris

+33 142 77 07 00

+33 142 77 07 21

www.junkoshimada.com

junkoshimada1@wanadoo.fr

Junko Shimada

Junko Shimada studied in the Sujino Gajen Dressmaker Institute in Tokyo and, after completing her studies, traveled to Paris. The city fascinated her so much that she decided to stay in the French capital. She has worked for Mafia Design Studio and Cacharel, where she headed the children's wear collection and later men's wear. In 1981, she started her own company and opened her own first boutique three years later.

Junko Shimada studierte im Sujino Gajen Dressmaker Institute in Tokio. Nach dem Abschluss ihres Studiums reiste sie nach Paris. Fasziniert von dieser Stadt, entschied sie sich in der französischen Hauptstadt zu bleiben. Sie arbeitete für Mafia Design Studio und Cacharel, wo sie zunächst die Kollektion für Kinder, später die für Herren leitete. 1981 gründete sie ihre eigene Firma, drei Jahre später folgte ihre erste eigene Boutique in Paris.

Junko Shimada étudie dans le Sujino Gajen Dressmaker Institute de Tokio et, à la fin de ses études, voyage à Paris. La ville exerce sur elle une telle fascination qu'elle décide d'y rester pour y vivre. Après avoir travaillé au Mafia Design Studio, elle entre chez Cacharel où elle dirige la collection de vêtements d'enfants, et ensuite, celle pour homme. En 1981, elle décide de créer sa propre société et trois ans plus tard, elle ouvre sa première boutique à Paris.

Junko Shimada estudió en el Sujino Gajen Dressmaker Institute de Tokio y, al finalizar sus estudios, viajó a París. La ciudad le resultó tan fascinante que decidió quedarse a vivir allí. Después de trabajar en Mafia Design Studio, entró en Cacharel donde dirigió la colección de ropa de niño y, más tarde, la de hombre. En 1981 decidió crear su propia firma y tres años más tarde abrió su primera boutique.

Junko Shimada frequenta il Sujino Gajen Dressmaker Institute di Tokio e, terminati gli studi, realizza un viaggio a Parigi. La capitale francese la affascina a tal punto che decide di trasferirsi a vivere lì. Dopo avere lavorato nel Mafia Design Studio e alla Cacharel, dove è responsabile dapprima della collezione d'abbigliamento infantile e poi di quella maschile, nel 1981 decide di creare la propria azienda. Tre anni più tardi segue l'apertura del suo primo negozio a Parigi.

1960's
Settled in Paris, France

1973
Enters in Cacharel as stylist

1981
Creates her own design studio

1984
Opens her first boutique on rue Etienne Marcel in Paris, France

2001
Opens the second store in Paris, introducing the new line Junk by Junko Shimada

2006
Presents her 50th collection coinciding with the one designed for autumn-winter 2006/2007

Interview | Junko Shimada

Which do you consider the most important work of your career? I always look toward the future and always expect more, which is why I think my most important work must be ahead of me. It is not in the past; it is yet to come.

In what ways does Paris inspire your work? The day-to-day Parisian lifestyle inspires me the most.

Does a typical Paris style exist, and if so, how does it show in your work? Being and feeling totally free is the ultimate Paris style, and that definitely inspires my work.

How do you imagine Paris in the future? Always the same, Paris is eternal, it will never change!

Welches Werk halten Sie für das wichtigste Ihrer Karriere? Ich blicke immer in die Zukunft und erwarte mehr, daher glaube ich, dass mein wichtigstes Werk noch vor mir liegt. Es liegt nicht in der Vergangenheit, es wird noch kommen.

Wie inspiriert Paris Ihre Arbeit? Der alltägliche Pariser Lebensstil inspiriert mich am meisten.

Gibt es einen typischen Pariser Stil, und wenn ja, wie macht dieser sich in Ihrer Arbeit bemerkbar? Der ultimative Pariser Stil ist es, vollkommen frei zu sein und sich zu fühlen, und davon wird meine Arbeit definitiv inspiriert.

Wie stellen Sie sich Paris in der Zukunft vor? Immer gleich, Paris ist ewig, es wird sich nie verändern!

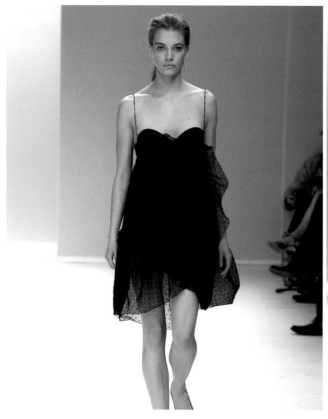 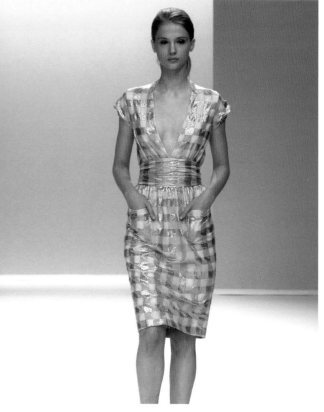

Quelle est à vos yeux l'œuvre la plus importante de votre carrière ? Je regarde toujours vers l'avenir et attend toujours plus, c'est ce qui me fait dire que la plus importante de mes œuvres est devant moi. Elle n'est pas dans le passé, mais elle va venir.

Dans quelle mesure votre œuvre artistique s'inspire-t-elle de Paris ? C'est surtout le style de vie parisien au quotidien qui m'inspire le plus.

Existe-t-il un style typiquement parisien, et si oui, comment se manifeste-t-il dans votre œuvre ? Être et se sentir totalement libre, c'est ça le dernier style parisien, et c'est définitivement la source d'inspiration de mon œuvre.

Comment imaginez-vous le Paris du futur ? Toujours le même : Paris est éternel, il ne changera jamais!

¿Cuál cree que es el trabajo más importante de su carrera? Siempre miro al futuro y espero más, por lo que considero que el trabajo más importante debe estar por delante de mí. No está en el pasado, sino todavía por llegar.

¿Cómo le inspira París en su trabajo? Lo que más me inspira es el día a día de París.

¿Existe un estilo típico de París? Y si es así, ¿cómo se muestra éste en su obra? Ser y sentirse totalmente libre es el último estilo de París, y esto sin duda alguna inspira mi obra.

¿Cómo se imagina París en un futuro? Siempre igual, París es eterna, ¡nunca cambiará!

Quale ritiene sia l'opera più importante della sua carriera? Sono sempre rivolto al futuro e mi aspetto sempre di più, perciò credo che la mia opera più importante debba ancora venire. Non si trova nel passato ma è per così dire in divenire.

In che modo Parigi ispira il suo lavoro? Lo stile di vita parigino di tutti i giorni è la mia maggior ispirazione.

Esiste un tipico "stile parigino"? Se sì, come si manifesta nel suo lavoro? Essere e sentirsi completamente liberi rappresenta lo stile parigino più attuale ed è una chiara ispirazione per il mio lavoro.

Come immagina Parigi nel futuro? Sempre uguale: Parigi è eterna e non cambierà mai!

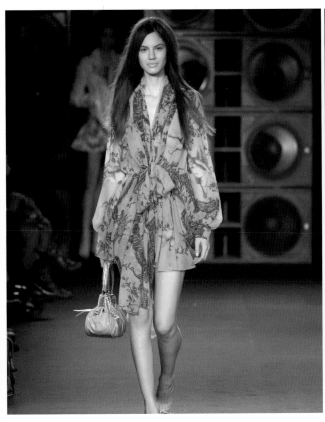
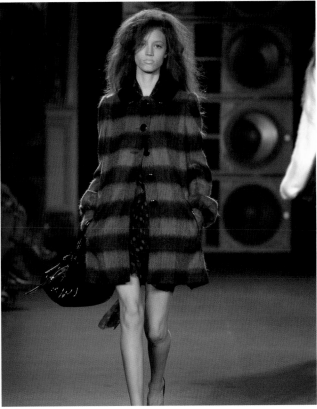

Collection Spring/Summer 2006

Year: 2006
Photographs: © Olivier Claisse

Junko Shimada presents a collection that's more Parisian than ever and it's aimed at the ultra feminine woman: A revised early Bardot style. The lingerie and the street dresses, with checks and polka dots in vivid colors or made from semitransparent delicate fabrics in black, wrap around the silhouette of the woman, transmitting the lightness of the fabric. Thanks to the delicate and innocent aspect of these creations, the collection successfully expresses the essence of femininity.

Pariserischer als je zuvor präsentiert Junko Shimada eine Kollektion, die sich an die ultrafeminine Frau wendet: ein neu konzipierter Bardot-Stil der frühen Jahre. Die Dessous und die Kleider, kariert und gemustert, in lebhaften Farben oder aus zarten, halbtransparenten schwarzen Stoffen, hüllen die Silhouette der Frau ein und vermitteln die Leichtigkeit der Stoffe. Durch diese zart und unschuldig wirkenden Kreationen erreicht es die Kollektion, die Essenz der Weiblichkeit auszudrücken.

Plus parisienne que jamais, Junko Shimada présente une collection destinée à une femme ultra féminine en revisitant le style Bardot des débuts. La lingerie et les vêtements de ville, dotés de carrés et de pois aux couleurs vives ou de subtils tissus semi transparents en noir, enveloppent la silhouette de la femme, lui conférant la légèreté du tissu. Grâce à l'aspect subtil et innocent de ces vêtements, la collection parvient à exprimer l'essence même de la féminité.

Más parisina que nunca, Junko Shimada presentó una colección dirigida a una mujer ultrafemenina mediante una revisión del estilo Bardot de los primeros tiempos. La lencería y los vestidos de calle, con cuadros y lunares en colores vivos o de delicadas telas semitransparentes en negro, envuelven la silueta de la mujer, transmitiendo la ligereza de la tela. Gracias al aspecto delicado e inocente de dichas prendas, la colección logró expresar la esencia de la feminidad.

Più parigina che mai, Junko Shimada ha presentato una collezione rivolta ad una donna ultrafemminile, attraverso una revisione dello stile Bardot dei primi tempi. L'intimo e l'abbigliamento, a quadri e pois dai colori vivaci o in tessuti delicati semitrasparenti in nero, avvolgono la siluetta della donna, trasmettendo la leggerezza della stoffa. Grazie all'aspetto soave e innocente di questi capi, la collezione riesce ad esprimere l'essenza della femminilità.

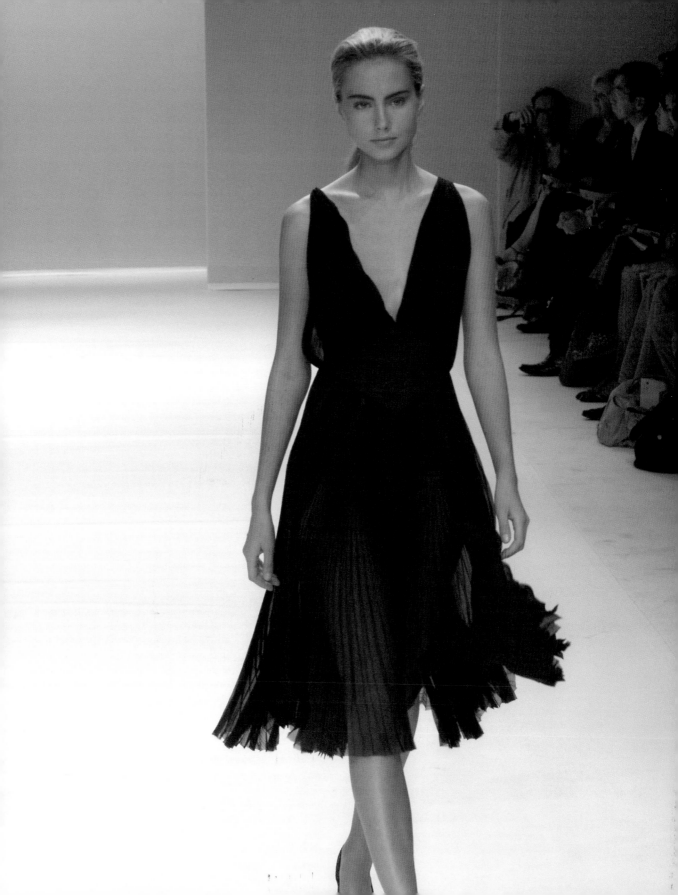

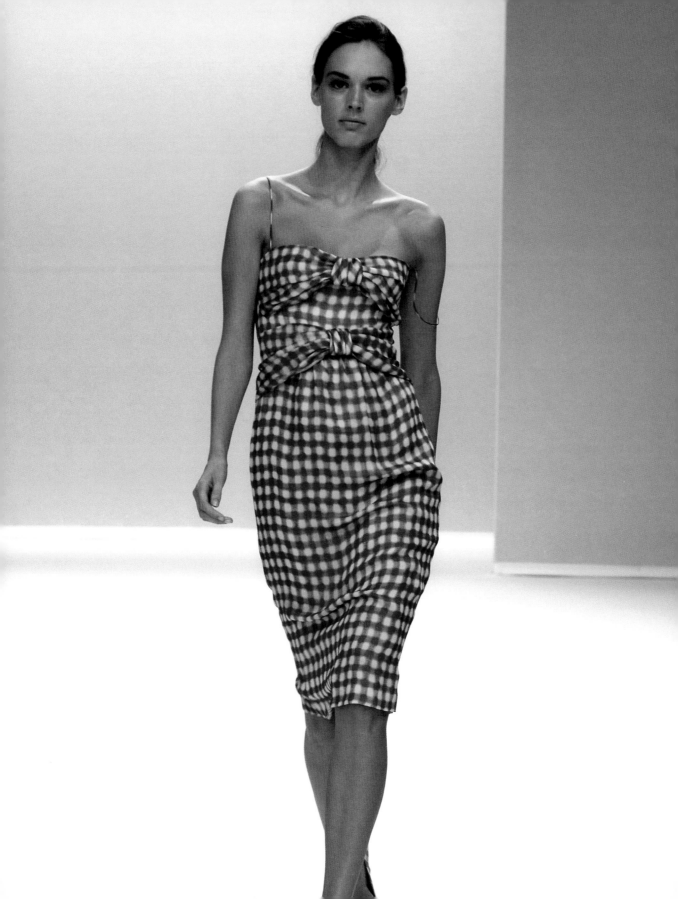

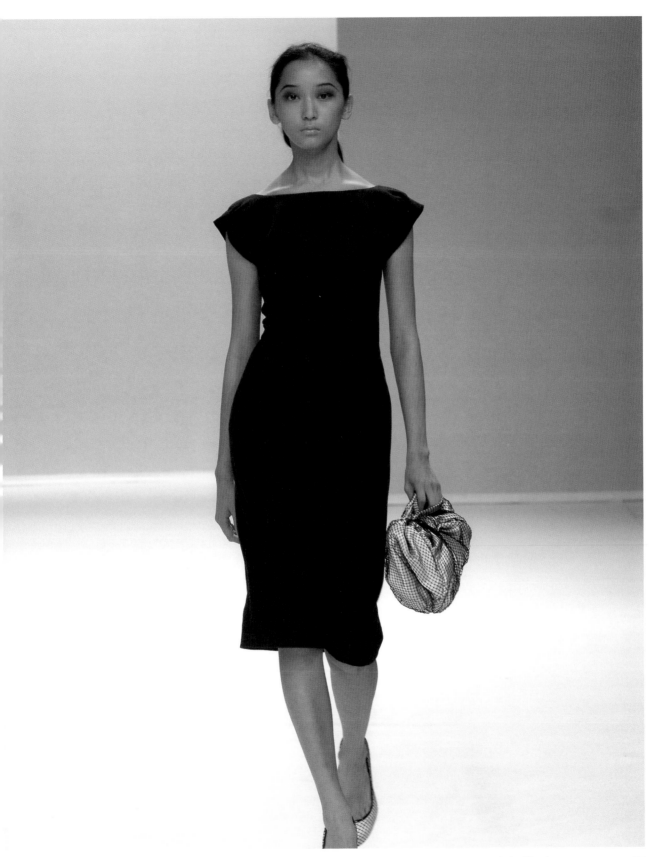

Junko Shimada 465

Junko Shimada

Junko Shimada 467

Collection Fall/Winter 2006-2007

Year: 2006/2007
Photographs: © Olivier Claisse

This collection pays homage to the style of the Eighties. Junko Shimada has rediscovered the style of that decade and introduced his version on the catwalk–sans the fashion excesses of that time. Large, knitted, balloon-shaped, shoulder-free dresses, with stand-up collar or with a chessboard pattern, capri trousers, A-shaped dresses or padded jackets are once again making their debut in conjunction with materials like leather and wool.

Diese Kollektion ist eine Hommage an den Stil der achtziger Jahre. Junko Shimada hat den Stil dieses Jahrzehnts wiederentdeckt und eine von ihren modischen Exzessen bereinigte Version auf den Laufsteg gebracht. Große, globusförmige und schulterfreie Strickkleider, mit Stehkragen oder mit Schachbrettmuster bedruckt, Caprihosen, A-förmige Kleider oder wattierte Jacken haben erneut ihren großen Auftritt in Verbindung mit Materialien wie Leder und Wolle.

Cette collection est un petit hommage à l'esthétique des années quatre-vingt. Junko Shimada redécouvre ici le style et les excès de cette décade et les reflète sur le podium. Grandes robes en crochet en forme de globe, sans épaules ou avec un col haut, imprimés aux grands carrés, à l'instar d'un échiquier, pantalons Capri, robe en trapèze ou vestes matelassées triomphent à nouveau sur la base de matériaux comme la peau et le tricot.

Esta colección es un pequeño homenaje a la estética de los ochenta. Junko Shimada redescubrió aquí el estilo y los excesos de esta década y los reflejó sobre la pasarela. Grandes vestidos de punto en forma de globo, sin hombros o de cuello alto, estampados con grandes cuadros como un tablero de ajedrez, pantalones capri, vestidos trapecio o chaquetas acolchadas triunfan de nuevo retomando como base materiales tales como la piel y la lana.

Questa collezione è un omaggio all'estetica degli anni '80. Junko Shimada ne riscopre lo stile e gli eccessi, rispecchiandoli in versione purista sulla passerella. Grandi vestiti di maglia a palloncino, tanto scollati da lasciare nude le spalle o a collo alto, stampati a quadri grandi come quelli di una scacchiera, pantaloni capri, vestiti svasati o giacche imbottite tornano a trionfare, recuperando materiali come la pelle e la maglia.

Junko Shimada

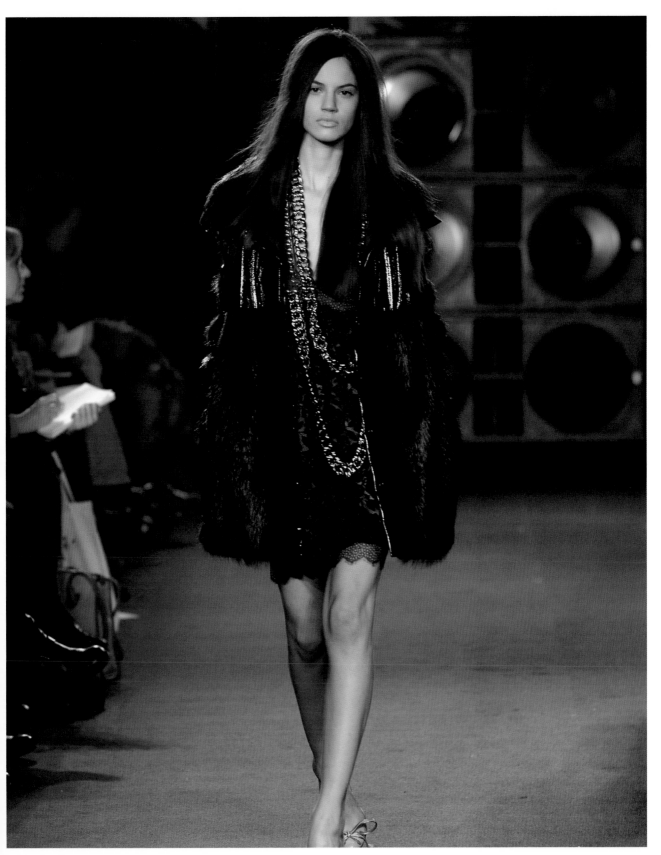

Junko Shimada 471

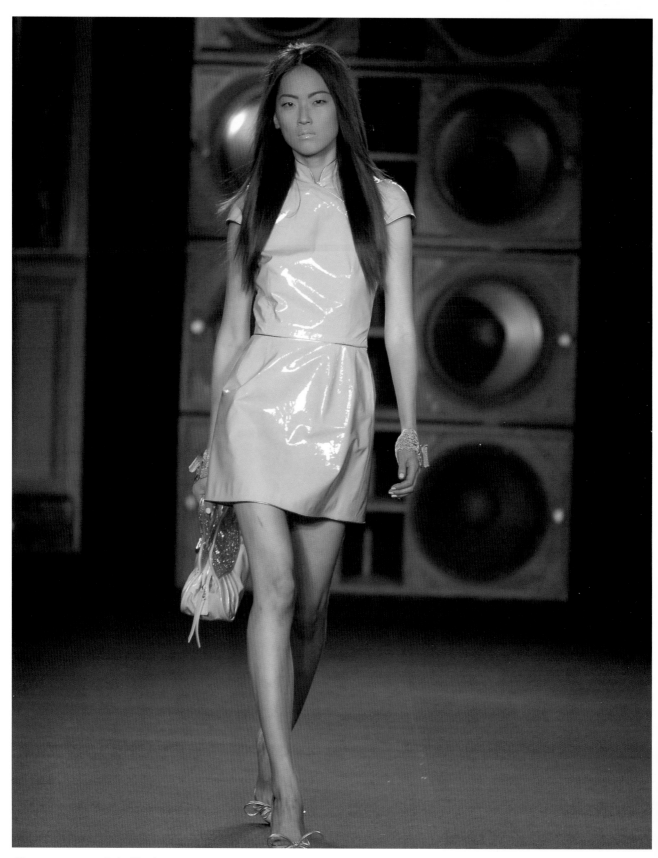

Junko Shimada

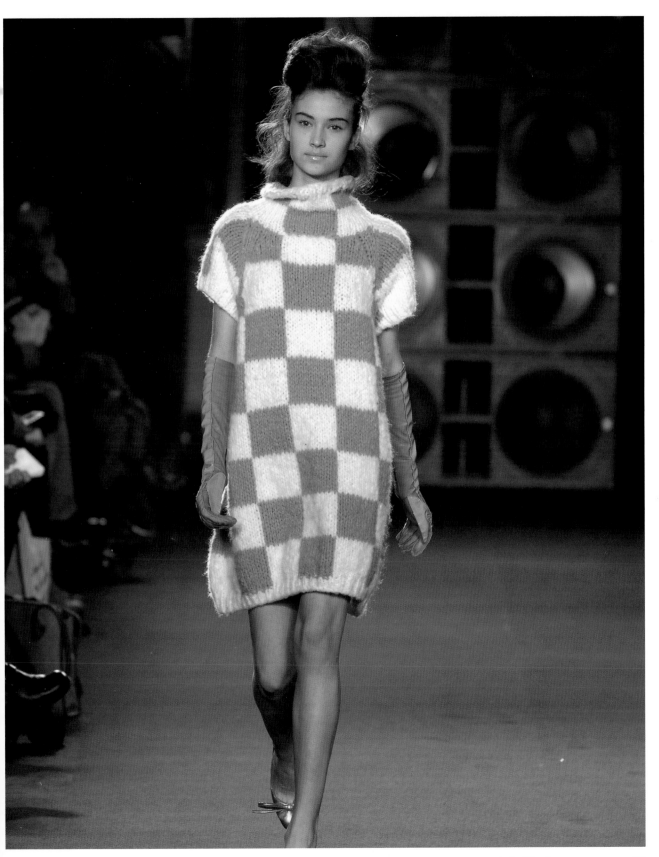

Junko Shimada 473

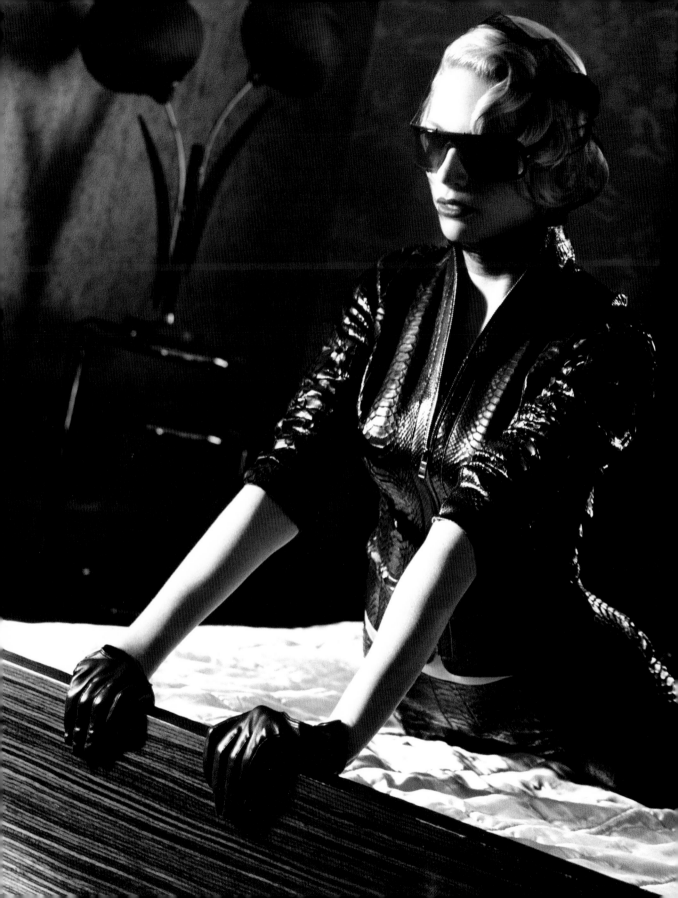

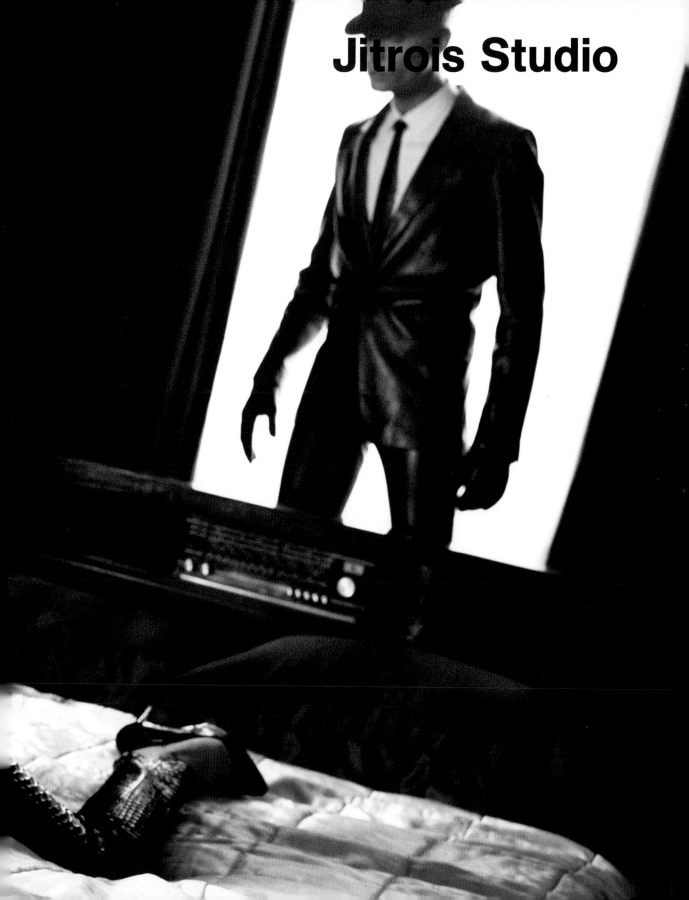

Jitrois Studio

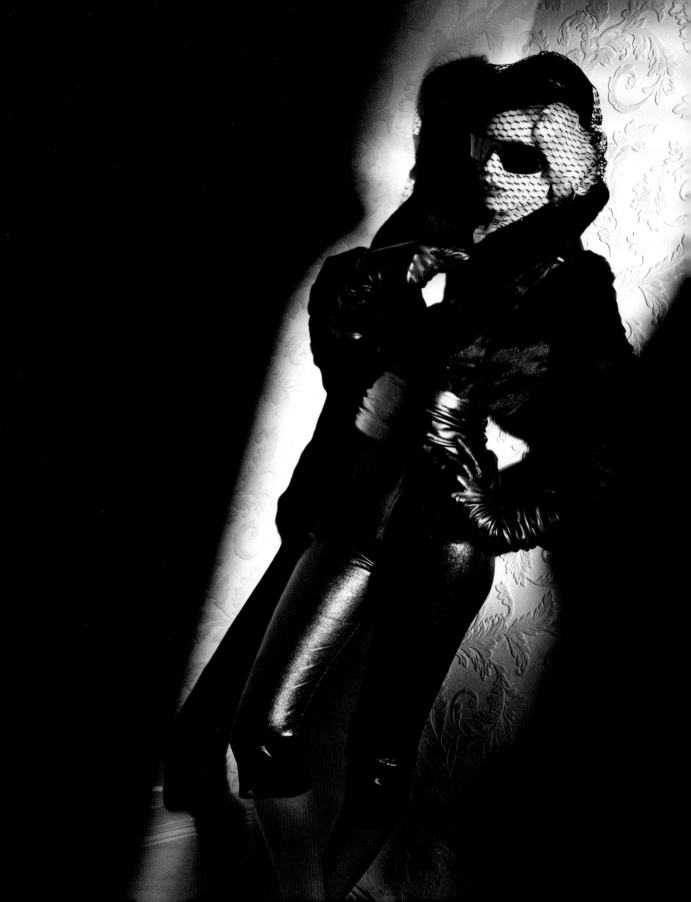

Jitrois Studio

48, rue du Faubourg Saint-Honoré, 75008 Paris

+33 158 18 38 49

+33 158 18 38 83

www.jitrois.fr

style@jitrois.fr

Jean-Claude Jitrois

Originally inspired by a jacket his father wore, Jean-Claude Jitrois has revolutionized the use of stretch leather. He applies this material to create unique clothing, which is admired and sought after by artists and celebrities. In 1983, he started his first business under his name in Paris and continued his research into leather with innovative techniques.

Jean-Claude Jitrois, der einst von einer Jacke seines Vaters inspiriert wurde, revolutionierte den Gebrauch von Stretchleder. Dieses Material verwendet er für die Kreation von einzigartigen Kleidungsstücken, die von Künstlern und Berühmtheiten bewundert und begehrt werden. 1983 eröffnete er in Paris das erste Geschäft mit seinem Namen und führte seine Forschungen im Lederbereich mit neuartigen Techniken fort.

Ce designer, s'inspirant au départ d'une veste de son père, révolutionne l'usage de la peau stretch qu'il emploie dans des vêtements uniques, recherchés et admirés par les artistes et célébrités. En 1983, il ouvre à Paris la première boutique portant son nom, poursuivant sa recherche dans le domaine du cuir grâce à de nouvelles techniques.

Este diseñador, que se inspiró originalmente en una chaqueta de su padre, revolucionó el uso de la piel elástica y la utilizó en prendas únicas, perseguidas y admiradas por artistas y famosos. En 1983 abrió en París la primera tienda con su nombre y continuó con su investigación en el campo de la piel gracias a novedosas técnicas.

Ispiratosi originariamente ad una giacca di suo padre, questo stilista rivoluziona l'uso del pellame elasticizzato, materiale che utilizza per la creazione di capi unici, stimati ed apprezzati da artisti e personaggi famosi. Nel 1983 apre a Parigi il primo negozio che porta il suo nome, continuando le sue ricerche nel campo del pellame con il supporto di tecniche innovative.

1944
Born in Narbonne, France

1983
Opens his first shop on the Faubourg Saint-Honoré in Paris, France

1989
Launches his first bag line

1998
Launches de "skin jeans" line

2002
Smocked leather in the "Guernica" line

2004
Spring-Summer collection: he uses vintage oiled leather, for the "O'Ren" line and introduces the stretch python

Interview | Jean-Claude Jitrois

Which do you consider the most important work of your career? The invention of stretch leather, which hides those little imperfections of the body. Leather becomes elastic and doesn't get baggy. We have extended this technique to elastic suede and, this season, to the python, transforming woman into a "snake woman"!

In what ways does Paris inspire your work? Paris is the labyrinth of fashion. Those who find their way are between the Rive Gauche and the Rive Droite, which differentiates young stylists with crazy talent from designers who create haute couture collections.

Does a typical Paris style exist, and if so, how does it show in your work? The work of these stylists influence *prêt-à-porter*, the material innovation where we mix suede with leather or printed cotton with exotic leathers.

How do you imagine Paris in the future? Always a labyrinth.

Welches Werk halten Sie für das wichtigste Ihrer Karriere? Die Erfindung des Stretchleders, das die kleinen Makel des Körpers verhüllt. Leder wird elastisch und beult nicht aus. Wir haben diese Technik auf elastisches Wildleder angewandt und in der letzten Saison auch auf Pythonleder und somit die Frau in eine „Schlangenfrau" verwandelt.

Wie inspiriert Paris Ihre Arbeit? Paris ist ein Modelabyrinth. Diejenigen, die ihren Weg finden, stehen zwischen dem Rive Gauche und dem Rive Droite, das junge Schöpfer mit verrücktem Talent von Designern, die Haute Couture entwerfen, trennt.

Gibt es einen typischen Pariser Stil, und wenn ja, wie macht dieser sich in Ihrer Arbeit bemerkbar? Die Arbeit dieser Designer beeinflusst das Prêt-à-porter, die Materialinnovation bei der wir Wildleder mit Leder oder bedruckte Baumwolle mit exotischen Ledern mischen.

Wie stellen Sie sich Paris in der Zukunft vor? Immer als ein Labyrinth.

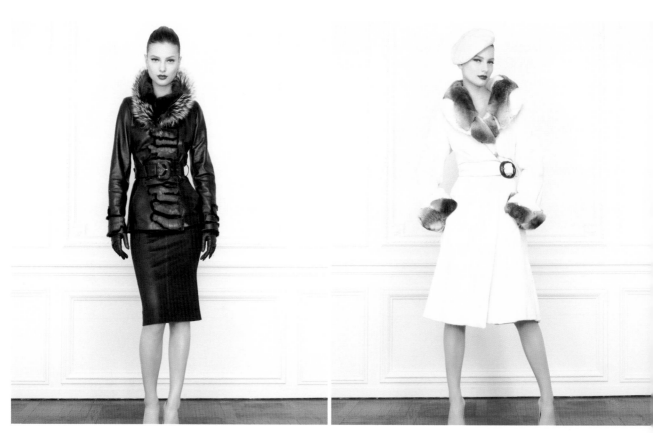

Quelle est à vos yeux l'œuvre la plus importante de votre carrière ? L'invention du cuir stretch qui masque les petites imperfections du corps. Le cuir devient élastique et ne fait pas de poches. Nous avons étendu cette technique au daim stretch, et pour cette saison, au python, transformant la femme en « femme serpent ».

Dans quelle mesure votre œuvre artistique s'inspire-t-elle de Paris ? Paris est le labyrinthe de la mode. Ceux qui s'y frayent un chemin sont entre la Rive Gauche et la Rive Droite qui font la différence entre les jeunes créateurs au talent fou et les stylistes qui créent les collections haute couture.

Existe-t-il un style typiquement parisien, et si oui, comment se manifeste-t-il dans votre œuvre ? Les œuvres de stylistes influencent le prêt-à-porter, l'innovation de la matière avec notre mélange de daim et cuir ou d'imprimés de coton et de cuirs exotiques.

Comment imaginez-vous le Paris du futur ? Toujours comme labyrinthe.

¿Cuál cree que es el trabajo más importante de su carrera? El descubrimiento del cuero elástico, que disimula esas pequeñas imperfecciones del cuerpo. El cuero se vuelve elástico y no se queda flojo. Hemos aplicado esta técnica al ante elástico y, esta temporada, a la piel de pitón, por lo que hemos transformado a la mujer en una "mujer serpiente".

¿Cómo le inspira París en su trabajo? París es un laberinto de la moda. Los que encuentran su camino están entre la Rive Gauche y la Rive Droite, lo que diferencia a los jóvenes creadores y talentos locos de los diseñadores de la alta costura.

¿Existe un estilo típico de París? Y si es así, ¿cómo se muestra éste en su obra? Los trabajos de estos diseñadores influyen en el *prêt-à-porter*, en la innovación de materiales donde combinamos el ante con el cuero o el algodón estampado con pieles exóticas.

¿Cómo se imagina París en un futuro? Siempre como un laberinto.

Quale ritiene sia l'opera più importante della sua carriera? L'invenzione della pelle elasticizzata, che nasconde le piccole imperfezioni fisiche. La pelle diventa elastica e non si affloscia. Abbiamo esteso questa tecnica alla pelle scamosciata elastica e, questa stagione, al pitone, trasformando la donna in una "donna serpente"!

In che modo Parigi ispira il suo lavoro? Parigi è il labirinto della moda. Quelli che trovano la loro strada si dividono tra la Rive Gauche e la Rive Droite, differenziandosi tra giovani creatori dal folle talento e stilisti che creano collezioni di alta moda.

Esiste un tipico "stile parigino"? Se sì, come si manifesta nel suo lavoro? Il lavoro di questi stilisti influenza il *prêt-à-porter*, l'innovazione dei materiali che ci fa unire scamosciato e pelle o cotone stampato e pelli esotiche.

Come immagina Parigi nel futuro? Sempre come un labirinto.

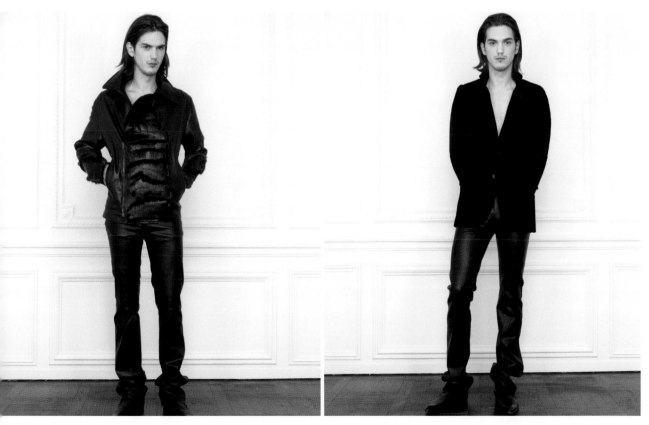

Collection Fall/Winter 2006-2007

Year: 2006
Photographs: © Rankin

The theme of this Fall/Winter collection is the Parisian woman, chic and elegant, wrapped in the designer's favorite material: Leather. She's wrapped in waist-fitting, sophisticated leather jackets or in slim-cut coats, which take the best and most luxurious kinds of leather and combine them. The skirts and trousers, both for men and women, are made of leather and python and hug the body to highlight the figure. Caps as well as tight-fitting leather and suede gloves are the prime accessories of the collection.

Das Thema dieser Herbst/Winter-Kollektion ist die Pariser Frau, schick und elegant, umschmiegt von dem favorisierten Material des Designers: Leder. Gehüllt in taillierte, raffinierte Lederjacken oder in schmal geschnittene Mäntel, bei denen die besten und luxuriösesten Lederarten miteinander kombiniert werden. Die Röcke und Hosen, sowohl die für Herren als auch die für Damen, sind aus Leder und Pythonleder gefertigt; sie schmiegen sich an den Körper und betonen so die Figur. Mützen und enge Handschuhe aus Leder und Wildleder sind die wichtigsten Accessoires der Kollektion.

Le thème de la collection automne/hiver est la Parisienne, chic et élégante, enveloppée dans la matière préférée du designer : la peau. Une femme qui s'habille de vestes taillées, raffinées ou de manteau ajustés au corps, mélangeant les meilleurs cuirs et les plus luxueux. Les jupes et pantalons, d'homme ou de femme, sont réalisés en cuir et python et sont près du corps pour styliser la silhouette. Les bérets et les gants de peau et en daim ajustés sont les accessoires phares de la collection.

El tema de la colección Otoño/Invierno es la mujer parisina, chic y elegante, envuelta en el material favorito del diseñador: la piel. Una mujer que se viste con chaquetas entalladas, refinadas, o con abrigos ajustados al cuerpo, que mezclan las mejores y más lujosas pieles. Las faldas y los pantalones, tanto de hombre como de mujer, son de cuero y pitón, y se ciñen al cuerpo para estilizar la figura. Las gorras y los ajustados guantes en piel y ante son los complementos estrella de la colección.

Il tema della collezione autunno/inverno è la donna parigina, chic ed elegante, avvolta nel materiale preferito dello stilista: la pelle. Una donna che si veste con giacche sagomate raffinate, o con cappotti aderenti che mescolano le migliori e più lussuose pelli. Le gonne e i pantaloni, sia da uomo che da donna, sono realizzati in cuoio e pitone e aderiscono al corpo per stilizzare la figura. I baschi e gli stretti guanti di pelle e camoscio sono gli accessori protagonisti della collezione.

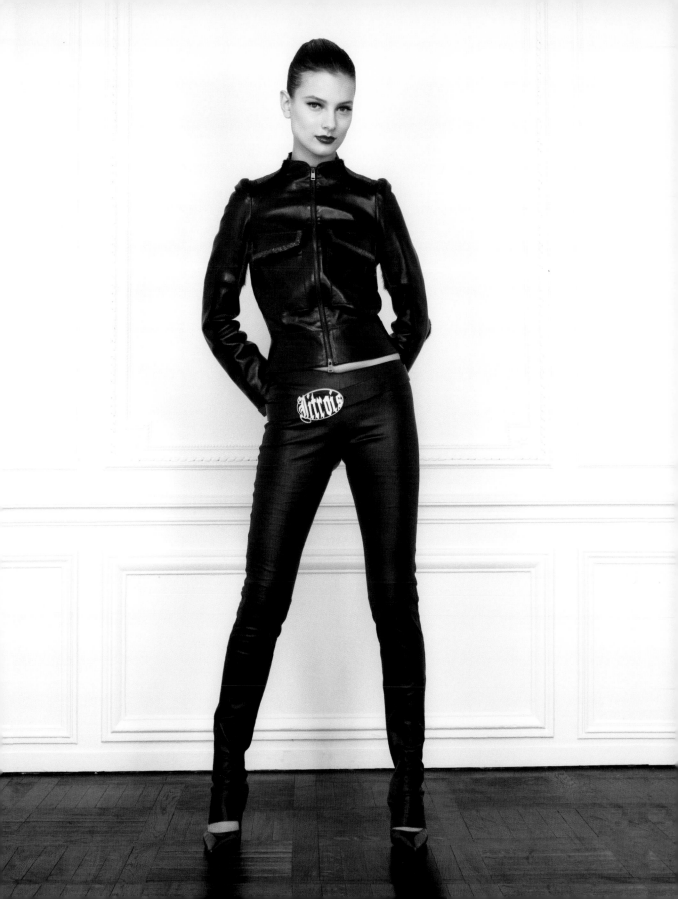

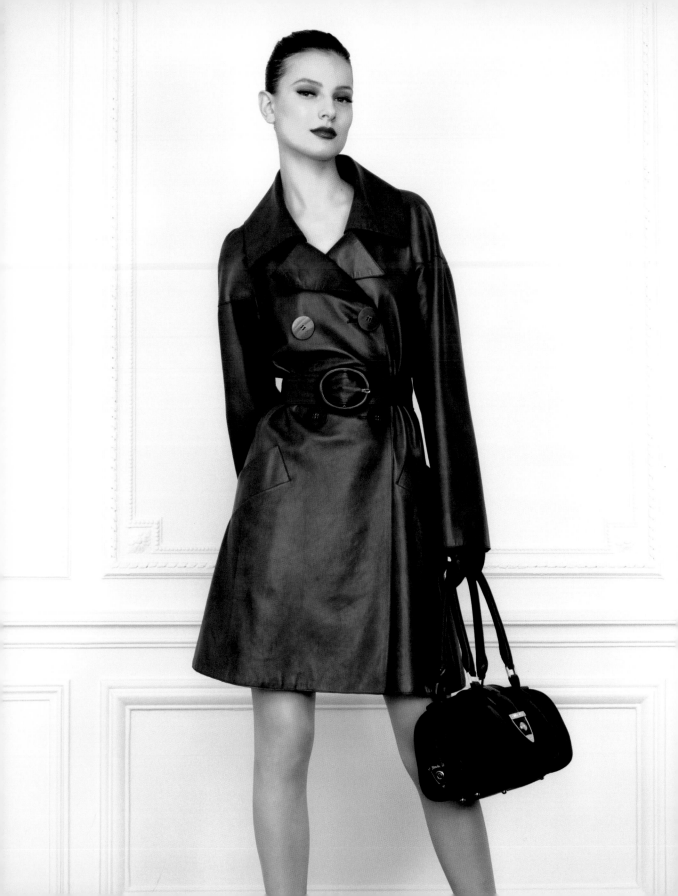

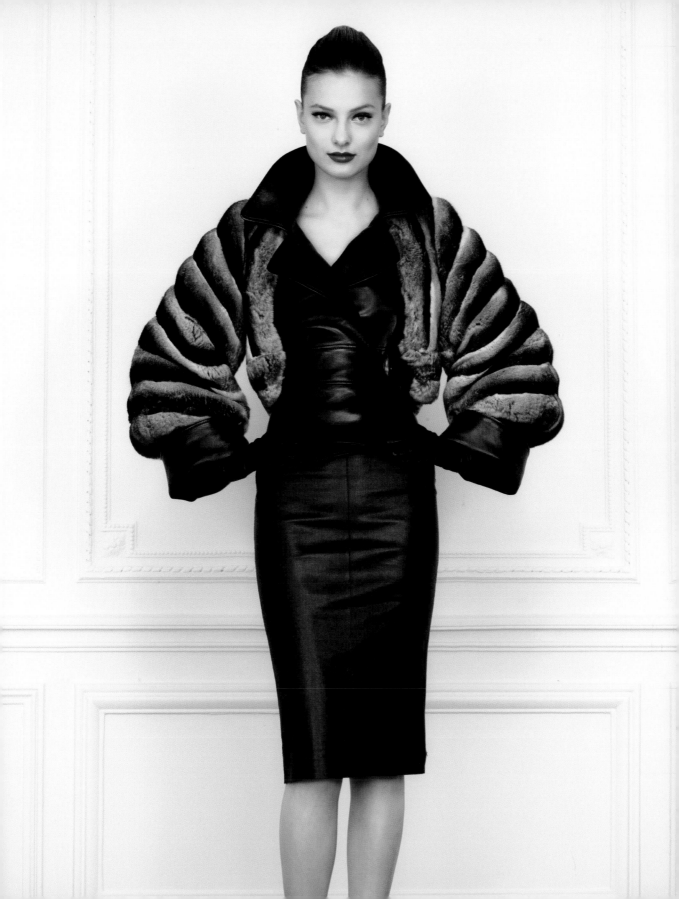

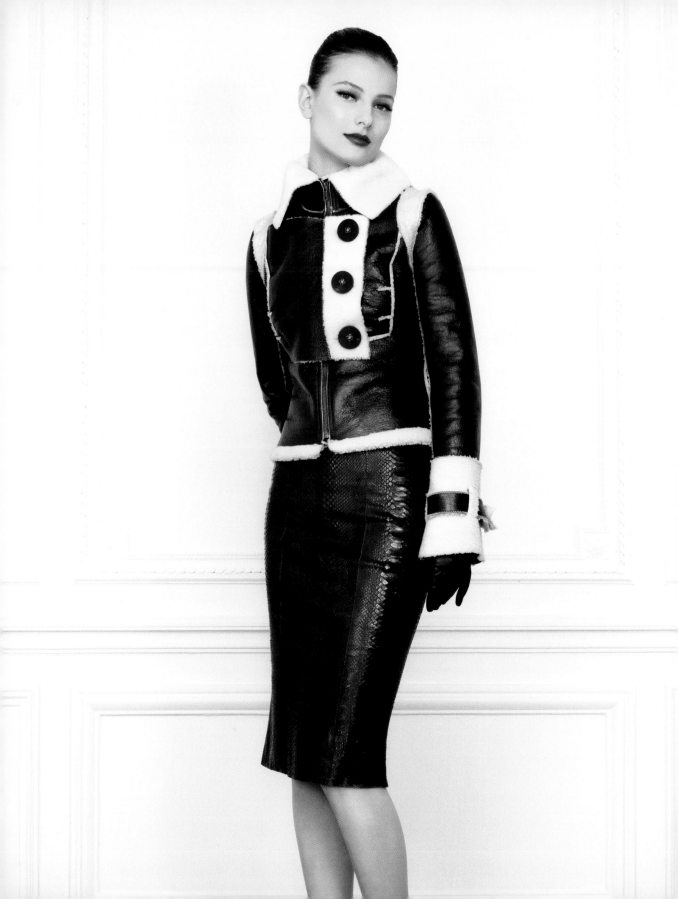

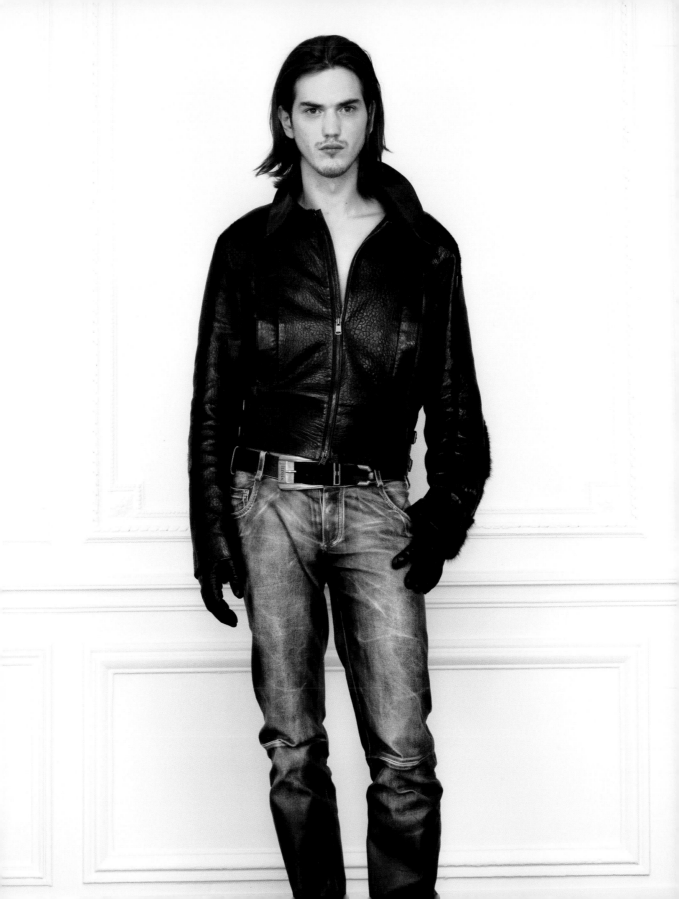

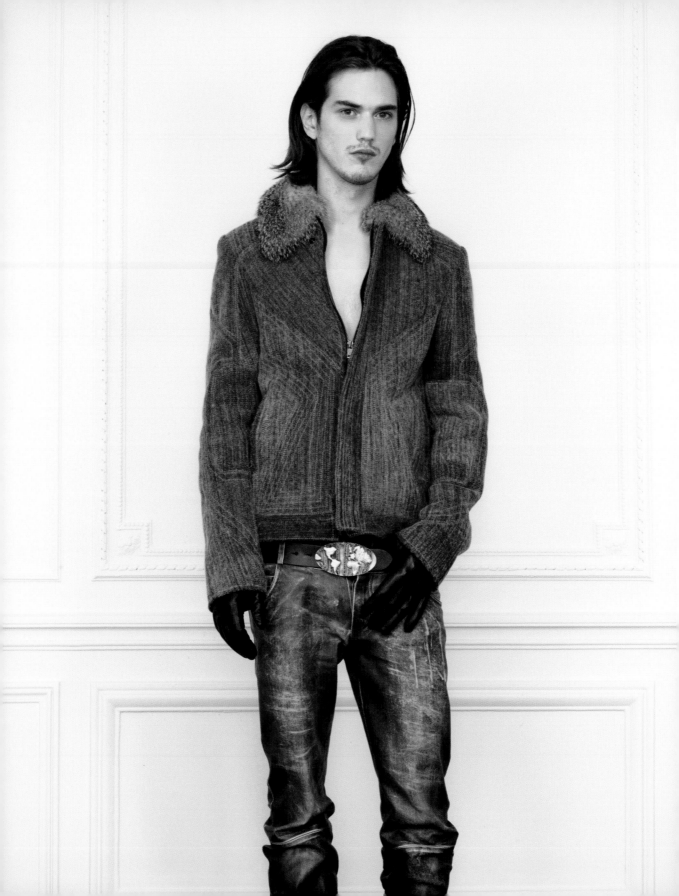

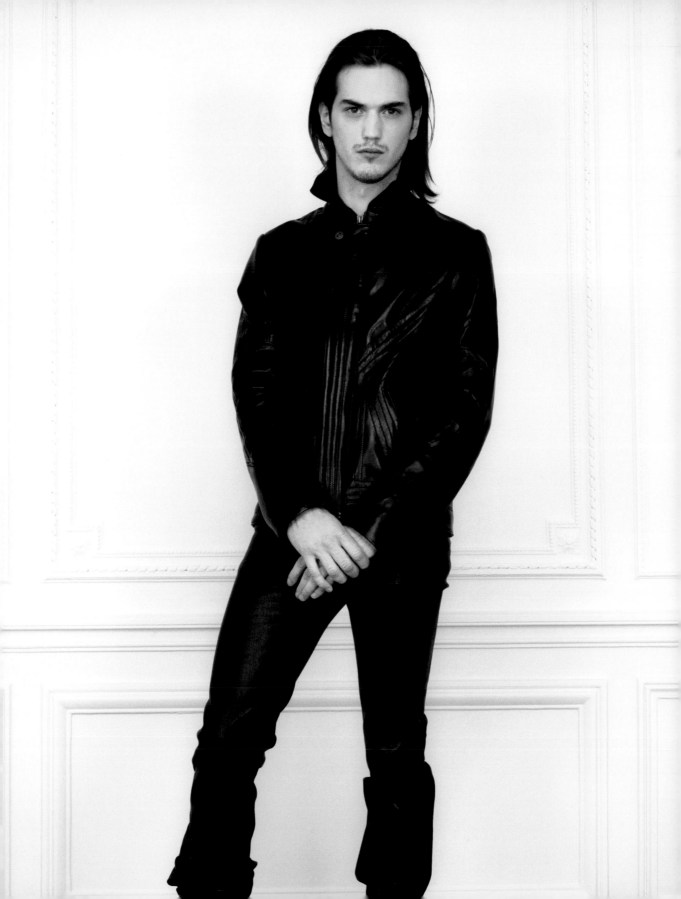

Karl Lagerfeld

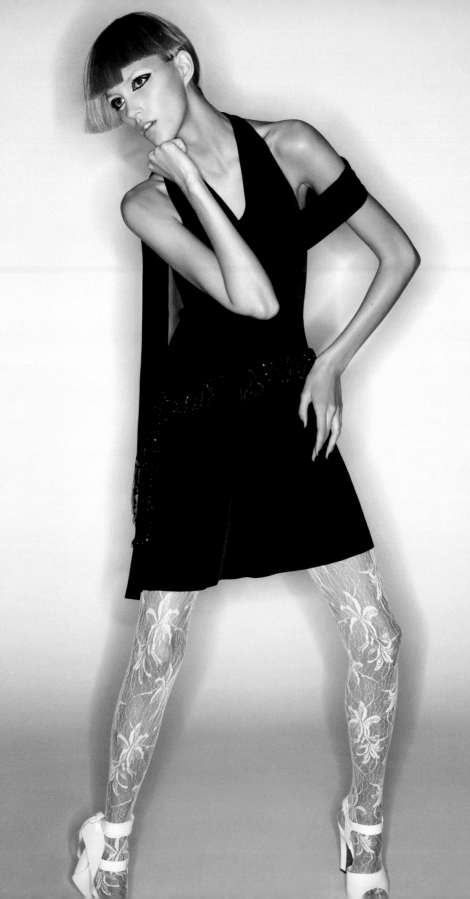

Karl Lagerfeld

2, rue Vivienne, 75002 Paris

+33 144 50 22 22

+33 144 50 22 05

www.karllagerfeld.com

info@karllagerfeld.com

Karl Lagerfeld

Born in Hamburg and a Parisian by choice, Karl Lagerfeld began his career as an assistant to Pierre Balmain and eventually became the driving force behind brands such as Chloé and Chanel and his own brand, Karl Lagerfeld. His fascination with the art world led him to photograph his fashion campaigns and to found his own book edition, Edition 7L. He later sold his brands to Tommy Hilfiger so that he could fully dedicate his life to his new passion.

Karl Lagerfeld, gebürtiger Hamburger und Wahlpariser, begann seine Laufbahn als Assistent von Pierre Balmain und wurde schließlich zur Seele von Firmen wie Chloé, Chanel und seiner eigenen Marke, Karl Lagerfeld. Seine Faszination für die Welt der Kunst führte ihn dazu, seine Modekampagnen zu fotografieren und seine eigene Buchedition, Edition 7L, zu gründen. Später verkaufte er seine Marken an Tommy Hilfiger, um seine neue Passion voll ausleben zu können.

Designer précoce, né à Hambourg et parisien d'adoption, Karl Lagerfeld débute comme assistant de Pierre Balmain et finit par devenir l'âme des sociétés comme Chloé et Chanel et de sa propre ligne, Karl Lagerfeld. Sa fascination pour le monde de l'art le pousse à se placer derrière l'objectif pour photographier ses défilés et fonder ensuite sa propre édition de libre, Edition 7L. Plus tard, il vend ses marques à Tommy Hilfiger pour laisser libre cours à sa nouvelle passion.

Precoz diseñador nacido en Hamburgo y parisino de adopción, Karl Lagerfeld empezó como asistente de Pierre Balmain y acabó siendo el alma de firmas como Chloé y Chanel y de su propia línea, Karl Lagerfeld. Su fascinación por el mundo del arte lo llevó a ponerse tras la cámara para fotografiar sus campañas, y después a crear su propia edición de libros, Edition 7L. Más tarde, vendió sus marcas a Tommy Hilfiger para dar rienda suelta a su nueva pasión.

Nativo d'Amburgo e parigino d'adozione, Karl Lagerfeld comincia la sua carriera come assistente di Pierre Balmain, riuscendo ben presto a trasformarsi nell'anima di aziende come Chloé e Chanel nonché del proprio marchio Karl Lagerfeld. Il fascino nutrito nei confronti del mondo dell'arte lo porta dapprima a mettersi dietro l'obiettivo per fotografare da sé le sue campagne pubblicitarie, più tardi a fondare una propria edizione di libri, Edition 7L. Successivamente vende i propri marchi a Tommy Hilfiger per dare briglia sciolta alla sua nuova passione.

1938
Born in Hamburg, Germany

1952
Moves to Paris, France

1955
Wins the first prize in the contest organized by the International Wool Association with the design of a coat, then produced by Pierre Balmain. Lagerfeld becomes his assistant

1975
Launches the perfume Chloé

1984
After Lagerfeld for Men launches his own line Karl Lagerfeld

2000
Founds his own book edition Editions 7L

2004
Designs 30 models for H&M

2005
Sells its marks to Tommy Hilfiger

2006
Lagerfeld Gallery's name changes into Karl Lagerfeld

Interview | Karl Lagerfeld

Which do you consider the most important work of your career? I have no consideration for things done, I like doing.

In what ways does Paris inspire your work? Paris is an idea, not so much a reality.

Does a typical Paris style exist, and if so, how does it show in your work? For me the typical Paris' style is Rive Gauche, not the label but the streets around Saint Germain des Prés and my Bookshop.

How do you imagine Paris in the future? My job is not to imagine the future of cities, I just hope it won't become boring.

Welches Werk halten Sie für das wichtigste Ihrer Karriere? Ich schenke vollendeten Sachen keine Beachtung. Ich mag es, zu schaffen.

Wie inspiriert Paris Ihre Arbeit? Paris ist weniger eine Realität, es ist eine Idee.

Gibt es einen typischen Pariser Stil, und wenn ja, wie macht dieser sich in Ihrer Arbeit bemerkbar? Für mich ist der typische Pariser Stil Rive Gauche, nicht das Label, sondern die Straßen rings um Saint Germain des Prés und meine Buchhandlung.

Wie stellen Sie sich Paris in der Zukunft vor? Es ist nicht meine Aufgabe, mir die Zukunft von Städten vorzustellen. Ich hoffe nur, dass es nicht langweilig wird.

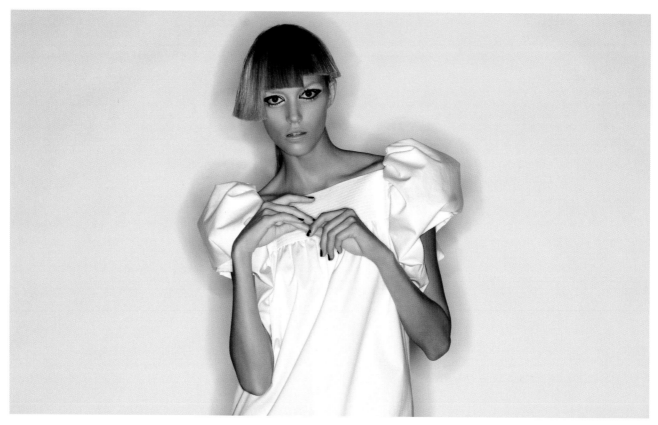

Quelle est à vos yeux l'œuvre la plus importante de votre carrière ? Les choses réalisées ne m'intéressent pas, j'aime créer.

Dans quelle mesure votre œuvre artistique s'inspire-t-elle de Paris ? Paris est une idée plus qu'une réalité.

Existe-t-il un style typiquement parisien, et si oui, comment se manifeste-t-il dans votre œuvre ? A mon avis, le style typique de Paris c'est la Rive Gauche, pas le nom mais les rues autour de Saint Germain des Prés et de ma librairie.

Comment imaginez-vous le Paris du futur ? Ce n'est pas mon job d'imaginer les villes au futur, j'espère seulement que l'on ne s'y ennuiera pas de trop.

¿Cuál cree que es el trabajo más importante de su carrera? No tengo en cuenta las cosas realizadas, lo que me gusta es realizarlas.

¿Cómo le inspira París en su trabajo? París es una idea, no tanto una realidad.

¿Existe un estilo típico de París? Y si es así, ¿cómo se muestra éste en su obra? Para mí el estilo típico de París es la Rive Gauche, no la etiqueta sino las calles alrededor de Saint Germain des Prés y mi librería.

¿Cómo se imagina París en un futuro? Mi trabajo no consiste en imaginar el futuro de las ciudades, simplemente espero que no se convierta en una ciudad aburrida.

Quale ritiene sia l'opera più importante della sua carriera? Non ho nessuna considerazione per le cose fatte: mi piace fare.

In che modo Parigi ispira il suo lavoro? Parigi è un'idea più che una realtà.

Esiste un tipico "stile parigino"? Se sì, come si manifesta nel suo lavoro? Per me il tipico stile parigino è quello della Rive Gauche, non delle griffe ma delle strade intorno a Saint Germain des Prés e alla mia libreria.

Come immagina Parigi nel futuro? Il mio lavoro non consiste nell'immaginare il futuro delle città. Spero solo che non diventi noiosa.

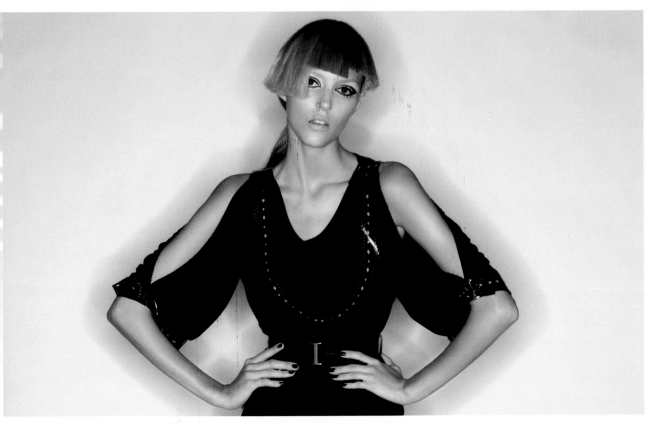

Karl Lagerfeld 495

Collection Spring/Summer 2007

Year: 2006
Photographs: © Karl Lagerfeld

Contrasts characterize this collection by Karl Lagerfeld for the next spring/summer season. White and black, masculine and feminine, come together and intermingle. His creations are wide around the shoulders, tight around the waist and legs, which are left bare by the short skirts and create a sensual touch of absolute femininity. Narrow belts, necklaces with large beads and mini ties combined with sashes round off the collection.

Kontraste charakterisieren diese Kollektion von Karl Lagerfeld für die kommende Frühjahrs/Sommer-Saison. Weiß und Schwarz, das Männliche und das Weibliche, treffen aufeinander und vermischen sich. Die Kreationen sind breit an den Schultern und eng an den Taillen und Beinen, welche unter kurzen Röcken unbedeckt bleiben und somit einen sinnlichen Hauch von absoluter Weiblichkeit erzeugen. Enge Gürtel, Halsketten mit großen Perlen und kleine Krawatten, mit Schärpen kombiniert, ergänzen diese Kollektion.

Les contrastes caractérisent cette collection de Karl Lagerfeld pour la prochaine saison printemps-été. Le blanc et noir, le masculin et le féminin, se heurtent et se mêlent créant des volumes sur les épaules et se rétrécissant à la taille et sur les jambes, les laissant découvertes avec des jupes courtes, dans une touche sensuelle de féminité absolue. Les ceintures resserrées à la taille, les colliers de grandes perles et mini cravates assorties à des ceintures complètent la collection.

Los contrastes caracterizan esta colección de Karl Lagerfeld para la próxima temporada primavera-verano. El blanco y el negro, lo masculino y lo femenino, chocan y se mezclan creando volúmenes en los hombros y estrechándose en cintura y piernas, dejándolas al descubierto con faldas cortas, en un sensual toque de feminidad absoluta. Los cinturones estrechados en el talle, los collares de grandes cuentas y mini corbatas combinadas con fajín completan la colección.

I contrasti caratterizzano questa collezione di Karl Lagerfeld per la prossima stagione primavera/estate. Il bianco e il nero, il maschile e il femminile, si 'scontrano' e si mescolano creando volumi sulle spalle e stringendosi in cintura e sulle gambe, lasciate allo scoperto da gonne corte, con un sensuale tocco di femminilità assoluta. Le cinture strette in vita, le collane di perle grandi e le mini cravatte abbinate a fusciacche completano la collezione.

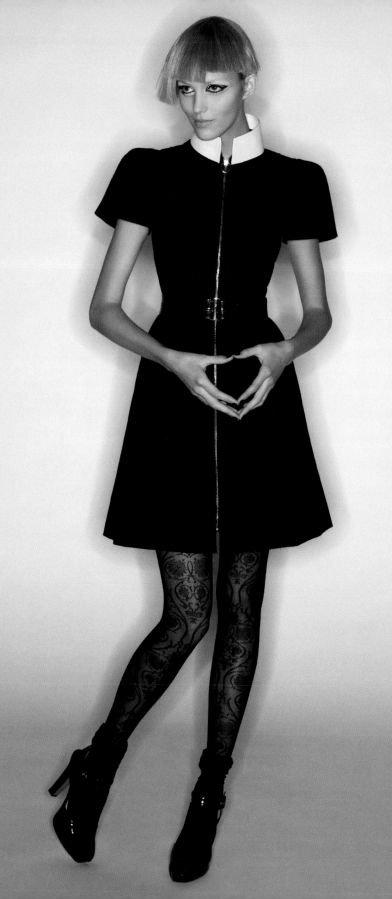

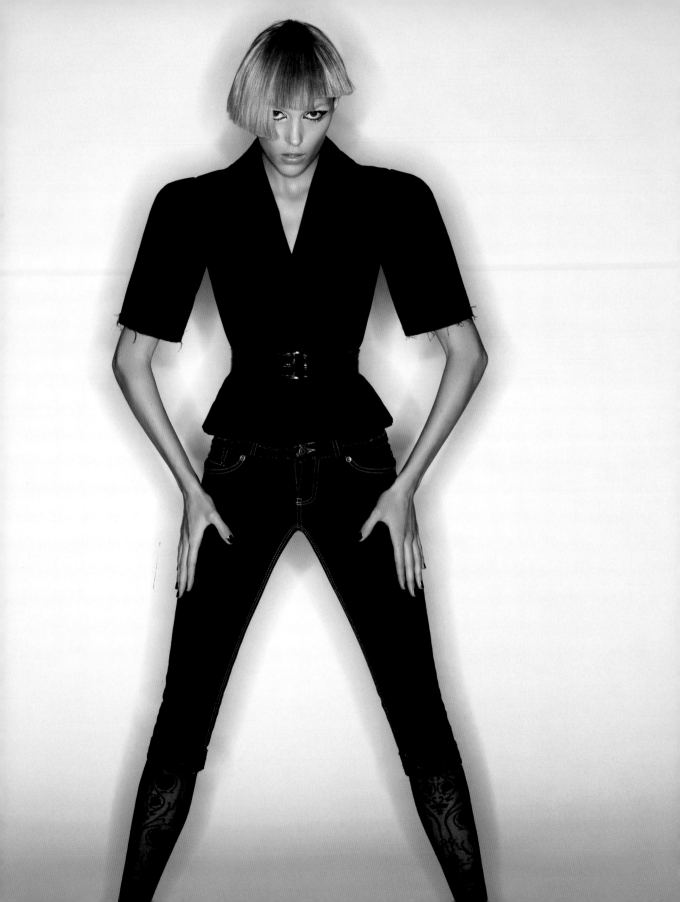

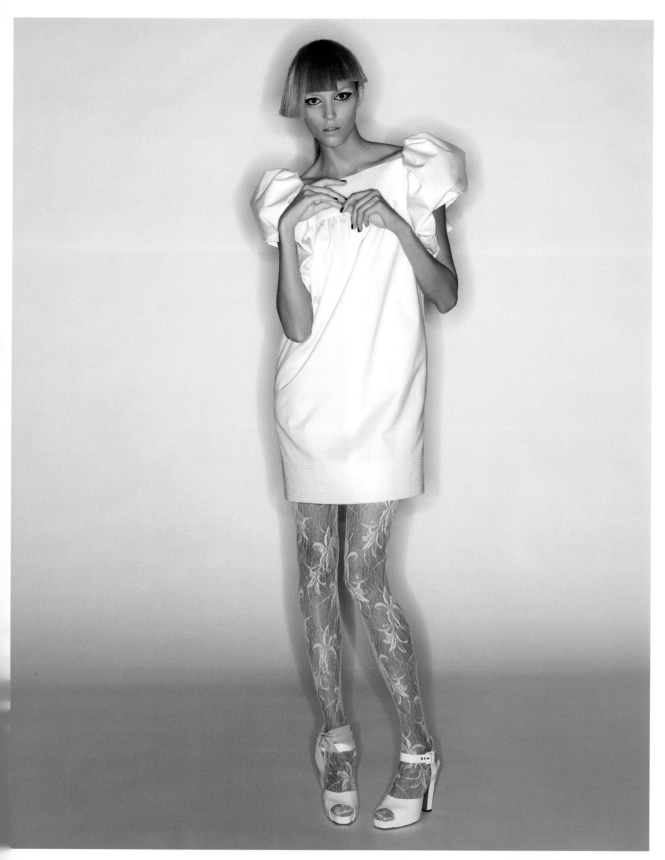

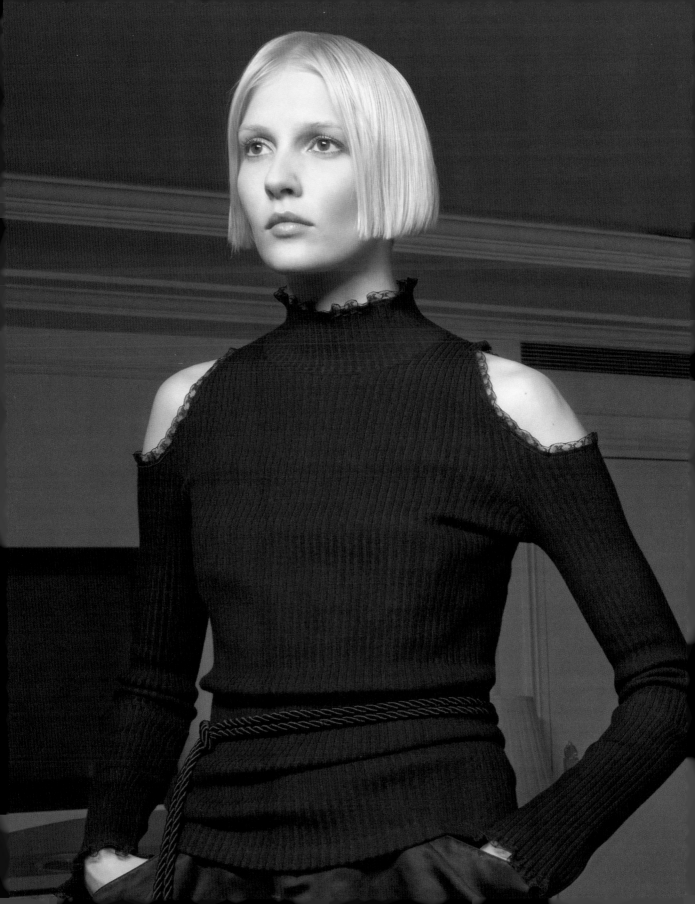

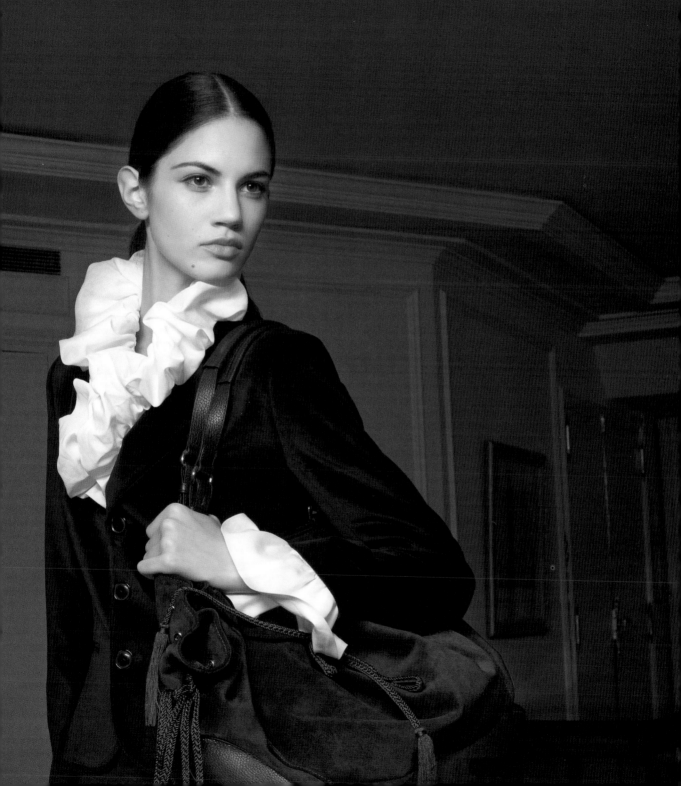

Anne Fontaine

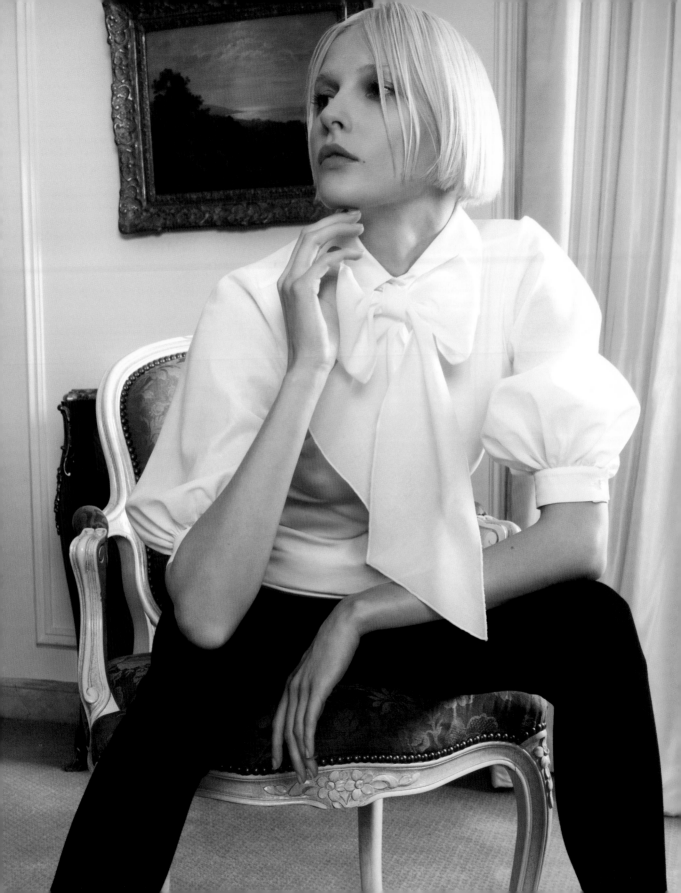

Anne Fontaine

50, rue Etienne Marcel, 75002 Paris

+33 231 14 67 67

+33 231 14 67 68

www.annefontaine.com

p.melot@annefontaine.com

Anne Fontaine

1971
Born in Rio de Janeiro, Brasil

1993
Launches her first collection

1994
Opens her first boutique

1995
Opens her second boutique in Japan, in the Aoyama area of Tokyo

2000
Opens her boutique on Madison Avenue, New York, USA

2004
First Anne Fontaine fashion show to mark the 10 year anniversary

Anne Fontaine was born in Brazil and began her career in Paris. Together with her husband, who comes from a family that's active in the textile industry, she started a business specializing in white blouses. In Brazil, this color symbolizes spirituality. With shops subsequently opened in Paris, London and New York, they have successfully carved a niche for themselves in the world of fashion.

Anne Fontaine wurde in Brasilien geboren und begann ihre Karriere in Paris. Zusammen mit ihrem Mann, der aus einer Familie stammt, die in der Textilindustrie tätig ist, gründete sie eine Firma, die auf weiße Blusen spezialisiert ist. Diese Farbe symbolisiert in Brasilien die Spiritualität. Mit ihren nach und nach in Paris, London und New York eröffneten Geschäften schufen sie sich erfolgreich eine Nische in der Welt der Mode.

Anne Fontaine est née au Brésil, même si c'est à Paris qu'elle a fait carrière. Après avoir rencontré son mari, fils d'une famille travaillant dans le secteur textile, tous deux décident de créer leur négoce, axé sur les blouses blanches, couleur qui symbolise la spiritualité au Brésil. Peu à peu, ils ouvrent des boutiques à Paris, Londres et New York jusqu'à ce qu'ils finissent par connaître le succès, réussissant à se faire une place au soleil dans le monde de la mode.

Anne Fontaine nació en Brasil, aunque París ha sido la ciudad en la que ha desarrollado su carrera. Tras conocer a su marido, hijo de una familia dedicada al sector textil, ambos decidieron montar su negocio, que han especializado en blusas blancas, color que simboliza la espiritualidad en Brasil. Poco a poco han ido abriendo tiendas en París, Londres y Nueva York hasta que finalmente les ha llegado el éxito y han conseguido hacerse un hueco en el mundo de la moda.

Anne Fontaine è nata in Brasile, anche se è Parigi la città che vede l'esordio della sua carriera. Insieme al marito, figlio di una famiglia dedita al settore tessile, crea un'azienda specializzata nella produzione di camicie bianche, il colore simbolo della spiritualità in Brasile. Segue l'apertura dei negozi a Parigi, Londra e New York che consente loro di ritagliarsi gradualmente con successo uno spazio tutto proprio nel mondo della moda.

Interview | Anne Fontaine

Which do you consider the most important work of your career? Although I've done many things, the most important part is still to come. We have many projects lined up. We will know which is the most important one when it is done.

In what ways does Paris inspire your work? Paris inspires me a lot. It's the capital of fashion and the symbol of fashion and elegance.

Does a typical Paris style exist, and if so, how does it show in your work? Yes, Parisian women have a natural elegance and sophistication. They never play the "total look" but mix different clothes to create their own look. So, I design clothes made to be mixed with different pieces and accessories. You can create a different style and look whichever way you decide to wear it.

How do you imagine Paris in the future? For me, Paris will always be a dream city. It is full of history. It will maintain its personalized lifestyle..

Welches Werk halten Sie für das wichtigste Ihrer Karriere? Obwohl ich viele Dinge gemacht habe, liegt das Wichtigste noch vor mir. Wir haben eine ganze Reihe von Projekten in Planung. Wir werden wissen, welches das wichtigste ist, wenn es vollendet ist.

Wie inspiriert Paris Ihre Arbeit? Paris inspiriert mich sehr. Es ist die Hauptstadt der Mode und ein Symbol für Mode und Eleganz.

Gibt es einen typischen Pariser Stil, und wenn ja, wie macht dieser sich in Ihrer Arbeit bemerkbar? Ja, die Pariserinnen haben eine natürliche Eleganz und Raffinesse. Sie folgen nie einem „totalen Look", sondern kombinieren verschiedene Kleidungsstücke, um ihren eigenen Look zu schaffen. Daher designe ich Kleidung, die mit anderen Stücken und Accessoires kombiniert werden kann. Man kann einen anderen Stil schaffen und sie so tragen, wie man möchte.

Wie stellen Sie sich Paris in der Zukunft vor? Für mich wird Paris immer eine Traumstadt sein. Sie ist voll von Geschichte. Sie wird sich ihren persönlichen Lebensstil bewahren.

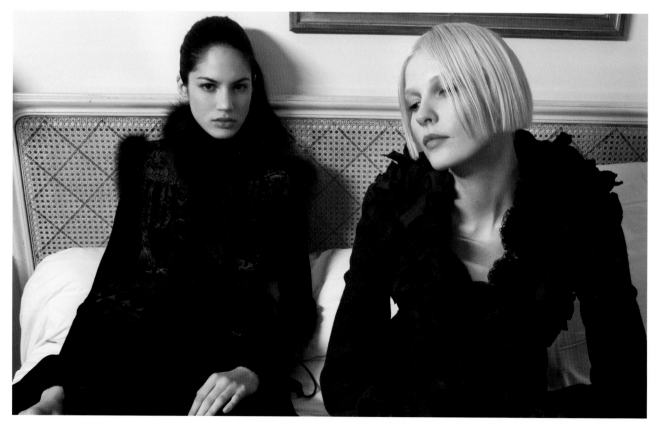

Quelle est à vos yeux l'œuvre la plus importante de votre carrière ? J'ai déjà réalisé beaucoup de choses, mais la plus importante est encore à venir. Nous avons plusieurs projets en vue. Nous saurons lequel est le plus important lorsque nous l'aurons réalisé.

Dans quelle mesure votre œuvre artistique s'inspire-t-elle de Paris ? Paris m'inspire beaucoup. C'est la capitale et le symbole de la mode et de l'élégance.

Existe-t-il un style typiquement parisien, et si oui, comment se manifeste-t-il dans votre œuvre ? Oui, la Parisienne possède une élégance naturelle et sophistiquée. Elle ne joue jamais le « look total » mais mélange divers habits pour créer son propre look. Alors, je conçois des habits faits pour être combinés avec divers éléments et accessoires. Vous pouvez créer un style et un look différents en fonction de ce que vous décidez de porter et comment.

Comment imaginez-vous le Paris du futur ? Pour moi, Paris restera toujours une ville de rêve. Elle regorge d'histoire. Elle gardera son style de vie typique et personnel.

¿Cuál cree que es el trabajo más importante de su carrera? Aunque he realizado muchos proyectos, el más importante está por venir. Tenemos muchos proyectos "en cola". Sabremos cuál es el más importante cuando lo terminemos.

¿Cómo le inspira París en su trabajo? París me inspira mucho. Es la capital de la moda y símbolo de moda y elegancia.

¿Existe un estilo típico de París? Y si es así, ¿cómo se muestra éste en su obra? Sí, las mujeres parisinas poseen una elegancia y sofisticación naturales. Nunca apuestan por un "look total" pero combinan la ropa para crear su propio estilo. Así que mis diseños están para combinarse con ropa y accesorios diferentes. Puedes crear un estilo diferente y llevarlo de la forma que te apetezca.

¿Cómo se imagina París en un futuro? Para mí París será siempre una ciudad de ensueño. Está llena de historia. Conservará su estilo de vida personal.

Quale ritiene sia l'opera più importante della sua carriera? Anche se ho fatto molte cose, la mia opera più importante deve ancora venire. Abbiamo molti progetti in previsione. Sapremo qual è il più importante una volta che l'avremo realizzato.

In che modo Parigi ispira il suo lavoro? Parigi mi ispira molto. È la capitale della moda e il simbolo della moda e dell'eleganza.

Esiste un tipico "stile parigino"? Se sì, come si manifesta nel suo lavoro? Sì, le donne parigine hanno un'eleganza e una ricercatezza naturali. Non ricorrono mai al "total look" ma abbinano capi diversi per creare il proprio stile. Per questo, io disegno vestiti che possono essere abbinati con diversi pezzi e accessori. Si può creare uno stile ed un look diversi a seconda di come si decida di indossarli.

Come immagina Parigi nel futuro? Per me, Parigi sarà sempre una città da sogno. È piena di storia e manterrà il suo personale stile di vita.

Anne Fontaine

Collection Fall/Winter 2006-2007

Year: 2006/2007

Photographs: © Marcus Man

The central element of Anne Fontaine's creations is the primarily white blouse. She draws her inspiration from classical blouses and plays with all the various design possibilities. Her creations exude sensuality, elegance as well as a formal touch, ranging from strict, starched white shirts with buttoned collars to black blouses with subtle transparency and pronounced necklines. Anne Fontaine's collection comprises manifold versions of a classic garment that will never go out of style.

Die, vornehmlich weiße, Bluse ist das Kleidungsstück, um das sich bei Anne Fontaine alles dreht. Sie lässt sich von klassischen Blusen inspirieren und spielt mit den verschiedenen Designmöglichkeiten. Ihre Entwürfe sind voller Sinnlichkeit, Eleganz und auch etwas Formalität und umfassen sowohl strenge weiße Stücke mit zugeknöpften steifen Krägen als auch schwarze Blusen mit dezenter Transparenz und ausgeprägten Ausschnitten. Es handelt sich um vielfältige Varianten eines klassischen Kleidungsstücks, das niemals aus der Mode kommen wird.

La blouse, d'un blanc paradigmatique, d'une pureté extrême, est l'élément central autour duquel s'articulent toutes ses créations. Anne Fontaine s'inspire des tenues classiques et joue avec tous les éléments que ce classicisme lui offre. Ses designs dégagent sensualité, élégance et une allure formelle qui se reflètent sur des pièces allant des chemises blanches strictes au col boutonné et amidonné jusqu'aux blouses noires aux transparences subtiles et décolletés prononcés. Autant de multiples façons de revisiter un habit basique qui ne sera jamais démodé.

La blusa, de un blanco, purísimo, es el elemento central alrededor del que se articulan todas sus creaciones. Anne Fontaine se inspira en las prendas clásicas y juega con todos los elementos que este clasicismo le ofrece. Sus diseños desprenden sensualidad, elegancia y un aire formal que se refleja en piezas que van de las estrictas camisas blancas de cuello abotonado y almidonado hasta las blusas negras con sutiles transparencias y escotes pronunciados. Se trata de múltiples revisiones de una prenda básica que jamás pasará de moda.

La camicia, di preferenza bianca, è l'elemento centrale intorno a cui si articolano tutte le sue creazioni. Anne Fontaine s'ispira ai capi classici e gioca con tutti gli elementi che questo classicismo le offre. I suoi modelli irradiano sensualità, eleganza e un'aria formale che si rispecchia in capi che vanno da capi di rigore in bianco, con collo abbottonato e inamidato, alle camicette nere con sottili trasparenze e scollature pronunciate. Si tratta di molteplici rivisitazioni di un capo basico che non passerà mai di moda.

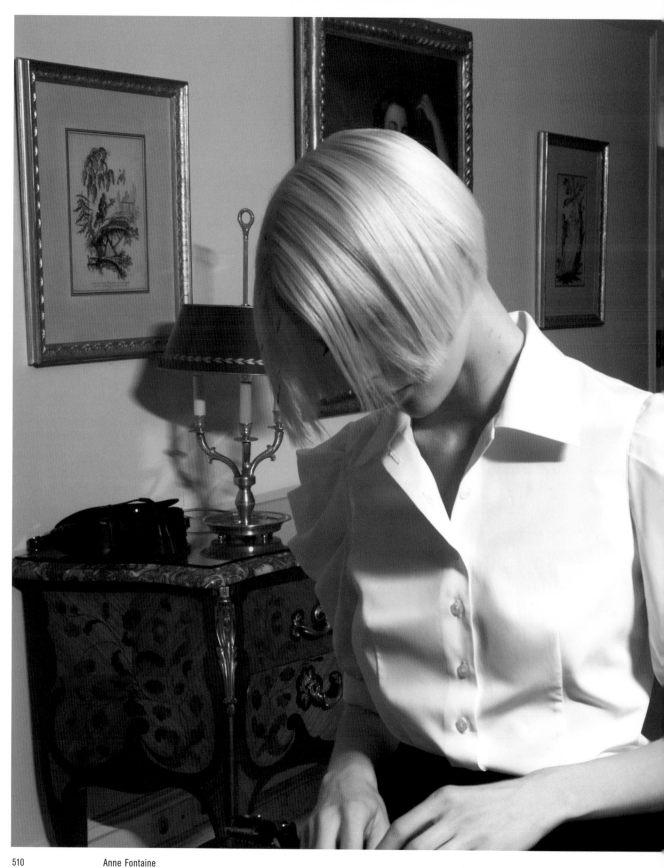

Anne Fontaine

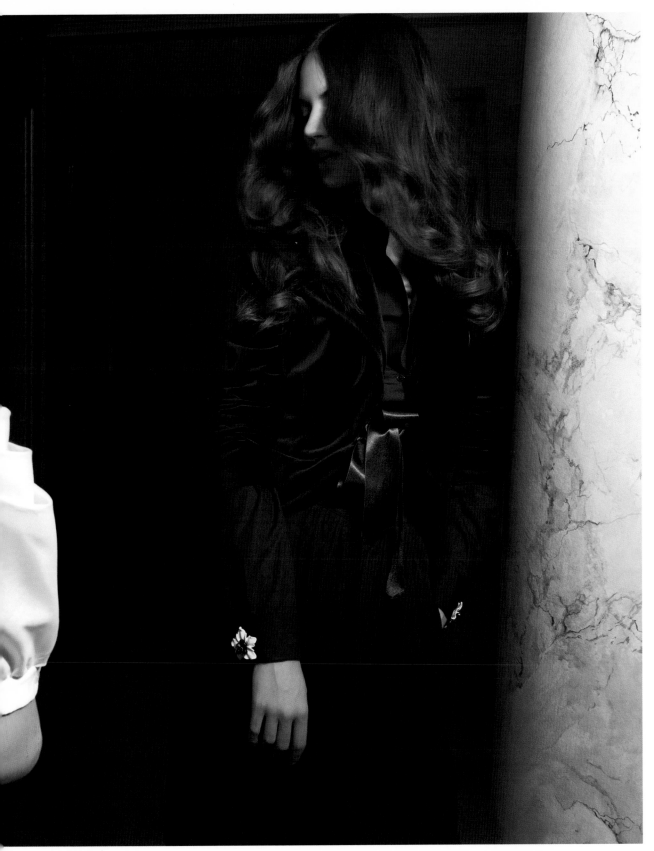

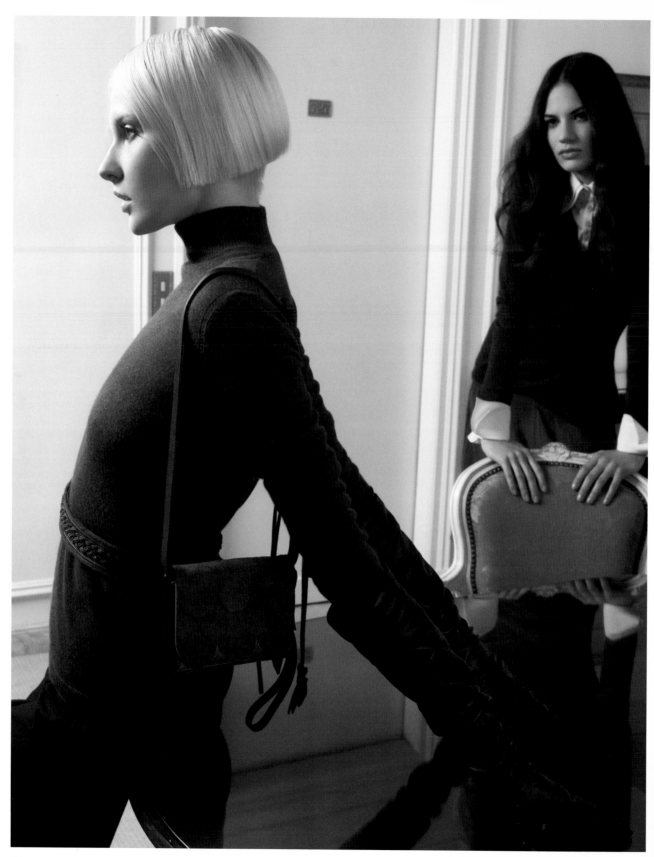

Anne Fontaine

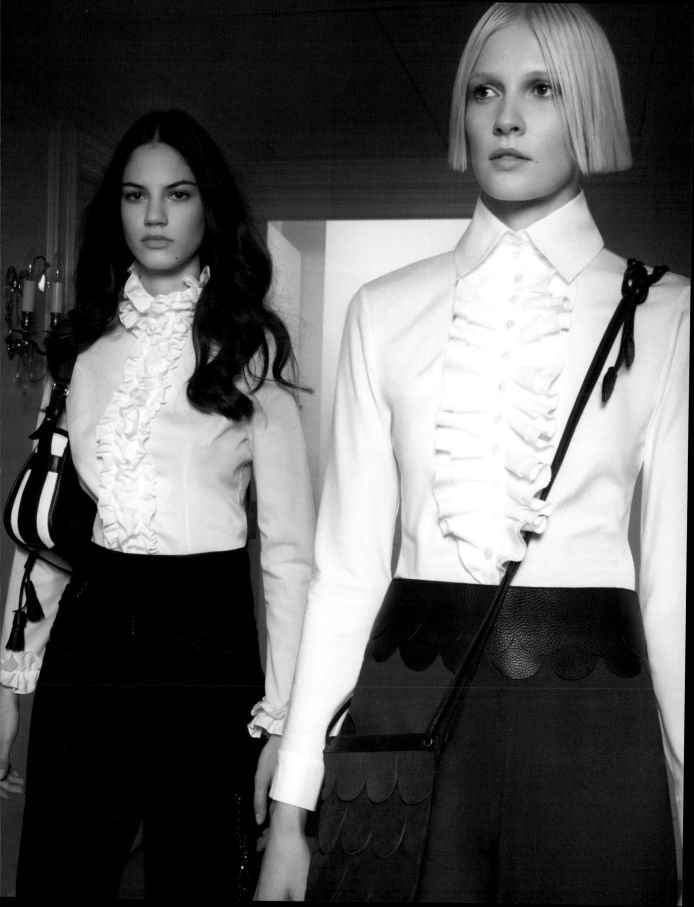

Dior Homme

Dior Homme

40, rue François Premier, 75008 Paris

Hedi Slimane

Hedi Slimane has revolutionized the world of men's fashion, first with Yves Saint-Laurent and, since the year 2000, with Christian Dior. His creations, elegant and chic, with sharp, almost extremely thin silhouettes, have earned him the admiration of many famous designers and have made him a name in the scene. A passionate music lover and great photographer, Hedi Slimane has now designed his first furnishings as well.

Hedi Slimane revolutionierte die Welt der Herrenmode, zuerst bei Yves Saint Laurent und seit dem Jahr 2000 bei Christian Dior. Seine Entwürfe, elegant und schick, mit scharfen, schon fast extrem dünnen Silhouetten, brachten ihm die Bewunderung vieler bekannter Designer ein und haben ihn zu einer Referenz der Szene gemacht. Der Designer, der ein großer Fotograf und Musikliebhaber ist, hat nun auch seine ersten Möbelstücke entworfen.

Hedi Slimane a révolutionné le monde de la mode masculine, d'abord chez Yves Saint-Laurent et ensuite en 2000, chez Christian Dior. Ses designs, élégants et chics, aux silhouettes effilées frôlant l'extrême maigreur, ont éveillé l'admiration des designers plus connus, faisant de lui un point de référence de la haute couture. Passionné de musique et grand photographe, il a fait récemment ses premiers pas dans le design de mobilier.

Hedi Slimane ha revolucionado el mundo de la moda masculina, primero desde Yves Saint-Laurent y desde el año 2000, en Christian Dior. Sus diseños, elegantes y chics, de siluetas ajustadas que rozan la extremada delgadez, han despertado la admiración de los diseñadores más consagrados y lo han convertido en todo un referente de la alta costura. Apasionado de la música y gran fotógrafo, también ha dado recientemente sus primeros pasos en el diseño de mobiliario.

Hedi Slimane ha rivoluzionato il mondo della moda maschile, prima alla Yves Saint-Laurent e, dal 2000, alla Christian Dior. I suoi modelli, eleganti e chic, dalla siluetta filiforme che sfiora la magrezza estrema, hanno suscitato l'ammirazione degli stilisti più consacrati e lo hanno trasformato in un vero e proprio punto di riferimento dell'alta sartoria. Appassionato di musica e grande fotografo, recentemente ha esordito anche nel disegno d'arredo.

1968
Born in Paris, France

1992
Assistant to Jean-Jacques Picart for the Louis Vuitton Monogram Centenary project

1997
Enters Yves-Saint-Laurent

2000
After his "Black Tie" collection for YSL, joins Christian Dior as Design Director for Men's Collections

2002
Named International Designer of the Year, by the CFDA (Council of Fashion Designers of America)

2004
His first book, Stage, is published by Steidl/7L

2006
Exhibition "As tears go by" at the gallery Almine Rech, Paris, France

Interview | Hedi Slimane

Which do you consider the most important work of your career? I have interest for the moment when my entire perspective changes and I have to reconsider everything. This is very interesting to me.

In what ways does Paris inspire your work? I am inspired by all that is part of my background since I was born and by the energy transmitted by certain particular moments. This is what I try to capture with my camera.

Does a typical Paris style exist, and if so, how does it show in your work? I was born and raised in Paris. I didn't travel very much while growing up, and now I find it difficult to spend much time outside of a big city. I'm inspired by different things I see, which I've been capturing with my camera since I was eleven years old.

How do you imagine Paris in the future? Paris is about being established. If you want to be able to push new ideas, there is only one way to do it: use your status within the establishment as a tool. It happens everywhere.

Welches Werk halten Sie für das wichtigste Ihrer Karriere? Ich interessiere mich für den Moment, in dem sich meine gesamte Perspektive verändert und ich alles neu überdenken muss. Das finde ich sehr interessant.

Wie inspiriert Paris Ihre Arbeit? Ich werde von allem inspiriert, das seit meiner Geburt Teil meines Lebens ist, und von der Energie, die von besonderen Momenten übertragen wird. Dies versuche ich mit meiner Kamera einzufangen.

Gibt es einen typischen Pariser Stil, und wenn ja, wie macht dieser sich in Ihrer Arbeit bemerkbar? Ich bin in Paris geboren und aufgewachsen. Während meiner Kindheit bin ich nicht viel gereist und heute fällt es mir schwer, für längere Zeit außerhalb einer großen Stadt zu sein. Mich inspirieren die verschiedenen Dinge, die ich sehe, und die ich seit meinem elften Lebensjahr mit der Kamera einfange.

Wie stellen Sie sich Paris in der Zukunft vor? In Paris geht es darum, etabliert zu sein. Wenn man neue Ideen vorantreiben will, gibt es nur einen Weg: Man muss seinen Status im Establishment dazu benutzen. Das ist überall so.

Quelle est à vos yeux l'œuvre la plus importante de votre carrière ? Je m'intéresse à l'instant précis où ma perspective totale change et où je dois tout reconsidérer. C'est ce qui m'intéresse le plus.

Dans quelle mesure votre œuvre artistique s'inspire-t-elle de Paris ? Je suis inspiré par tout ce qui forme mon expérience depuis ma naissance et par l'énergie transmise par des moments donnés. C'est ce que j'essaie de capturer au travers de mon objectif.

Existe-t-il un style typiquement parisien, et si oui, comment se manifeste-t-il dans votre œuvre ? Je suis né et j'ai grandi à Paris. Je n'ai pas beaucoup voyagé pendant mon enfance, et maintenant j'éprouve de la difficulté à passer beaucoup de temps en dehors de la grande ville. J'ai différentes sources d'inspiration que j'ai tentées de capturer à travers l'objectif de ma caméra, dès l'âge de onze ans.

Comment imaginez-vous le Paris du futur ? Paris est une ville établie. Si vous voulez parvenir à imposer de nouvelles idées, il n'y a qu'une façon de le faire : utiliser son statut au sein de ce qui est établi comme un outil. C'est partout pareil.

¿Cuál cree que es el trabajo más importante de su carrera? Estoy interesado en el momento en que toda mi perspectiva cambie y tenga que reconsiderar todo. Esto me resulta muy interesante.

¿Cómo le inspira París en su trabajo? Me inspira todo lo que forma parte de mi mundo desde que nací y la energía transmitida en determinados momentos especiales. Esto es lo que intento captar con mi cámara.

¿Existe un estilo típico de París? Y si es así, ¿cómo se muestra éste en su obra? Nací y me crié en París. No viajé mucho cuando estaba creciendo y ahora me resulta difícil pasar mucho tiempo fuera de una gran ciudad. Me siento inspirado por cosas diferentes que veo, que he ido recogiendo en mi cámara desde que tenía once años.

¿Cómo se imagina París en un futuro? En París hay que estar establecido. Si quieres ser capaz de impulsar nuevas ideas, sólo hay un único camino de hacerlo: utilizar tu estatus dentro del sistema como una herramienta. Esto ocurre en todas partes.

Quale ritiene sia l'opera più importante della sua carriera? Mi interessa il momento in cui la mia intera prospettiva cambia e devo riconsiderare tutto. Lo trovo molto interessante.

In che modo Parigi ispira il suo lavoro? Sono ispirato da tutto ciò che fa parte del mio retaggio dalla nascita e dall'energia trasmessa da alcuni momenti particolari. Questo è ciò che cerco di captare con la mia macchina fotografica.

Esiste un tipico "stile parigino"? Se sì, come si manifesta nel suo lavoro? Sono nato e cresciuto a Parigi. Non ho viaggiato molto da bambino ed ora trovo difficile passare molto tempo fuori da una grande città. Sono ispirato da diverse cose che vedo e che ho catturato con la mia macchina fotografica da quando avevo undici anni.

Come immagina Parigi nel futuro? A Parigi tutto è una questione di status. Se vuoi riuscire a promuovere nuove idee, c'è solo un modo per farlo: usare il tuo status all'interno dell'establishment per ottenere il tuo scopo. Ma succede ovunque.

Collections 2006/2007

Year: 2006/2007
Photographs: © Franck Barylko/Stéphane Feugère

Hedi Slimane remains true to his style for his fall/winter collection 2006/2007 as well: Unmistakable models with slender, angled silhouettes, slicked-back hair, narrow trousers, tight jackets and very thin ties. For his spring/summer collection 2007, the hair falls over the eyes like a helmet, the trousers are narrow and the upper portion of his clothing make the shoulders and torso appear broader. Both collections are dominated by black and white.

Auch in der Herbst/Winter-Kollektion 2006/2007 bleibt Hedi Slimane seinem Stil treu: unverwechselbare Modelle mit schlanken und kantigen Silhouetten, gegelten Haaren, schmalen Hosen, engen Jacken und sehr dünnen Krawatten. Für die Frühjahrs/Sommer-Kollektion 2007 lässt er die Haare wie einen Helm über die Augen fallen, die Hosen sind eng und die obere Kleidung lässt Schultern und Oberkörper breiter erscheinen. In beiden Kollektionen herrschen Schwarz und Weiß vor.

Comme dans ce cas particulier, la collection automne-hiver 2006/2007, Hedi Slimane reste fidèle à son style habituel : ses incontournables modèles aux silhouettes minces et anguleuses, aux cheveux gominés, pantalons étroits, vestes ajustées et cravates extrêmement fines portent son sigle personnel. Pour la collection printemps-été 2007, les cheveux tombent sur les yeux en forme de casque, les pantalons sont étroits et les vêtements supérieurs élargissent les épaules et le torse. Dans les deux collections, les couleurs toujours protagonistes, sont le noir et le blanc, sa palette de base.

También en este caso, la colección otoño-invierno 2006/2007, Hedi Slimane sigue fiel a su estilo habitual: sus inconfundibles modelos de delgadas y angulosas siluetas, los cabellos engominados, pantalones estrechos, chaquetas ajustadas y finísimas corbatas son su sello personal. Para la colección primavera-verano 2007, el pelo cae sobre los ojos en forma de casco, los pantalones son estrechos y las prendas superiores ensanchan los hombros y el torso. En ambas colecciones el negro y el blanco siguen siendo protagonistas.

Anche in questo caso, la collezione autunno/inverno 2006/2007, Hedi Slimane si mantiene fedele al suo stile abituale: i suoi inconfondibili modelli dalle magre e spigolose siluette, le chiome ingelatinate, i pantaloni attillati, le giacche aderenti e le sottilissime cravatte sono il suo marchio personale. Per la collezione primavera/estate 2007, i capelli cadono a caschetto sugli occhi, i pantaloni sono stretti e i capi spalla fanno apparire più ampi busto e spalle. In entrambe le collezioni il nero e il bianco continuano ad essere i protagonisti della tavolozza di base.

Dior Homme